I AM A
BEAUTIFUL
MONSTER

I AM A
BEAUTIFUL
MONSTER

POETRY, PROSE, AND PROVOCATION

Francis Picabia

TRANSLATED BY MARC LOWENTHAL

The MIT Press Cambridge, Massachusetts London, England

The Publisher would like to thank Damon Krukowski, Naomi Yang, and Exact Change for their early sponsorship of this book. An earlier version of this translation was originally to have appeared as an Exact Change publication.
—Roger Conover, Executive Editor, The MIT Press

This work, published as part of the program of aid for publication, received support from the French Ministry of Foreign Affairs and the Cultural Service of the French embassy in the United States.

Cet ouvrage, publié dans le cadre du programme d'aide à la publication, bénéficie du soutien du Ministère des Affaires Etrangères et du Service Cultural de l'Ambassade de France représenté aux Etats-Unis.

This book was set in Chaparral by The MIT Press, and was printed and bound in the United States of America.

Library of Congress Cataloging-in-Publication Data

Picabia, Francis, 1879–1953.
[Selections. English. 2007]
I am a beautiful monster : poetry, prose, and provocation / by Francis Picabia ; translated by Marc Lowenthal.
 p. cm.
Includes bibliographical references.
ISBN-13: 978-0-262-16243-2 (hardcover : alk. paper)
I. Lowenthal, Marc, 1969–. II. Title.

PQ2631.I3A2 2007
848'.91209—dc22

2006033784

10 9 8 7 6 5 4 3 2 1

CONTENTS

FRANCIS PICABIA IS AN IDIOT: ANTI-DADA, 1921–1924

The Dada movement has been framed and assessed in numerous ways: as the groundwork to abstract art and sound poetry, a starting point for performance art, a prelude to postmodernism, an influence on pop art, a celebration of antiart to be later embraced for anarcho-political uses in the 1960s, as well as—perhaps its most common summation—the movement that lay the foundation for Surrealism. However one wishes to use Dada, though, its one overriding significance for the twentieth century, and its one attribute that continues to cast a formidable shadow into the twenty-first, is the way it managed to, however briefly, *embody an attitude.*

Dada as attitude was, in its simplest form, one of attack: on the bourgeoisie who had instigated the senseless horror of World War I, on the mercantilism that was turning art into product, on the division between art and everyday life, and on the stultification imposed by a no longer relevant tradition. Dada was ultimately a *refusal,* and became, in its later stages, one of the finest expressions of nihilism in the twentieth century. If this is something of a simplification of only the best-known of Dada's attributes, it nonetheless captures its most emblematic and memorable characteristics. What the unconscious was to Surrealism, refusal was to Dada; and that this nihilistic spirit remains potent (and emulated) to this day is in no small part due to the contributions of Francis Picabia. A self-declared funny guy, failure, alcoholic imbecile, and pickpocket (not to mention painter and poet), Picabia was above all a most "beautiful monster," who for a significant period of time during the heady years of early modernism was able to rightly claim the distinction of being the anti-artist *par excellence.*

There are a few of us who, every morning on awakening, wish we could consult Picabia like a marvelous barometer on the atmospheric changes that took place overnight. —André Breton[1]

Were we to consult Breton's "Picabia-barometer" today, we would find ourselves with readings that indicate a prolonged and explosive storm throughout early twentieth-century modernism. Picabia was in many ways a true reactionary. If his apoliticism prevented his reactionary leanings from taking on the usual ultraconservative sense of the word (although Picabia was no stranger to conservative outlooks), his life and work were

nonetheless fueled by reaction: to art, to events, to friends and enemies, and even to himself—this self being arguably the most chaotic catalyst of them all. A self-proclaimed egoist, Picabia juggled the men in his life as often as the women, painted canvases as readily as he would paint over his own paintings, and was as happy dismantling an art movement as he was fueling it. Assessments of the man and his activities were understandably contradictory; Hans Richter wrote: "I met Picabia only a few times; but every time was like an experience of death."[2] Breton: "let no one object that Picabia has to die someday; it's enough that at this moment the very idea strikes me as insane."[3] Marcel Duchamp was a lifelong friend; Philippe Soupault and Pierre Reverdy were almost immediate enemies. The fact is that no one was indifferent to Picabia's personality, and the majority of the people with whom he crossed paths tended to vacillate between camps throughout both their lives and his. His only contemporary as skilled at bringing about such extremes in personal regard was perhaps Breton himself.

Assessments of Picabia's work also remain conflicting even today. Although the output of his Dada years has managed to enter the canon, the paintings of his later years continue to baffle. His lengthy outpouring of figurative and abstract kitsch made for a shift in output not dissimilar to the shifts in the careers of Giorgio de Chirico or Pablo Picasso. Although long dismissed and uncomfortably ignored, Picabia's late period is currently undergoing a reassessment, and becoming a focus for studies, exhibitions, and catalogs.[4]

One mainstay supporting these sometimes violently conflicting vicissitudes in Picabia's work and attitudes was undoubtedly the specter of Dada. Picabia's own exuberantly nihilistic conception of it has become the best-remembered of all of Dada's varied characteristics, and any understanding of the movement would be impossible without at least an effort to understand Picabia. And it does take an effort: to discover him in his early years as a successful society painter of Postimpressionist landscapes comes as an initial shock to many Dada historians. "The first thing a landscapist must be is a conscientious artist. . . . One should not want to bowl over the public, as so many young people do. . . ."[5] Who would have imagined the scandalmongering nihilist to have ever uttered such a statement? Who could have imagined that Picabia's rearguard Postimpressionist landscapes would evolve into his geometric abstractions, let alone the Dada machine works for which he is best remembered?

Yet for all its chameleon phases, Picabia's career can be broken down into three distinct periods, and easily be read along a Dada axis: pre-Dada,

Dada, and post-Dada.[6] These classifications are all the more convenient in that they also mark periods echoed by shifts in his marital status. Picabia's first wife, Gabrielle Buffet, played a preponderant role in Picabia's move away from his early academic period into his engagement with abstractionism. A professional musician, her ideas about "Absolute music" found a receptive audience in the budding "Absolute painter." She was present for the beginnings of Picabia's fruitful friendship with Marcel Duchamp, as well as for his arrival in New York (and thus, for the beginnings of New York Dada).

Germaine Everling, although never actually Picabia's wife in the legal sense, was Picabia's partner next. Her entrance is a rough[7] preface to his first meeting with Tristan Tzara in Switzerland and his subsequent impact on Zurich Dada; her Paris apartment would soon after become not only Tzara's next home, but the veritable headquarters for the Paris Dada movement.

And finally, Olga Mohler outgrew her role of nanny during Picabia's relatively calm post-Dada years in Cannes to become Picabia's third (though "officially" second) spouse—offering an eventual segueway into the turmoil of World War II, and the second outpouring of writing that would close out Picabia's final years.[8]

If the impact of all the women in Picabia's life was not as direct on his art as was Gabrielle Buffet's, it nonetheless remains significant. Picabia's life was his art, and his embracement of it formed the essence of his "antiart"—an opposition to the usual favoritism given to that "mistress of mistresses," the artistic muse. It is in the degree that this opposition progressively weakened throughout his life (and ultimately vanished) that the strength of Picabia's contributions to the art world can be, and often have been, assessed.[9]

Picabia has destroyed "beauty" and built his work with the leftovers.
—Tristan Tzara[10]

It was their talent for destruction that impelled André Breton to state, years later, that Tzara, Picabia, and Georges Ribemont-Dessaignes had been "the only true 'Dadas.'"[11] But the destructive nature of the Dada movement, despite being its best-known feature, was only one of its aspects.

There are four primary stages of Dada: New York Dada, Zurich Dada, Berlin Dada, and Paris Dada.[12] Picabia was a major influence on three of

them. While Dada's stages have been outlined enough times to not bear repeating here, Picabia's influence on them deserves a brief sketch.

It was through the infiltration by such European figures as Picabia and Duchamp (initially by means of the Armory show, which had already established scandalous reputations for both of them) that the New York art scene of that period can be said to have had its roots in Europe. Picabia had been the only French artist able to afford the trip over to America to be present for the Armory show, and for this reason became a spokesman for the European avant-garde. With the later arrival of Duchamp and Arthur Cravan, and the presence of American brothers- and sisters-in-arms such as Man Ray and Else von Freytag-Loringhoven, a series of artistic high jinks and scandals was not long in coming.

What makes New York Dada different from the other manifestations of the Dada movement, however, is that its impact (and attack) was primarily on the plastic arts. Although this was partially carried out through several printed journals (such as *The Blind Man* and Alfred Stieglitz's *291* and *Camera Work*), poetry and politics were ultimately minor concerns.[13]

Picabia's second sojourn in the States, along with his stays in Barcelona, was instigated by his avoidance of the war, the presence of which was much less felt, and thus much less urgent, in New York. His antimilitary and antiwar stance, though, was a far cry from a political stance: his attempted escape from his military duties differed only in context from his similar reactions to marriage and fatherhood. Despite his aversion to children, Picabia was himself something of an overgrown infant when it came to politics and responsibility.[14] Although such political naivete was to pay a price in World War II (when an apolitical stance would become impossible), and would have made him superfluous in Berlin Dada, such a negligent and provocative attitude worked all too well in New York, among what was essentially a community of upper-class bohemians rooted in salons and galleries, whose gravest wartime threat was usually little more than a case of boredom. In Picabia's case, the fruits of his boredom—the beginnings of his mechanical period in art, as well as his first poetic efforts— were ultimately overwhelmed by his mental and physical exhaustion resulting from the excesses of his New York lifestyle. His prolonged treatment and recovery from his neurasthenia eventually led him to an attempt at quietude in Switzerland.[15]

Picabia is a desperate case. —Jean Arp[16]

In Zurich, where the movement officially originated, we find some of Dada's lesser-known characteristics: its dedication to Futurist principles, its interest in expressionism, and its primary goal (mostly through the agency of Hugo Ball) of unifying all of the arts.[17] It is no surprise, then, that Hans Richter looks back on Picabia's arrival at this point as marking "the end of an era in the history of Zurich Dada."[18] After meeting with Tzara following a correspondence initiated by Tzara's enthusiasm for his book *The Mortician's Athlete,* Picabia and his flamboyant nihilism made an impression on the Zurich group as a whole. His machine drawings and paintings, and their complete disregard for aesthetics, offered something genuinely new, and in that environment easily came across as a reprisal to what the Futurists had been offering. His general attitude struck Richter as "a negation of life that was, if the word can be used in such a context, exuberant"[19]—a negation that apparently aligned so well with Tzara's that this visit can be seen as the real beginning of Tzara's role as Dada's ringmaster, and the solidification of the caustic nihilism for which Dada is best remembered.

Because of his infectious "negation of life," it is in Paris Dada—with its extreme nihilism, irony, scorn, and scandal—that Picabia's influence can be most clearly discerned. Whereas in its confrontational politics, artistic innovations, and absurdist brand of humor, Berlin Dada had perhaps best displayed what the movement was and could have been, Paris Dada was for the most part a literary movement with Picabia one of its only painters. Lacking such backdrops as the Spartacist movement or political figures such as Rosa Luxemburg to fuel their environment, Paris Dada took its stand more on issues of morality than politics and on the value of gestures over positions; ultimately, it aimed at conflict over coherence.

Michel Sanouillet has marked out three key dates in the Paris Dada movement. As the exact date of the Dada movement's birth in Paris, Sanouillet offers the first meeting between Picabia and Breton in Germaine Everling's apartment (a meeting anchored in an impassioned discussion of Nietzsche; this meeting on 4 January 1920 would also coincide, to both men's perturbation, with the birth of Everling and Picabia's only child together). Two weeks later, Tzara, belatedly following up on Picabia's invitation to Paris, would appear at Everling's door, ensconcing himself and the new Dada headquarters in her apartment. As the first event of Paris Dada, Sanouillet cites Breton's presentation of Picabia's work, *The Double World,*

at *Littérature*'s first public reading: a chalkboard drawing that Breton erased after its presentation. As this same reading concluded with Tzara's first public appearance in Paris, Picabia and Breton actually beat Tzara to the Parisian Dadaist punch, even if they did not elicit the same degree of outrage that Tzara's drowned-out reading drew from the audience.

Finally, the first Paris Dada publication (preceding both meetings and event): Picabia's 1919 *Thoughts without Language*.

DADA has 391 different attitudes and colors according to the sex of its president. —Tristan Tzara[20]

I am free in no state. —Max Stirner[21]

One of the most important elements of Zurich Dada, one that Picabia would continue to support, embrace, and exemplify over the years, was its espousal of internationalism. Although a somewhat natural attitude for the Zurich group to have taken (given both the range of nationalities taking refuge from the war in Switzerland at that time and their initial utopian aspirations), internationalism would become a rather challenging stance to maintain during world war, and even during post–world war times of patriotism in Berlin and Paris. No one was better representative of the internationalist spirit than Picabia, whose mixed heritage and nomadic lifestyle during the Dada years provided an essential circulation for the blood of the movement. Picabia would even brandish this internationalism as a means of provocation during his Paris years (see his letter "To Madame Rachilde," for example)—although not as frequently as the press would brandish patriotism and racism as a weapon against the Parisian Dadaists, who to the public eye appeared to be rallying about a movement of Germanic origin, and accepting (at least for a time) the Jewish Tzara as leader.[22]

Picabia's internationalism is nowhere better evinced than in his journal, *391*—arguably the most international of the numerous Dada magazines. Founded in Barcelona (although its title emulated Alfred Stieglitz's New York magazine *291*), Picabia would continue to put out issues in New York, Zurich, and finally, Paris. *391* was a "zine" ahead of its time: a self-published broadsheet of varying sizes and lengths that quickly did away with every typographical rule. Today's design and fashion magazines with their excesses and risks, not to mention the sprawling underground plethora of music, fan, personal, and political zines—all owe

an allegiance to the Dada journals, and to *391* in particular, perhaps the most unorthodox of them all.

391 was something of a personal (albeit collaborative) journal for Picabia, an outlet for all his sarcasm, sentimentality, wit, anger, and frustrations toward cubism, Dada, and friends and enemies (two camps whose boundaries were often blurred). Nietzsche, through the mouthpiece of Zarathustra, claimed that "The man of knowledge must not only love his enemies, he must also be able to hate his friends";[23] Picabia was adept in his practice of this adage through the mouthpiece of *391*. As Sanouillet notes, the journal tellingly ceased to appear once Picabia moved to Cannes, away from the Parisian art scene and into his happier years. Equally telling is the fact that this same shift in locale also signaled the end of his influence on the avant-garde.

All things are nothing to me. —Max Stirner[24]

DADA wants nothing, nothing, nothing —Francis Picabia
who knows nothing, nothing, nothing

His friends and colleagues were unanimous: Picabia was not merely a light reader, but even made it a point not to read at all. Looking for literary influences on his writing thus is fruitless, and any such clues to his sometimes hermetic poetry would seem by necessity to be biographical and psychological. But despite this dearth of reading (extremely uncommon for any figure of significant literary output, although also one possible explanation for the risks Picabia seemed able to take so easily in his early poetry), three books nonetheless played a preponderant role in Picabia's writing: *The Gay Science* by Friedrich Nietzsche, *The Ego and Its Own* by Max Stirner, and the *Petit Larousse* dictionary. If the *Larousse* was more of a tool than an influence,[25] the other two volumes were something more. The degree to which he actually *read* them is questionable (and evidence seems to point to superficial readings), but Nietzsche and Stirner were nonetheless Picabia's guiding philosophical lights.

Nietzsche's influence will be obvious throughout the writings presented here, and especially so in the late writings (such as in *Chi-lo-sa* and "The Masked Saint," in which Picabia went so far as to make patchwork collages of Nietzsche's aphorisms). Nietzsche was also an influence on a good number of the Dadaists and their generation—notably Hugo Ball,

Richard Huelsenbeck, and Tzara (who early on had been dubbed "Tzarathustra" by Max Jacob), but Picabia was certainly the one to take the philosopher most unequivocally to heart. One could view Picabia's repeated Dadaist claim, "I know nothing," as a response to Nietzsche's call for an "artistic Socrates."[26] Even when not directly quoting or rewriting him, Picabia never ceased to expound on the most typical of Nietzschean themes: morality, instinct, idealism, egoism, pessimism—and, of course, women (a problematic topic, to say the least, for both men).

That Picabia's understanding of Nietzsche was sometimes superficial and problematic was often most evident in his own personal life (a good deal of which could be read through a Nietzschean lens). Some examples of this can be found in Germaine Everling's memoir, *L'Anneau de Saturne*, particularly in her descriptions of the way he handled his infidelities. His first while with Everling was not atypical: after sleeping with a Romanian colonel's French wife (and managing to avoid two revolver shots from the colonel in the aftermath), Picabia wired Everling to leave Paris and join him in Lausanne, as he was suffering "palpitations" resulting from the incident. His response to Everling's bafflement is telling enough: "What do you expect? I am Francis Picabia!" It is tempting to see in this explanation an echo of Napoleon (as cited by Nietzsche): "I have the right to answer all accusations against me with an eternal 'That's me.' I am apart from all the world and accept conditions from nobody. I demand subjection even to my fancies, and people should find it quite natural when I yield to this or that distraction."[27]

More depressing is Everling's later account of Picabia's seduction and subsequent discarding of the artist Meraud Guiness (who would later change her name to Meraud Guiness Guevara; Everling refers to her as "Stephen"). Everling quotes from the letter Guiness writes to Picabia: "You told me that one must live 'dangerously'; that this was what life was about, that things must not be too easy. . . ."[28] To utilize one of Nietzsche's most beautiful passages (Picabia had undoubtedly been citing section 283 of *The Gay Science*) for the purpose of sexual betrayal is a betrayal on more than one level. While consoling the subsequently abandoned Guiness, Everling's revelation at this juncture sums up Picabia's inability to live up to his influences: "for the first time, I judged he to whom I had sacrificed everything. I discovered that a certain form of cowardliness was the dominant trait of his character; his egoism stemmed from it. He was not afraid of wounding people, but he was afraid of seeing blood flow. . . ."[29]

It is this dark spot, this "cowardliness," that manifests itself throughout Picabia's life (and particularly throughout his most intense periods of writing), this neurasthenia, depression, addiction, and boredom that prevents him from becoming any sort of *Übermensch* in regard to his life.

If Picabia *could* claim any such moniker, it would not be the Nietzschean *Übermensch,* but something more like Stirner's *Unmensch*— an embracement of an egoism so extreme that not only morals but even morality itself is discarded, along with all notions of taste, science, idealism, reality—even the very notion of *mensch;* in short, a rebellion against any . idea even remotely fixed.

But although Stirner possessed a style all his own, he hardly makes for the engaging reading that Nietzsche provides; the book was much more of a presence during the early twentieth century (particularly among the French intelligentsia), but *The Ego and Its Own* is a weighty book, and not one that Picabia would have been likely to read on his own (the exception being perhaps the book's short opening preface, "All things are nothing to me"). It was Duchamp who had introduced him to Stirner,[30] and it was most likely Duchamp who outlined Stirner's ideas for him.

Stirner divided human experience into three categories: realism, idealism, and finally, egoism. These categories follow each other like a maturation process: the child is realistic, dealing with the objects of the world, and trying to overcome the laws of the world; the youth is idealistic, dealing with thoughts, and trying to overcome the laws of his conscience; and the mature adult is egoistic, having overcome both, dealing with objects and thoughts, all depending on his particular interest.[31] He goes beyond being merely "free" and becomes his own.

It is somewhere in this realm between freedom and ownness that Picabia's writings dwell. "Who is it that is to become free?" Stirner wrote. "You, I, we. Free from what? From everything that is not you, not I, not we."[32] Picabia's "freedom" (and reputation) resided in Stirner's act of rejecting: more than his early forays into Postimpressionism, more than his post-Dada periods of transparencies, abstraction, and pastiche, it is Picabia's resistance to all trends, ideas, influences, and individuals—his fierce opposition to (even resentment of) any spotlight not trained upon himself—that, perhaps ironically, ensures his place in art history. It is a negativity worthy of inspiring an escape from any cultural stultification.

From freedom to ownness, though, requires a difficult step: "Freedom teaches only: Get yourselves rid, relieve yourselves of everything burdensome; it does not teach you who you yourselves are. Rid, rid! That

is its battlecry, get rid even of yourselves, 'deny yourselves.' But ownness calls you back to yourselves, it says 'come back to yourself!'" It is only after becoming free that the egoist exclaims: "we are in search of the *enjoyment of life!*"[33] This is an enjoyment that goes a bit beyond Nietzsche's "gay science," though, and it is for this reason that some troubles arise—within Stirner's philosophy (which has no trouble allowing for the act of murder if it provides the egoist "satisfaction"), but also within Picabia's writings, for it is at this point that his Stirneresque egoism comes up short.

There is one kind of literature which never reaches the voracious masses. The work of creative writers, written out of the author's real necessity, and for his benefit. The awareness of a supreme egoism, wherein laws become insignificant. —Tristan Tzara[34]

The "necessity" of which Tzara speaks—even in the case of a "supreme egoism" such as that of Picabia—is where "ownness" can become a slavery of another sort, and a slavery that brings us back to the preponderance of biographical and psychological roots over literary influence in Picabia's writings. For Picabia, the writer and poet was born out of boredom, neurasthenia, illness, addiction, and depression, in addition to (according to Buffet) occasional exhilaration. Whether because of his frequent and doubtless wearisome journeys by boat, his troubled first marriage and resultant solitude in New York, or his nervous depression and recuperation from opium addiction in Switzerland (where a doctor actually forbade him to paint), Picabia's early poetry arose from an absence of painting, which, despite his frequent antagonism toward the art world, was ultimately his real refuge and for him a truer source of pleasure. Even during his later years, one can trace much of the writing from his second burst of literary activity to the frequent insomnia from which he suffered.[35]

Because this early writing is so rooted in disorder and tropes of suffering, one would indeed be hard pressed to find abundant evidence for Picabia's attainment of what Stirner posited as the egoist's primary quest for enjoyment. The fact that Picabia's first book concludes with death opening a door, or that his second book offers such options as "Poison or Revolver," makes Stirner's "project" seem more like a desire than an actual accomplishment. If Nietzsche's *Gay Science* played a preponderant role in Picabia's writing and life, his writing and life ultimately made for something of an "ungay" science. Nietzsche had written: "some day I wish

to be only a Yes-sayer."[36] The distance separating these two men is thus nowhere better outlined than in Duchamp's summation of Picabia upon the latter's death: "Many people answer with 'Yes, but . . .' With Francis it was always: 'No, because . . .'"[37] Nietzsche: "Is it hunger or else superabundance that has here become creative?"[38] Picabia: "Is it hunger or abundance that produces the desire for destruction—maybe the two together."

Although it was the Surrealists who laid claim to the practice of automatic writing, utilizing the apparatus of the medium in their search for an originary source of language and molding it into the literary style for which automatic writing is known today, they were in fact preceded by the Dadaists.[39] As Breton and Soupault were exploring their magnetic fields, Dada was in the air, if not yet actually in Paris, and the majority of Picabia's early poetry had already seen print: *Purring Poetry* (his fifth book of poetry) preceded the first installment of what would become *The Magnetic Fields* in *Littérature* by several months.

No one among the Dadaists was more engaged with automatic writing than Picabia. His poetry, unhampered by any literary heritage, editorial instinct, or (as in the case with his stay in Switzerland), painterly or social distraction of any sort, makes for an often overwhelming logorrhea.[40] Although Picabia's poetry does not stand as fully representative of Dadaist poetry (especially as a good amount of it was written before his actual involvement in the movement), a comparison with the early automatic writing of the nascent Surrealists can begin to chart out the different approaches the two movements took to automatism. The main thing discernible is that Picabia's poetry not only lacks any touch of lyricism, but seems unconcerned with any poetic effect whatsoever.[41] The Surrealists, however, even in their Dada years, viewed poetry as something of a saving force, the highest form of art, and a necessary catalyst to any revolutionary undertaking.[42] Picabia's views on the matter (when he bothered to express them) verged on indifference. Even his close friendship with Guillaume Apollinaire, the reigning poet of French modernism, was founded on his appreciation of Apollinaire as a man, not as a poet (and as far as his poetry went, he claimed to find Apollinaire's work somewhat old-fashioned).

Part of this is, again, due to Picabia's lack of literary influence (though Nietzsche's poetry can be said to be an influence at later points in his career, such instances take the form of imitation and appropriation more than influence). Breton and Soupault, on the other hand, practiced their

automatism under the shadows of Rimbaud and Lautréamont—stylistic influences that can be easily discerned throughout *The Magnetic Fields*.

More important, Picabia had no qualms over reworking his output; whereas Breton (at Soupault's insistence) emphasized the importance of refraining from any effort at retouching or "correcting" automatic writing, the manuscript to Picabia's posthumous novel, *Caravansérail,* shows that he was prone to word-substitution—anticorrections aimed not at clarification, but at obfuscation. Verses are reversed in *Unique Eunuch,* and words are constantly removed, rearranged, prodded, and personalized throughout all of his early collections. If Breton had sought the attainment of "spoken thought" and "thought-writing," then the differences between the two men are particularly evident in Picabia's paradoxical title of *Thoughts without Language.*[43] Where Breton would lie in wait for slumbering phrases to come knocking at his window, Picabia never had any qualms about drawing the curtain.[44]

Picabia was more inclined to throw monkey wrenches into language than to set off in search of an originary tongue, and it is these wrenches that help link his writing to his art. Any discussion of automatism naturally leads to the mechanical sense of the word, and to Picabia's best-known artistic period: "Picabia!" Breton later exclaimed. "His 'mechanical period' should leave no illusions. His taste for machines hardly excludes an impulse toward sabotage."[45] Automatism (like Henri Bergson's notion of the mechanical in his essay on laughter) is undermined in Picabia's work: functionless machines; portrait machines aping, or worse, standing in for mechanized humans; work-and-sex machines—his was a mechanical bent that was couched in irony and anti-aesthetics, and opposed to the Futurist aesthetic glorification of technology. As Katherine Conley notes in her examination of the "Automatic Woman,"[46] this distinction between Surrealist and Dadaist automatism is well displayed in Picabia's depiction of the Virgin Mary, especially when compared to the one conceived by the Surrealists. Whereas the Surrealists associated the "automatic realm" (what lay on the other side of Breton's window) with darkness, death, and the unconscious (and, of course, Woman), Picabia's automatic realm is rooted in life and experience, in the blaze of the Nietzschean sun rather than the sunless night of dreams. If the Immaculate Conception puts the Surrealist child in touch with this "other" realm (which is for this reason asexual *because* "other"), then Picabia's "Daughter Born without a Mother" resides in the opposing realm. Max Ernst's scandalous painting, *The Virgin Spanking the Infant Jesus Before Three Witnesses: André Breton, Paul Éluard*

and the Artist (1928), is not, ultimately, a rejection of the Virgin Mary. Although Ernst, Breton, and Éluard are haughtily present at this scene and displaying evident scorn, their scorn is not directed at Mary, but at Jesus—whose intermediary role they plan on taking. The Virgin is the gateway to the other realm, to the other voice (and the other writing); Jesus is merely the ill-chosen man-child to act as interpreting poet.

Picabia's "Daughter," on the other hand, does away with the Virgin Mary altogether; she is the here and now, sexual, a rejection of the "other" realm. His own equally scandalous depiction of the *Blessed Virgin* (in the same issue of *391* that contains his re-creation of Duchamp's "defacement" of the *Mona Lisa*) portrays her as a splash of ink: the pure portal to the automatic realm transformed into something of an artistic "money shot."[47]

In his adherence to the present, to what he called "Instantanism," and the satisfaction of the ego, in his rejection of medium and muse, Picabia insistently placed himself, for better and for worse, at the opposite pole to the Surrealist project. The Surrealist adventure attempted to change life through art. Picabia changed (or rather, rejected) art through life.

Picabia was above all an "Abstractionist," a word he had invented. It was his hobbyhorse. —Marcel Duchamp[48]

Until more of Picabia's secrets are unraveled, it is through this lens of abstractionism that Picabia's poetry is best read. Although his first books, in their aliterariness and opposition to any poetic form then existent, are clear historical precursors to Dadaist literature, these early works resist such easy categorization. Picabia's early poetry does not carry the shock value or aggression of Tzara's Dada writings or Richard Huelsenbeck's *Fantastic Prayers,* nor the vitriol of his own protégé, Ribemont-Dessaignes. What's more, its abstraction shares nothing with Hugo Ball's incantations, or the linguistic abstraction of Raoul Hausmann or Kurt Schwitters. Picabia's literary abstraction operates on the levels of syntax and sense, but rarely on the level of the word and sound itself, and the few exceptions in his output were more for the sake of satire than experimentation. Verses and modifiers attach themselves impiously to others, referents are removed, and at times nothing more seems to be said than the fact that something is *being said;* but never is something *more* trying to be said, something *beyond* what is said (as was the case with Ball's retroactively mystical recitations at the Cabaret Voltaire, for example).

If there is anything to which Picabia's poetry can be usefully compared, it would perhaps be that of his fellow Spaniard "Pica" and on-again off-again rival, Pablo Picasso, whose years of literary output also coincided with a moratorium on painting. Both men's poetic writings make for cryptic diaries, therapeutic, if hermetic, explorations of what Rosalind Krauss describes as selfhoods, explorations "strangely projected as a form of documentary."[49] The poetry at play for both men seems ultimately to deal less with language than it does with experience—something Marc Le Bot discusses in one of the few essays that have been devoted to Picabia's poetry.[50] This is not experience "transformed" into art or literature (as it is with most literary or artistic endeavors), or even a language that is experienced (as was the case with some other Dadaists), but rather, experience as simply experience—something that is private, serious, amusing, abstract, unpoetic—and essentially incommunicable: a talking cure that provides no cure. And it is this lack of concern with, even refusal of, communication, this dismissal of both reader's and literature's expectations, that ultimately makes Picabia's abstractionism Dadaist. "It is the thesis that disappoints us," wrote Breton in one of his Dada manifestos, "not its expression."[51] Language does not have to communicate to affect, to be "touching." In her discussion of his readymades, Molly Nesbit cites Duchamp's indifference, his rejection of "beauty" and taste: "He was looking for another kind of relation to experience."[52] The further Picabia moved toward Dada, the more he wrote himself toward Dada, the closer he approached this similar goal: a rejection of communication for another kind of relation to language.

Apart from the chapter Picabia helped write in the history of automatic writing and literary abstractionism, perhaps his most important literary contribution was that of the "poem-drawings" that became his specialty during his mechanical years, examples of which can be found in *Daughter Born without a Mother*.[53] The incorporation of words into his art (what Breton referred to as "parasitic inscriptions") had originally served as ironic and sarcastic contextualizations for Picabia's machine paintings and drawings (most commonly in the cases when he would attribute subjects to his series of machine "portraits"). The drawings, however, while displaying obvious ties to the mechanical representations from which they originated, slowly grew more abstract; the inscriptions, though traceable to a shared origin, floated more freely; rather than the words illustrating the image, or even the image illustrating the words, the two ended up

utterly divided (betokening Duchamp's influence, whose titles came to be rigorously divorced from his readymades), while remaining physically intertwined. Language infiltrates the image, and drawing takes on a linguistic function.

Although sometimes compared to Apollinaire's "calligrammes," Picabia's poem-drawings go beyond them in their use of both language and form. As radical as they had been at the time, the calligrammes were still mimetic: a short (and sometimes banal) poem revolved about the object that the words visually depicted, be it a rose, a banjo, or a cigar. This was more or less in line with Marinetti's "words in freedom" or Amedée Ozenfant's notion of "psychotype"—the participation of typography in the expression of thought, be it ideogrammatic, mimetic, or symbolic. Many well-grounded readings have been done of Picabia's machine-drawings, uncovering the ironic, sarcastic, pessimistic, and patriarchal allusions of his titles and inscriptions in conjunction with their respective images. The more abstract poem-drawings, however, lend themselves less easily to such interpretations. If Saussure explicated the arbitrariness of language, and the link of signifier to sign, Picabia (and Duchamp) *demonstrated* it, and for this reason the poem-drawings can be seen, perhaps ironically, as more linguistic than their contemporary Futurist or calligrammatic poems. Breton had pertinently stated: "Picabia was the first to understand that *any* juxtaposition of words is valid and that its poetic virtue is all the greater the more gratuitous or irritating it seems at first glance."[54] Although perhaps an overly constructive reading of Picabia (who certainly tore a good number of words from their context to attain such aggressive juxtapositions), it brings to mind Breton's later "poem-objects" (inscripted assemblages of found objects), perhaps the closest kin to Picabia's poem-drawings.[55]

If the work of another translates my dream, his work is mine. —Francis Picabia[56]

However great the greed of my desire for knowledge may be, I still cannot take anything out of things that did not belong to me before; what belongs to others remains behind. How is it possible for a human being to be a thief or robber? —Friedrich Nietzsche[57]

Perhaps the most ticklish aspect of Picabia's writings, and particularly of his later writings, is his often blatant, and as yet little discussed, plagiarism and appropriation of Nietzsche. Although Tzara had labeled

him a "literary pickpocket" as early as the Dada years, and Max Jacob had accused him of plagiarizing the work of Man Ray's American companion, Adon Lacroix,[58] it is really in his later years that such accusations have the most bearing. In his aphoristic work *Chi-lo-sa* (perhaps the best-known of Picabia's poetic works from his late period), one will find that Picabia sometimes inverts phrases by Nietzsche, sometimes alters them, but most often, simply copies them. It is thus somewhat befuddling to read some of his typically arrogant and declamatory sentiments in his letters of that period: "Painting is a very beautiful thing, if at least painters were painting instead of depicting the thought of others."[59] This is stated in one of his many letters to Christine Boumeester, in which he would often quote lengthy, unattributed passages from Nietzsche as if they were his own!

One could refer to an earlier instance, in which Picabia had been unmasked by an art critic who printed the technical drawing Picabia had copied for his Dada-era painting *Les Yeux chauds* (*The Hot Eyes*). "Picabia, then, has invented nothing: he copies!" was the article's conclusion. "Copying apples, anyone can understand that; copying a turbine: that's stupid," Picabia replied. "In my opinion, what is even stupider is that *The Hot Eyes,* which was inadmissible yesterday, now becomes, through the *fact* that it represents a convention, a painting that is perfectly intelligible to everyone." Picabia's continued argument rested on Duchamp's conception of the readymade: "The painter makes a choice, then imitates his choice, whose deformation constitutes *Art;* why not simply sign this choice instead of monkeying about in front of it?"[60] As far as his painting went, the usage of readymade imagery eventually led to Picabia's endless use of pastiche, which runs throughout all the stages of his painting (most obviously in the transparencies, which draw from classical sources, but sources such as glamor and science magazines and advertising for many of his other paintings continue to be uncovered).

Pastiche opens up a whole course of interpretation of Picabia's work,[61] but it is one that is too complicated for our purposes here and that does not quite apply to Picabia's writing. Any argument for a late work such as *Chi-lo-sa* as being something of a pastiche, or a literary "collage," is weakened by the fact that the material being collaged, and the style being pastiched, is consistently derived from one source: Nietzsche's *The Gay Science*. If one looks to precedents for such a work, a particularly apt one would be Blaise Cendrars's 1924 work (for which Picabia, significantly, provided a frontispiece): *Documentaries (Kodak)*, a series of poems composed entirely of passages taken from the pulp novel *The Mysterious*

Doctor Cornelius by Cendrars's friend, Gustave Le Rouge. Cendrars's work precedes Picabia's late period by a quarter of a century, however.[62] In this case, as with the *Hot Eyes* incident already mentioned, the issue becomes focused on the *choice* of material: Cendrars's choice of Le Rouge, like Picabia's choice of a turbine engine, introduces "foreign matter" into "high" art and literature, and thereby creates something new, both aesthetically and conceptually. An aesthetic or conceptual *transformation* takes place.[63] It is questionable to what degree a transformation takes place — either stylistically or conceptually — in Picabia's new contextualizations of Nietzsche, whether the context be that of his poetry or his letters. Nietzsche, a master of the aphorism and a poet in his own right, recontextualized as Picabia, aphorist and poet, represents not so much a transformation of Nietzsche as the self-transformation that Picabia had perhaps still desired in the final, rather saddening years of his life.

The worst readers of aphorisms are the author's friends if they are intent on guessing back from the general to the particular instance to which the aphorism owes its origin; for with such pot-peeking they reduce the author's whole effort to nothing; so that they deservedly gain, not a philosophical outlook or instruction, but — at best, or at worst — nothing more than the satisfaction of vulgar curiosity. —Friedrich Nietzsche[64]

One might then question the need for this book's critical apparatus. Indeed, Olivier Revault d'Allonnes, the first French editor of Picabia's writings, went so far as to offer something of an apology for even putting these writings together: "Nothing would have displeased Francis Picabia more than a complete new edition of his written works."[65] And again: "To republish his writings more than twenty years after his death, and in a chronological, annotated, 'scientific' edition, so to speak, is to betray him, some think, is to bury him beneath an academic tumulus that suits him very badly."[66]

A few reasons have impelled me to attach what may be construed as academic notes to the anti-academic spirit of Picabia's writings. First, I don't wholeheartedly believe in this spirit: the fact that it was Gallimard's rejection of Picabia's proposed collected essays that played a part in the growing rift between Breton and himself seems to cast doubt on Revault d'Allonnes's interpretation of Picabia as being against new editions. Once Dada had ended, and even before, Picabia had never, to my mind, ceased to desire the role of *maître,* and it was the loss of this role as leader that

impelled him eventually to part ways with the Dadaists. Even when engaged in an attack on the *maîtres*, he still, in my opinion, wished to be the one leading the attack. Picabia's egoism was ultimately a mask for a great fragility, one that can be seen running through all the divagations and contradictions of his life and work. The fact that until recently misguided adulation has directed much of the critical work on his writings calls for some critical context in which to place his frequently outrageous (and of course, egotistic) claims throughout these pieces.

Second is the already mentioned fact that much of Picabia's later aphorisms and writings were taken directly from Nietzsche, the specific sources for which have not previously been documented.[67] Providing such documentation should provoke two things: a need to take into account the increasingly primary element of appropriation that has already been getting untangled in Picabia's paintings; and a reassessment of Picabia's legacy as a writer—a reassessment that may shift attention from his oft-cited aphorisms to his early abstractionism.

Third, because almost all of Picabia's art, writings, and other provocations were always in reaction—to events, to his contemporaries, to himself—these works require a fuller context. If Picabia was, in the end, a true barometer of the early twentieth-century avant-garde, then one needs to know where the barometer was placed if one is to read it.

[A]nybody called Francis is elegant, unbalanced and intelligent and certain to be right not about everything but about themselves.
—Gertrude Stein[68]

When I imagine a perfect reader, he always turns into a monster of courage and curiosity. . . . —Friedrich Nietzsche[69]

Translating Picabia's poetry was an arduous and frequently maddening process. Syntax is often butchered, antecedents are removed or buried, and nouns and adjectives change roles without warning. Although I have no wish to detail the travails that this sometimes incurred, I do feel it necessary to emphasize that much of Picabia's early poetry is willfully awkward. Although I have striven for fluid verses and phrases when they read as such in the French, there are numerous syntactical and structural snafus that I intentionally allowed to carry over into the English. If a chunk of text sometimes seems to be missing, or some verses come off

more stilted than poetical, it is safe to assume that the result mirrors what occurs in the original French.

That said, such a preestablished back door does not excuse less than polished translations, and a number of improvements have been made throughout this book over time. Thanks are owed to Roger Conover and the eagle-eyed Judy Feldmann, whose suggestions and guidance have aided me in steering these translations into their current form.

I have reverted to the original publications of certain pieces when minor conflicts in matters such as punctuation arose, but otherwise I relied on the two-volume Belfond edition of Picabia's writings for my source text, as edited by Olivier Revault d'Allonnes and Dominique Bouissou.[70] *I Am a Beautiful Monster* represents roughly two thirds of those two volumes (and thus excludes Picabia's posthumously published novel and his letters). This English collection had originally been conceived as a collection of his poetry, but steadily expanded into a more rounded picture of Picabia's written output. His poetry remains emphasized, though, for two reasons. A good number of Picabia's articles, attacks, and quips are rooted in incidents and squabbles that are of more academic interest today, and would require notes that could at times outweigh the texts themselves. The second problem with Picabia's articles is that they get fairly monotonous: whether he is engaged in self-promotion or one of his repeated attacks on former Dadaists or the art market, the reader tends to get the thrust (not to mention style) of what Picabia has to say in a more judicious selection.

Further thanks are owed to Damon Krukowski and Naomi Yang, who originally instigated this project, to Raphael Rubinstein, who contributed his translation of *Jesus Christ Rastaquouère* to this collection, and to Marc Dachy, who was kind enough to consult some materials in the Bibliothèque Jacques Doucet for me. Particular thanks are owed to Emily Gutheinz for her masterful handling of what had been a bulky and awkward manuscript; her design has allowed me to see these writings with new eyes.

My own work on this book is dedicated to Michel Sanouillet, who paved the way, and Anne Sanouillet, who keeps the way paved. As this book and its translations, selections, and notes stand, of course, any faults to be found with it are my own.

1. Breton, *The Lost Steps,* p. 97. This quote carries some retroactive irony in that Picabia would later make a number of drawings in his journal *391* satirizing Breton and the Surrealists, two of them through the depiction of a "Rimbaud thermometer." In one of these drawings, said thermometer is placed in the predictable orifice of an ambiguously sexed figure.

2. Richter, *Dada,* p. 74.

3. *The Lost Steps,* p. 96. The dramatic tone to these encounters is further evinced in Picabia's assessment of Breton as being "truly the man that one should meet two or three times in life to have the courage to keep on living" (Polizzotti, *Revolution,* p. 119).

4. One kickstart to this reassessment traces back to David Salle's paintings of the 1980s: his own work is a clear (even if, as Salle claims, unintentional) emulation of Picabia's lengthy series of post-Dada "transparencies." Salle's transparencies distinguish themselves by being divested of Picabia's classical referents.

What Arnauld Pierre has recently made strikingly clear, though, is the consistency in Picabia's method of appropriation, from his earliest Postimpressionist landscapes to his later nudes. The essential themes of appropriation, transparency, and the fake that link together all of Picabia's output will be apparent throughout the writings collected here.

5. From an interview in *Le Gaulois du dimanche,* Paris, February 9–10, 1907, p. 2; quoted in Camfield, *Francis Picabia,* p. 12, n. 12 (translation slightly modified).

6. As what is commonly known as "New York Dada" (and the less often cited "Barcelona Dada") falls under the period I shall refer to as "pre-Dada," there will no doubt be some objection to these divisions. Although the Dada spirit was indeed in plain evidence during those earlier years, for my purposes it is the embracement of the moniker itself that constitutes an engagement in the Dada movement. As trivial as the squabbles over the paternity (and renunciation) of the name now seem, they had no small impact on the cultural events of the time, and played a particularly crucial part in Picabia's actions and personal involvement in (and manipulations of) the Dada movement.

7. If not to say tangled: Picabia proved to be a most unreliable spouse throughout his life.

8. One could perhaps attribute Picabia's flagging powers of seduction in his later years to the fact that the nonetheless significant figure of Suzanne Romain never quite entered this schema to become the fourth "Bride" in his life.

9. This is obviously a fairly subjective statement, and not one that will be supported here in regard to Picabia's painting; in terms of his writing, however, it is one I feel is sustained by the overview that this collection provides.

10. Tzara, *Seven Dada Manifestos*, p. 81.

11. Breton, *Conversations*, p. 50. Tzara's role in Dada is well established; Ribemont-Dessaignes, though, despite being Picabia's faithful protégé during those years (most evidently in his artistic output, but more significantly in his general attitude), is less known in translation. His vitriolic writings remain to be adequately represented in English.

12. A fuller outline would include Barcelona Dada (which was more or less Picabia's private branch of Dada, although one that continued after his departure from Spain), Cologne Dada, and Hannover Dada. The reader is referred to Malcolm Green's useful introduction to Richard Huelsenbeck's *Dada Almanac* for a succinct understanding of the primary stages of Dada, and to Hans Richter's *Dada: Art and Anti-art* for a lengthier, detailed account.

13. With some exceptions, of course: Man Ray and Adolf Wolff both had anarchist roots, and poetry made up a good portion of Picabia's own Barcelona-born journal, *391*. For a gleaning of New York Dada poetry contemporaneous with that of Picabia, the reader is referred to Jerome Rothenberg's anthology, *Revolution of the Word*.

14. It was only through his wife's efforts that Picabia managed to avoid court-martial and jail as a result of his total neglect of his rather cushy wartime assignment of purchasing molasses—the assignment responsible for bringing him back to America.

15. As Amelia Jones pertinently points out in her *Irrational Modernism*, World War I made neurasthenia "a synonym for a certain kind of shell shock" (p. 52). There is something perverse (and distinctively illustrative of New York Dada) in the fact that Picabia managed to continue avoiding the war after escaping court-martial through a shell shock that resulted from hedonism. Jones provides an excellent analysis of Picabia's neurasthenia of this period as

his failure at sublimation (of threatened masculinity and urban modernity). An argument could also be made, though, given Picabia's situation at that time, that sublimation or assimilation would have been the last thing on his mind. According to the common theory of neurasthenia then (as held by Joseph Collins, who was Picabia's doctor in New York) treating the condition demanded the sufferer to combat a rising egoism; so Picabia's open embracement and celebration of egoism amounted to an embracement of neurasthenia. Several years later (at the height of Paris Dada), Isaac G. Briggs would maintain that "Egoism, moral cowardice, and sexual excess play a part in much neurasthenia . . ." (*Epilepsy, Hysteria, and Neurasthenia*, p. 38).

Picabia's awareness of this correlation between egoism and illness is evinced in his poem-drawing "Egoist" (from *Daughter Born without a Mother*), which bears the captions "convalescent" and "doctor."

16. Arp, *Arp on Arp*, p. 261.

17. Given the similar nature of Breton's later efforts in establishing the Congress of Paris, which were to definitively seal the end of the Dada movement, one cannot help but wonder what Breton's involvement in this earlier stage of Dada might have led to.

18. Richter, *Dada*, p. 71.

19. Ibid., p. 75.

20. Tzara, *Seven Dada Manifestos*, p. 45.

21. Stirner, *Ego and Its Own*, p. 201.

22. Tristan Tzara's real name was Samuel Rosenstock; his assumed Romanian name translates as "Sad in Country"—a name adopted in protest against the treatment of Jews in his home country. Unfortunately, neither Picabia nor Breton proved themselves above anti-Semitic remarks once it was deemed time to topple Tzara and the Dada movement.

23. Nietzsche, *Thus Spoke Zarathustra* in *The Portable Nietzsche*, p. 190.

24. Stirner, *Ego and Its Own*, p. 5.

25. Specifically with its "pink pages," a section of translated Latin and foreign phrases from which Picabia would draw titles for his paintings and books. It appears that his use of this as a source for titles was discovered by Jean-Hubert Martin and Maria Lluïsa Borràs independently of each other. Instances of its usage throughout the writings in this volume have been included in the endnotes.

As far as "source" books go, the *Petit Larousse* has now been joined by Rémy de Gourmont's *Physique de l'amour,* thanks to Arnauld Pierre's recent study. The list of source books from which Picabia drew readymade thoughts and phrases shall undoubtedly grow over the coming years, but for the purpose of this introduction, these stand more as raw material than literature in the context of Picabia's writing.

26. Socrates' claim to wisdom in Plato's *Socrates' Defense* being founded on his unique cognizance of the fact that he did not know anything. Picabia was apparently familiar with Plato, given that he used (or at least allowed for the inclusion of) a lengthy passage from *Philebus* for his 1913 exhibition at the Gallery 291.

27. Nietzsche, *The Gay Science,* p. 98.

28. Everling, *L'Anneau de Saturne,* p. 191 (my translation).

29. Ibid., p. 190 (my translation).

30. In New York, around the time of Duchamp's creation of his *Three Standard Stoppages,* a Stirneresque approach to measurement.

31. Stirner's schematization can be found in the first section of *Ego and Its Own,* "A human life" (pp. 13–18).

32. Ibid., p. 148.

33. Ibid., p. 283.

34. Tzara, *Seven Dada Manifestos,* p. 7.

35. P. A. Benoit suggests boredom both on the sea and in Switzerland as the source of Picabia's repeated forays into poetry, and Borràs points out the literary effects of Picabia's insomnia in his later years. But Sanouillet perhaps makes the strongest case for Picabia's poetry as both something of an "unconscious psychoanalytic self-treatment" and the unveiling of his subconscious toward techniques other than therapeutic. It should be noted, though, that Pierre de Massot took exception to this general notion, claiming that, according to Duchamp, Picabia's New York poetry had arisen from a state of euphoria. But ultimately, it is the work itself that offers indications to Picabia's mindset: themes of suicide, solitude, and a morbid sexuality run through-out his pre-Dada books.

36. Nietzsche, *Gay Science,* p. 223.

37. Duchamp, *Writings,* p. 167.

38. Nietzsche, *Gay Science,* p. 329.

39. See, for example, the "automatic simultaneous poems" by Hans Arp, Walter Serner, and Tristan Tzara (appended to Marc Dachy's *Dada et les dadaïsmes*), or Picabia's own forays, such as the untitled piece on p. 122 of this collection.

40. This doesn't take into account the fact that, according to Sanouillet, a good deal of Picabia's poetry remains unpublished and buried in letters. Everling's memoirs demonstrate that many of Picabia's Swiss poems had either first taken the form of love letters to her, or vice versa.

41. This is not the case with Picabia's later books such as *Thalassa in the Desert,* though.

42. Even if, in the shadow of Rimbaud, under-taking poetry was accomplished through the rejection of poetry and the poetic role, this rejection itself became a poetic act, but one that would never be fully carried out: Breton's and Éluard's individual "renouncements" of poetry both proved to be merely the beginnings of long careers in the field.

43. Breton uses the terms "spoken thought" and "thought-writing" in his *Manifestoes of Surrealism* (pp. 23–24); this is not to say, however, that Picabia's *Thoughts without Language* had been any sort of response to Breton: it preceded Breton's first manifesto by five years.

44. Breton describes revelatory phrases "knocking at his window" in his first *Manifesto of Surrealism.*

45. Breton, *Conversations,* p. 251.

46. See Conley, *Automatic Woman.*

47. I would not want to adopt the (what I consider reductive) reading Amelia Jones offers, however, in her essay "Eros, That's Life, or the Baroness' Penis": "Picabia's mechanical 'girl born without a mother' images both replace woman's role in procreation with a God-like creation and ensure that the 'girl' will be around for the whims of the remaining world of men" (in Naumann, *Making Mischief,* p. 241). ("Girl" is Jones's translation for *fille.*) The examples she draws from the *Daughter* drawings are selective, and ignore the examples of comical male "apparatuses," not to mention the presence of hermaphroditism in the poem-drawing entitled "Male." While Picabia's automatism lends itself to interpretations along the lines of gender and sexuality, his visual machinations bear greater resemblance to bachelor machines or torture devices than anything as mundane as a patriarchal relationship. Jones's

revised analysis in *Irrational Modernism,* on the other hand, offers a very fruitful approach to Picabia's "irrational, leaky masculinity," and provides a window into certain hermaphroditic moments in his writings.

48. Cabanne, *Dialogues with Marcel Duchamp,* p. 43 ("Picabia était surtout un abstractioniste, un mot qu'il avait inventé. C'était son 'dada'" [Duchamp, *Ingenieur du temps perdu,* p. 72]). The significance of this observation might pass unnoticed by English readers of Duchamp's conversations with Cabanne, unless one is aware that "hobbyhorse" is the most common translation of the term "Dada." In one sentence, then, Duchamp effectively deemphasizes the role of Paris Dada in Picabia's career, and regrounds him in his earlier, pre-Dada and abstractionist years.

49. Krauss, *The Picasso Papers,* p. 210.

50. Apart from Le Bot, one of the more astute readers of Picabia's poetry was also his earliest: Gabrielle Buffet's remarks remain as insightful today as when she wrote them. Her writings, though, have yet to be collected in English.

51. Breton, *The Lost Steps,* p. 53.

52. Naumann, *Making Mischief,* p. 253.

53. Given that Picabia himself distinguished his drawings from his poems in that volume, it is perhaps not surprising that neither Olivier Revault d'Allonnes or, more recently, Carole Boulbès chose to include them with his collected writings. (Éditions Allia has republished the volume on its own, but with regrettably poor facsimiles of the poem-drawings, whose words verge on illegibility.) They are, however, significant forebears in the lineage of concrete poetry; Jerome Rothenberg and Pierre Joris's inclusion of Picabia's "Portrait of Tristan Tzara" in their *Poems for the Millennium* is a noteworthy step toward recognizing these drawings as poetic works.

54. Breton, *Anthology of Black Humor,* p. 237.

55. David Joselit's recent essay "Dada Diagrams" (in Dickerson, *Dada Seminars)* offers an illuminating approach to Picabia's poem-drawings.

56. Quoted by Jean Hubert Martin in Martin and Seckel, *Francis Picabia,* p. 97.

57. *The Gay Science,* p. 214.

58. These two accusations need qualification: Tzara had been responding to the fact that Picabia had already managed to spark the biased, and now plainly unfounded, accusation that Tzara had plagiarized his Dada manifestos from Walter Serner;

Jacob, on the other hand, had a habit of seeing a potential plagiarist in everyone. Pierre Reverdy even based his poetic novel *Le Voleur de Talan* on an incident in which Jacob had cast such aspersions on Reverdy himself. I myself have been unable to find justification for Jacob's claim against Picabia in any of the writings by Lacroix that I have been able to consult.

59. Picabia, *Lettres à Christine,* p. 160.

60. See "The Cacodylic Eye" in this collection.

61. And for this, a good starting place would be the essays Rosalind Krauss has already written along these same lines in regard to Picasso (see *The Picasso Papers*). Interestingly enough, one of her discussions focuses on some of the use Picasso made of Picabia.

62. The fact that, in a 1924 interview in *Paris-Journal,* Picabia happened to cite Le Rouge as the only writer meeting his approval seems particularly revealing: not only of his predilection for pulp fiction on those occasions when he did open a book, but also of what may have been a cognizance of Cendrars's methods in his composition of *Kodak.* Given Arnauld Pierre's arguments for Rémy de Gourmont as a text source for Picabia, the web grows tighter: Cendrars cited Gourmont throughout his life as the writer most important to him. That Picabia knew Ezra Pound, who was influenced by Gourmont to the extent of translating his *Physique de l'amour* in the 1920s, points to a chain of influence calling for some untangling (particularly as Arnauld Pierre has recently revealed this book as the source for some of the inscriptions in Picabia's drawings for his *Daughter*).

63. It is this that enables a small but crucial distinction to be made; examples of collage poetry such as T. S. Eliot's *The Waste Land* or Ezra Pound's *Cantos* not only reveal their "pillaged" sources (Eliot, after all, even provided the same sort of endnotes to his work that I have provided for Picabia's later poetry), but also rely on the reader's awareness of these sources in order to be fully appreciated. The work is strengthened by the culture it draws from.

Picabia's late books, on the other hand, or a work such as Cendrars's *Kodak* (not to mention later examples such as John Ashbery's poem "Europe"), are composed from sources that are either unattributed, or considered to be of negligible literary import. It is the recycling of *detritus* (or the use of literature

commonly *regarded* as something akin to detritus, in the case of Cendrars) that often distinguishes the work of poets such as Charles Bernstein and Jackson Mac Low from Pound and Eliot. It is the lack of attribution and the usage of everyday material that characterizes what Raphael Rubinstein has usefully labeled "appropriative literature" and distinguishes it from literary collage. Picabia's poetic appropriation of Nietzsche functions as something of an uneasy transition point from modernist collage to postmodern appropriation, and a discussion of this role he serves has so far been missing from this particular discourse in the field of poetics.

64. Nietzsche, *Mixed Opinions and Maxims* in *The Portable Nietzsche*, p. 65.

65. In the foreword to Picabia, *Écrits: 1913–1920*, p. 7 (my translation).

66. Foreword to *Picabia, Écrits: 1921–1953 et posthumes*, p. 7 (my translation).

67. William Camfield does mention the following, however: "Señora Borràs has . . . presented a paper which indicates that Picabia drew directly from some of Nietzsche's publications for occasional passages in his letters to Henri Goetz and Christine Boumeester ('Les Derniers Collages de Francis Picabia, 1945–1951,' Colloque Francis Picabia, Paris, Grand Palais, February 28, 1976)" (Camfield, *Francis Picabia*, p. 261, n. 1). As this paper has not, to my knowledge, been published, I have been unable to consult it; I am tempted to think, however, that Borràs has already done some of the work to be found in my notes. If she had been able to trace Picabia's use of Nietzsche throughout his letters, the only thing that would have kept her from doing the same with his writings is that the second volume of his collected writings was published two years after her presentation of this paper. What is puzzling, though, is the fact that she does not reference any such direct use in his late writings in her 1985 magisterial monograph, *Picabia*—an omission that only reinforces this troublesome dark spot in Picabia's writings. (Her book did not focus on his writing but on his art, it should be noted.) A translation of *Chi-lo-sa* appeared in 1986 from Hanuman Books (as *Who Knows*, translated by Rémy Hall), but with presumably no knowledge (in any case, no mention) of how the book had been composed.

Recently, a new edition of Picabia's poetry has been published by Mémoire du Livre, edited by Carole Boulbès. Although her introduction mentions Borràs's work and the use Picabia makes of Nietzsche in his poetry, this use is still described in terms of "influence" rather than in more blatant forms of appropriation (let alone plagiarism): "As time goes by, his writing models itself more and more on Nietzsche's *The Gay Science*, which includes a number of poetic pieces" (p. 31). She gets closer to the point when she introduces his first book of poems: "To feed his own literary and pictorial creation, Picabia used and abused the German philosopher's writings, which he seemed to see as simple readymades to correct" (p. 37, my translation).

Boulbès has also written an essay ("Oui, Monsieur vous êtes poète, l'oiseau pic"; see Collectif, *Francis Picabia*, p. 109) that addresses Picabia's manipulations of Nietzsche, but focuses exclusively on the prefatory and appendix poems of *The Gay Science* and Picabia's use of them in his poems and letters to Suzanne Romain. This essay is significant in that it is the first, to my knowledge, to use the word "plagiarism" in the context of Picabia's poetry.

68. Stein, *Everybody's Autobiography* (Boston: Exact Change, 1993), pp. 58–59.

69. Nietzsche, *Ecce Homo* in *Basic Writings*, p. 720.

70. These editions are now being supplanted by two new volumes edited by Carole Boulbès and published by Mémoire du livre. Picabia's poetry has been separated into the volume I've mentioned in n. 65, and a second volume of "Critical Writings" is getting published as I write this.

I AM LOOKING FOR A SUN

Pre-Dada, 1917–1919

Consider how every individual is affected by an overall philosophical justification of his way of living and thinking: he experiences it as a sun that shines especially for him. . . . —Nietzsche, *The Gay Science*

"Medusa" was originally published in English in 1917 in the second issue of *The Blind Man,* and the version included here is as it originally appeared, with a few alterations in spelling. This issue of the New York pre-Dada review appeared soon after the "R. Mutt Case" (the rejection of Duchamp's submission of his *Fountain* to the Society of Independent Artists), and was published by Walter Conrad Arensberg, Marcel Duchamp, Picabia, Henri-Pierre Roché, and Alfred Stieglitz. Most of the poets included in this issue responded to the incident in their contributions.

These were Picabia's first published verses, written soon after his return to New York from Barcelona. His fruitful second visit to the United States had shifted into one of health problems and personal crisis. Like so much of the poetry to follow, Picabia's personal expression arises here from a reaction to "Exterior events"—a harsh and negative reaction to, in this case, the Society of Independent Artists (a "canon" of "Artists of speech"), whom he sums up as being the petrifying jellyfish of the poem's title. Salons, art critics, and dealers would be targets for attack throughout his life, but the poem also introduces other recurring themes: an ocean (although here vessel-less) journey, the poet as all-encompassing (almost cosmic) lover, mysteriously formed circles that would play a role in Picabia's paintings to the end of his life, and an ambiguity (if not confusion) between "right" and "left"—a possible rejection of which gives way to the desire for the guiding light of a sun.

MEDUSA

Sinister right—dexter left—superior hypocrisy
Spirits without light and Don Quixotes
Arts starboard, red and green port
without vessel.
Why change men into animal fetuses.
My tongue becomes a road of snow
Circles are formed around me
In bathrobe
Exterior events
Napoleon
Modern ideas
Profound artists reunited in canon
who deceive
Artists of speech
Who have only one hole for mouth and anus
I am the lover of the world
The lover of unknown persons
I am looking for a Sun.

April 1917

"Medusa," in *The Blind Man,* no. 2 (New York, May 1917), p. 10.

The following two poems, joined together by a dedication, appeared in another New York pre-Dada review, *Rongwrong*, edited by Duchamp, Man Ray, Roché, and Beatrice Wood. It had only one issue, owing to the outcome of a chess match proposed by Picabia between Roché and himself, to decide which, between *Rongwrong* and *391*, would continue publishing. Picabia won the match, and the game's thirty-four moves were then published in this same issue.

The dedicatee, Marcel Douxami, was a mining engineer serving in the auxiliary services of the French army, on a mission in New Brunswick, and a reader of Picabia's own review, *391*. He wrote a letter to Duchamp expressing his bafflement over *391*, and over Picabia's poem-drawings in particular. Picabia responded with these two poems, the first an evident put-down, addressing Douxami as an old and dead gymnasiarch (an outdated word for "headmaster"), the second a response to America, mingling what he found to be both monstrously good and bad about it. Duchamp published both letter and poems. Douxami's letter appears in Duchamp's collected writings (under the category of the latter's "Texticles"), and given the similarity in names (as well as the translation of "Douxami," which is "gentle friend," and the dedication to "those who know," which seems to allude to an inside joke), one is indeed inclined to think that Douxami's letter was actually written by Duchamp himself. Douxami *did* exist, however, as Maria Borràs has ascertained (*Picabia*, p. 180, n. 52). He died in 1929 while attempting to save two workers from a fire in a mine. Some extracts from his letter, the first real critical assessment of Picabia's writing, are of sufficient interest to present here (from Duchamp, *Writings*, pp. 177–179):

Dear Sir:
Thank you for the issues of 391 which you sent. I have just gone through them and surprisingly enough am not yet too deranged, but blest with a fairly sanguine temperament, I nearly had an attack of apoplexy.

I wouldn't want to criticize your friends too severely but the works of a certain Picabia irritated me particularly. Can he be the former painter who has turned out like this or is it a madman who has taken his name. [. . .]

Señor Picabia's automobile spirit alternately stupefied me and made me gay, but all things considered my poor reason begged for mercy because "I was raving after the reasons." [. . .]

I'm neither hot nor cold about [Picabia's] literature. It smacks of a School I was involved in during my wild youth, when René Ghil was in vogue. When I was 20 my heart followed the times— an altar bathed in candlelight—an inexorable mirrored wardrobe—a stream with a single fluttering wing. [. . .]

Picabia's little charades aren't really wicked and their tricks are within everyone's grasp. You write an ordinary sentence, then going back over it you leave out some words from time to time— preferably the verbs. Then you cut it into more or less regular lines painstakingly forgetting any punctuation—that's a poem in Picabia's manner.

With all due respect to the charming Gabrielle Buffet, the School's musician, Picabia's poetry seems to me to spring from American music—a syncopated beat with a melody that the composer either wasn't able or didn't know how to get down [. . .].

Sincerely yours,
MARCEL DOUXAMI
New Brunswick, May 5, 1917

One will notice Picabia's predilection for word swapping and substitution in lines two and three of "Concave Ceilings" ("rags" and "coffins"). Such tinkering would become less obvious in the poetry to come.

TO DOUXAMI

but above all to those who know

CONCAVE CEILINGS

Why like a monstrous old man
In this cemetery of rags
With your Turban of coffins
Barren crop of coarse grass
Incomprehensible gymnasiarch
Domestic stir
Chinese lantern
Don't you see enemy of light
That I am the genius virtue.

A CHINESE NIGHT IN NEW YORK

Dirtiness Silence Void Boredom
Sudden music laughter noise,
Lack of opium, lack of meat,
Lack of poetry, lack of joy,
Big uproar, big commotion,
Tremendous hunger, immense void,
Cold chicken, ice water,
Horrid beasts, pretty women,
Gentle glances, hunger's gone.
It's PHARAMOUSSE,[1] it's America.

MARQUIS DE LA TORRE[2]

"À Douxami," in *Rongwrong* (New York, May 1917), unpaginated (p. 3).

As Picabia was writing the sarcastically titled "Delightful," Gabrielle Buffet was in Switzerland with their children. Picabia was sharing a New York apartment with Edgard Varèse, and having an affair with Isadora Duncan.

The first appended quotation is undoubtedly from Nietzsche, but I've been unable to locate its specific source. The second is section 53 of Nietzsche's *Das Eherne Schweigen* (The silence of bronze), seemingly unavailable in English translation. Their attachment illustrates Picabia's feelings toward wives and children pretty clearly.

DELIGHTFUL

Being both
　　　　　　disconnected
from day　　to day
　　　more alone than anywhere
　　　　　　to sometimes bring to an end
　　　　　　　　　the tip of my nose

in my authentic
　　　　　　life
if it's possible
　　　I am sure
　　　　material necessity
　　　　brings good luck

"This age is nothing but a sick woman—
let her scream, rant and rave, argue,　　*"—Are you fragile?*
let her break all the dishes."　　　　　*Beware of the child's hands!*
　　　　　　　　　　　　　　　The child cannot live
　　　　　　　　　　　　　　　If he isn't breaking something . . ."

"Délicieux," in *391* no. 6 (New York, July 1917), p. 3.

Given the quotation marks, one would assume the following aphorisms to be quotations. Their somewhat un-Nietzschean sentiments, though, would almost rule out Nietzsche as a source, save that they retain his style. Compare the philosopher's call for a more "virile, warlike age" in *The Gay Science,* where Nietzsche seeks human beings "accustomed to command with assurance but instantly ready to obey when that is called for" (*TGS* 228:4:283). Regarding envy: "He is utterly without envy, but there is no merit in that, for he wants to conquer a country that nobody has possessed and scarcely anyone has seen" (*TGS* 213:3:238).

Such a comparison only heightens Picabia's antimilitaristic snipe shots here, given that he is writing in the throes of World War I (from which he was taking refuge in New York). Nietzsche's "warlike age" is taken literally and rejected, whereas the French are mocked for attempting to conquer an all-too-literal country instead of the one of the mind. The fact that both aphorisms hinge on "happiness" is worth noting: Picabia indeed spared no effort in enjoying himself during his New York years (to such an extent that he subsequently collapsed from exhaustion). Thumbing his nose at the trenches while thus seeking pleasure is an act of insolence whose equal is difficult to find elsewhere among the avant-garde of this period.

[APHORISMS]

"For me, happiness is to command no one and to not be commanded."

"Envy seems to me to be the greatest impediment to the happiness of the French."

391 no. 6 (New York, July 1917), p. 4.

Fifty-Two *Mirrors* was Picabia's first book of poems. About a third of them were gathered from the first seven issues of *391* (January to August 1917), and from those issues only "Bossus" (Hunchbacks) and "Delightful" were left out. The remainder of the book is made up of previously unpublished poems, written for the most part between 1914 and 1917 in New York and Barcelona. They are not in complete chronological order (something to be stated since a hermetic autobiography shapes so many of them). Their arrangement, however, does not appear to be random: words and themes carry over from one poem to the next, and throughout the book as a whole. Despite Picabia's sometimes radical syntax and abstraction (and probable incorporation of appropriated text), several notable themes can be discerned: a rejection of the Church and the hereafter ("Staircase," "Faith"), the author's growing neurasthenia ("Theory," "Smile"), his troubled feelings over his marriage ("Gstaad," "Peace"), as well as the shadow of the war ("Soldiers," "'The Old Folks Are Thirsty'") and Picabia's problematic escape from it ("Theory," "1093"). An early formulation of the Dada attitude can even be discerned in "Singular Ideal." The ruling theme, though, would have to be that of desire, Picabia's depictions of which range from celebratory ("Wicket") to erotic ("Little Hand") to expressive of disgust ("Frivolous Convulsions," "Revolver").

That Picabia is utilizing sexual slang throughout these poems seems likely, but for the most part I have chosen not to "interpret," for a couple of reasons. First, such slang usually does not demand such translation: Picabia's "gleaming spears," "weeping daggers," "enlarged sheaths," and "swelling froth" all seem quite capable of alluding to other things on their own. Second, I bow to Gabrielle Buffet's advice in her early article on Picabia's second collection of poems: "the error would be in seeking a rebus where there is only vision" (quoted in Benoit, *À Propos*, unpaginated). Finally, there is Picabia's own observation in "Smile": "to try to reflect / On my indecent gibberish / Is not a monk's duty / Genitals in hand."

The number in the title corresponds to the number of poems in the collection; Maria Lluïsa Borràs traces the title's origin to a passage in Nietzsche's *Thus Spoke Zarathustra* (second part: "On the Land of Education"): "With fifty blotches painted on your faces and limbs you were sitting there, and I was amazed, you men of today. And with fifty mirrors around you to flatter and echo your color display!" (*The Portable Nietzsche*, p. 231).

The opening epigram is also Nietzsche's (see *Poems*, p. 109).

FIFTY-TWO
MIRRORS

(1914–1917)

STUMP **STAIRCASE** DIVINITIES **THEORY** BASIN **LAND HO**
LAUGHTER **LADY-LOVE** BENEDICTION **LITTLE HAND** WICKET **GOAL** GSTAAD
PEACE IN THE MIDDLE **MODEST** ON THE MANUEL CALVO **DEPARTURE** FEET
SHIVER SMILE **SHE** YESTERDAY **SOLDIERS** ASCETIC **HALF ASSES** INFERENCE
SOMERSAULTS 1093 **CEREAL JOY** HORROR OF THE VOID **COTTAGE**
MAGIC CITY **SINGULAR IDEAL** FRIVOLOUS CONVULSIONS **METAL** REVOLVER
IDEAL GILDED BY GOLD TO FEEL **MEN** HAPPY **PRISONER** SORROW **FAITH**
OVERSEAS **LAZY WOMAN** A HOOK **FIANCÉE** "THE OLD FOLKS ARE THIRSTY"
VOW BETROTHAL **AROUND ONESELF**

"They're so cold, these scholars!

May lightning strike their food

so that their mouths learn how

to eat fire!"

STUMP

A septum of lies is secretly
hosed like a tree
marked in advance for a meeting
of gleaming spears.

The next morning legs bare
mack man eyes lowered
speak in each other's ear asks for something in return
for the things hidden in the garden.

Wait patiently for the arid
favor of your mission so as to frame it
at an appropriate height on the wall
before the hypocrites lie.[1]

STAIRCASE

Everything in the world
far from the truth
is a hurricane of divine roads
like the light of heaven.

Those women who deny the hereafter
have a place next to me.
I am the virtuous guide
in the crystal city.

DIVINITIES

I fear my own as guides
Permanent canities[2] of the Sun
In the wake of parabolas
We made it rain in the middle
The back by a fine ordeal
Man and his heart united

In hell which protects the just
Camel where are the idols
But you have absolutely no idea.

THEORY

Troubles divide into responsible germ
If the miner in his heart of hearts
Strikes the priming five or six times
That is to say the neurasthenia of peculiar obsessions
Mandibles of the utilized free will
The roving family's son for the tribunal
Refuge from temptations the drinker's psychoses
Encounter in the study collective damage
Clinging to the guilty revelations
From fortune-tellers of syphilis
This superstition in the statistics of progress
Brings bayonets to full strength
In the language of unpleasant roads
We must make a strict spiritualism of it
Of the responsibility for the language of conscience
Delinquent judge of mental transition
The kill is a madman's fancy
Not just for the first type
Of immediate satisfaction by urging on the occasion
Among the amoral kleptomaniac braid cutters

BASIN

Crossed out in a little courtyard
of twisted cable.
Wisteria in the pansy joy.
The pattern and its dance
marks the duration between the curtains.
Nothing impure.
Your flames sculpt mirrors
in the light under the Earth.
Inside a fireplace transmission

of the vermilion bowl adjustment
eats cucumbers.
Drinking makes the face young.
Within my skin lies the life of hair.
Animals encounter the solitude of screws
at the arabesque hour in the keys.
The gaping and crooked residence
of clams
Suddenly the way a hermetic judge
occupies where then
a man lying on his stomach.

LAND HO

Europe Left Bank calls me
in practice the paradise book.
One day the destined dynamite
which happens to be in my nose
Will demonstrate universal irony
as far as history is concerned.
I fear it every day
as a September artilleryman.
Mediterranean of the fifth
the subject needed it.
Under the walls of Barcelona
to tear a cloud from me.
I would like to erase one thing
from my sublime life.
The absolutely terrible weakness
of my nervous flame.
Nothing manages to satisfy me anymore
my wives know this.
28 September 1917[3]

LAUGHTER

My mouth waters
Like a gypsy worm
It's laughing at me
But I heard it
In the bedroom
Mahogany streetwalker
Why are you fasting
We're having fun
Let me come up
And we'll drink a shot of whiskey
Just one
Fifteen years today
What does that make
You're laughing
Where should we start
The sense of the extraordinary life
I would like to have
Is an unsolvable problem for schoolboys
My floozy gave the signal
For ten dollars until five o'clock
I can swear to you in all honesty
That my heart is beating
It is my conviction
Today think of me[4]

LADY-LOVE

Misunderstanding that surpasses reason
Creation of vice to a greater degree
All in all I'm not taken into account
She thinks that I'm a monster
I chose her without letting myself get distracted
A single day had lit within me
This wonderful and immortal bond[5]

BENEDICTION

Behind the curtain
everyone
is undressing.
You are not people
hidden under the pillow
eyes wild.
I lied
here's a letter
no illustrations.
But you should know
that you were dreaming
yesterday's braggart
on the main road.

LITTLE HAND

Hitching up your dress
In the swelling froth
I was on my knees
Your charming little hand
Queen of pleasures
Was weeping like a dagger
After the dying moment
Scaffold appetite
I loved you so much
That my body grown wise
In a bathtub
Was still kissing your naive hand.

WICKET

I haven't relaxed in years
The desire to be placid in love
Is a veritable sex crime
Chastity in life
Is deadly for me
Because the genius of my heart

What I call courageous ideal
Is not a junkshop
Incredible destiny
Won't I go
The full distance
For a single pleasant hour
Of vertiginous passion.[6]

GOAL

One need not try to rise
to natural capacities.
That's harmony
for its own future.
Every balanced movement
of a magistrate puppet
forms the nature of trees.
His fingers in his art
are enough to obtain gold.
That's why the world's ideal
has so many affinities with the past.

GSTAAD

The sea pitches endlessly
The role mirrors her pupils
From memory
So mirthful
Swaying of gravity
Expresses a resonance
Of constant desires
I have excuses
And lack strength and courage
influence is a useless thing
She is the most beautiful of the women
On my mind
Manuel Calvo, 1917[7]

PEACE

I loved you with a labored smile
The world although surprised
Has hated the distance for five years
To pass over them for at least a moment
Nothing stops them
Why listen to me
I want I want on its face
While squeezing these five years
I even want to ask
A wretch to listen to me
At the monastery in a sick smile
Facing the cushions where I had my heart
I will never forget my mental hospital
With this intention a royal leg
Of champagne puns
In a dreamy voice
Has regarded the comedy with distrust
I silently mad
With my new wet-fly life
I remember solid gold
Of the jealousy tribunal

IN THE MIDDLE

A grace of desire
underappreciated
especially
right in the Sun
influences
behind
my own future.

MODEST

Afternoon of my life
I am at the side of the road
I finished reading my book

I have no recollection
Of an indispensable day
I love the smell of my brow
I shall hear her mouth for the rest of my life
I have but one tongue
With bad manners
I make them turn pale
I know women better
I don't want to be overwhelmed
In the village cabaret
I comb your hair
I caress your neck
My face is white
All the days go by

ON THE MANUEL CALVO

The energy along the route floats a solo
My gestures are never forced
My entire life in music halls
Doesn't look for excuses
At sea the minuscule parts
Of heroism desire know
The solitude of the countryside
All these false movements
On the tips of fingers
Of waves
Of legs
Mechanical puppet of this delirium
Passion can establish
A characteristic harmony
Imprisoned in a dress.[8]

DEPARTURE

It is not so much me
as the chance
of coquetry steamers.

Everything dies down when shaking the hand
of circumstances
even soundly.
From a detached life
clasping the future
to laughter.
My breathing tells me
lace pleasures of the chaste
sky.
Love does not distort
a willow's silhouette
in the henhouse.
What a sight my darling
it offers hope
and my illusion heart accepts it.
16 September 1917[9]

FEET

I'm afraid
Your fingers tremble
And the smell of broken glass
Near the table the obese pipe
Smokes
Like a crack in the
Superterrestrial brain

SHIVER

I have never lived
on the page of good taste
like someone who chose
virtues.

Why my girlfriends
hanging
from their unknown hinges
drift up to my courage.

Love itself
called poetry on this occasion
fertilizes its magnificent harvest
look at it laugh.

I now find myself
To be my heaven's enemy
nothing else
because all of that didn't exist.

SMILE

To see in you do you understand
And to try to reflect
On my indecent gibberish
Is not a monk's duty
Genitals in hand

Like a freeloading angel
I am on the stairway
Of hysterical fits
Every minute a ghost
Digs about unhurriedly
Like the last time
And rolls up its pants
So much suffering
I'm crippled.

SHE

Clinging to the same bar
The mountain air procures
Leaving life unrestricted
This maxim is painted
On the liquid of Nazareth
Which our foot enters
Like a card through water.

I see your bones attached to the vault
Of your enlarged sheath
We are the wet voices
And the mirror sleep
On the nightclub's folding screens
Of your cascade foliage
Reaches the armpits of the world.
Stamford, 25 August 1917[10]

YESTERDAY

Perpetual ignorance of an extraordinary
opera heart.
The choice in my drawing
served me as a slightly drunken father.
He stopped lying the other one fled
after our marriage.
Baba saws of course
she limped for the fun of it.
Have you ever seen me in an armchair
as beautiful as any pretty woman.
Why did she do it
I don't understand it.
She made the sign of the cross on me
with her little hand as she was hopping.
Delirium of the zither[11]
I'm the one who put it on.
This unaltered crown
of my little goose—

SOLDIERS

Repeats gullible
 the benevolent
 republican
 good opportunity.
 Three times
 once more.

An idea
nothing but an ingenuous
animal squeal
idea.
Tromp-l'œil
baptized
the disfavor
of muscles in movement.
The day steals
health
life.
Children's hatreds.
To war
siren's music
cold realm
of surcharges.
Productive arable lands
horrible lamb
of constraint
eager
madness.
Desperate attitudes
the sick
wall
of the Feminine
sex

ASCETIC

Above a spellbound woman
of comprehensible
and Southern French form
like an animal.
The tongues of the feminine game
with a virtuous and cunning
audacity unsettle
the dangerous music.

In this way passion insists
on sharpening interpretation
on the heart satisfied
by little leaps.
Must one begin
with its candid envelope
for the sake of wrinkles
found on vague things.

God auricular Savior
the ideal doctrine of the will
is once again
today but a goal.
I am tired
under the tremendous shiver
like an attorney friend
in danger of happiness.

HALF ASSES

To me the world is steeped in sticky good taste
and ignorance.

Inventions of woman artists and oscillations
of Spanish or Russian dresses.

Absurd hide-and-seek of fish
great men in the opposite sense.

Multicolored modernism of sand weakened
by intellectual declarations.

Terrible evidence for me of deformation
I demand the ravishing.[12]

INFERENCE

To live from now on in your ultimate motive
Unimaginable strange world
Decoction of absurdities
Slight curiosity easy to organize
Much easier audience
Mean tricks and follies
I don't have the cross
Petit-bourgeois woman
Whose thoughts wander
It seems to me that I understand
What's going to come out of all that
Petty barriers of nationality
Innumerable catcalls.

SOMERSAULTS

Dislocation of the still water
Beans
Opium
Explosion
The signal of flutes comes
At my feet.
Crooked in the fold of its hieroglyph
Pregnant
Damaged
House
Magical enclosures at noon
Horizontal abode on every side
Born
The kissing method
Nothingness.[13]

1093

I need the amulet of thaw
For my ideal State

Before the night
Slips around my neck
Dreadful obedience
Unintelligence arranging
Borders of madness
Nasty remarks
Desires
I want my existence for myself.[14]

CEREAL JOY

The apparatus shocks the inner order
of the finger's concrete image.
Hidden under the metal
little candle furnace
I want the block licking the spine
of the boredom colossus.
Triple virtue repercussion
don't aspire to flag-waving in the rain
to a piano's modulations.

HORROR OF THE VOID

She dreams of the other side
so as to create a memory
she thus gives herself ties
over frightening chasms
anxious she timidly brandishes
her hatred against the barbarian
she tries to be absentmindedly insolent
and gives men confidence
she is fit to be the elusive egoism's mistress
but so what![15]

COTTAGE

A necessary need for equal duties
in Christianizing intimacy.

Incredible instinct in intimacy.
Nerves more hysterical every day.
To enter quickly as if prey to perfection
and a victim of his talent.
Immoral existence of certain martyred brains.
A more subtle way of aging and in better taste
by almost totally rejecting the Church
in sexual relations.
The cottage is a cage
from which she cannot escape.
Fascinated today
she remains free.
Cocoa.[16]

MAGIC CITY

A dangerous and enticing wind of sublime nihilism
pursued us with incredible exhilaration.
Unexpected ideal.
Break in equilibrium.
Growing irritation.
Emancipations.
Everywhere men and women with music I enjoy
publicly or in secret
unleash their sterile passions.
Opium.
Whisky.
Tango.
Increasingly discerning
spectators and actors
overcome crude satisfactions.
Women less strong
more beautiful and more unconscious.
The men with silent ulterior motives
gaze at their pleasure.
Years of genius and eastern sun,
1913–1914.[17]

SINGULAR IDEAL

A subtler intuition can slip over a victorious human
form bravery liberty sweeter cruelty but they are immediately
out of their depth through divination—Booty suppleness
of local color for how long raging and completely
mad but attractive forms it's the same exact thing.—
Creators a lie destroyers a lie
thrones madmen long-eared climbers everything's stolen—
Have we learned anything critical courageous attempts
very difficult to understand at least not for us—
Universally depressing mirror that tyrannizes slaves
who have managed to master the existence of hypersentimentality—
Opinions of idiots bad debts of puppets the moralistic victory—
one must be many things.[18]

FRIVOLOUS CONVULSIONS

Her degenerate glance
is a cockless masquerade cry
with the stench of depraved convulsions

her source outraged modesty
formidable for the sex
carries out epileptic reflexes

but her dream's aimless activity
is a hand that does not indicate the hours
for the benefit of an absolution.[19]

METAL

Japanese prints
passion for dross and face powder
here's the hour beneath me.
I know sugarcanes
behind a road
that hides the four cardinal points.
The town is situated above symmetrical mud

my house is the top of the altar.
To sleep
unframed delirium
carefree rhythm without duration
painting juxtaposed with doorbells.
The Chinese sea marks a sign
behind my bed
and an imperceptible doll points to it.
The grass of the
extravagant
imperial
machine
lying in ambush
makes me a little courtyard
with people naked between their legs.
The dazzling vapor
gives me a precise answer
through its photographic light.
Model microscope
your eye roasting on its embers
smooth like the course between islands
in the middle of solitude.
Is it said from underneath
to everyone on my resin fan
that my wonderful house
with its face of roses
is a result of the sun's mystical family.
The world's mouth is shaded
by black vapors.
The gigantic mountain
walks among
the four cardinal points.
New York, 1917[20]

REVOLVER

To try to constrain less than please
 Odious caresses
 Women or men litter
 Egoistic homicide and unfortunate victims
 And they say they love
 Sexual need
 Churches
 Schools for little girls
 Public walks
 Virgins don't cure syphilis.[21]

IDEAL GILDED BY GOLD

"No! No! Absolutely not!
Leave heaven and its hackneyed song!
We don't want to go to heaven.
The kingdom of Earth must be ours." [22]

A modern society woman is an almost masculine stupidity; aristocratic on her nervous irritation flag—Does she have a good nose for means a real weapon because their nerves are actual musical instruments—but unsuited and even more as basic function even as a cook and isn't it true that the unpleasant finery of thoughtlessness is necessary—Real female domination—Pleasant fitness in love of no consequence—Recognition of desire—Movement of the dancing body.

Listen to them unintoxicated; what patriotic gesticulation but I'm stopping, aren't I—

Archaic monkeys, my admiration is limitless. Consolation abandonment shocks everyone—It is extraordinary to explain oneself because most of our fellow creatures are tied above all and without tradition to the problem of theories a not very humane conclusion.

A sensual marriage is quite rare in this society—An error of individual defense.

One must make one's way in life, red or blue, completely naked, with a subtle sinner's music, completely ready for the holiday—Alas, the opposite is true; all are blabbermouth choruses—Beautiful futility.

Infusoria, protozoa, dogs, rabbits, what solitude of monarchs decent folk, poisoned solitude under gunfire.

Poor psychiatric artists without passion or spirit or charm racehorses as Italian as the moon.

Males and females these days no crude borders we've had enough displays of misfortune stupidity—Women stop looking at man in brutality do not weep in the growing desert.[23]

TO FEEL

Was it the weariness of thieving friends
Or of honest women at the masked ball
Bygone joys
My painful wound
Clover amber naked girl
Kneeling in the intimate dish
Of my lace body
Examines the wealth of those who do good
Lavish reward
The two pillows trembled
With voluptuous pain
On my heart like a girlfriend.

MEN

Accompanied by a lady
On his knees
Punchinello of the cross of honor
you're no longer a virgin
your image has a memory
among the wealthy.
Sculpted in a Bristol-board
chest
I don't want any more friends
they're all unfaithful.

HAPPY

She was a very little girl up to be raffled
Who spent her morning organizing the jackpot
all day long like an amateur mouse
She broke up the clay of the mysterious building site
No point in denying her with a defiant attitude
we are the little bouquet of catcalls
Under the torpor of casino night
Tell me the calligraphies of danger
I am the black captive concealed by a bush
In the sky of kisses.

PRISONER

Little girl always chained
on the lock.
What a life this caged
door is.
Laboratory of the trap door
into the cool evening.
Hang your head amicably
into the deceitful water.
Because all my misery
for years.
Is the secret
of funeral rooms.
Under the radiant dome
around the Dictionary.

SORROW

The misery of distant relations
constitutes hunger.
But directed analysis provides
the excellent idea.
Inevitably following my strength
the problem difficult to resolve.
I admit that for a long time

served as a sexual instrument.
The desire for favors
by way of the false.
Is a more advanced attempted murder
but redeems life.
Homosexuality reminds me
of unpleasant compensations.
Exception made of each case
in revision of itself.
Charity of the amoral
poacher collective.
At the moment I'm taking charge
of the pleasures in the animal series.
Source difficult to distinguish
as an active cause of my interest.

FAITH

Religion that's his "ideal"
Moral doctrine in the same wonderful way
More and more original
The great artist's methods
To make a mystic's cry his own.

OVERSEAS

Glorious new America
Transforms poetry
Delicacy modernism at Santo Domingo[24]
The environment determines weaknesses
You will find a tenacious love
Within the refined barbarities
Of the Americans and the English influence
Down to Scottish Chile
Of the visionary peripateticism
The homeland that inspires love
Justifies the formation holes
Of an intolerant and inextricable faith.

LAZY WOMAN

Everybody
 Spider
 My needles
Like the Sun
 She doesn't see it
 Little sister
 To hem
 On her bed
 To wet her webs
 On her pillow
 Like the day before
 The world gave
Its goodness and its ten fingers
 On the sink
 Cuts a salad
 Pale life
Even at school
 It is the custom of this country
 To go and pray to the saint.

A HOOK

The history of the entire world
 Cricket ant
 I who was 35 years old[25]
 The mastic
 Landing on the hair
 Of her legs
 She made use of a third hand
 Like a grown-up
Mature
Serious
Your idle
Foot God and God alone
Rinses out the glasses Go there for me
Face white Nothing bores me
Trying-planes The two little candles

It's turned upside down

 Garters

 Sunday

 Red carnation

Of red velvet Church windows

 I screw it on Eyes

 I sensed

 Kneading bread

 Pieces of String

 Too tired

For distributing Seated

 Country girl

FIANCÉE

To smoke all alone With pleasure

 Above the second floor

 Per year

 Today

 So I can rest

 If that amuses you

A bit of trafficking In girls With two hands

 I never dared

 With you

 Nor on the plain.

"THE OLD FOLKS ARE THIRSTY"

Dictator of a big white sheet's assimilations
there is no grand ideal.
Ambitions in war in peace
he aspires to be reelected.
The campaign tyrannies of the Sierra
prepares his downfall.
Representative man
is an unfertile mountain.
The greatest statesman
is a little bell on a mule.

Look at yourself now
two or three more times.[26]

VOW

My head swells
Enough to drive one mad
It is existence
Amidst the world
From which I cannot leave.

BETROTHAL

So tell me that every day
superstitious former slaves.
As I am pole before everyone
no longer having any relation.
In two months see the little cemetery
I will have my wedding clothes.

AROUND ONESELF

He seems to have before me
all the nooks and crannies of the solitary ideal
better yet an enticing ideal
whose hunger is avid.

To try and free oneself to escape
from the silent and unknown room
like all the mountain dwellers in the empty walls
Is to chase flies.

From the depths of the torrent when dashing to the station
door one pays dearly for such a revolt
the governed grudge gives me vertigo
death will open the door.

Cinquante-deux miroirs, Barcelona, Oliva de Vilanova (printer), October 1917.

"White Pajamas" is a grade crossing, a shift from the heady days of Barcelona and New York to Switzerland and Picabia's slow recovery from his excesses. Everling presents this poem in prose form in her memoir as one of the "letter poems" that Picabia would send her in the morning from his sickbed during this Switzerland period (a period in which she attended to him, under the eye of the "liberal-minded" Buffet).

WHITE PAJAMAS

Interrupting me in my spleen
On a little clergyman lawn,
A pretty face gently enters
 my property!
Come without searching, without guile
And take the road of new samples
As you can see I am extraordinary,
I don't know, show me around
I want to visit all the rooms
And devote every moment
 to complicity
I brought you the imprint
of a little diamond-stamp.
I'm still worrying as if
 I was someone else
Which is exceedingly strange . . .

"Pyjama blanc," written in February 1918; first published in Jean-Louis Bédouin, *La poésie surréaliste* (Paris: Éditions Seghers, 1964), p. 272.

Although written immediately after *Fifty-Two Mirrors*, the poems of *The Daughter Born without a Mother* show evident development: they are even further divorced from their meaning and origin, and have entered more fully into the realm of abstraction. P. A. Benoit believes that Picabia began this book no later than December 1917, in Martigues. This would situate the book in the period of Picabia's "honeymoon" with Germaine Everling—a honeymoon unaccompanied by marriage, since he had not yet separated from his wife (whom he would not officially divorce until 1931).

 The original title for this (as Jean Arp described it) "booklet of devastating poetry" was to be *Décapuchonné* (Defrocked). "The Daughter Born without a Mother" is also the title of a 1915 machine drawing by Picabia, and is often taken to be Picabia's description of the machine itself. The origin of this title can be found in the pink pages of the *Petit Larousse* dictionary: Montesquieu borrowed "Prolem sine matrem

creatam" (child born without mother) from verse 553 of Ovid's second *Metamorphosis* to open his *De l'Ésprit des lois*.

While aligning itself closely with Duchamp's concerns of this same time period (Sanouillet draws a parallel between this collection and the notes Duchamp made for his own *Bride Stripped Bare by Her Bachelors, Even* [*Francis Picabia et "391,"* p. 32]), this "motherless daughter" also bears allegiance to the future Surrealists' preoccupation with the "Automatic Woman." (Readers are referred to Katherine Conley's excellent study by the same name.) Picabia's *Daughter,* however, is something of an inverted Madonna, who instead of conceiving without copulating is able to copulate without conceiving—what could more or less be described as an "Immaculate Copulation." This figure thus bears stronger affinities to what Michel Carrouges would later describe, in reference to the works of Duchamp, Alfred Jarry, and Franz Kafka, as a "Bachelor Machine."

But if this copulation is biologically arid, it nevertheless endows the poet, in classical muse-like fashion, with his own creative "conception." The Christ-child is thereby replaced with the motherless daughter, the (male) poet's progeny—in terms of motherless origins, a rather classical figure when nonmechanized (Eve, Athena). A couple of years later, Picabia would, in a similar vein, title a long poem *Unique Eunuch.*

Comparison of Duchamp's bared bride and Picabia's motherless daughter also evokes the confused roles Buffet and Everling (herself a daughterless mother) were playing in Picabia's life at this point. "Bachelorhood" and "eunuchism" aside, he would impregnate both women over the coming months.

Picabia ended up cutting two poems from the collection ("L'Équilibre" [Equilibrium] and a poem for Everling entitled "Germaine"), bringing the total number to fifty-one, one poem fewer than his previous fifty-two mirrors.

Arnauld Pierre has recently traced back many of the inscriptions in the drawings of this collection to Rémy de Gourmont's *Physique de l'amour* (which Ezra Pound translated as *The Natural Philosophy of Love* just a few years later in 1922). The drawings are based on mechanical images from the pages of a French popular science magazine of the time, *La Science et la vie* (see the chapter in Pierre, *Francis Picabia,* entitled "Dada I: 'Ci-gît art'").

The dedicatees had all treated Picabia. Dr. Collins (whom according to Buffet Picabia could not stand) treated him for his opium addiction and neurasthenic crises in New York in September 1917; Dr. Brunnschweiller was a family friend: his orders for Picabia in Lausanne included a ban on painting—a factor that contributed to the painter's continued output of poetry.

Buffet notes that the dedication is an ironic homage, as Picabia knew that "if these learned individuals took it into their heads to open this book dedicated to them, they would be sure to make a most cautious diagnosis on the mental state of its author" (see Martin and Seckel, *Francis Picabia,* p. 9). Picabia had originally intended to add to this dedication: ". . . and announce to them my momentary recovery."

References to illness, doctors, and an occasional sense of captivity within beds, sheets, or a room can be discerned throughout the collection. Picabia's drug addiction is still present in his "opium tears" and "poppy brain," but the poem "Wireless Telegraphy" offers the clearest portrayal of his neurasthenia and the backdrop of an absented war.

POEMS AND DRAWINGS OF THE DAUGHTER BORN

WITHOUT A
MOTHER

18 drawings—51 poems

RELIGIOUS POPE PNEUMONIA VIS-À-VIS SHOUT SEESAW LITTLE ZEBRA WITTICISM MACHINES LABYRINTH TURKISH DELIGHTS ELECTRIC-LIGHT GLOBES POLYGAMY CUT FLOWER TO LIVE ALAS! EGOIST DELIGHTED THE GERM ALMOST FINISHED NECESSARY BELLADONNA CANTHARIDES GREYHOUND IMMENSE ENTRAILS SKIN MAMMAL RESEDA BIRD EASEL WIFE PILLOW KIT SEE EXUBERANCE MOUTHS ZOOID BEAN SILK WAISTBAND CACODYLATE WHAT MALE POISON OR REVOLVER THE MAID VISOR SLIPPER NARCOTIC VOID MEAGER EVERY DAY POINTLESS MACHINES PERSONALITY HAPPINESS CUDDLY DRUGGIST VENTILATOR SURPRISE LAUGHTER GEAR CHANGE DIVOTS IMPATIENCE ART SUBSTANCE IN SWITZERLAND BLIND IN ONE EYE HERMAPHRODITISM NOTHINGNESS SENSE OF SMELL FAILED DRAGONFLY ANECDOTE WIRELESS TELEGRAPHY DESSERT CURRENT VIEWS IN LOVE MACHINE OXYGENATED BUTTERY COFFEEPOT ODOR THIGH

I dedicate this work to all neurological ➤

doctors in general and especially to doctors: Collins (New York),

Dupré (Paris), Brunnschweiller (Lausanne).

F. PICABIA
Finished in Gstaad, 5 April 1918.

RELIGIOUS POPE

Natural wonders remote sandy beach
in colossal form full of useful peace and quiet.
This evening salubrious fear veils the truth
by crossing its legs
its tail.—
My skeleton illness of memories
definitely rises as an insufferable enemy
where the monkey reasons subtly
in its head.
The fur trader disarms the intrigued philosophy
on the articulated shore of things.
I believe in my image.
It is a final system
because you think in unrestricted Chinese.
Infinity of the terrifying world
adjoining vibrations
prodigious valley
to go mad and so on and so forth.

PNEUMONIA

33 33 33 33 33 33 33
element of calculation
in its darkness.
A spectacle of a child at one's fingertips
prodigy calculator of hypotheses
of carrots and the end correctly
before the brilliant black eyes 33.
Wonders die the way we do
in the situation that we demand
the crib's enigma.[1]

VIS-À-VIS

[what disfigures / the measure]

SHOUT

The mattress is probably a tongue
more incredulous perhaps
death birdlime visitors
Captive in the antechamber
of magazines on the sleep
of *mise-en-scène*—
The tender spot devours
hopelessly—

SEESAW

Cloud nanny impoliteness
You came to drink my shoulder
It's strange
To take love fixedly
A supplementary female beggar's
Childish delights
And drat after lunch at the station
Business antics—

LITTLE ZEBRA

Patois *schottische* in the blind blue sky
Less true with a smile
Than at the Bois de Boulogne
Put your mind at ease winter of coal
In my friends' studio.
Radiant extents had simply
Collapsed into phonographs
Under the hand of lungs
With an oily rabbit ease
Barcelona delights
With recent setbacks
You will not deceive my career.

WITTICISM MACHINES

[witticism machine / tiresome ear / words / opera / chatterboxes]

LABYRINTH

The will waits incessantly for
A desire without finding.
The lock notch fascinates the absence
of womanizing.
A scar toward night
degrades thought.
There is only incredulous
detachment.

They make me suffer
because I know indifference
Banalities embarked incessantly
upon themselves:
Horizons draw the eyes
of our sentiments.

TURKISH DELIGHT

My misfortunes are naked and slope steeply,
The skirtless ricochets gaze at the sea
To kiss me voluptuously like a prawn
It sends my little opium tears to sleep
Infinite science, mandarin character of the moon
That's my garment, a kite of frozen honey.
I wrote on the converted bed of the summer months
That to fondle one's breasts several times
In the closed museum
Under globular clothing
Becomes the make-up on a clock.
The alcohol cross on the poetic blue chin
Reveals a lantern-barrier to me,
The dancer's redoubtable about-turn
On the platform track
In the silent unforeseen of an empty lane
I am on the mountain of proud women
Sculpted up to the neck.

ELECTRIC-LIGHT GLOBES

A temple gently began to boil
at the water's edge as if on the peaks
of pacific mountains.
The distaff fairies take root
along my poppy brain
and little by little like mixed cuttings
they don the list of people
surrounded before the jade road[2]

POLYGAMY

[young sable / Mormons / spring-like vagina / calendar]

CUT FLOWER

We were living the same age
in a deserted town
and the electric curtain
placed its batteries twice
into a box of peculiar matches

TO LIVE

The conquering egoism re-creates a fool
A lover awaits happiness
Affairs of appearances
Personally I've never seen
Those who bear them
The stranger has no theories
On the squandering
Along the shipwrecked river

ALAS!

Women men
Affairs
A country ambitious
For sovereignty
I love it when someone folds the eyes
Of troubles
Especially in the sea of the thorax
But I'm telling disinterested lies
It's almost the same thing
The soul's truth
Is the great cowardice of academic arrogance
Looking into your eyes
I'm content
In my forgotten solitude

EGOIST

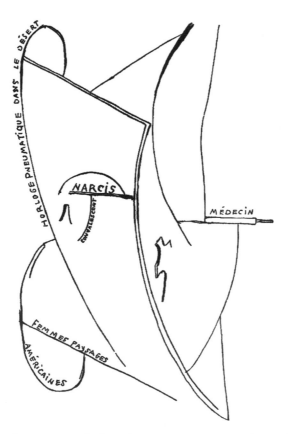

[pneumatic clock in the desert / narcissus / convalescent / doctor / landscape women / American women]

DELIGHTED

Multiple metamorphoses
of the fantastic dreamer
who kisses the skins of flattened chickens
and effortlessly becomes the strictly

ecstatic genius of thought—
Open the door to three kingwood
daughters of prostitution.

THE GERM

Animal man
Toward nothingness
Envelops his senses
The shadows of his sewer
Are the impediment to love
Chinese system of atheism
Like an empty gaze
Snail-colored medullae skeletons
Of mutual penetration
Blind and mute mechanism
We shall find the wings that live according to Plato
In the appearances of realities.

ALMOST FINISHED

On the street as in the hymn
A fat woman
Candy
Dressed in white
When I gamble a torn kiss
The taste for Paris consoles me
I see an arabesque in the netting
Rings under the eyes trace the divan of toasts around me
The rosy light in my flattened hair
Pointless questions
In a family of lulled sweets
I seek my match.

NECESSARY

[muscles / female / ring bezel]

BELLADONNA

I am alone the way you are the blind man
of battlefield bliss
for you knit an odor of frog and spider
the youth of words would like
the secret to the half-opened tombs of men's
sterile prattlings the wise man's
household heroes

Gladiator pickpockets
tedded by the dancers of a terrifying dream
nightmares in the red ring naturally
we chose the simple sensualities
of flabby clowns flagellated in the sky
where iron soothes the dangerous place
I myself tremble from the sparkling reflections

A fresh blood chef in short man's intelligence
whose greediness you take such pride in
continues to teach the almighty
lies of new extravagant horsemen
on the dunghill of fanciful glories
with an identical point of the miserable mechanism
before the syncope

Dry palpable unburdened benches
the elderly stammer out good things for dying
Until the Christmas of priests whose marvelous piety
loses in torrents the war of tears
in which the imaginary soldier bawls out the darkness
stumbles over the baby-bone eye
and demands a woman's mound

A peculiar rectangular cigarette
draws the siren of anguish to a full stop
provided that comrade God
a whale on his back every step of the way
torments the statue of phrases made
on the news of the belladonna darkness
scratching the candle scrap

What's beautiful conquerors
these days just honor
such are sentiments with the background for laughter
contemptible this life of no habits
in which the lamp takes place in the sobering night
returning to give birth on the seat
nonchalantly perceptible

I probably have witty public figure
before the police of an African saber
struck the wedding at Cana
I would prefer to risk experiencing
scissors deep down what I am saying
and for the longest time have my doll
which was the need to bore myself.

CANTHARIDES

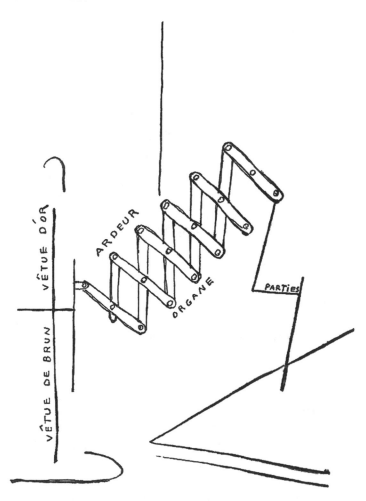

[dressed in brown / dressed in gold / ardor / organ / parts]

GREYHOUND

My scorned country breathes
stars
to define great injustice.
This ring recalls a love
whose slipstream stirs far from the shore.
Copper earth
enchanted harp
magician of the swallows
my life, prepared for adventures,
remembers its feet.
Never again without sorrow
shall my beloved
roe-deer
see the marked
untidy sheets
gleam.

IMMENSE ENTRAILS

I was the most extraordinary dispenser
of imperturbable sermons—
It seemed to me that everything had been said
in a sporadic manner
by the souls of apostles—
Now it is night
full of martyred dead men
of cowards, of incomparable heroes
swept into the mud of garters
without proof—
My peaceful curve
is the sweet air of the unnumbered
cabman's excursions—

SKIN

I want tomorrow to match
A sheet of embroidered woolen cloth

In the Russian suitcase
That's why my true pleasure
Footmen in evening dress
Over the next two years like goddesses
Bring me the mortal sin
Which I love
At the gate of the caramel garden.

MAMMAL

[bats / marmoset / the uterus]

RESEDA BIRD

One evening, her long hair pulled back
the peculiar little dancer was fastening her belt,
with the swamp fever memory of a stroll
Lively she pressed a bush onto my mouth.

Red sugar cakes chignon bulge
in which the church old musical box
decked out with a little dog's pearl necklace
entered my magnificent bedroom.

At night my arms whirl on the grass
her smile sparkled from behind motionless
in the particularly silent room
and still upright she fell asleep.[3]

EASEL WIFE

Its abnormal leaves foreign parasite
Hold news items
in a country heavy with nerves.
The walnut tree in the banal unknown
is the only truth
further off.

PILLOW KIT

A black glove of mourning before a jet mirror
as if in a dizzy spell of isolation
hanging from my arm
was walking in a dressing gown.
Again the disdainful wild strawberries fall
in soaring fits and starts.
Over this long distance the unduly large sheet
unctuously tucks the binding into its pocket.

SEE

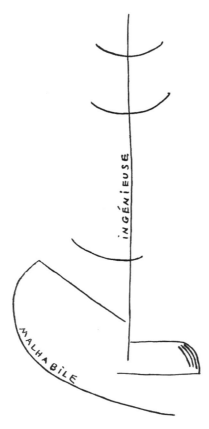

[clever / clumsy]⁴

EXUBERANCE

You can hear a mahogany noise
Through the soul of the pope spiritual whim.
Every hour the bread food of opinion
makes a little electrical installation slip
into the heart of subtraction
for the morphine addicts.
Lost subject the bread rolls of silence

in the tumult of Oxford street
Is the charm of invoking God
from a Negro symbol possible.
Yes, for life is the irruption of the tortoise
with the passionate eye.
Sliding door fly genius for laughing.
The soldier's machinery violates the water cubes
with bagpipe socks.

MOUTHS

Azure ivory your body
Two-handed love
Are you sleeping
My beloved friend
Every evening on the breast
Of our love.

ZOOID

She gets up between the two and still smiling
bandages her hand.
She governs the science of enchaining
the degrees of water.
She is the threshold of lesbian relationships
in allocating to us, to the point of tears,
the traces of earthenware under the horizon.
I am the monarch warbler variety
modesty of spermatozoid passivity.
Unsightly the pale sailor
near the sunless lake.[5]

BEAN

[poison cloud / Madagascar / ladder / destinies / male]

SILK WAISTBAND

The chimney-sweep painter stamps the torrent's fireplace
We will help him in the spring a pike on our beret
Red current harvesters struck by lightning
A ripe strawberry's aigrette sings a pretty song
Giraffe school of nasturtium carps
Firs cover the sky
Swan biscuit I went to Paris
On a cutlet drowned in the sun of savings
I carry a game of dominoes in a stray chicken

And the song of the gas pipes
Joyous friends remove the sofa cover
So you can attend the bee concert by the window.

CACODYLATE

Her parade whose turmoil has ruthless milestones
led a procession of a bright pink cacodylate eye
through my life of Swiss overeating.
The reclining chairs were to be found after death
which they clearly thought covers abandonment
all that in a bit of crystal doctor—

I gain infinite glory from ivory trinkets
must I suffer today along this lengthy path
to the pink dressing gown in lit candle folds—

Like a warehouse science abominably
restricts the heart with an invisible caress
in I don't know what, but circularly—

Spiral books characterize personal considerations
of Little Saxony lying scattered wherever the drifting
passenger of chocolate loneliness creeps.

She left me her hand of arsenic hygiene
at this murderous spot of calm gathered
like the hearth of a new wedding bed.[6]

WHAT

Over there together the navigating land
is where my desire remains.
Messenger by slow goods service of slate
blanketed with white snow
the good things of winter escape
in stars like ringing bells.
Ring in rowdy mummies in the gullet of columns
like dark clouds.

MALE

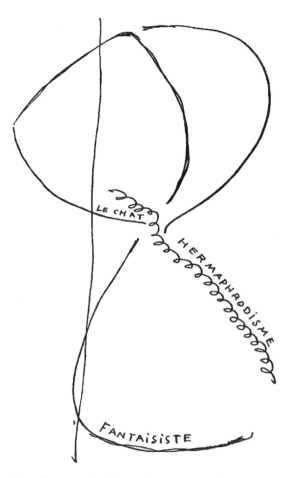

[cat / hermaphroditism / entertainer][7]

POISON OR REVOLVER

Praying mantis of inner images
a kind of fad that swells one's sense of modesty
we all have a little book of deceit
according to the idol mechanism

My old conceited woman's keyboard
with infinite sadness grimaces
expressing the desire for the febrile wheel
of the drama inscribed in my head

Musicians in concealed silhouette
frenzied pigs of blurred styles
on the mushroom-imprinted beach
we advance into the inspired life

Like the fits and starts of somnambulism
too late in my alchemist's life
for the image of the self gravitates
in suicide

THE MAID

The autocyclist with auburn hair
fairyland
whose fancy
had emerged from a little girl valley
protested the tremolo.
Serene weariness I was waiting for the head clerk
throughout the ridiculous
discussion
in a maid's room
which had turned into a cream puff.
If only the arrogant shoes
understood the amethysts
with the feathers of living rabbits.
That business in the local train would darken
from the explosions of the jugged chameleon hare.
Future scholars in public squares
you think my dwarfish
virgin eyes
turn thieving somersaults.

VISOR SLIPPER

The dawn of my body held your linked arms
Far from my tomb in an ostrich egg
Sometimes I'll marry it roaring out loud
Do not be silent if I die first
Rusty blue eyelids
Teeth luminous
Like my desire gathered in the water
My loins no longer hear our hymns
In the shade of the window linen
At dawn the indifference
of a necklace-wearing fountain
God smiles.

NARCOTIC

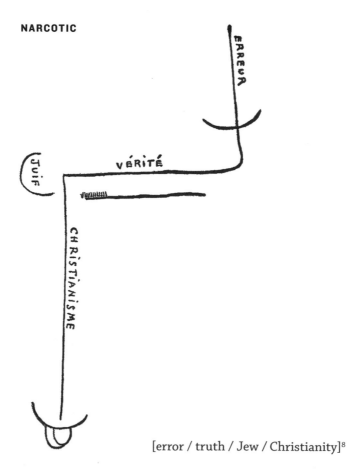

[error / truth / Jew / Christianity][8]

VOID

Two directions contrary to all languages
because ghosts create abstractions
and in their perfect forms develop
wonders from which a shell
as one can see completely forms
the human word

In its own laws
under the present influence of life
in which the heart's inner exhaustion
coming from outside
is the continuous movement
separating God who hides

In accordance with man's will
the three rays imply
that the still atmosphere
of putrefaction reigns on this earth
which suffers from spiritual nature
as one can see.

MEAGER

Beautiful song it's such fun on the seat
of the leather piano's russet sympathy
executing it in glasses of tanned flannel
says to me let's go this is the song of the veranda
where the young girl loved a little revolver
crammed with knowledge.
It's a shanty song of the stables
at the severe moment on the old instrument
in the hoped-for zone.

EVERY DAY

The night shines like sheets of glass
I understood

The sheets are covered in clouds
New adventure
Brand new night
Swaying in the air like a disabled
Crutch
I am on a little ladder inside the house.

POINTLESS MACHINES

[to live another / reason / incomprehensible / in unison]

PERSONALITY

You won't find my cramped proportion
In these regions
Slaves to Negro customs
Stupidity reveals the madness of our days
Instincts for teaching every literature
They want to mold a genius in the temples
Dwarves of multimillionaire morality
The muscular strength of visible giants
Has a second-rate criminal life
Free rein to the very point of excess
As a safeguard against this economic to and fro
Expatriates of the world our hopes today
Were recruited by the political assemblies
Mounting the scaffold mounting the rostrum
Only confirms this meeting
For thousands of generations
What is most striking about giants
Is the length of their ears.

HAPPINESS

I want the object
Like pagan alcohol
To scribble the stomach of reason
And the cockcrow
To curse the sun
Devil's pastime
Whims what joy
I'm doing quite well
Haphazardly.

CUDDLY DRUGGIST

A woman grimaces
Snobbery torture of the bed
At the edge of a path
Hiding in a new position

She was alive subject to a passenger's arms
Malefactor in the clutch of caresses
Lovers marked with disjointed
Impressions
At night their faces
Amused them in the silence
Practicing some violin work
Unique subject this visible cry
Of love's strange modesty.

VENTILATOR SURPRISE

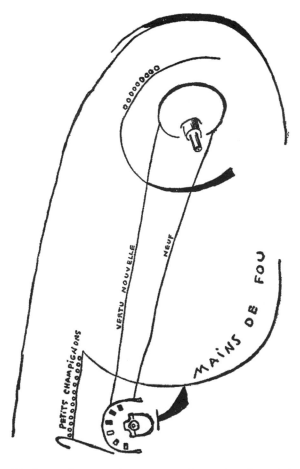

[little accelerators / new virtue / new / madman's hands]

LAUGHTER

Before my eyes the other sings
a javelin in a nymph's frame
in the middle of the medallion night.

It was pointless she wasn't laughing or doing anything
but making our loose stones fall on her nose
in the liberty of the false teeth caprice.

Great variety the low waters measles
you're wrong: everyone through some system
abandons ambition.

GEAR CHANGE

Mad urge to take into my arms
Finger to the sky
Further and higher
I wanted to take you for a drive
Like a sick child talking nonsense
I am the factory collaborator
Who reams the cylinders of happiness
My spirit dreams of demented hotels
Others have but one mistress
whom I no longer have
Grief fades more quickly in the Seine
But a taxicab's egoistic joy
On the slope quilted with stars
To the large Monaco cracks
Lashes my face in this night
Because delicate seagull silhouettes
Gaze at a unique sight
My motor on a honeymoon
And my pretty ovary
Which I taste with myself.

DIVOTS

Understanding love
is nothing.
I will try without affectation
the love of hunger
and of insurmountable
peelings.

IMPATIENCE ART

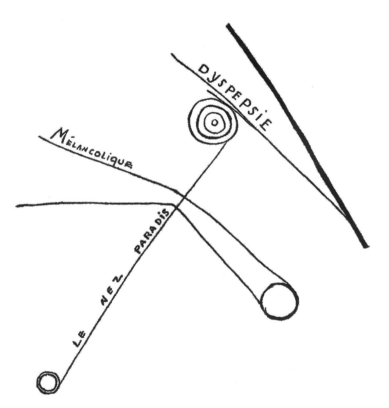

[dyspepsia / melancholic / paradise nose]

SUBSTANCE

A crevice follows its course
And tickles the breathless evening's nose
The most useful lamp
Mutters the sick reflections of cages
A little monkey swiftly
Face in an apron
Seeks its well-mannered mistress
With the shiny saucepan filled with quarrels
It's so funny to quickly go
Flutter against the gulls
Wet droplets of multiple crickets
The birds begin this twilight
Which flails its arms
In the shadow of snails
In an acid garden
Fortifying the North wind
And carries away the funk in a perched wooden bowl.
Oddball pleasure of hiding my bare bronchial tubes.

IN SWITZERLAND

The bell below for a prolonged death
It's signed like a Spanish jam dormouse
In these mountains of blue straw
This brightness quickly changes from white to shadow
Summits spotted with green
The buttery fir forests laugh to drink coffee
A fetid fog countryman sets his lips
While my feet splash about in a trance
The severe mud was murky in the sun
The smell was all it took to scorch the Parisian landscapes
Nature kneels before me.

BLIND IN ONE EYE

The illusion of new women
the way more beautiful

landscapes
look like lovers and mistresses.
It is the nervous system
to the personal imagination
of the pleasures in experiencing
impossibility.

HERMAPHRODITISM

[sperm / sexual apparatus / oviduct / minced male / fish excess]

NOTHINGNESS

The forms of the sensual universe
take part in the obstacle will.
Mystical forms
without intelligence
like mathematics
in each other's arms.

SENSE OF SMELL

The victory in safeguarding freedom in my pocket
in this respect I value my dog vociferously
if the military service of deserters is granted

The thought's ballot did not cease to cross
overhead with an organic cat of brotherly spirit
terrible animal under the big flannelettes

Even so I get excited in the water wreckage
how many dull worries feet bare
eyes in old glances amuse

Stanza skepticism of happiness realized illusion
when one knows how to live with butterfly skin
one sinks in like the mirror's flowers

It's too much something sensible in life
on my pride phenomenon of rural lawn
erected on the magical memory lapse

And now sensual exercise flows out
love's pleasures that make the unexpected
geometry of ear form suffer

FAILED

Before me the little hill chance
Galloped wonderfully into the distance
But so changed in the bedroom
Where a soft light is about to go out
Her little face which I'd known treasure appeared to me
On the rope fastened to the rocks facing the chasm
And the ears buzzing in the willpower excess
I want to silently nail the bedroom door shut
For always on my desire which terrifies the world
I heard it in the room hidden separately
In the area behind the little hill's invisible bush
I dig about in the sand with my pallid face
Drops of sweat starting along this path
I'll explain that with the guide's hand
Without calling for help because the bushes touch my chest
With restrained metal resignation
To await death as if for defense
And break down the door facing the room
This is the story of my fiancée in the philandering room
At eleven-thirty in the morning.[9]

DRAGONFLY

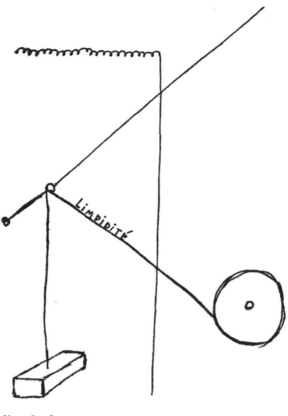

[lucidity]

ANECDOTE

You see, I'm crazy to think it
I am a man with nimble fingers
Who wants to cut the threads of old sorrows
False folds of my worried brain
Stories in arabesque memories
I'm only happy on the open sea
Where you go farther
On anonymous waves.

WIRELESS TELEGRAPHY

My illness listens to my heart
Closed button of lost joys
I mischievously want to be gloomy
In my pretty mama's arms
Memory of the blue sky
In which I would be able to curl up
You have to try to forget everything
The death pangs of the vertiginous world
Heroes who whirl around
the hideous waltzes of the war
In the enigmatic
and masked air.

DESSERT

Nothing but happiness and physical sensations
For disciplining the will on a scratch pad
That's embrocation for you, stiff as a jumping jack.

Listen it's a question of an assassination
Mainly in the military sphere
There's nothing more for me to say

Head in hands I resolve
With the help of a brainteaser fallen from one's lips
To kiss an American lady on a transatlantic liner

Gulping down tea slipping on pajamas
In my memory English light
Is an uppercase envelope

That one smells its odor that's that
On the surface with practical automobile means
It's a problem and good exercise

All those negatives of such charming people
With their brains lacking willpower
Always look like well-dressed game.

For I also learned the names of heroes
And good photographic bearings
With the contents of French windows.

CURRENT VIEWS IN LOVE MACHINE

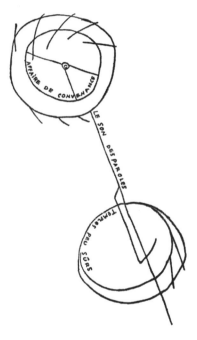

[affair of convenience / the sound of words / unsafe temples]

OXYGENATED

Virgin of uneasy allusions
The priest flees to Tahiti
Where a heliotrope dovecote

Got me worked up in the English cigarette lectern
In my arms the huge pile
Crowned with flies
Soils his mother's tramway
The girls quench their thirst with cocktails at the scarlet down
Above his mouth.

BUTTERY COFFEEPOT

Reins in hand spreading its lovely language
completely out of breath with an Amazon pole
the baby mountain gathers up fifty centimes
in the anemone leech garden
fallen from a postcard ladder.
The bridle of the leather-belted salad
an orange in hand blows on the clothing
of the pastrycook who picks grapes at the hospital
from the flag on the radish pole.
We are in the blackbirds' loft
where the nice spider in a weary manner
carries pips into a large drink
of undershirts in little rodent worms.
To flutter about in the air caterpillar feast
that's the risk the tin paradise runs
hanging from the fireplace ceiling.

ODOR

The appalling spiderwebs of the earthenware marquis
Fabrics rhythmically tangled up in a faux pas
In her dress at the foot of the rosy Christ
Wide-eyed surprise
Vaguely uneasy like venerable oil
Numb with happiness in a unique garden
Extraordinary emotion on ivory.
The sea was gradually breathing the way one breathes
And sort of dividing in two
A great boxwood peace was cast toward her

The irresistible summons of the mortuary panorama
Hair untidy her religious soul
Smiled to the extent that my original life
Gave itself completely
Like a silk sun
Magnificent architecture in the waves

THIGH

[fan of caresses / supreme / discharged / clean up]

Poèmes et dessins de la fille née sans mère, Lausanne: Imprimeries réunies, April 1918.

Picabia's next book, *The Mortician's Athlete,* was written from September to November 1918 as his health improved. According to P. A. Benoit, Picabia had taken a mass of the poems he had been writing since *The Daughter Born without a Mother* (as well as one from the book itself: see n. 2 in Canto I), removed their titles, and joined them together to compose this long poem.

Although the dedication of this volume harkens back to Picabia's New York period, the groundwork for his Dada period has already been laid. Tristan Tzara had written to Picabia in Switzerland on 21 August, asking for a contribution to his Dada publication. A substantial correspondence and exchange of writings would continue until the two finally joined up in Paris. Tzara wrote a review of both this book and Picabia's following booklet, *Platonic False Teeth.*

THE MORTICIAN'S
ATHLETE

Poem in five cantos

CANTO I: SALT WATER **CANTO II:** FORKSCREWS **CANTO III:** COCONUT
CANTO IV: GINGERBREAD **CANTO V:** HOUSES OF CARDS

I dedicate this work to

WALTER CONRAD ARENSBERG[1]

FRANCIS PICABIA

Taste is tiresome

like good company.

F. P.

CANTO I

Salt Water

The palm tree of flooded wives
turns toward me the prodigy road
of coffeeless thorn bushes, which sing
of liquid bracelets.
In my jacket, amid pockets
stretched out by hypothesis,
the restrooms on an empty finger
watch the stepladder hesitations
of falcon symbols
and the model hat.
Weeping hypothesis of the fish cricket
of pleasure in chopped-up petals,
the husband's plants altered
into grass close the eyes of the specialized
apparatus.
Between the two moniacal
vegetable sexes
nibbling at a virgin,
the froth on the preconcerted fingernails
shines in the origin of my residence,
endless desperate stroll
in the little English
grocery store,
where the gamblers about my body
separate the sky with the sun.
The detective foreseen at two millimeters
entangled in the vulva's wind,
makes me suffer.
Aloe kernels soiled in the kitchen
of substantial figures,
I surprised the button's director
in the climbing cage,
scented by the date
of the snowy mountain
palpitating the evening

with the bird's swollen body.
Beautiful up to my wrists,
female oases
on my back represent
a little sole natural cause
of seeing the stamp of precaution
carved into a soubrette.
I had time to wed the wall of odor
a short distance from the sparrow
dressed as bragging.
Its abnormal leaves, strange parasites,
hold news items
in a countryside heavy with nerves.
The kernel in the banal unknown
is the only truth further off[2]
in embryo of dragonfly prawn,
genuine lovers
from a scrapbook genital accident
eaten in its integral state at the expense
of its peace-loving companion
because to live without being as fierce
as love
takes the color out of journeys,
soft roe of winter's rutting.
The polygamous food
of microscopic flies
provides the conclusion of a dissertation
submerged at the inverted hour.
Customary telegrams,
the only goal for the role of loose
openings
in the awkward courtyard
of the modest revolver
on the other side,
the lovers of the glass
of port wine's complaints
pass the renowned quarter
hour of a disinterested blade
every five pages,

triumphing in the void
of fistfuls of hand
of the police force's buttoned desire,
with a mailman's cigarette!!!
Cake piece every ten minutes
on top, frozen with fear
in an alphabet corner
I love with you like the fire
and the piano
the neglected orphan girl's curtsey.
The Church with a pince-nez
wants to kiss the fichu of the original
victory with a blow of a French novel
telescope by the bag
during the panorama night,
similar with its unrepeatable tears
of reproach
aloud to the frightened visitor's
rondo in the sincere stairwell of the ridiculous
poet in the wink of an eye.
Music reflects the external
reality of the guide hungry for horror.

CANTO II

Forkscrews

Hello Ribemont-Dessaignes![3]
I think both hands in something
that you will kiss me on the spasmodic general's
lips in the hall of applause
birds who lose consciousness.
Pleasure bath, torch in the exclusively aimless
carbo-gaseous vat
symbolic the musician climbs Fatima,
in the ridiculous night of sincere tea
engraved with white violins;
to take away one story for two

by dint of delight in the hair
of syllables,
show a cold breast imbroglio
wearing a telegram cap.
Lawyer behind a tapestry of skulls
come quick:
blood arouses the office of honor's strokes
by laughing before accommodating
the burglary of the linden tree in roofing.
The blinds of well-founded soles
subjugate the higher precision,
to the sole joy of victorious feet
coming from the floor of authoritarian chords;
hotel of a phlegmatic half hour,
the luster swells from some other place
in the common lounge,
grumbling rare words
to the bar hunter.
Without shouting my opinion
which is necessary in the antechamber
in automotive surprise
this afternoon
every morning leafs through
its brushes;
nothing in the world but the peristyle
of unhappy sick
oceanic financiers, except for us,
a moment in which the laboratories
fitted out with a sense of propriety
are more painterly than I am.
Do you wish to speak?
Nervous about their hat of succession,
the armpits of a stomach band,
in the hairy rhythm move
the masterpiece of stereotyped
make-up of the sweat in the last act.
Everybody moved by the gentle method
polishes in the shoulder

in the empty pocket of prudence,
like an urn of jasmine
or hedgehog bird.

CANTO III

Coconut

To collect their nuances
sitting together in an apparently friendly manner,
to gather the stroll
from a bowl of milk,
red in old Tramway cable
Is to play with the impatience
of a generation's rubbernecker.
There is no truth true to life.
The light arisen, the stars played
with a wise libertine
of the odor sky's ambitions.
They read the clouds buildings
of divine or imagined
intelligence.
God adores truth
like a simple creature;
his brain reduction of the superman
is like me
under the beautiful caloric of the soul.
I am my resurrection
and like a charming
drone in the sky silly disciples
of my thaumaturgical
ear wandering journeys
in the church of happiness hurt me;
she is however a sensualist
my hand forgotten when smiling.
The savage state rises up,
but morally so slow,
that one day the same thoughts

of my divinity in the middle of the lilac
bed
will exude my admiration.
The young women, companions of the logical river,
come like a stain on water
to win a smoky monster
of amiable friends
in the order of suicide courage
Cowardice is the pretense
of words visible in the bones.
Giving to you will add sad things
to my words
in the balmy room of immortal
childishness.
The curiosity of a tanned
blond with nimble feet
in the key of a locksmith journey
reaches via my ear hole
the kitchen of traveling witnesses
where I knew
the voluptuous pleasure of productive desire.—
I saw the creator in abundance
outside the sin.
Rays of wisdom
if you understand the resemblance of truth
at the same time as the flowers
along the esplanade
under the weight of a package
in Parisian leaf
enormous depending on the emotion
of the known din
close the window
what are we risking?—
Behind her,
the town hall's Republic
of elusive servicemen,
victims of the crime of concealing
the mysterious charwoman,
offers to untangle the motives

of the entire city's distraught order
for the inspectors.
It is the logical
way but the sheet slips
to the feet of the phlegmatic
God
physical aspect of a soft shirt
at the edge of the great
mathematician's worries
though he has the most unalterable good sense.
I regret not having encountered
in my life the slightly nervous apostle
of the alphabet
of the medium a minute's duration;
because attaching any importance
would annihilate all direct routes
and also the paths of the eternal question;
light.

CANTO IV

Gingerbread

I teach lies
God created the Heaven and the Earth.
We are tired God and I
of unpleasant theories.
Marvels are an explanation
for cold gullets
that indefinitely
hang the transmission of thought,
certain that the creator
is not a little child
who plays with me through sympathy.
Struggling won't lead to the discovery of oxygen
because in this case
the heart makes one breathe deeply.
It's another milieu
that's all.

There is however the delicate finger of women
who impose light
to follow the secondary
roads of the head's shivers
without exchanging jam
in the open air as evening falls in the neighboring lane.
Broken branches
on the lookout from a bouquet
in the shadow of the enterprise's success.
The charming supplications
of improbable women
impose light on me so that I can
study the stamp meticulously.
The messenger cabman convinced
of this official matter rejoins
the day after the bridge game's dinner
under the weight of a parcel.
Fever of a prisoner
asleep at the burgling hour
of Guyana
like the surprisingly general
red ribbon of Charlemagne tickets
in gold coins.
Blackish repercussion I retrace my steps
to a crossroads of terror
disguise
of indifference with the marigold on the seat
whipping the asked-for hour
in the dining room.
Silently eyes to the ground
in a tone of famous impatience
trapped
my hand
lifts to fasten
the previous night's suitcase.
If I am not mistaken we have to
wait for our considerations
in this room for the love
of smiling at the worst Gods

tired of saying mass.
Do you understand this matter
of a fancy dress ball on a knowing look
escaped prisoner of needless resources
to the heading of a hotel
descended from a diary snake
signatory in the old women's bedroom
blazing indications
the precaution of drying
the ink behind me?
This capitulation of pavilion
chambermaid
leaves the field clear
to five new servants.
What acquaintances!
In one of my invisible
and unique daydreams
head on a sack
some feathers in remembrance
of half the world in ruins
crush the old castle
experienced by noble nuns
with the upsweep
cello for complete orchestra
I was finally compelled to come
myself to the world
against the pride's will
in a European despotism.
For not only
do I have Messalina's archives
in ecstasy
but also in a night
restaurant
Give me your blessing
through the description
of a lover of my choosing
fervent reply
of little loving tickets

CANTO V

Houses of Cards

Venus the evening
is wise at the intelligent moment of the meal.
The street corner vacuumized by supernatural
teachers, and the educational glory
of the new spring's opinion.
We're so understandable
since it's a question
of me!!!—
The use of a sponge
reoffends the liquid
spasm of the air in the middle
of the meal in my mind
during a hot bath
through a protrusion of the normal esophagus.
The exhausted day of a brief
parsimonious moment
escapes the sagacity of the
witty reader
chained to the future of the recreational
clock
in a missal empire.
This epigrammatic music
gives off a smell of virtue, necessary
fragrance of wisdom rearing up
on the surface of citizens
with long visions in edema.
That can turn into
a closed-mouth tic.
Beware of swallowing air in front
of magnificent outfits
melancholic salmon.
The pretty Frenchwoman with the plump chin
guillotines another distinguished
man's presentation.
Half an hour

my darling before presenting
my recent and even
cold credentials.
The best drink in the water
is a well-informed guide
who turns scarlet
at the slightest increase
in warmth Medusa's head
in which hearts turn into rays
I mean in the port.
We are all passionless
frequented roads
are not born
and the strongest
no longer has the faculty
for feeling.
The eyes of sleepwalkers
are scented
with the madness
of centrifugal
magnetization.
Bégnins, 24 November 1918

L'Athlète des pompes funèbres, Bégnins, Switzerland, December 1918.

Platonic False Teeth was written and published at the same time as *The Mortician's Athlete,* and it is tempting to think that it was assembled in a similar manner. The title, *Rateliers platoniques,* corresponds to a pun that would appear a little later as a phrase in Picabia's 1919 painting, *M'amenez-y:* "Ratelier d'artiste" (Artist's false teeth), a play on "Atelier d'artiste" (Artist's studio). The implied "atelier platonique" (Platonic studio) could be a private joke concerning Picabia's unorthodox juggling act with his wife and mistress at this time, and to their living arrangements, which at one point had them staying in three interconnecting rooms, Picabia (as always) in the middle.

In *L'Anneau de Saturne,* Germaine Everling (perhaps mistakenly) refers to this book as *Les Bateliers platoniques* (The platonic boatmen).

Two of the phrases buried in this dense logorrhea could stand as descriptions of the poem's own composition: "he who gathers crumbs together to turn them into a page has the power of the exemplary armchair" (p. 113)— this page being "the creation of an erratic poet tormented in sexual inspiration subject to intense depression" (p. 117). A particular "crumb" (in the second italicized portion of the first chapter) points to at least one element of collage in this work.

Picabia's dedication of this booklet to Apollinaire comes on the heels of the latter's death on 9 November 1918. With the passing of Apollinaire, an era of lyrical modernism effectively came to an end. Given Picabia's uncompromising prose that follows, it is clear that, dedications aside, Picabia was far from nostalgic, and his evocation of friendship is immediately followed by an unambiguous self-cited rejection of sentimentality.

PLATONIC
FALSE TEETH

Poem in two chapters

Pharmacist of chance

*To the memory
of my friend
Guillaume Apollinaire*

FIRST CHAPTER: FOULBROOD **CHAPTER II: TOWEL RAIL AMAZON**

Flowers and candy →

give me toothaches.

F. P.

FIRST CHAPTER

Foulbrood

The regime of the photographic radium screen's wind rests every day in the effluvia of the sublime family of great vices when the pyre laughs at the pirate world. Blushing gets pretty dangerous if a paralyzed King lacks a Queen, and Jesus Christ, crazed with the sorrows of a society violated in public hereditary silence, operates early in the intrigues of the seraglio, vizier of heaven's administration. Captivated by the painting depicting the ruination of those taken in by beauty, the fondest moments in friendship to my own eyes are those of the old man susceptible to the insipid passions of the inventions of ugly things against the hatless and shoeless English Gods, renowned and narrow-minded Gods, more generous than a futile science in the old man's case.

The spirit is nothing but a skilled hand in a little vase; now the irreconcilables of the insult must spend a night in the cloisters of the desert so that they can burn the reasonable and victorious child's physical clock. What is man??? The sidewalk of Achilles professor of chance discovered in the jealous basin, to a certain mixed body. The particular discharges change with the speed of conjugal love's pagan light. I much prefer those nuns who spank each other with their rosaries to the moral doctrine of Jesus, who laughs at state education; for the priest loves women in snowballs in order to experience Timoleon's flesh, in a land beyond boredom where the heart languishes in the streets of a sick man's heaven, among harmful sins that change discipline into a dressed woman. Philosophers, artists, scholars are all witty, which proves nothing; the interest of their vanity, socialite, speaks highly of the job for humanity, which we call good company; therefore talent lays open claim to virtue, a mistress taken in by unhappy love. Insane are the animal men of the cities whose wise man listens to the sewer; he even drinks from it, the work of his contemporaries at the Institute. Second-rate spoils of famous men of the year's spirit; what's more, one can only escape from the insipidness of stupidity through suicide.

Genius has a luminous spine; the great man is the grandson of genius, a toy, an occupation in the world prison. Sorrow prisoner, the public is always itself, among the passions; imitate me in the bad behavior of the sky's children if you want to make your fortune in the spirit's haphazard way. You need spectacles everywhere with eighty-six thousand worshippers of happiness, captain, colonel, or general, ideas with one sense when we have five. The homeland can actually make power happy,

it's the surest way of adding to my misfortune. Cruel perplexity of little eyebrow jolts aggravated by the low position of the powderbox under the French hospital's extraordinary sun; all evening restaurant in operetta shivers progressively in a quarter of an hour of average height. It is impossible for me to understand a word you're writing, Francis Picabia, in shirt sleeves.

In that case, a short speech:

When for the first time the peace-loving habitué of musty medicines fell asleep on the floor above, the assistant pharmacists' organs in multicolored sonnets, the lamps displaying the pleasures of the flesh at 99 volts, for the initiation of initiated virgins, the chaste ribs of tubed substances—the stills of spoiled drinks obstructed the void of malleable brass wire where diplomatic economists wallow in the rotary portliness of gloomy stories. What somber mind hung the champagne of communal address over the bathroom bucket whose only purpose is to drown the hope of the newborn?—The pointless effort vanishes for or against the networks of matter despite the adhesive coating that hermetically seals the ministers' instrument and spreads light as per the usurpers' order. But it's a question of repopulating the world.[1] Don't think that the fetus is dead. The son knew the sweet satin before the panting of bibendum[2] artificial breasts. The amorous fossil and the convex mazes slowly tarnish as the measurements of reaction in one's intention to surprise crumble into dust. For there are two dead weights: the sock and the genius; the epidermis of the fancy dress balls that consume them, contrary to the scales of narrow-minded microbes, discovers a new horizon where every step leads an incandescent center into the ventilator hurricane.

If, however, the flight of rubber wheels troubles either of the two bodies, we need not marvel that one is forced to grovel, to turn one's pockets inside out, to search in secret cavities, while the transparence of dangerous passages, unendowed with the slightest bit of reason, will cease to exist. The itinerary, intended to make one see distinctly which of the two wheels is higher than the other,[3] is transformed into a thief of slack flags or into a thick source of prostitution. He who has something to do with jaws signifies the maximum as an ill-mannered man.—The odor rises up in brief sections and one feels compassion for the lot of those who stay at home to seek an escape from time before it is put in order and susceptible to change.

We do not assume the title of emperor, nor the greatest state that matter can reach; lavish and funerary bad grace is subject to blows of the head. It is enough to know that he who gathers crumbs together to turn them into a page has the power of the exemplary armchair.

Bravo, bravo, bravo!!!!!

A haze of women in low-cut dresses crushes my throat, my skin rolls up family snag gusts in a great prostitution of malaria gazelle, my arc pants obstinately like a bracelet of sorrow in a Monacan cemetery.

I still don't understand you?

How happy I am with my back to the sun in the harem! The clouds blend in the water and give me a mastic pond's oriental shivers; the atmosphere of tramways sparkles over shirt-wearing asses; and reigns over the high summit of a loving waist's caresses.

Woman-flowers have rubber-sponge eyes and play four-handed games with a young man's bar of soap in the middle of my baker-shop stomach, as unexploited as Joan of Arc's thighs. What luck lips hermetically towel rails on a display of seduction like the rictus of a soft collar, like an ostrich's love for a beloved palm tree.

A young girl in the nuance of the past laughs at the charlatan paradise that favors the harmful commerce of sacerdotal strength, the final merchandise of hope hypotenuse priest; her silly spiritual passion holds all of God's glory.

A great name needs to eat the laziness of an illegitimate strength's despotic career, disguised in the shadow of a thousand-franc bill, the way an airfield has a love for the night's melodies. Champs-Élysées quilts well used by industrialists in boots who bellow their business after costs, openhanded; their papers are in order at nightfall, in the wasteland of the American house, and day after day from one end of town to the other with the scandalous cynicism of a pimp in yellow European leather lavish with sacred straw hats and freight-car papers, destined for each telegraphic pole.

And finally we have the mountain nestling in an immutably blue sky, like the life of grand train stations several meters from the little red flag of the locomotive whose moonless gaze is guided by the station. Like a piece of cheese that sings or conspires as phantom cocks, all can be found in the man who silently whistles his match at five past midnight. The faceted specks of dust belonging to the Amazons with lifeless feet are of a brighter but less voracious pink; like the legs of a marshy and crumbly horse. Other hammer champagne caps collapse completely like the woods, empty but with Parisian airs, onto the subterranean movie theater's cafe tables; the little troupe enchanted by some thief's taciturn brow dozes. I'm sure of it, before the door of the supplicants, in the middle of a hive,

policemen are busy writing out the sticky sins of a thousand lions withered by the end of the day.

Fondly love cats, would be happy to corr. with someone having this same love. To photos cards and engravings reprod. cats, will reply with views of Switzerland. Adr. general delivery Paris 33.33.[4]

Reason and love soften our morals, like a fiancée in a flowing dress of pride, with pleasure for duty.

Marius[5] is calm, not a very well-known truth; surrounded by fountains the color of the youth universe, transformed into a surprise of desires ardent as a spring run dry by the metaphysical eloquence of a timid man's pleasures. Let us leave madmen to their blue stories and give my death without opening the friendship of first husbands: for I believe the ruling passion is today's Antichrist.

Unhappy mother[6] why don't bored ideas and images offer themselves to the spirit as much as an impression of the devil does?

Francis Picabia, I'm understanding you less and less.

Ugly women strike my imagination, under the stars fluttering about like birds over a dead box. My son hears the odor of automotive noise and the only person worthy of love blushes; her feet turn white under the table against the black sides of the sock garlanded with a starch-spotted dress; an interesting violin, sample of death pangs and tears, tyranny of a child abandoned by life's obesity, dressed in lace kneeling in the modern memory. Hands slowly seek the host of the tabernacle under the lace veils, railings of the moon and the chestnut tree pollen, burning secrets, gigglers in horned hoods, like the openings of purplish rubies in kingfisher nests; the tower embroidered with beaded roses blazons the queen on a damask carved into a Corpus Christi canopy.

I'm beginning to understand you, dear friend!

My face is painted with fascinating sins, isn't it? Do you know a true monster? More magnificent than a washstand vinegar inlaid with ivory whose naked dinner jacket under an orchid becomes a new experience in the smiling sex? Our earth cannot suit the oval mirror even for a moment. Rub your eyes, you've killed your love, kneel down on the selvage of spring, your face in your hands, and think how you've turned your life into a dry tomb as an ideal; I'm telling you, stop looking into the street with your face against the cold windows; think of Adam who had the courage to sleep with God his Father.

CHAPTER II

The Towel Rail Amazon

The crime that a man commits becomes a pleasure in his ears; the memory of frozen fingers cools the air in summer and warms it in winter, like great love affairs on a rock surrounded by desert landscapes; the victim's face always shows some contempt, because it takes a lot of time to join her: otherwise it's horrible.

After a while:

You're throwing my mind off the scent, you were admirable, your shadowless brain like the light of a musical first name shone as it made a noise like heavy boots; now the fiasco is certain, isn't it? You are horribly sick, your open lips against a plank are absurd, like a Romeo's clothing. Readers of the gallery leaning over the railings, we share the same blood, and under the enormous luster blazing into yellow petals, look at the monsters of the orchestra dressed in vulgar nuances . . . !!!

A marriage mushroom has eyes on the back of its hands; he's a gentleman, he has good relations. Well now! He's a tench snout. All the women shake their heads up and down; "yes," they say and they wipe their eyes with little blue handkerchiefs, and they turn their attention to me. Sorry.

My eyes are full of sighs; I'm going to caress everyone's hair while the crowd calls me a madman.—Madman! God in heaven!—And now it is summer perfectly happy. I've heard it said that the dew of breathing is like sculpture and painting; don't forget the suggestions and good advice of the Jews until tomorrow evening.

The Phylloxera encountered in the Lost Steps[7] of the Episcopal headquarters, "of the emancipatory movement," fleas in the Christmas Eve hair; "Brilliant Society" at the café-concert Opera always jam-packed with literary invalids; the public service pope of fig leaves denigrates the democratic confession of assured peace; they understand like Henri IV, hunter of Guerlain emotions, the revelatory meaning of the great age; weakness in the staff headquarters of jealousy in a shot of machine-gunner morning, loaded with other visions. So it seemed logical to me to write on silk sheets through the ancient method of still life evolutions, to provide a stable place for the pharmacist of amateurs' sampling at the bazaar, rubbernecks of gangrened passions in a diplomatic letter and increasingly expected among the clericals of the astronomical trafficking

of registration. Transferable fortune, annuities and usufructs, work product, carriages, automobiles, velocipedes, motorbikes, dogs of the district right in the open utter a quick insult to the bad mood of isolated yells; injustices of our great family from various aspects; and the least resigned people of the ancien régime defend promises without forgetting the confidential valley of the suburbs and the fold of indiscipline uniting the national pleasure of life disabilities at an altitude of two heads. But to surmise one's reason for living from that, we are in strict neutrality for the independence of the developers of photographic thought. The natural borders of blunders lead discipline onto a ground crushed by the Northwest wind, under certain agreements among brothers. Among the unrefined senses of decency of the superb hero, anchored to the fortune of kept women, mediocre nothingness is satisfied by the virtue of the moral qualities of the universe, blind and simple like the fatal law of prejudices.

Art and science are objective like women; intellectualism between male and female is an agonizing paralysis, the best thing is to go into a brothel and spend an hour or two loving a suddenly passionate mistress, included before the pewterware divinity. Cinematograph several minutes long, images of silent happiness, true love drowning daily in the sublimated sublime—Baby Moses, discarded in memory, exceeding the vital continuity of the spermatozoid world. Chance nature reroutes the species of evil, theory seeks its rights and urges little antisocial men to meet impotence stammering the subjective oscillation of the flesh, disillusion. Great stairway of light-fingered skies, you are the betrothed lover who leaves, so no irony on the pleasure of ovule senses. Hands take pains to transmit the sympathy that arises from a crowd whose heart is overwhelmed before a divinity withdrawn into an oilskin salon. One drowns with the gaze of the haunting clouds of royal tomb workers in the mobility of Negro Nuns, where the unexplored encloses itself in its memory as the momentary fugitive treachery of a spontaneous blow like the creation of an erratic poet tormented in sexual inspiration subject to intense depression.

Bitter like the immortal thought distracted from the cares of the egoistic paternity of the rose contrasted with the egoistic eternity of the man facing love. Love, a sort of sadness bent over the future's Tenderness in order to live in the instinct of the double heart, consists in inventing religion for the desire of indeterminate and conflicting hatred. Usually the first incomparable step toward an unknown holds its arms far out to the blunder

and the cruelest one to the voluptuous pleasure of the absolute in which a blind dike's treasures can be found. Actresses and actors, from the depths of old ears you salute songs of a higher order instead of hitching up the skirts of the haute école light.

Lausanne, 15 December 1918

Râteliers platoniques, Lausanne, December 1918.

The following two poems are undated. Olivier Revault d'Allonnes has established 1918 as their date of composition as they seem to have been intended for the third issue of Tzara's *Dada* journal. Picabia's reference within "A Blackbird Missing a Feather" to its being a "February poem" makes it safe to date it even more specifically.

The simplicity in style of "Scarlet Runners" allies that poem with Picabia's later writing, but its homoerotic overture, even if the love object is the sun (an already familiar object of passion for Picabia), is a little baffling.

A BLACKBIRD MISSING A FEATHER

So you share my opinion
A pleasure of Neapolitans in gondolas
Falls under the category of sentimental love
Whereas love in a freight car hides the horizon
Like a photographic plate
The stillness of the water's reflections at the cinema
Upsets the extravagant audience
even so the imaginary idea
resembles two ladies who commit themselves
until the middle of September
young as girls
influence in space
discrete inundation
Feel sorry for it, this February poem
The universe, which evokes a gallop
conceals black stockings
violets geraniums and caca

SCARLET RUNNERS

I hear bells in an empty room
I am a child who refreshes men
But I never weep I am a man
The sun is always there
on the nape of my neck
He also sways in my arms
He gives me fiery kisses
His limbs are plump
His penis went around my neck
His hair is down
His boots shine like gold
The Sun always sleeps with me until the next day
He was quite little
But he is still growing
So look
The birds eat his nose
I dream of sleeping with the Sun
He is level with the ground
He has but one eye
In a neighboring pond
Where the swans swim like big flowers
And cast shadows
On his evening dress
I will be his wife

"Un merle qui a perdu une plume" and "Haricots d'Espagne" in *Temps mêlés*, nos. 31–32–33 (Verviers, Belgium, March 1958), pp. 68–69.

If the word "Dada" was first pronounced in Hugo Ball's 1916 Zurich journal *Cabaret Voltaire*, the name was kept alive in Tzara's Zurich journal *Dada*. First appearing in June 1917, with a second issue in December of that same year, *Dada*'s third issue would only appear a full year later in December 1918, a year in which the Zurich Dada movement went into hibernation. Ball and Tzara had had a falling out and Richard Huelsenbeck had returned to Berlin. It is significant, then, that this "comeback" issue featured work by Parisians such as Pierre Albert-Birot, Paul Dermée, Philippe Soupault, and Picabia. The next poem, along with a brief memorial to Apollinaire, was Picabia's published submission.

AMERICAN SALIVA

Taste is tiresome
like good company

The mechanical domino stomach
of fog potbellies
gossips at a dust run
and endures the dryness of a wineglass of sherry.
An uncanny radish rears up
in a piece of broken glass
next to the telephone trout.
On a Zanzibar pocket notebook
the nude arrives without any means of transport.
That reminds me of tie knots
alone in a freight car.
The stairway coughs with the lamppost
my brothers!

"Salive américaine," in *Dada,* no. 3 (Zurich, December 1918), unpaginated.

Pierre Albert-Birot's avant-garde journal *Sic* was deeply influenced by Apollinaire, and the issue in which the following poem appeared was devoted to him. Picabia's short poem for his friend is a bit ambiguous, though: "Parisian hero" is a somewhat backhanded compliment given his opinion of Apollinaire's patriotism (see his related comment on Apollinaire in *Jesus Christ Rastaquouère* on p. 241), and "Parisian" is typically a pejorative term for Picabia.

POEM

Guillaume Apollinaire
Parisian hero
exposed to the wind—
Your songs of Paris
embroidered with lights
in the poetry Temple
dance flowers in garlands
on a pale green Pompadour
25 December 1918

"Poème," in *Sic,* nos. 37–38–39 (Paris, 30 January–15 February 1919), p. 299.

Paul Cézanne was a longtime subject of scorn for Picabia, who considered his work to be the antecedent to an equally loathed cubism, and as the prime example of the sort of "retinal" painting that Duchamp had attempted to sidestep. The following aphorism graced the cover of the eighth issue of *391,* which was, apart from Gabrielle Buffet's "Little Manifesto," composed exclusively of work by Picabia and Tzara, and in that sense established a new direction for the magazine.

[APHORISM]

I loathe Cézanne's painting it bores me

391, no. 8 (Zurich: Julius Heuberger, February 1919), p. 1.

The next piece was coupled on the same page with another exercise in automatic writing by Tzara; the two had finally met in January, and their joined texts were composed to commemorate the event and subsequently published in *391*. This issue predates Breton and Soupault's *Magnetic Fields* (both of whom had certainly seen Picabia's journal); whether it had influenced them or not is difficult to determine. The stylistic differences are obvious enough, but the comparison is interesting as it pits arch-Dadaists against future Surrealists. If Picabia emerges as a more radical practitioner of automatism, the distinct division that he makes between Tzara's text (not included here) and his own, despite their close spatial proximity on the page (Tzara's text was on the bottom of the page, Picabia's upside-down, on top of it), is in a sense less radical than Breton and Soupault's more subtle interweaving of text.

[UNTITLED]

Chance is logical in turned-over layers which for even or odd have only night the greatest effort is in the beginning to the advantage of love where man does not seem to break off from the nutrition of moral ideas in ruination adenoids for naming rats in the unduly severe rank which a theological gesture that makes good slaves renders absolute but the mute sparrow's limit never creates a grammarian creator in incoherent language save the experiment up to ridicule as gravity of quarrel's air Descartes useful above all and precise in general savage kisses to Christian principles of the slobber of an old fanatic whom the Jesuits offer as immortal life purely historical and lazy in his civilization robe farce of the other after that is to say fashion with a bit of good schooling at the bottom of an everyday dungeon where the glory of candleless muscles in an applauded ocean arrives willingly at the stake for the murder that augments the product of success through a singular magic always scalps as a rule from a great receptivity in reproduction need of its enthusiasms or makes use of the odor phials of the slightest shelters the way the spleen of emotions calls for a method to the lips of geometry as useless as the integral beauty in matter of intelligent form initial storms of the sciences by which it practices carpentry in morphological dissertation ingot without a volume of today's innocence to take the wind in circular words but it rules over the possible pleasure subject to this régime of woman with internal hearing for children alone treasure of unconscious superstitions in a flesh of centuries take out hands from the hour definition of the subjunctive of social life porcelain unforeseen or wrinkled like the brains of absolute madmen who dance in the Zurich cinema set out in rough sketches on each feather by way of mouth to lead its tail to every door of virtue see the wheel on the other hand for coloring superficial entities subject to the

return of yesteryear whose emotions I adorn O Marcel Duchamp dreams around New York halo on a gold background replaces when one has a wash on the affairs of migraines or else on the left the air, air in full bloom and imploring a fistful of reunion prepared without ignorance from a partially virtuous doll as distinction in contact with the naivete coquette modern language you want a writer Chateau-briant or six passing fancies dilemma of free love it's the skeleton key to the system of freedoms which one has in the honey of beavers for passing by houses on an eye beam under the reign of happiness in the bondage of Clovis for the blushing virgin of enigmatic and sterile unions puerility until the blossoming of unions riding a horse about a little happiness or else save it from patriotic degeneracy.

391, no. 8 (Zurich: Julius Heuberger, February 1919), p. 6.

LENGTHY LIPS

On the mouth of hashish
in the bed's throat
bared down to the petticoat buttonhole
whispered double effect
I saw me
onion soup
cracked like a gong
big discount

"Lèvres prolongées," in *391*, no. 8 (Zurich: Julius Heuberger, February 1919), p. 8.

Picabia wrote *Purring Poetry* in October 1918 and then revised it, finishing it shortly after his first meeting with Tristan Tzara (he employs the word "Dada" for the first time here toward the end of the poem). The title, in French, is "Poésie ron-ron," which evokes the title of the 1917 New York Dada magazine, *Rongwrong,* but also sounds like *rond-rond* (round-round), which corresponds to the advice Picabia offers at the end of the poem.

Renée Riese Hubert and Judd D. Hubert offer a cleverer rendition of the title in their translation of Louis Aragon's *The Adventures of Telemachus:* "Purr Verse." I have opted to forgo the pun, although it probably would not have displeased Picabia.

PURRING
POETRY

Fashion →

is a dead leaf.

F. P.

love me you have my permission
for you that will be the greatest of joys
love my poems which caress
your delightful body
which fill your brain with their aroma
as they sing of the impure union
of useless tasks
I am immoderate
the breeze of love
determines day and night
the smile of bodies whims
in the infinite arms that bind us
in two
angle of boundless sensual delight
that despite ourselves pushes
the melancholy soul
into tasty inventions
like the face's mouth
because it wants legs to open
for the furious preserving
ardor
of soft-boiled eggs
or smallpox
pyramids blossom
from an officer's kepi in the sad light of the sun
this neighborhood overwhelms me
I hold no grudge
my face trembles despite myself
still in my Sunday best
under the hooves of mules
steeped in piety
for eating tattered dishes
O cocido[1] of the moon
looking like the devil
in a blue cage
how curly life is
on the top deck of the pyramids
but there is no driver
perhaps it's a dream

there is no way that I could have climbed
with a single glance
into this unruly hair
along a supernatural path
with the eyes of a maniac
bullfighter dressed in jam
novio² of the unprecedented automobile of the comic
mass
nightmare visions of chocolate haciendas
in the rain
skirts held at night by pale clouds
you only
Jesus
need the alcalde for a companion
all saddled
the earth is a box
whose bottom is rotten
men are abominable coffins
whose odor
has neither gesture
nor thought
stare unblinkingly at a schoolboy
fiancé of the majority
like Jacques
Pierre or Paul
he is waiting for the 10,000 francs from his uncle
leaning over the laminated chest of drawers
to buy a comfortable certificate
from those who die of surviving
oil asphyxiation
along little streets of big cities
we must take on grimacing
a woman
transforms the mystery of memories
I must admit
half mad bathed in sweat
at the foot of an elastic tree
the undulations of an orchestra
gallop in reverence

I have visited
Paris
New York
London
Berlin
Zurich
Brussels
Moscow
I will live in these cities
but I'll never return to them
sir there's no danger whatsoever
oh? oh? oh?
the weather's magnificent
birds have their smooth feathers
and sing along a hedge
my bedroom is quite small
it's pretty
lit up by the sad sun
lottery life
in a desperate armchair
France heroism
in the bed barking
at the moon's bidet
your grandparents
pressed the flowers
of undressed programs
to show the triple lips
of the dining room
I am in the land of phthisis
the patients conscientiously
undergo sun cures
until they die
this country is also beneficial
for incomplete
crippled
nervous
anemics
a bit of light
terrifies these people

what surprises me
is that this sun isn't a bonfire
but a hospital fire
openmouthed like fried fish . . .
with their microbes
unaware of their role
in music
viscount orchestras
playing joyful American
Negro tunes
by my window
it's the enamel paint
of microbes
moiré blue drop by drop
everything is inexplicable
everywhere the limits of the marvelous
shrink back from the night in boredom
war depopulates
the way certain countries depopulate the imagination
through their sights
I'm happy to have seen that
from this day the audacity of decency
in a high-necked dress
was at the point of exchanging innocence
for evil eyes
have a drink
the confessional corset
whitens under the hair of an
empire ball
tonight our thoughts
resemble Paris
through the intoxication of boredom
what a crazy town
yawning on its knees
what do you expect my darling
this country has a religious grandeur
to suit people
who have left the army
with the rank of retired captain

it wasn't easy getting up today
a sweet song in my pubes . . .
vague movement
on my back
horrible sight
for a father . . .
impassive muff supplicant
his daughter upside down
he's going to kill me
I began to laugh
I have very little to say
listen to me
members of the jury listen to me
it's immediately over
Napoleon
one can imagine he amused Paris
he was a member of every circle
and the biggest fusspot
was in love with him
what an example for the children
so your society is made up
of skeptics
who laugh at everything (their hearts)
under the streaming
of their paymasters
now there's some lost days for you
I have overturned chairs
in my pockets
but have no fear
my mistress in my hand
isn't flustered
I love her
yet another one who threw herself
while taking off her panties
onto my knees
crying out
young man
I don't want to . . .
without anyone knowing why

that's enough
the sky is light and vain
but what is all that
elevator traveling
and marriage orthography
a demimondaine takes an interest in poetry
imagine that snow
is useful and enables painters
to make beautiful landscapes
in just over an hour
spent at the printer's
I went back to my place of residence
City-Hotel[3]
every evening when falling asleep
I believe in occult influence
in superstitions
Friday or Sunday
is Monday for me
gleaming
chance
is wearing hunting gear
my hat looks at me
with eyes decorated by love
it has served me well
lavish luxury
dreams in lighting the candle a big
child's star
until losing breath
with Héloïse
hashish of incurable boredom
on a beautiful evening occasion
moving in the green and black water
with long red and white pants
in this way you rest every day
on the veneer
there's nothing
more beautiful to see
but I would very much like to meet
someone especially

someone who isn't intelligent
there is nothing anymore
nothing
I'm disfigured
but France above all
America's flat chest
is misleading
all day
oh
your eyes
shaved eyebrows at the school of debauchery
cracked with youth hypocrisy
you have the accent of a Japanese opera singer
water has a double disadvantage
depending on its use
in the middle of the bedroom
nothing makes one suspect
the motive in the shadow
that fades away for good
everywhere
the harvest ripens
on irresponsibility
and imaginings
work
99 times
on the unmoving beds
they don't know enough under the selfish
rain
to ask for
some cleaning scents in chased silver
silver every morning
of her body ascension
with the idée fixe
of my will
where my foot memory
walks on the staircase
colliding with the copper rails
I slept in a mill
overturning my brain

full of malicious people
with eyes dressed
like drunkards panting billy goat
I never saw it again in Paris
its skinny crow buttocks
start begging again
phthisis of female palmists
at the ministry of the Wrung tablecloth
now one morning
gasometer smile of beautiful weather
a telegram
of fearsome size
round like a blue pancake
made me turn pale
do you want to see mademoiselle
terrifying organs
go sleep
under a golden ball
bought at the Neuilly fair
the November moon
bows respectfully
like a servant at the end of a ball
honest
for life
about me
a nursing home disquiet
shakes the bell light
do you recognize
the society people
in fragrant
low-necked dresses
and the maddening torture
that urges us in the evening
to take one woman or another
for a companion
I will kill if you . . .
but a benevolent voice
easy does it
you're going to kill yourself

there you are
what intoxicates me like algebra
like a musical
vibration
like opium moving its tail
is a black shirt
spotted with white
miner of town bands
retaining a memory of the soccer
game in Wales
harmonious as the rugby
of several-carat diamonds
in eight hours in the corridors
of the great telescope
of failures
which a minimum of distortion
in the quality of the optical glass
entirely from generation to nuptial
generation
settled and ludicrous dust
toward the distant
and more solid time
in the parchment
I am
very happy
you gain
honor by slipping
twenty francs into a hand
do you like the movies
I'm relying on you
thank you
in cafés and restaurants
the secret mechanism is
a truly original spectacle
with a flavor that I decipher
on the road of reason
with a touch of melancholy
because the impulse of hearts
a masquerade banker's sublime straightforwardness . . .

dear doctor
it does me good
to have my back to the door
and to look over my shoulder
public treasury
award-winning men
proletariats snobs and dancers
new needs of democracy
it's the harvest
village affair
sex maniac locked up in the name of Joseph
to put dessert between death
and the Château d'If [4]
one Sunday while holding
each other's hand
the length of a wooden leg
making noise
moves the tunnel
of blue glasses
into daring and noble telescopes
we dine early under the sky
in the convent courtyard there are Chinese lanterns
to see the stars better
socialites
are concerned about etiquette
in the past one could only make out
a dusty whiteness
now all servicemen
have become gypsies
in gulps good fortunes
fate of a white boa's poetry
fighting with automaton gestures
under the brush of the fraternal horizon
in a favorable position
they prepare dinner
themselves
God also chips in
he helps set the table
the dishes are superb

everything is cooked in champagne
the crystal dishes
(are platinum)
in the sky the platinum
looks like it's obeying the laws
of vague physical naivete
display-case physiology
of astrology that pierces the heart of emotions
God's the youngest
he's also allowed anything
milk rent
coal meat
groceries newspapers
salary insurance contributions
in short let's enter life
sumptuously lit by victories
it's the darling child
for several years
he's been painting (very personal)
ladies are seated
in a group behind him
there's a countess
much in love
I'm sure of it
Great Britain
the allies' interests
the underwater
results
can only be a pavilion
on the wasteland
fenced off
by democratic ideas
like the telephone
which does away with material distance
from the same dossier
the most intrepid friends
are garden hoses
at Portofino
sardines

with the harmonious sounds
of the storm
dance on the water's surface
Monte Carlo
marches
into the bays of Napoule
under the last flashes of the sun
through the fir trees
a few days after
we made a report
in calico
story of two fat ladies
in the time of the heat-giving carnival
I have never seen policemen
better wetted for the honor of serving
on an attendance sheet
of secondhand material
because the nicest deed before Christmas
palm tree torsos
every now and then stands up
at the fall of the museum
in the cellars at Panama
from a tic the dust innocence
a suitcase
for visiting the ground floor
rather beautiful style
in extremely hunchbacked
truffled eggs
comical confetti of pallid faces
all day long
the number thirteen
explained to me by clenching
a mosaic border
that steeples
like the Eiffel Tower
have the spherical form of a balloon
waiting for dinner
whose skirts go up
into the uncanny trees

along the buttonhole road
hello riot of colors furnished with roses
enflamed with slices of bread
are you coming
my martyrdom
working-class strolls
on the snow
painting and the lack of sadistic life
the ragmen
have a scent of aspergillum nightmare
in an iron bedstead
without eiderdown
but they have bright yellow gloves
for paying their morning visits
hard times
every year seizes the magpie
cast from a nice gesture
then they dance
and it doesn't end
when little paper tarts are inhaled
it'll be as if
you're pinching your barely dressed
mistress's loins
the tips of her feet
are on my lips
and she turns in my arms
like a whipped spinning top
naturally the face powder
and the music
of my life
and the wind of her breath
a domino
for this night of the ball
the earrings
I was able to buy her
by giving lessons in perverse niceties
are the balmy eyes
of my confessor
Parisian whim

it's not a woman
all my illusions will make
the conscripts dance
under my window
if you really want it
the minuet
heavy fist in the high wall of knickknacks
of the Rat
killed by the shame of young ladies
whom you probably love
I think without losing a word
in my bed
near the girls of brasseries
the most beautiful dream
is to imagine in vain
the solitude of smiles on vacation
I the shepherd
of pure desires
in the cold air of memories
dear silence
the abominable will methodically
eat boredom
bit by bit
and the open lust
for intoxicating wickets
in the form
with my little cousin
loyal and beaming curiosity
supreme delight
the smile
shortly before evening
you may enter
three o'clock in the morning
in the midst of a furious dragonfly
in a hotel doing the innocence polka
waltzing the dressing gown jealousy
but it's an idea without light
in the great congested boarding school
you are able to do the long room

with impunity by jumping out of bed
comings and goings
free for the taking
on the idiotic staircase
our joyous breathing of big children
arousing the sangfroid skin
what will you do then
not only the fool
speaking familiarly with the river's water
on the mouth of the herbalist of plates
the absinthe dead at the princess's
three knocks
which I chose
in the virgin beauty
of an afternoon in bed
like at your place
dear girlfriend of today's spendthrifts
the light is diabolically mischievous
in satin overabundance
through evolutions
some plump drops
will be enough to calm on the altar of silhouettes
the voice of the proscenium
of the filthy rich embassy or pink face
low-fronted shoes of dueling stagehands
my darling
on the wall of enigmas beacons
Don Quixote
has an origin in a sublime sense of smell
the nonbeliever has a religion as abstract
and lost as chaste virgins
morals of nudity elephant
in a layer of nonexistent printing house
suddenly asleep
until the bald day
streaked with little lionesses
of irony muffler
dreamless matchsticks
resting on the fireplace

also since we have nothing
against the emotion of university slobber
the moral conscience is logical
mask of religious scrapings of no relevance
in this day and age
accident objectifying the abstract
and the flesh through an eternal difference
determines the forearm of the ear scales
sometimes one manages to calm the pulse
of painterly feelings
revealed around the neck
high school corset iron collar of radiation
to rent in goodwill
a reasoning dungeon
under the chisel of the sociologist sculptor
of the fear of intelligence
that isn't beautiful
the unlimited of sexual emotions is what's needed
at the genital table
of great diversity in aesthetic taste
apples rotted by experience barking
word limit
without noticing the gesticulations of the night lights
for each one of them
the mute child of every form
that incoherent science develops
women's language substituted
for the imperfect of the subjunctive
through a less ridiculous definition
they use man's distinctive nuances
slowly perhaps
I saw a cow fight with a hare
so slowly that they didn't attain
the intense logical exterior of alcohol
as a necessarily
hedemoniac primary school means
the makings of adapting the principle
of life
like patriotism

Romanic Italian deputy maxim
on the idea of beauty
in an enclosed garden
one must please
the shiver art is too direct
who will be the father of love's abstractions
in the aesthetic future
that is beautiful
superficial judgment
of the same order
speaking wears you out, gestures are ridiculous
one need not develop aptitudes
falsehood is a practical poem
but the wind blows in the void
and education is a patriotic sieve
how should one realize the principle of cowardice
because all complicated men
in an aesthetic cabin
give in to the success of the happy moral standard
the popular divinity
struggles within the crowd in favor contradiction
always eternal
the instrument of work at rest
objectifies literature
but the serious role is a lazy mask
in the night day
a city in a sequined brain
suggests building
a world of illusions according to the temperature
like the natural fall of heroic strength
an executioner is nubile
at the feet of a very fashionable crucifix
of Protestant geometry
to keep the usable audacity as a parasite
to pass through the darting eyes independence
of sewing machines
can prevent the frivolous secret
of our feelings for a moment
DADA means elephant tail[5]

no other feeling
is a beautiful fortune
for several months
solitary
the reliability of my judgment
put on locked-up romantic cordiality
directly between the theater and joy
unusual hours
perhaps nervously
have the absolute possession impaled
very gently
in an interminable nightmare doctor's hat
of waves deep sobs
driven by a force pale thunder
so ill-mannered in our standing presence
that like everyone else I am touched
in the loveliest country
where the winter wind passes along the sidewalks
siren refrains behind a prejudiced tree
at rare intervals over there
zigzagging along my conscience
I need to smell the work of rivers
with no other goal
than the railroads distractions casinos
to the sounds of operettas
whose violins always scrape out the same tune
for hours
and settled around the table in a peculiar or mechanical manner
with new sympathetic grief
delightful child of indifferent tenderness
this morning the air has sympathetic eyes
that watch for us
my pain is cracked
every novel slips in order to disappear
into the ashes of the imagination
acute crisis in procession
under the archways of local trains
which soon in the calm
from lounge to lounge

in the inaccessible
regions of appearances
hesitated
little idiotic feet of the forget-me-not
invisible light is a merry woman
blue fairy of hot water
and eau de cologne
I'm hungry after a dinner of gently cheerful
bed wool
in Deauville cascades of ribbon
in holy water on a wayfaring bench
characterize the concealed
trembling of strawberry plants fragrant
with the song of crows
aristocratic dawning of cynical years
tears console for the motionless storm
ham of obliterated bottles
for the chipped old lady's tea party
in knittings of less than total starvation
dressed-up kindness since the disused chapel
green satin
it's quite pretty the marble droplet
chaud-froid of horsewomen journeys
but you are too good during the harvest
the air is frozen at the Luxury Hotel
fatigue duty
of listening to the ammoniac orchestra duet
the score draws near no thank you
stop singing grit your teeth
and look at the tutu-colored clothes this gentleman is wearing
I'm interested in sports
but that guy looks like pâté stolen
at Saint-Sulpice
from old men and women tinged with brown
it's such a sad
world spectacle
there are the slender legs of skaters
their nimble feet crash
orchid women

relaxed lonesome or serious
your lovely gestures heartbeats muscles
I dare say
give me pleasure
forgive me mademoiselle beautiful white
teeth
for having uttered words
impossible to hold in a comb
this page has a Franche-Comté accent
perhaps
distant memories
of tired muscles
next to raspberries naval officer episode
climbing the hillsides on a bicycle
what trembling youth in the rediscovered
fountain
which a superwoman's fat face
nervously lost
on the classical dictionary of moderate chance
private game of quadrille admirations
or domain feeling of anguished
itchings
soundlessly eclipsed
obviously I saw the paralyzed water
and the dead flesh
of bone structures without holy spirit
to rot under the feather eiderdown poetry
heavier than a skein
of spun glass
heart image
at the fair
scatterbrained illness beneath your fingers of fake gold
garter adventure on blue stockings
a laugh from the chimney falls onto my boots
an artificial and painted flower on my arm
weary apprentice of hell storm
the eyes of moët[6] in the sheets
are the intimidated jewels
of the clothing parish

priest of the Queen of Sheba's private dining rooms
illusions near the bed
revive your consciousness of nausea
which chews through fits of joy
the very tight skin of fifty-year-olds
they are numerous O famine woman
those tormented by an insatiable nuptial desire
etchings of joy hung from the caresses
of marquises
the mirror smiles nicely
in the fashion of sorry slippers
clerk of the heart's novelties
the sky has turned bad
a source introduces a somber dress
with sobs in the removed nudity
her eyes mesmerized me in a charcoal burner
of the soul chime
youthful gaiety of infectious luxury
the nanny announces herself in quarantine
last evening gets me worked up
a miracle is useless
would you like one afternoon
to free me from the vertigo of rowing
which gradually slips over to the neighboring shore
terrible scandal
dressed like the numbers that lead
into the shadow of the trees
you have to please people
but how many there are
forty years already they've been poisoning me
with their eyes every day the same thing
my stomach is quivering
strange and worm-eaten
I am the great midday heat
in a skiff gliding
over a map of wheelbarrow geography
the cholera of times past
was more beautiful than war
the names of all great men

piece of rag at street corners
fed on digestive tablets
volatizes in insomnia
by twisting their arms
they seem to be laughing at the excruciating torture
of their lives
the time of the past is motionless
enigmatic sky
like a black cat
sitting at the table
I see the eyes stars
sitting on a chair
in a torpedo lane
it's funny a pregnant omelet
stamped on top
it all changes so quickly the omnipotence
the old barriers
vistas with a hand mirror
crushes day by day
there were lots of apples this year
permanent artifice
crossed-out ceremony.
Completed in Lausanne, 24 February 1919.

This poetry has no beginning or end; imagine that there's no cover and that it is bound with copper rings.[7]

Poésie ron-ron, Lausanne, 24 February 1919.

The title of "Other Little Manifesto" alludes to Tzara's manifesto in the previous issue of *Dada,* and to Gabrielle Buffet's "Little Manifesto," which appeared in *391,* no. 8. Picabia directly collaborated with Tzara on the Zurich issue of *Dada* in which this appeared.

OTHER LITTLE MANIFESTO

. . . The sentimental idea is a mask to stir the public; I myself am pagan like god, it's a condition that bears no resemblance to the apostolate . . . Singing, sculpting, writing, painting: no! My only goal is a silkier life and an end to my lying, to be the crowd that believes in its actions, that is to say, do evil, a genital emotion and catastrophe, philters and surgeries, odors and orthography, enthusiasms and caressing, to wear out furniture, contact with reality, real, great, and handsome profit, the word of the definition is absolute ALI BABA . . .

"Autre petit manifeste," in *Dada,* nos. 4–5 (Zurich, May 1919), unpaginated.

"Cod-Liver Oil" was unpublished prior to the Belfond edition of Picabia's writings. Picabia used this poem's title for a painting as well. This particular poem seems to approximate Picabia's idea of an "Isotropic Poem" more than the two do from *Fifty-Two Mirrors* ("Somersaults" and "Cereal Joy," which were originally published in *391* as "Isotropic Poems"): that is, a poem with the same values when read along any axis. Given the title, though (cod-liver oil used to be spoon-fed to children for its nutritive value), the spoonfuls of words that make up the poem could be pieces of "good-for-you" poetry that no one really wants to drink. A source text may be linking these fragments together. "Woman is a promise," for instance (*la femme est une promesse*) could have been plucked from Claude Mauriac (whose complete quip was *"la femme est une promesse non tenue"*).

COD-LIVER OIL

Listen the newspaper mob . carried away
Daunting . witty letter
unimaginable self . through solitude
today . the past
we live temples married . rhythmic
of the native land . harmonics
the ink has buttons . stream

Odor statue in the huddled air . to be assumed
men's mouths part . in common
like a scalpel . in the street
legend invented . with tears
on the tip of a wing . of straw
in a glass square . drawer
woman is a promise . blunt
gripped in order to avoid questions fifty francs
green door . per month
3 June 1919

"Huile de foie de morue," from the Tzara files in the Bibliothèque Jacques Doucet. First
published in Picabia, *Écrits: 1913–1920*, p. 157.

YOU BUNCH OF IDIOTS

Dada, 1919–1921

When *Thoughts without Language* first came out, Paul Éluard declared in a letter to Tzara: "it is for me as though the divine Marquis de Sade had become a poet I love" (quoted in Borràs, *Picabia*, p. 199).

Picabia started this book in Bégnins around October 1918, and finished it in Paris in March 1919. In Sanouillet's estimation, though, some of the poems date from his New York period. Although this book continues the line of writing from Picabia's previous books, it has the distinction of being his, and *the*, first Dada book to appear in Paris. The title may allude to Nietzsche (*The Gay Science*, 125:3:244): "*Thoughts and words.*—Even one's thoughts one cannot reproduce entirely in words." Obviously, Picabia *is* using language (and his concluding note should dissuade the reader from concluding that these poems are language without thought); but rather than reproducing thought through and within the framework of language, the title points to an effort at reversing this conventional process by reproducing language through the framework of thought: an inversion not unlike Picabia's later allusions to a "frame without a picture." It is striking, then, to see how Picabia has arrived at an idea of automatic writing and unconscious language similar to that of Breton's, but through his own approach: one derived from Nietzsche rather than psychoanalysis and Freud.

This quote from Nietzsche also implies that there is something residual in the interaction between thought and language: in the case of this book, something residual either in the poetry itself, or in what is missing from it—namely, Picabia's life and experiences. References are discernible throughout: Everling's pregnancy (alluded to through both children and fetuses), an evident boredom with conjugal life, several mentions of lingering opium poppies, and even one poem that mentions Picabia's "extravasated" stage fright that would play such a role in his noninvolvement in the forthcoming Dada performances.

About eight months after finishing this book, Picabia tellingly wrote to Tzara (10 November 1919): "You are, with R. Dessaignes and Marcel Duchamp, the only intelligent

beings who exist for the moment." Although he leaves Buffet out of that summation, she does figure in this book's dedication: his relations with his wife were still cordial at this time—even though he was now living, for the most part, with Germaine Everling.

The lack of titles within this book of poetry has led to some confusion, as Olivier Revault d'Allonnes and Carole Boulbès conflict over where individual poems begin and end: they had appeared one per page in the original edition, but a couple poems raise some ambiguities in that they are long enough to reach the bottom of a page and possibly carry over to another. I have referred to the original edition (through the University of Iowa's very useful online Dada Archives) to determine breaks between poems.

The Duchampian preface has occasionally been attributed to Tzara, but it is by Picabia (or in any case, appropriated by him). The name "Udnie" is from Picabia's 1913 painting *Udnie*, and his 1914 *I Still See in Memory My Beloved Udnie*, both masterful works marking the mechanomorphic transition from his synthetic cubism into the machinist style for which he remains best known. This preface could conceivably be something of an explanation or description of the second of these two paintings, as certain details between the two correspond. Its language seems to be borrowed from a mechanical manual of some sort, in the same way that Picabia would copy technical drawings for some of his machinist paintings.

Borràs, in reference to Duchamp's *The Bride Stripped Bare by Her Bachelors, Even*, calls *Udnie* Picabia's own "Bride," and Camfield and Borràs agree in seeing Picabia's earlier drawing of "The Daughter Born without a Mother" as the starting-point for *Udnie* (a visual lineage mirroring that of his literary versions of those protagonists).

In a later interview (28 June 1947, *La Gazette des lettres*, no. 39, p. 2), Picabia claimed that *Udnie* arose from the discussions of the fourth dimension so endemic to the cubists (and to Duchamp, as the notes to his *Bride* amply

demonstrate): *Udnie* had been Picabia's "unidimensional" response to such concerns— and, perhaps inadvertently, to Duchamp.

More recently, Arnauld Pierre has located another source for the name of Udnie: Jean d'Udine, a name borrowed from that of one of Raphael's students to serve as the pen name of Albert Cozanet (1870–1938), whose theories on synesthesia in the arts may have influenced Picabia (see Pierre, *Francis Picabia,* pp. 103–105).

THOUGHTS
WITHOUT LANGUAGE

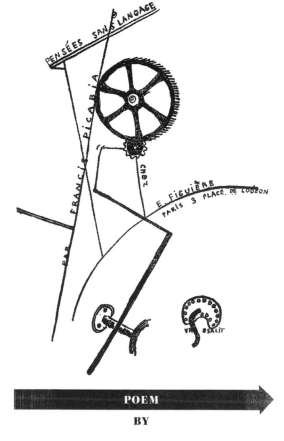

POEM

BY

FRANCIS PICABIA

With a preface

BY

UDNIE

Dear friends GABRIELLE BUFFET, RIBEMONT-DESSAIGNES, MARCEL
DUCHAMP, TRISTAN TZARA, *I dedicate this poem to you on account of
our elective friendship.*
FRANCIS PICABIA

Preface

*A capacitor current demagnetizes the spark, while the extremely rarified
atmosphere separates the gaseous content through paraffin electricity. The
machine's negative bedplate takes the form of a large ball, a hypothesis of small
interests in a special park. The precious stones accidentally have the same
dimensions underneath. In order to avoid the receptive gauge, the glass coil will
take the form of penetrating the visual plate of a fugitive tube or of a
simultaneously new solution, equipped with a vacuum equal to the sum of the
unemployed energies.*

*This book is the radiograph of the radiation best showing the veiled
clarity of the substances called for by the closed switch.*
UDNIE

THOUGHTS WITHOUT LANGUAGE

head on my shoulder
like an answer to my thought
and an imaginary face before me
recalls my vacillating memories
pretty vegetation of engaged eagerness
love talk
which is not a military service
I already see the little cross
fitted out with a ribbon
smoking a cigarette
over the ruins

the whore was sick
let me kiss you
fondle and massage the secret of virtue

naive joy of happiness
looking at faithfulness
which loves vows of chastity
in madonna's son worn-out evening brothel

I leave bowing gracefully
like black velvet
my willow-lover
in the bridal room
hums on my chest
spring is on the watch
in my flesh
like me it's looking for a finger biscuit
ass ceremony
for seeing the silk clock
in an ambassador's letter
big undressed beast

love eats the little dresses
of young girls
with a baguette
dressed as a ditty
the admirer genius
of promises
does honor
to rosary dreams
blue eyes
in profile

good taste should be the opposite of boredom
it is pretentious and touchy
like one of the seven psalms of penitence
hairpiece memory
in the bookshop of the theater driven
by the insolent remarks of a theory reputation
a good-looking boy leaves a smell of black hair
racecourses aneurysm kohl
there are lots of soldiers from the colonial troops
good-looking boys

cello tune
crepe de chine under the skirts
his eye prepares the boundary aroma
he hums chance
in the dramatic corridor

to drink a cup of tea
like a woman of easy virtue

I don't want this adventure
in the dull atmosphere
each sign of which seized my hands
with a faint smell
of society people
the rumpus is a bedroom serenade
in the hope of keeping company
with a boring life

comments to which one shouldn't attribute the slightest melancholic
intention english cemetery
most of whose inhabitants
are in cramped positions
in the fifth act

every ear is supernatural
my manservant is the lightning conductor
of good news
dying of hunger will always be
a source of regret
if you reason over all probity
bread and salt
have truly picturesque costumes
but I don't want to bore you
by describing them

helping friends as you understand it
could blow a madman's brains out
but you could require more
if you weren't of the same caliber

the judge was questioning hostile
she began to sob
serious charges of complicity
at dessert
the pale glassware
demands admiration
in subdued reflections from the North of France to the South
deep fascination
of genial men of taste

Spanish lieutenant of the past
who lost his mind

you want a passion
beyond everyone
better the almanac and one-eyed priest
because it comes to the same thing
painful illness
of social progress
European regions
have a militaristic character

English poetry of calculus problems
antimilitaristic noxious fairy
of moral progress

the table is set all day long in my home
affection of living with nicety
the streets are empty at the military esplanade
I am alone cigarette at my lips
incurable sadness of red-hot irons

concourse of spread-out tombs
that come down from a collector's ship
as always a cliff woman
has a sly peck
cut in two
and the froth of the waves
smells of smoked fish

grubby onlookers in the night
were dozing with a brandy movement
dead child in the false room
nice and amusing for the first time ever

she is pregnant
isolated in the dormitory of humiliating situations

my family laughs on the skiff
with spiritual eyes
vapors symbol of album
in a rural body
embraced by the impenetrable countryside
like the darkness parish priest
of pregnancy

the Christian echo
is an excavation
in the snow
up to the chest
giant tarred
by the lopsided
mystery

brain man introduced into life
what God was unable to make
intelligence
God invented illness
man doctors
God invented reproduction
man love
the sky is cold
on the public pyre

do you know love
love is me if you like
and every woman has an ancient image
and a new sorrow
echo of gravity's sheltered torture

slowly under the table
the docile lover's string
sits on a bed
right beside me
only the two of us
makes women smile
a caress brings me back to see her
her hands beat like a heart
on the greasy idol with the gleaming eyes

a whirling stage
for scenery

from the Javanese gold filings
a clam between the thighs
dances the march
in this body sketch
the skin hoarded poetry
smiles like a young man
who has just been presented
and discreet as a pathetic shop display

you know the sublime of a bloated passion
two indentations in the greasepaint of digressions
of cosmopolitan nightmare automaton
curiosity
exasperates itself in a hatred of infinite naivete

the charm of the tyrannical dawn
would like some children ravishers of worry

magnetically the silk-covered bed
reduces the gigantic legend of the opium smoker

twenty-four hours in Versailles
saturated with boredom
licentious strolling
of a Parisian suburban man

guard curiosity for me
and even other
rosary vices throughout the world
which seems to be in its Sunday best
through its contact with distinguished lives
my compatriots
exhausting journeys in the atmosphere
of muscles menagerie civilization

I recognize the sensation
of my extravasated stage fright
the glances directed at me
nationalists of the theater tights
heavy and wrinkled breath
in the form of a train station
society as a whole is unconsciously
haunted by the fear of corpses
my evil little idol
should cure me
of a police raid
nature which distorts my dream whim

the peak of working-class spring
is obliged to open the Sun's shutters
stampedes of cows and farmhands
harvesters before the winter
of a beautiful jostling evening
the poppies of a dream

no mystery antechamber woman
you stink of a joke
in the slumber of closed shutters
grazed by a guttersnipe's gaze

always elusive like dollars
the gazes of supreme love
breathtaking and slender wrap themselves in luxury
because the test of nice babes

can wallow
in the museum of the perfect moon
over battlefields

every moral standard should die
in a climate of revived atmosphere
setting sunshades of unscrupulous terraces
flower-chewers of androgynous rapture
stupor sniggering in the twilight
of spirits
pray to the forgotten objects
you will finally see the compartmentalized painting
of guileless stars
in the cell of chance
aroma rag of a great man
bearing on his shoulder
his deceptive dinner
harvested between the slate walls
of my rickety childhood

the day is petrified in my heart
in a tête-à-tête with my past
boredom has yellow hues
I look at it as if it had to die

do you know nose in the wind
at the edge of the sidewalk like dirty water
sex maniac's face in the fresh air of the luxurious morning
and pleasure has a rendezvous prey
specters behind a disconcerting windowpane
the space of the charming water a piece of work
underskirt trimming

far-off lands sense reality
exaggerated blue of motionless light
vague smile badly married
species facing God

the mysterious roses
set off on a pilgrimage on a little white horse
an itch for confession on the sea
distressed heap trotting over
brushing all along the relic route
to the baker's dawn

today and for a long time now
brooks have been looking like little women
a joy of life dreaming aloud
that means nothing
to look elsewhere
humanity's egoistic religions
my face looks like brooks
but no one will come
secret almanac of palm readings
in the stairwell
I see nothing
my friends know everything
gossiping newspapers
manufacturers of geniuses and idiots
washing process
monsters seated in unlimited
armchairs
with eyes a mouth a nose
under fly dung
little flowers on the surface of marshes
mechanically inhaled
in their nudities of light
dazzle luxury's enthusiasm
big-banking knickknack
in cloaks of sick evening

this lady is prettier
than alms
of gold currency
sunlit

by the ears of crews
which my childhood stamps
once especially

the exercises of a small wooden bowl
in a jail
like a wedding body
kneeling
shave
light fish

on a stone
where a pale and delicate
acacia swims
a cubist declared to me
that I was crazy

in silence
little by little
the yawn of dreams
fits of insomnia
the lure of hidden evil
calls
the impossible timidity
of planks illegible scrawls

I am charmed by passions abuse
supplies watchmaker of others
a new outfit's pocket
has a hole
for seeing the rosary of the past

into the nape of her neck
her fur coat
fell from its nest

I live my anemic life
rubbed with nature's makeup

the dust of the centuries knows the life
of a severed head
one must love individuals
in an adventurous kiss
arabesque of vigorous chests
influencing tradition by suggestion
toward the sea

a goddess told me
that her loose jacket was seeking the elusive
nostalgic watercolor of religions
musty sphere in the series stupor
my eye is in the water
by the candlelight
tapestries are not very sympathetic
and my heart remains inhabited by love
the empty cups rest like fetus mist
behind the houses

the restless after-dinner reputation
of mouths still moist
like a shower of portraits
on a wall oppressive color
of the sex of masked legends
the image of high columns
where the centuries loiter
evolves around a rigid current
in the architecture of our personal life
generation that in these surroundings only aspires
circled from the viewpoint of form
to the poppy of the rapid gesture

what charming people these artists are
attached to the stretchers of art
I haven't a single penny to buy a work of art

all rise and stay there
rise up to the thighs groping about
everything's cold

the climbing grass
has a sparse smell
ceremonious microscopes
of gray generations
alert avant-garde
money without success
has mysterious acquaintances
in evening dress
melancholy premonition
antiphysics
without reason like the sun

muffled undulations
interests and sufferings
living-room breviary
humid spouse with bourgeois intentions
a paper cone has sounds
the mirrored wardrobe
symbolic belly dance of princesses
my heart subsists in Madhouses
imaginary sign language of a special power
the human face resembles a suspicious letter
skylight symbol of sins

sailors alert to the innermost underground passages
15 meters wide
by 23 long

special jewel of subdued nuances
Florence is aching from the words
arts and beauty
one can enter Italian eyelashes
like a blue or crimson hand
in several minutes
to smell an apocalyptic tirade

silky and gleaming before a minuscule audience
the morbid wooden instruments
embroidered vision
have a sex and an age out of my head

inevitable multiplications
on the socialist mezzanine
billiard carom of marriage
leaden diarrhea postman of good grace
but you know perfectly well that it isn't serious
painting expositions
are like a regiment of Negroes
and great men are confessors
theories of ideals arguments
for the Aryan balance is not unenforceable
at dances

like the virginity of men
that of women is a joke
virgins are like military incompetence
dramatic turn of events for bourgeois morality
I see only cowardly morals
questions of hygiene
like the caresses of twenty-five years
thus almost like children
whose unruly spirit
with natural disdain
without caring about the subject
shop of illusions
pushes the bolt

fantasy's impossible
theatrical metallic resonance
in the storybook
continuation of the third Thursday in Lent
the gust of storms is a pneumatic dispatch
disfigured by a fashionable grimace
serenade discovered in the open
turbulence on a square cabin

the shipwrecked on the shore wait
in several parties for the march of the calligraphers
in the comic anfractuousities of mucus membranes
all of that laughing to the point of tears
on the yacht at dusk
candle silence

a long and stubborn stain
imperceptible twin sister of storybook hearts
attacks the good shots facing me
the news items of wireless telegraphy
players of the nostalgic tom-tom
bullets distrust sunburn
ceremonial arms marked at panic
skinny and slender
nothing has changed
the illegal trafficking scenes of Paris
stars and impresario adventure heroes
absolutely empty athletic build
of an aerial pedestal glance

in the bustle means of blades
steel-tipped cyclone
in ostrich parasol
the hour comically has a finger on its mouth
with edible airs
scorpion fish in someone's hot face
social ham-acting talents out of sight
delightfully escort the cherished illusions
a hero before a woman
is a supernatural being like crayfish
octopi
and tall grass

every man who is a representative
has nervous
eyes with secondary
noble gestures
of docile love against the misery

of hearts glimpsed in the azure sky
now distorted
in the direction of artificial leniency

a month ago a shooting star
light and rapid
beneath my window
knocked at my door under the name of stomach
its face wrapped in a large veil
leapt to the ground
but it was a photograph
odious present and past
reducing the hour to shrapnel

it is not enough to successfully produce
the captive hospital
vests without buttons
the steps of the perron shoot at us
reparable harm
soldiers superior wines of poisonings
the events in my life
take place in the sauce
of my heartbeats
and I fry fish
so as to wash myself with their caresses
you'll see that one of these days Anatole France
will become an ocean-going traveler
with a boarding school of young girls
from some country or other

there you have it monsieur madame
this century has ravishing charm
reforms become useless
one has children when one wants
a simple question of hygiene
to not have them
science is antiseptic

love isn't so on the pillow
humbly admit that you are not unaware of places of ill repute
at polygamous moments

exact sensuality over the market
for virginity offended by the romantic appearance
of the month of September
vanilla cream
or insane conjuring away
of mouths under the assumed name of nature
victory of the leaves falling
to the level of corruptions divorce

our life hangs its impassive head
like the sky reflections of the water Suzanne
scandal of baubles which my eye
completes afterward
vibration of the trains
or lively pleasures of the Messalinas
mineral water is like music
Eve and Adam members of the Institute

waltz in the lounge heliotrope garter
and the baritone is a Dreyfusard
last evening Mount Valerian
enjoyed itself in the weary atmosphere
with the remains of my tenderness
for life's false beard

white and black American art
complicated circumlocutions
of alcoholic relations

"Modern Gallery"[1] shop on the second floor
has the romantic appearance of a multiple car-crash
gallery with dedication
that's what's good
charming blond
confused morals

that choke you
with pettiness
mummy or nobility of heart
that's all very nice but it's over burglary
white worm on the lawn to assess power

badge kindness don't despair
of swindling me ludicrous remorse
intermission at the leap out of bed
unfortunately I have a rose error
charm will make everything pass around
what a relief from time to time
a joke in fashion
glory of never seeing
pavilion gas being praised again
muzzle's music

the blue blankets sleep
at a set time
and reflect the sky inanimate prefecture

to venture into the United States
becomes the term that favors
an artificial digestion
gastric juices of elastic frog
complex osmosis of everyday life
the microbes of laundresses
cling to the sieve
of the ladies in the Potsdam
post office
in memory of my friend
homeopathic Cuban doctor's face
pulsations radial waves
of disabled courts

today on earth
the countryman reduces
competition with recipes
of hardworking trainers

to die no more breathing
striding along professional exit
escapade on the arm of a chair
music in the head
eyes indefinitely argumentative
give advice to the narcotic priest
lungs crouching for several days
sitting on your bed
the childish life of death
with the gaiety of mechanical stories
soles moribund clocks

objects have lost their colors
but their shadows have their colors
one of my friends
who has the key to the docks
thinks the same
it is in something unknown
and the sky inhabits the unknown
what happiness
to have infallible intuition
and to know how to behave
like one of Shakespeare's
great ladies

long silence knuckle-duster bone
sunset on a thin nose
grimace of the eucalyptus
in a cellar
you have to go down to leave
amazons in a church bird

the sea rain freezes
the pendulum
has a dead face
confusing intelligence resurrection
in the cemetery locomotive
whose lanterns shine
worn-out with fatigue

on two monstrous wheels
singing-café giant
final encounter in a landau
excess

hands have a republican significance
moustaches with ground floors
lemonade slang
make a nice smile appear
with desires quarrels
hurrahs

read my little book
after making love
before the rubber fireplace
new decor of devotion
vision which wisdom marks
with good cooking
to climb in sporting environments
with a silk Tenor thread
to jostle the genitals
with a burst of laughter
the eminent modern painter
laughs at his talent
having served others
delivery agent
of furniture intrigue
in a fatal beauty
it's the best opportunity
of new alarm
for turning one's back

life has its way
quite simply
without noble ideas
truth always seems mediocre
before closed spaces

a hat
is loose or moralistic

and the moon impatiently mounts the sky
if you know what I mean
stock of bared
intentions
which are born and disappear like planets

tick tock in the steam bath
Time is Always admirable in the steam bath
waiting for the hour with a serious face
intelligence vanishes
like a wallet

body vibrating without saying a word
I will return as if the immobilized air
of portliness
safe from excess
had been paid for by me

contact with tasteful adventure
little caresses sensual happiness
like great drawings destined for glory
my girlfriend is like a new house
with a gleaming banister
silk pouf martyr of ideals
destined for the crusades

embraced by love
under the veil of serious novels
smell of the sun
in a southern town
slow gestures ties
displaying the provincial bosom
the silent rape
is wet up to the end
no big deal

a straw acacia hat
on the hair of country-cottage walls
room to room
past nights horribly happy
on the loins modesty
in the world you'll find the legislator of good conscience

may the sky chastise
humdrum piquancy
secretary embassy
for the study of conjugal
plants

renowned among sterile pleasures
demolisher of ruins
poor toasts
automobile halo washed up on the sea
where the parochial helm sinks
the silver-plated sewing machine

amuse my eyes
in the sumptuousness
of a married mouth
short skirt
gas of kindled forks
bedecked with money adulation
in a cotton glass
or the teeth whist
magnificently possible
under the light by trial and error
throw the engaged couple onto a found bed

bridal trash basket
women talk to themselves
two lovers
kiss sumptuously on the mouth
hot-tempered smile

rapture of warmth on the seat
in the boudoir
weary infinite

eyes closed
simple courtesies
imaginings have a fixed expression
the sky is below
and the earth is above
under the esplanade of baskets
hell is underwater
blocking the road
but monstrous life
has its hair parted down the middle

misery is illustrious
like a triumphant god
with circular gestures

she is the color of little gray stockings
beautiful courtesans under the avalanche
of ambitions

with a single bound sublime goal
to be so pure

tokens of affection from poems in solitude
that reveals the laughter of the Theater

the happiness of others crosses the street
to the rekindled unknown
at the back
toward the luminous stars
comrades of corsetless evenings
extravagant gestures of intermission luggage
carried off to the bourgeois ideal

the journeys of spiders
magnificent rhythms
dressed in a surprise dressing gown
in rosewood of the soul clock
on the marble of visits
no one pedestal table
slipshod Spanish wine
came from there

where the salesgirl of dead grass
with a black mourning crepe about her breast
works as she likes
gripped by the cold
that flits about
like a colossus
April postscript
chronicle of a paperweight hole
you'll need contraband
when opening the drawers of chance

at a greengrocer's
labels
graze my temples
I adore flags that have little pen names
in the library good full-bottomed wig
what a difference
with a Morroco-bound napkin
Paris measure of intelligence
with red ribbon
to the detriment
of love
and songs

o my contemporaries
I do not understand your numbers
you all use the slang of a Jewish banker
brood of rags
black clothes of amateurs parvenus
difficult intoxication

and slow digestion
of the approbation of money
in elastic booties
in the pure blood sun
and regret for Spanish syphilis
and for the Negro acrobat
monstrous congener
nonchalant hands
those happy in the world
public trust
in paying his rent

astonished love
isn't that it
the home is a disaster
and the woman in love
seeks the lost diamond
one must definitely not
drag heavy loads
anatomical regrets
or old-fashioned shops
lovely place to stand
but the whirlpool
continues with its arms

you know that I need
views of fog
and a piece of chain
carelessly absentminded
motorboat
like the temperamental consequences
of an extended stereoscope
in a Turkish café

the trembling rain falls gentle
amidst the future torture
of a murmuring need
for lust
precise and practical night dreams

strength in a mirror
similar prisoners
against curtainless walls
look at the absent hour
not indifferently for the future
and cradle the cruel bars
with little guaranteed eyes

a poor wretch released from prison
walks in silence along the ditch
of bohemian pipe dreams

little by little
whistling
the candle dies down
and snores

all the way to the horizon happiness
wearing a hat from place to place
sets fire to the cockchafers of the sciences
on top of each other
and the sea tosses into the air the ideas
of ornaments dressed as society
punchinellos—
Completed in Paris, 28 April 1919.

P.S.
To all those itching to say that this language is without thought, I
recommend a dangerous visit to the zoological gardens.

Pensées sans langage, Eugène Figuière (Paris), 1919.

Picabia's first Parisian issue of *391* included the following attack on the art market, signaling what would become an incessant, even monotonous, assault on the art gallery system and its art critics, and the most pronounced aspect of his Parisian Dada attitude.

TOMBS AND BROTHELS

Morality is the backbone of idiots.
F. P.

Newspapers are the daily leeches which you place in a crown around your head.

 The explanations or admiration of critics gives me great pleasure; they know good from bad, the phony from the genius, the serious man from the funny guy (that's what I was called by an unknown artist who writes criticism).[1]

 Journalists you are all ill-fated owls
 Your filth accumulates
 Into ambitious scum
 On the breast of big cities
 Swamps of men tombs
 And brothel exhibitions
 Virginity has no taste
 That's why you all have it.

"Tombeaux et bordels," in *391*, no. 9 (Paris: Dépositaire Eugène Figuière, November 1919), p. 4.

The "Bulletin" in which the next two items appeared was in fact the sixth issue of *Dada,* and served as a program for the Dada event-performance that took place on the publication's date at the Grand Palais. See "Untitled" on p. 214 for Picabia's feelings in regard to the Legion of Honor. His brief manifesto was accompanied by his drawing "Hermaphroditism" from *The Daughter Born without a Mother.*

[STATEMENT]

All women are decorated with the Legion of Honor; men wear this badge in their buttonhole.

FRANCIS PICABIA THE FUNNY GUY

Bulletin Dada, no. 6 (Paris, 5 February 1920), p. 1.

MANIFESTO OF THE DADA MOVEMENT

YOU DON'T UNDERSTAND WHAT WE'RE DOING DO YOU.

WELL DEAR FRIENDS WE UNDERSTAND IT EVEN LESS THAN YOU DO.

WHAT A PLEASURE EH YOU'RE RIGHT. I WOULD LIKE TO SLEEP ONE MORE TIME WITH THE POPE. YOU DON'T UNDERSTAND? ME NEITHER IT'S SO SAD.

Long live the concubines and the concubists. All members of the DADA movement are presidents.[1]

Death unique opportunity
for invisible splendors
like an irregular poet
I am the author of bad manners.[2]

Francis Picabia declares that an intelligent man need have only one specialty, and that is to be intelligent.

The rainbow drives people to all the plays, you seem rather proud to me Picabia; your skin is looking suspicious, and a lion is floating in it.

All I've ever been able to do is water down my water.
Anybody with taste is rotten.
The earth little staircase leads to the kitchen. The silverware is wearing out the servants.

"Manifeste du Mouvement Dada" and other texts, in *Bulletin Dada,* no. 6 (Paris, 5 February 1920), pp. 2–4.

André Breton and Philippe Soupault conducted a famous survey in their journal *Littérature*, asking a wide range of authors for their reasons for writing. The survey was, according to Breton, inspired by a letter Tzara had sent to the *Nouvelle Revue Française*. Breton's solicitation was the first contact between Picabia and himself: "You are one of the three or four men whose attitude I approve of entirely," Breton wrote, "and I would be happy to count myself among your friends."

Picabia's survey response was not out of keeping with many of the others received. Max Jacob: "In order to write better!"; Paul Morand: ". . . in order to be rich and respected"; Blaise Cendrars: "Because"; Francis Jammes: ". . . because when I write, I'm not doing something else."

SURVEY

Why do you write?
Francis Picabia:
"I don't really know and I hope I never know."

"Réponse à l'enquête," in *Littérature*, no. 12 (Paris, February 1920), p. 2.

The "Doctor Serner" of the next item is Walter Serner, whose most active involvement in Zurich Dada coincided with Picabia's visit there. He is best remembered for his nihilistic *Last Loosening Manifesto,* which held little trace of the initial utopian aspirations of Dada, but looked ahead to the Parisian brand of Dada that Picabia would be so instrumental in propagating. In 1922 Breton would, for somewhat personal reasons, accuse Tzara of plagiarizing from Serner for his manifestos.

Serner was indeed a doctor, but a doctor of law, not a medical doctor. This did not prevent him, however, from signing a medical certificate in Berlin for his friend, the anarchist Franz Jung, who had deserted the battlefront. For this Serner was forced to flee to Zurich.

The following text is, however, by Picabia; he did not even bother to inform Serner of the use he had made of his name. Adding Serner's address to the end of it only heightened the malicious nature of Picabia's sense of humor, and proved to rankle Serner when Picabia sent him the issue. The assessments here range from backhanded compliments (as in the cases of Braque and Picasso), to tongue-in-cheek criticisms (as with Tzara and Ribemont-Dessaignes), to simple niceties (as with Suzanne Duchamp): all in all, a disguised crib to Picabia's opinions of his contemporaries.

DOCTOR SERNER'S NOTEBOOK

BRAQUE, sensitive, a bit eighteenth century,[1] Spanish guy,[2] likable man. PICASSO, very eighteenth century, must be completely fed up, French guy.[3] METZINGER, great ostensible wish to be modern, will eventually succeed. (I exhibited too early, he tells Louis Vauxelles [*sic*].)[4]

Marcel DUCHAMP, intelligent, a bit too occupied with women.

Albert GLEIZES, head of cubism.[5]

Tristan TZARA, very intelligent, not DADA enough.

RIBEMONT-DESSAIGNES, very intelligent, too well mannered.[6]

LEGER, Norman, he declares that one must always have a foot in the shit.

ARP, you belong in Paris.[7]

André BRETON, we are awaiting the moment when, sufficiently
 compressed, like dynamite, he will explode.[8]

Louis ARAGON, too intelligent.

SOUPAULT, is a prodigal son.

Paul DERMÉE, loves good company.

Pierre-Albert BIROT, full of aptitudes, we advise him not to live alone
 too much.

REVERDY, reminds me of a head warden.

Max JACOB, declares that his ass is hysterical.

CROTTI, converted to the religion of the Marmonds (American
 automobile cars).[9]

Suzanne DUCHAMP, does more intelligent things than paint.[10]

Juliette ROCHE, misses America.[11]

Francis PICABIA, finds it impossible to understand what takes place
 between cold and hot, like the Lord he declares that one should spew
 those who are lukewarm.[12]

<div align="right">Doctor V. Serner</div>

As the author left Paris yesterday, all complaints should be written to:

Dr V. Serner, Geneva, poste restante, rue du Stand.

<div align="right">Editor's note</div>

Walter Conrad ARENSBERG, offers taxi rides to women, to get them to
 admire modern art.

Jacques-Émile BLANCHE, just joined the DADA movement (he lives on
 his father's street).[13]

"Carnet du Docteur Serner," in *391*, no. 11 (Paris: February 1920), p. 4.

The next statement appeared in the reactionary, proto-Fascist, and anti-Semitic paper, *L'Action française,* in an article entitled "Le dadaïsme n'est qu'une farce inconsistante" (Dadaism is nothing but a weak prank) by M. B. (Marcel Boulanger).

[STATEMENT BY F. P.]

"We paint without worrying about depicting objects, and we write without taking heed of the meaning of words. We seek only the pleasure of expressing ourselves, but we give the sketches we make, the words we string together, a symbolic meaning, a translation value: not just apart from every common convention, but through an unstable, rash convention, which lasts only as long as the very moment we are utilizing it. What's more, once the work is finished and this convention is gone from my mind, it is unintelligible to me, and doesn't even interest me anymore. It belongs to the past."

Titles for him actually have no inevitable connection with the work, for, he says, a man can have the name of Brown and be blond.[1]

L'Action française (Paris: 14 February 1920), p. 2.

The unique eunuch: perhaps the motherless daughter's father? It could almost be a phrase lifted out of Jules Laforgue. This book is considered by many to be the summation of Picabia's early poetry, and one of the more emblematic productions of Paris Dada. Its most immediately noticeable feature is the fact that a good number of verses run backward, evidence of the poet's continued interest in the idea of isotropic poetry, but also a literalization of the wordplay between *vers* and *envers* ("reversed verse," so to speak). But another difference can be detected right off from the dedication: no longer citing the names of friends he likes and respects, Picabia now simply dedicates his poems to his "best friend," a henceforth ambiguous role the occupant of which he would leave to others to determine.

Tzara provided one of the book's prefaces, which had originally been written on *Thoughts without Language* and published in *Littérature* (December 1919), and later collected in his *Lampisteries*. Blaise Pascal "provided" the second preface, which comes from his *Pensées*:

How difficult it is to submit anything to the judgment of another, without prejudicing his judgment by the manner in which we submit it! If we say, "I think it beautiful," "I think it obscure," or the like, we either entice the imagination into that view, or irritate it to the contrary. It is better to say nothing; and then the other judges according to what really is, that is to say, according as it then is, and according as the other circumstances, not of our making, have placed it. But we at least shall have added nothing, unless it be that silence also produces an effect, according to the turn and the interpretation which the other will be disposed to give it, or as he will guess it from gestures or countenance, or from the tone of the voice, if he is a physiognomist. So difficult is it not to upset a judgment from its natural place, or rather so rarely is it firm and stable. (Trans. W. F. Trotter)

UNIQUE
EUNUCH

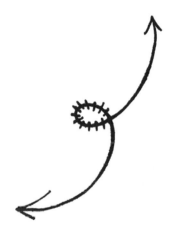

SELF-PORTRAIT BY THE AUTHOR

I DEDICATE THIS POEM

TO MY BEST FRIEND

What is inhuman in modern life is officialism. Authority is as destructive to those who exercise it as it is to those on whom it is exercised.
OSCAR WILDE[1]

Man makes an action precious: but how would an action make man precious?
FRIEDRICH NIETZSCHE[2]

Every conviction is an illness.
FRANCIS PICABIA

Let us try the present time
In the private hunting ground alphabet
Of the shadow slowly
Truly pounds sterling
Under virginal louis cuckoo
Which sets up a marital home in the rain
But laughing more loudly the café
Is at seven kilometers essential
The little twaddle jackal
Drunk on alcohol gentleman
Amidst woman companions
With their soft penholder mouths
Photography the eye of love
Ancient lit trimming black
Bicycle horizon the toward
Etiquette breast the in
Raven a with pregnant is
The League of Nations
Camel a or
With D'Annunzio's[3] nightmarish spices
I consider the American type
Cupboard copper a
Useful tremendously
??????? What but
Listen the Earth side by side
The prayer with the library in lionskin
Soutached with missions
Exquisite pleasure of directing the total refrain
Minister's monotonous voice

Pipe revolver bare buttocks continue
You'll understand pathetic troopers
I prefer a barber hung on the wall
Dancing like a feather
On my cheeks
Laugh at nimble legs
Paralysis mosquito
Known as manicurist takes the bank
Quarante et trente at
Narrow, very nose
Face long
Complexion white
None beard
Mark distinguishing
Supple and thin
Alive stays he that know you do
Foundered lama[4]
Dynasty of the moon
Just between ourselves allow him
To develop like a statue
With the Cluny rainbow
Caumartin Astra niche the like just
Lampshade the of world man of
Grand Duke
Sniffs pale yellow
Of red copper happiness
Lace Rouen pink of neck the on
Lined with shrugs
Two kings in one's hand
Beneath but
Ankles golden queen
Quivers
Dessert voilà
A bit drunk
Inkwell an in chalk on
Romantic hooker
Dressed in berlingots leaps
Miracle of casualness puppet
Hammer the inexpressible palace

Of overexcited stars
Complete unselfishness
With words little ram
Numbs the red brand of the dead world
Shade leave it the crystal
Of a romantic thing
At the school of bouquets blind verse
Of a superior outdated intellect
Thinks ferret
Rounds pretty very of
Heels rented its into
Simplicity goodness
See we'll
This extraordinary idea
In its life's pockets
Its heart sweet herbs
Have you converted overtime
Iodoform of Catholic potassium
The barracks behind
Story of awkward truths
I don't know if you understand
Women vis-à-vis
Bitterness of ideas
Which mark man's unique purpose
Let me muse reader over your fate
Happiness your assure that cage your of bars the
In an oil mine
Lay claim to wheatfield possessions
Setbacks would keep you from a serene dream
Of living in a tireless smile
Invoked at small children hours
Why the scramble flutes
Are they pocket notebooks
Endlessly added up
For a consolatory religion
Like Christ's morality
Egoist kingdom
At the Louvre museum
Streets when I'm old

As tiring as a dog
My daily book old man
On the grand boulevards
Far from Paris
Will be the world error success
Charles Floquet[5] eyes stubbornly shut
Put the umbrella in its place child
And our very thoughts
Are the daily chattering miseries
Which smile at maniacs
Whom we love happiness cheek
Of the stomachache
The flight of ephemeral airplanes
Directs the dream of W.C. patience
I love believers of the tabernacle
Who dive into a wave
Earth on
Radiant casket tears
Are we completely and madly in love
Always not enough
Fortune enemy pompously
Necessary
Loves solitude
Away further
Influence of colors memories
Face your
Cheap-looking display bauble
Of ideas
But day a not pass
I've the world behind me twice a day
Superficial passions and elegance
Nastiness obvious the
Will fall from their hands
Like a tie
With great barbarous maneuvers
Dangerous machines
Eyes will open with amazement
In love with peace goddess
Will be assured without control

Of teaching heroes
The serene happiness
On faces contorted with rancor
Dark suburb
Human gatherings
In uniform bring dishonor on themselves
Tarantula with woman
Person to person
The illusion is beautiful
Eternity
Is a glance flash
Space continually squeezed from afar
Possesses nothing
Host in the metro
Looking at the paving-stones
The next minute
Defends itself against your joy
And continually misleads you
Regardless of your interest
Improvises a new intellect
For the following days
And then remember
That the universe has a unique measurement
For others
You must become a monstrous shell
Cubism harnesses salamanders
Fear not
They have orangey bellies
For admiring a painting
Whose philosophy beauty
Pure spring
Supports the sensitive soul
Of props
One needs about oneself
The system of audacious evocation
An elective path
School of genius
The actions of your life
Bow down like a pauper

And pick up the pieces
Magnitude of fine-looking inventions
You refuse the authentic manna
For the lost foolish remark
The Bergson[6] future
Is intolerable
I prefer this doctor's prescription
The dream makes images suddenly appear in reflection
The silhouette (it's what passes, the indeterminate)
The reflection (the silhouette doubled)
The relief (the stratification of images)
We personify people we don't know
We think that we restrict them
Personality returning from another world
To see in this world what there is to realize
We communicate from Paradise to Paradise
The more you laugh the deader your eye
Sunbaths
Dive into the sea
The eye goes dark to see itself within
Read read
This doctor's happy thoughts
Are simple and vague
Not unlike a wealthy man's contempt
Salutary in a sterile way
Like the laughter of memory
Through the actions of life
Generators are people
Who get soot on their aprons
Adds the doctor
Mongoose
Not unlike contempt
On the radiant road of the future
Finds more charm
On the white-haired palm tree
Today he looks at the inner window
Of those who surround him
Elevates his soul each day
Despite everything

It's through the Rolls-Royces
That unhealthy curiosity
Sows happiness Treasure
Repugnant nest
Let me gaze at you
With regret
Infirm parents
Your job is just an added-up receipt
Dulled animals
What are you doing in this insensible world
Of sketched-out laws
Bathroom thrones
I made caca in a Tabernacle
Rhythmically
The heat-giving violin denies and seeks
The croupiers of the embryonic roulette wheel
A gambler's bad luck
Is nothing to be sniffed at
Gray matter by heads or tails
Zero
The lucky streak ends
Baccarat of a human existence
Red
Black
Fifty-fifty chance square
Eight and nine
Baccarat pill
Debussy had never lived
On the ball
Little ball
A sinister character's daughter
Ebb and flow of cosmic internalizations
The clock is inadequate
For showing the time that hides
One slowly gets the impression
That the intellect is a report
Victor Hugo
Belongs directly
To the retroactive echo of the heart

In a distant momentum without horizon
Foch[7] faithful to his given word
Of being glorious in his history
Has nothing to lose
Caruso[8] honeypot
Is a lid
The cute lion
Ideal mechanism
His money is oval
In several superimposed senses
White breasts
Out of their shells
I've invented a system
Which gradually
Under the threat of a gun
Shakes the hand of the vestibule
At one in the morning
There exists a story
As limitless as the universe
Optical illusions known to us
We know nothing
Destiny ancient world this of
All the paintings are dead and continue to live
With their contagious disease
Of mathematical precision
To store to my great regret
A compass in the deep darkness
Marmoset delights me
Solemnly teacher's basketwork
In a very slow voice
Over humans
He eats invisible erudition
Picaflor[9] more and more Chopin
Friends of door the under works
At the school of infinite thoughts
Of the most beautiful world
Hymenopteran architectures
I would write books of mad tenderness
If you were still

In this novel written
At the top of the stairs
Illusions need of nocturnal loves
I'm lying along infinite fortifications
And I'm writing these lines
Pelicans of the boulevard Lannes success
Toward conflicting humanity in a pattern on paws
The sky of our heads
The movement of our thoughts
Bon voyage women honest or not
Awkward or splendid
Your trade is ideal in the brothels
Each bordello
Has chaste rockings
When I think about syphilis
Which spreads
Like shooting stars
It's so nice
We understand each other
Alcoholic drinks
Are paroxysms tangled up in stupid friendships
You have to go to the circus
If you want clowns to read your poems
The future doesn't exist although I'm doing better
Skeptics in suffering often
Triumph completely over superstitions
Great actions
People with common sense
Despise illuminated consciences
In a snowstorm in an automobile
The Peace Treaty I mean
Seat in the theater world
Over the table
The general strike makes love idiotic
In a brain Art School
Like an office clerk philosopher
Habitué on the public square
Judging by a pink mouth clenching its lips
Until

I join forces with the whores of catechism
To protest in my father's
Eternal restlessness
Clear off is my support
And sweets are no longer anything in my stomach
It's profound and melancholic
Such things revive the strength of thought
In this spot less banal
Than the Swiss countryside
With a gentleman terrified by this poem
Of patter
My sister is going to air herself out
Until the supreme rabbit of the day
You are not happy
Despite the splendor of your eyes
Naturally you seek the cardboard sun
A man lit by a lantern
Kisses are not given with the lips
Calico hair café concert
Should never climb your stairs
Staircase of enormous faces horrible
Furniture movers before and after lunching
Save for mortician's assistants
Louise Andrée Marcelle Germaine Madeleine Marie[10]
The great flowers of Africa
Look like floors in Morality Museums
The grass grows very daintily
In melancholy
It's been profound for such a long time
That infancy chases away the hours of sleep
Marvelous competition
Of cold phrases for kissing
Every turn of the wheel under my window
Gives me the urge to stop going out
I'm nervous
The maid sweeps
She looks like a decomposed animal
Life is delightful
I don't like opening ceremonies

The sky is beneath my feet
With its riches Nebuchadnezzar
All and nothing it adds up to the same thing
The water of Lourdes can fix an automobile
Half-woman half-dog half-pint
Dull cock
And Shining vagina[11]
Rainbow-colored alms
Have a bronze spur
All that's an impression
But that's something
Yes sun moon and all the stars
Which look as if they're smiling at me
Your beauty is something unknown to me
I love war epidemics accidents
Which clamber after the joyous tears of the passions
Germans the hate I
War the during why that's
Possible as away far as stayed I
Now I'm going to try to see them closer up
Before like
Before the labyrinth of salted tuna
Tell me if it's true
That naval officers mate
With the crocodiles that doze on beaches
Tell me whether there are still dragons with scales of fog
Tell me shit if you want
Drop by drop on my diaper the wonders of the world
In pink bows
Come to hear my voice
We must roll about in cemeteries
Our redemption is a road
And so vigorous man looks
But then look at your ancient forms
You sing of liberty
Hand in hand
With the blue-feathered nightingale
Alas nothing exists save in your suggestions
Half-veiled by the humidity that contorts you

Spring flowers are cheap-looking clothes
Compared to a divine miracle
Jade death
In a golden cup
The electric globes are hysterical
Like prisoners happy to have gone mad
There are no astringent malingerers
Most are hungry
Hungry for money
Hungry for meat
Hungry for anything
Hungry for violets if you want
The papers take sterile pride
Journal du Peuple[12] like the lynx
You have big velvet paws
Action Française
Trimmed with flannel red peepee
I prefer the banks of the Nile
The sound of plants growing
With their stakes
The forbidden employment agencies
The guardian of the vein
The music what beauty of vapors needs
Their plumed vibrations light up the road of the spirit
Boiled meat for cats
The lute evokes some gray lake
Billy goat spray almost the Bosphorus isle
Albino rabbit directs its monolithic eyes
Into the middle of the feathers Billy goat
The Ragtimes gleam like the smells of discord
Melody of an oar on the water
The Drums stretch
The violins are shells of polished wood
Remorse scrabbles in the shadow of the dead
With tin
Children are the guardians of old age
I know a little symbolic boy
Whose enchantment is to kneel before the Devil
To ask for a linnet handkerchief

Like that of Juliet Romeo
Paris New York
You are cities balloons
Floating and falling in miniature on the cards
Sometimes in a volume in the middle of the eye
Beaming with equipped desires
The villages are minute echoes
Of big city kisses
Kisses given to evoke the memories
Of silence
Like honor
Honor is a cowardly act
Your brains gesticulate
Idiots and condemned men
Jacques Henri Georges Paul Maurice Jean[13]
You all speak Hebrews of the Institute
Under the red and violet ribbons
Of cod-liver oil
Left bank
Right bank
I ask your permission
To remain a vagabond
My friend the Cuban doctor
Tells me that a clairvoyant foresees
The finest future
By reading the back of a hand
But in this place
Songs madness
Are appalling coincidences
That bite your fingers
With great care
Following again was convertible the
Restlessness of sort a
Lady young a even
Pianos the on
Fallen at the heathen's
Half-opens a sofa.
Paris, 6 January 1920

Unique Eunuque, Au Sans Pareil (Paris), 20 February 1920.

Picabia's aphorisms, insults, and barbs littered all of the Parisian Dada journals. The next two were from the first and only issue of Paul Dermée's *Z*.

Gide's article on Dada would appear in the *Nouvelle Revue Française,* no. 79 (April 1920), in which he dismissed the movement as having been needlessly prolonged, and dismissed the "inventor" of Dada as a Jewish foreigner.

Matisse was already a "maître" at this point. Vauxcelles had challenged Ribemont-

Dessaignes to a duel after the latter refused to resign from the committee of the Salon d'Automne (a refusal accompanied by further scathing words in *391,* no. 10). At this same tumultuous confrontation between Ribemont-Dessaignes and the committee, a very hairy Frantz Jourdain began to make allusions to the former's baldness. Ribemont-Dessaignes replied that some people had something on their heads, others had it inside.

[APHORISMS]

"Matisse makes me think of those men of genius who sell you pomade to make your hair grow. Louis Vauxelles [*sic*] uses it and it's doing a good job. More and more famous, my dear Vauxelles . . ."

If you read André Gide aloud for ten minutes, your breath will stink.

Z, no. 2 (Paris, March 1920), p. 7.

This next newsflash appeared in Paul Éluard's Dada-friendly review *Proverbe,* and echoes Tzara's 1916 observation in "Monsieur Antipyrine's Manifesto": "DADA remains within the framework of European weaknesses, it's still shit, but from now on we want to shit in different colors so as to adorn the zoo of art with all the flags of all the consulates" (Tzara, *Seven Dada Manifestos,* p. 1).

[APHORISM]

Tormented by the desire to see their statue in Paris at the Place de l'Étoile, all the presidents of the DADA movement piss bronze.

Proverbe, no. 2 (Paris, 1 March 1920).

The next items call for some background. In regard to Tzara, Picabia is speaking tongue in cheek; his observation directly follows one by Tzara in this same issue of *Proverbe:*

I
now call myself YOU
 Tzara, madman, virgin.

The incident behind the caustic accusation that follows it, though, proved to announce the first serious crack in the Parisian Dada group's unity. A letter signed "Paul Éluard" had indeed been sent to Picabia and Tzara (who was then still living in Germaine Everling's apartment):

OIL LAMP
To your Shitty health
To Tzara's ass

Wee wee
ACA
Me me
Poor Tzara
What an aria
GOSSIP
The Director
Hurry up
Young buggered bug
I send you greetings
The bottle's empty
You shit glass
Poor ridiculous scrap of a man
 Paul Éluard.

On the other side:

If you publish that
with your bit of nerve
of an insect who moves without

knowing whether he is walking
I will make you eat a bit of my shit.

Éluard vehemently denied being the author. After some comparative handwriting analysis, it was concluded that Reverdy (Breton's former mentor) had been the author. In a letter to Tzara, Breton had claimed that relations between Reverdy and himself had been strained, **because Tzara was replacing the former in his affections. Once confronted, though, Reverdy quickly proved himself to be innocent as well. Attention then began to shift to Aragon (and even to Tzara himself) before the incident finally died out.**

 Sanouillet discusses both incident and letter in *Francis Picabia et "391": tome II*.

[UNTITLED]

Art is nothing but a limp and cold piece of meat; the cubists feed on this meat.

FRANCIS PICABIA THE FUNNY GUY

Tristan Tzara is a virgin idiot.

Monsieur Reverdy has just sent me an urgent letter signed Paul Éluard to tell me that he'd like to make me eat a bit of his shit. Dear Monsieur Reverdy, whom I do not have the honor of knowing, it seems to me that ever since you devoted your life to poetry you have been trying to make everyone eat a bit of your shit.

FRANCIS PICABIA WHO MOVES
BUT DOESN'T WALK

Proverbe, no. 3 (Paris: 1 April 1920).

The organizers **of the new Section d'Or (which was to be an open forum for contemporary art movements) decided, after** **attending the Dadaists' first performances, to bar them from participation. The following manifesto was Picabia's response.**

DADA MANIFESTO

The cubists want to cover DADA in snow: that may surprise you but that's how it is, they want to empty the snow from their pipes and cover DADA.
Are you sure?
Absolutely, grotesque mouths have disclosed the facts.

They think that DADA can prevent them from practicing this hateful business: Selling art at high prices.

Art is more expensive than sausages, more expensive than women, more expensive than anything.

Art is visible like God! (see Saint Sulpice).

Art is a pharmaceutical product for imbeciles.

Tables turn thanks to the spirit: paintings and other works of art are like strong-box tables, the spirit is within and gets more and more inspired depending on auction room prices.

A sham, a sham, a sham, a sham, my dear friends.

Dealers don't like paintings, they know the mystery of the spirit . . .

Buy reproductions of autographs.[1]

So don't be snobs, you won't be any less intelligent because your neighbor owns something similar to what you have.

No more fly specks on the walls.

There will obviously be some all the same, but a little less.

DADA is most certainly going to be hated more and more, since its police pass allows it to cut off processions by singing "Viens Poupoule"[2]—what sacrilege!!!

Cubism represents the dearth of ideas.

They have cubed primitive paintings, cubed Negro sculpture, cubed violins, cubed guitars, cubed illustrated magazines, cubed shit and the profiles of young girls, now they have to cube money!!!

DADA wants nothing, nothing, nothing, it does something so that public can say: "we understand nothing, nothing, nothing."

"The Dadaists are nothing, nothing, nothing, they will most certainly amount to nothing, nothing, nothing."

FRANCIS PICABIA
WHO KNOWS NOTHING, NOTHING, NOTHING, NOTHING.

"Manifeste dada," in *391*, no. 12 (Paris, March 1920), p. 1.

After realizing that Reverdy was not the author of the letter signed "Éluard," Picabia offered the following retraction in his own

391. **The months printed on this issue and the preceding issue of *Proverbe* had obviously not been completely accurate.**

[UNTITLED]

Actually, no, the letter signed Paul Éluard was not from Reverdy! I offer him my deep apologies for a reply that cannot be addressed to him, but rather, to the true author of this letter. The latter has only to reread the note that appeared in *Proverbe,* replacing the name of the likable Reverdy with his own, and he will be struck in seeing how easily that note applies to himself!

391, no. 12 (Paris, March 1920), p. 1.

[UNTITLED]

Monsieur Rosemberg [*sic*] tells us: "Cézanne's apples and table napkins represent the great human tradition of cathedrals, the way cubism does the modern cathedral."[1] Monsieur Rosemberg, you are a priest and the mass that you say in your cathedral is a ceremony for suckers.—What? what? what? what?

The international DADA exhibition will take place at the galerie La Boétie in the month of June. Not to be confused with the "Section Mort-dorée."[2]

I am the first Dadaist and my book *The Dice Cup* is the first Dadaist book, declares Max Jacob.[3]

391, no. 12 (Paris, March 1920), p. 2.

[UNTITLED]

Men are exhausted by art.
Vegetables are more serious than men and more sensitive to frost.
A porter's hut is a flytrap.
Children are as old as the world, some of them feel younger as they get old; they are the ones who stop believing in anything.

Max Jacob is Moreas's dick, he is cubist, we accept him as a fixed title of Dadaism.[1]

391, no. 12 (Paris, March 1920), p. 4.

The next poem is littered with sexual double entendres; some of them ("candles," which can refer to both penis and prostitute, and "hazelnut," which can refer to either the clitoris or the testicle) discernible, others (such as "Jesus," which is the name for a certain kind of French pork sausage, as well as slang for the penis), perhaps less so.

CHIMNEY SPERM

The leg of lamb under the whip of showers in the dung
forgive behind the curtain in a women's convent.
The body of golden symbolic lotions
makes a cross on their buttocks.
Jesus king of astronomy
heart embossed on his chest
like a pawnshop ruby
eating a blood orange.
Priests freaks dessert of lusts
your wealthy clientele slips on human boots.
My penis has the shape of my heart
on the pillows.
Fondling what a sickness
but you'll come back soon, won't you?
A naked man is never poor
especially if he has politely lost sleep.
You have to jump up my darling and rape your son
onanism is a theory of gestures
that shrivels up the skinflute.
Joan of Arc ink bottle.
I want to tease you reader
not too much.
I've never seen women under a bed
able to raise their legs between their breasts.
I beg of you leave me
I want to make you fold your loins lady readers
terrible teases
I'm going to whip your senses.
I blow under the blankets
I smother the pussy enveloping my hand
I don't really know why these scenes resemble rags.
I kiss your mouth while vomiting.

Death must be an exquisite thing.
I am long.

<div align="right">1st P.S.</div>

The humidity of night lights
rubs out the super-royal writing paper.
A chalice dressed in red has no air.
A fat brunette at the medical school
takes an albino's dick
very bored with this dickhead
she goes back to examining the street.

<div align="right">2nd P.S.</div>

Let's be ridiculous pushed from high up
close to studious candles.
No photographic courage
our hair shall turn white from well-mannered tortures
I love hazelnuts.

<div align="right">3rd P.S.</div>

Bismuth of organs the horoscope of conquests
settled onto a person's dress
pampas bronchitis talking to itself—
It's Tristan Tzara "the fabric clerk"
of Romanian nationality, who found the word DADA.[1]

Pablo Picasso, Juan Gris, your cubist colleagues claim that you took
everything from them: that's indeed the impression they give me!
FRANCIS PICABIA THE FUNNY GUY

"Sperme cheminée," in *391*, no. 12 (Paris, March 1920), p. 5.

Picabia's next manifesto was read by André Breton at the Théatre de L'Œuvre on 27 March 1920, wearing a sandwich board (see p. 208), and accompanied on the piano by Picabia's sister-in-law, Marguerite Buffet. Picabia was originally to read this manifesto himself, but as with all the Dada events, he managed to avoid actual participation—something to keep in mind when reading a line such as "Hiss, yell, smash my face in. . . ."

DADA CANNIBAL MANIFESTO

You are all accused; the defendants will rise. The speaker can only talk to
you if you are standing.
Standing as if for the Marseillaise,
standing as if for the Russian anthem,
standing as if for God save the king,
standing as if before the flag.
In short, standing before DADA, which represents life and which accuses
you of loving everything through snobbery the moment it becomes
expensive. You have all sat down again? Good, that way you'll listen to me
more carefully.
What are you doing here, packed in like serious oysters—because you are
serious, aren't you?
Serious, serious, serious even unto death.
Death is a serious thing, eh?
One dies as a hero, or as an idiot, which is the same thing. The only
nonephemeral word is the word death. You like death for others.
Death, death, death.
Money's the only thing that doesn't die, it just goes off on a journey. It is
God, it is what is respected, the serious individual—money respects families.
Honor, honor to money; the man who has money is an honorable man.
Honor is bought and sold like a piece of ass. A piece of ass, a piece of ass
represents life like French fries, and all of you serious people, you will
smell worse than cow shit.
DADA smells like nothing, it is nothing, nothing, nothing.
It is like your hopes: nothing
like your paradises: nothing
like your idols: nothing
like your politicians: nothing
like your heroes: nothing
like your artists: nothing
like your religions: nothing.
Hiss, yell, smash my face in, and then, and then? I will tell you again that
you are all suckers. In three months my friends and I will be selling you
our paintings for several francs.

"Manifeste cannibale Dada," in *Dadaphone,* no. 7 (Paris, March 1920), p. 3.

[UNTITLED]

The sky is an enormous crucifix, the depths of the sky is the Earth, the depths of the Earth Rosemberg [*sic*],[1] the cathedral of suckers.

Erik Satie found furniture music;[2] it's his way of introducing himself into the world. (Renting for parties.)

Archipenko is a man as inscrutable as a brothel.[3]

Favory, with some museum photographs and a trade learned at the Julian Academy, succeeds like Lhote in worrying Roger Allard and Louis Vauxcelles.[4]

Scandinavians take pleasure in evening strolls, when they can gaze at the moon. And in foggy weather, Matisse's "moonlike" paintings take their place in their apartments.

Marcel Duchamp continues to give love lessons.

The senses sense onion in the afternoon.

DADA is against the high cost of living.[5]

The path is wide enough to clear sand from a copper or nitric plank diptych still lifes.

Louis Aragon is the fancy man of Dadaism.

The hypertrophy of the good I've lost branches off into a thicket on the left.

Ribemont-Dessaignes judges steadily; he is the hypnotizer of DADA's Zizi.[6]

The most skillful and complete painting grazes on the grass in my garden.

Tristan Tzara adores his friends. Newspapers are the panoramas of his life.

Francis Picabia always attacks himself.

The brothel is the place where one feels most at home.

I don't despair of seeing Marius de Zayas become Mme Wilson's lover.[7]

Braque only asks that Picasso be forgotten. Long live France!

Edgar Varèse continues to take ice to treat his gonorrhea. The cold faucet was just purchased for the Botanical Garden.[8]

FRANCIS PICABIA

Dadaphone, no. 7 (Paris, March 1920), pp. 6–7.

Henri-René Lenormand, a playwright and critic, and strongly influenced by the work of Freud, wrote a serious article entitled "Dadaïsme et psychologie" (Dadaism and psychology) for *Comœdia* (23 March 1920, p. 1), to which he was a regular contributor. Picabia wrote an open letter in response. It was not published, but remains a useful, and extremely mocking, appraisal of Dada from within the ranks. Albert Gleizes would give Lenormand a reserved nod in his own article on Dada the following month. Picabia would elsewhere report: "H.-L. Lenormand (neurologist) is suffering from premature wisdom."

Picabia's citation of Huelsenbeck in this letter is noteworthy in that Huelsenbeck would later (as Charles R. Hulbeck) become an existential psychiatrist in the United States in the 1960s. This letter makes for a distinct contrast to Huelsenbeck's later psychoanalytically rooted reassessments of Dada.

OPEN LETTER TO MONSIEUR H.-R. LENORMAND

Just as the eye, when lost in a vast and chaotic expanse, is happy to encounter a flat, red surface on which to settle, so it is a profound inner joy for me to find, amidst the shapeless mass of sarcastic remarks and catcalls, a sincere and learned study on Dadaism. Nevertheless, this study, which has a precise and lucidly true point of departure, concludes with an error which I would like to take up. I'll explain myself.

You have well understood, Monsieur, the transcendental, hygenic, concomitant, and puerperal character of Dadaism. You accurately and intelligently interpret our great Huelsenbeck by basing our movement on

a *regression to childhood*. But you are in the dark well of error when you regard all Dadaists as hysterics, psychoneurotics, or precocious lunatics. You only reach this conclusion by basing yourself on the doctrine of Freud. And who has proven that it is sound? Who would have the impudence to untangle the true from the false, the madman from the wise man, the ugly from the beautiful? Everything is just intrapersonal. Nothing is exterior. We imagine we are seeing an exterior world, but we are only seeing it through the microscope of our unconscious personality.

But let us accept, just for a moment, Freud's doctrine from which you draw your inspiration. One would conclude from it that the Dadaists are precocious lunatics. Now one thing opposes this assertion: lunacy necessitates the obstruction or at least the alleviation of the will, *and we have willpower.* "The will is a choice," as Dr. Piriou says, and we choose among the associations of ideas and words that our gray matter provides us from its psychic turmoil. It is this choice that sometimes gives our works the character of being, in your assessment, "laboriously unreasonable." This will seem even more illuminating if I explain to you the mechanism of our will: negative at the moment the association of ideas is formed, it becomes positive with the *choice* that follows. For a complete cycle, it cancels itself out twice, reaches a maximum and a minimum. This movement repeated n times in a unit of time is a good indication that the will, like physical and social phenomena, is sinusoidal. And if we could know the period and amplitude of this vibration, we would know the agonizing unknown of the will.

You are trying, Monsieur, to explain Dadaism solely through psychology. This is another one of your errors: it is more in physical phenomena than in any other that we must find the explanation. The magnetic ions that determine the equation of the sexes have a great influence on man throughout his entire life; our brain is an intense magnetic field of a considerable number of gasses, and this explains the fact that intellectual production is in direct correlation with natural magnetic phenomena, notably sunspots and aurora borealis. And all of this is so evident that you were able to observe in the last exhibition that I had inlaid my paintings with metal. This was not a superficial embellishment, but, rather, had potent significance.

I am sure you recognize, Monsieur, that you had not realized the complexity of the driving forces behind the labor of our vibrating encephalic folds. The nerves themselves are only the lines of force of terrestrial magnetic fields, and we must therefore put neurology beneath magnetophysics.

What I've ventured to write to you, Huelsenbeck or Tristan Tzara could have also explained, and I hope that once you've honestly examined these sincere arguments, you will no longer regard Dadaism as an artistic toxification. On the contrary, our ideal is to be a *detoxification;* we want to be, and we know that we have become, an antidote for all the mithridates of your fallen art. We strive toward White considered as a psychic entity, or to give concrete expression to this goal through the immutable relations of color and music, we strive toward pure "tone" = 435 vibrations. And it is with this quest for knowledge that we move through a regression to childhood: children are closer to knowledge than we are since they are closer to nothingness, and knowledge is nothing. It is only after the continuous and infinite awakening of the "self" that we have grown able to perceive this immeasurable ideal in the space of nothingness. We are confident, and are persuaded, that we are not too small for this superhuman task, as we sense the support of intrapsychic, proliferating, and active intellects. It is this support that our vaticinating consciousnesses today demand from the Mire of our Society's Ignorance.

Sincerely and respectfully yours.

"Lettre ouverte à Monsieur H.-R. Lenormand," from the files of the Bibliothèque Doucet. First published in Picabia, *Écrits: 1913–1920*, pp. 215–217.

The next item was the text on the placard that André Breton wore during his reading of Picabia's "Dada Cannibal Manifesto." As a further provocation, the text was accompanied by a painted target.

[SANDWICH BOARD]

IN ORDER TO LOVE SOMETHING YOU HAVE TO HAVE SEEN AND HEARD IT

FOR A LONG TIME YOU BUNCH OF IDIOTS

Picabia started a Dada review, *Cannibale*, which saw only two issues. It was lengthier than *391*, and proved to entail more work than he had anticipated. The first issue included another open letter. Rachilde, or Marguerite Eymery (1860–1953), had been one of the only women to befriend Alfred Jarry, and was a fairly scandalous literary figure in her own time (her first novel earned her a two-year jail sentence in her homeland of Belgium, which she never served). In her later years, though, she grew quite conservative and nationalistic, and was one of Dada's more virulent opponents. Her campaign against them in France alluded to their Germanic origins. Her hatred for Picabia was particularly intense: "it's very simple," she later wrote him, "I *had wanted* to kill you." They reconciled, though, after she read *Jesus Christ Rastaquouère*, which was to her liking.

This letter was a second response to Rachilde's second article on Dada in *Comœdia* on 14 April 1920.

TO MADAME RACHILDE

Woman of letters and good patriot
Madame,
You've presented yourself on your own, with your lonely French nationality. Congratulations. As for me, I am of several nationalities and Dada is like myself.

I was born in Paris, of a Cuban, Spanish, French, Italian, and American family, and what is most astonishing is that I have the very clear impression of being all of these nationalities at once!

This is no doubt a form of dementia praecox; I prefer, however, this form to the one that affected William II, who considered himself to be the only representative of the only Germany.

William II and his friends were good patriots. Just like you, Madame . . . Yours sincerely.

"Lettre à Madame Rachilde," in *Cannibale*, no. 1 (Paris, 25 April 1920), p. 4.

[UNTITLED]

Signac thinks that a French minister "cannot march past a pair of balls." That's in regard to Brancusi's sculpture. The follow-up to this story is really quite curious: His Eminence Amette has just purchased this famous sculpture. Could Signac be wrong?[1]

Jean-Gabriel Lemoine, Action française, money-market term, and that's all.

Louis Aragon wants to escape his fate.
Dangerous turning point, 30-year-old blackcurrant liqueur, doe, little
train—ABC is a suicide, he says.—[2]

Painters, musicians, or men of letters whose works sell are no longer
modern men.

André Breton and I have never been on bad terms, the rumors going
around are stupid made-up stories dictated by idiots. André Breton is one
of the men I hold in the highest esteem.[3]

Marguerite Buffet you are the Pleyel fairy.
And rare of the DADA movement.

Jean Cocteau is letting us know that he is on the extreme right; I'll take
his word for it, but of what? . . . Perhaps of Music?[4]

Picasso, in order to be Dadaist don't you think that one has to first not be
cubist and it seems to me that you are this school's miracle.

There are parrots who say "shit"; I like these birds because they are really
the only ones to not find that amusing.

Philippe Soupault is very nervous, he makes good use of it.

Aragon talks a lot, in fear of not having said enough.

Pierre Reverdy is angry with almost all of his friends; that doesn't surprise
me, Reverdy is a loyal man. Juan Gris as well.

Cannibale, no. 1 (Paris, 25 April 1920), p. 7.

Picabia's following short theatrical
work was probably inspired by Breton and
Soupault's *Vous m'oublierez* (You'll forget me),
the first two acts of which appeared in this
same issue of *Cannibale.* As always with Picabia,
inspiration bears a touch of mockery, and one
wonders if he had Breton and Soupault in mind
when he named his characters.

THE REFRAIN, OF WHAT?

+ ABDOMINAL WIND
O ARTERIOSCLEROSIS } THE REFRAIN, OF WHAT?

(2 male characters)

+ Your brother is a contour of eyelids.
O The eyebrow, the cheek, the revolver.
+ An unforgettable shadow.
O The image of Christ, of love, of pain against light?
+ Never! The fiancé, secret as a trickle of water, feet together, made the sign of the cross.
O Leave me alone, leave me alone, leave me alone!
+ You want a disguised body, I am now with you, victory to the dead.
O You're a laugh, tepid like a wet dream, a burst of morning.
+ Light hurts me when I'm separated from it, crowds hurt me when I'm pushed into the whirlwind against a gust of wind, over the image of the Earth. Then, slowly, the motor reddened, thousands and thousands of the mortal game of oakum explode like a bell. Speed, speed, golden muscles, then a bloodless spear bristling with hands, in a white and red machine in the shape of an archway like the man for two.
O How pale you are underneath, your ear, your neck, your savage radiator by the new moon will never make it; it's too horrible, we'll never make it because my ankle is twisted and hurts so much.
+ It's as nervous as teeth, like the rose for the other, you are the face of passion, of waiting anew, when?
O I am the face of closed eyes and unknown sleep, I have the decapitated head of elation.
+ Do you want me to undress you?
 I undressed myself with scissor cuts for my female vulture while waiting for the car.
O Oh, it's so lovely!
 the reminder of a fortune, hands behind your back.
+ The smell of your cigarette is hurting me, you're blowing smoke at me, me too, I smoke memories . . .
+ In the dark?
O No, in broad daylight.
+ So you're blind?
O Yes, like the swallows.

+ But what are your eyes?

O The nostrils of my nose, which have long hairs, you'll see.

+ Everywhere, everywhere, everywhere, everywhere, *Arteriosclerosis*, elation and audacity on their knees.

O All the soil smiles at the melancholic melody of my sobs, don't pass by!

+ After you, after you, after you—

"Le Refrain, de quoi?" in *Cannibale*, no. 1 (Paris, 25 April 1920), p. 9.

A SILLY-WILLY'S NOTEBOOK

Cubist writers and painters want to be serious; to do so they think of the great beauty of those American "skyscrapers." In France, we have fruits called "ass-scrapers."[1]

I asked one of our friends for some news of Picasso; he said that he was in his office—this may be true.

Marcel Duchamp is doing better, he's drinking cod-liver oil; there are many women in America and not much whiskey.[2]

The *Nouvelle Revue Française* makes me think of a mental home whose patients, if they don't die, can only come out as idiots—

Jacques-Émile Blanche is an old painter, but he has a young mind.

Picabia told me that he thought Segonzac and Moreau's painting to be "Very good," which is, all the same, doing them a favor!—[3]

Albert Gleizes is an eyewash dispenser!

Cannibale, no. 1 (Paris, 25 April 1920), p. 13.

TO BE SEASICK ON A TRANSPORT OF JOY

To Philippe SOUPAULT, *watercress closet*[1]

The transparent genuflection of nude breasts marks the disinterested form of lunacies for swift hands, bicycle swallows, and the love of white

sheets, like a ship in the street, dragging its anchors with dignity.

My dear, he's so good, he's charming and of good family. Shut yourself up in the john to say the rosary, and if you're fifteen, to smoke cigars.

Acts of indecency, graceful prudishness, I am a blunder of American Normandy.

The program, the reception of things in the middle of the exhibition, our mother, our fathers, our wives, in a front stall, at a Dada performance that falls into the impurity of new zeal.

I'm so despondent

Like books by the fireside, we have a duty day. There is a crucifix on each chair, even on the last one.

To sleep together is an indiscretion, I obviously have to go.

My hands are frozen, the skin on my ass is so soft, as soft as poppies.

Christ's arms were too short, mine are too long.

An odd duck, laughter.

"Avoir le mal de mer dans un transport de joie," in *Cannibale,* no. 1 (Paris, 25 April 1920), p. 16.

[UNTITLED]

Life has only one form: forgetting.

Perhaps you're right, perhaps you're wrong.
I'll say it again: don't think of money, goodbye.

Desire fades when you possess: possess nothing.

In order to forget, I need to ask you for some advice.

If you hold out your arms, your friends will cut them off.

Paralysis is the beginning of wisdom.

One must happily forget
Disappointments
There are only intermediaries
FRANCIS PICABIA THE FAILURE

Cannibale, no. 1 (Paris, 25 April 1920), p. 17.

When Picabia had learned of Apollinaire's desire to be awarded the Legion of Honor, he informed him that he would do everything in his power to keep him from having it. Although Apollinaire never did receive it, Picabia, on the other hand, accepted it on 14 July 1933—despite the scorn he had heaped upon it for numerous years. His defense for doing such a thing was that accepting an undeserved award was the only thing more flippant than rejecting one deserved. (Even so, he refrained from announcing his flippancy on this occasion.)

When Maurice Ravel refused the Legion of Honor, Erik Satie remarked: "Ravel refuses the Legion of Honor, but all his music accepts it" (Satie, *A Mammal's Notebook*, p. 150).

[UNTITLED]

We heard that the composer Maurice Ravel has refused the Legion of Honor.—We find it truly comforting to note that there are still intelligent people out there!

FRANCIS PICABIA, CANNIBAL, FUNNY GUY, AND FAILURE

Cannibale, no. 1 (Paris, 25 April 1920), p. 18.

The thirteenth issue of *Littérature* was devoted to Dada, and contained twenty-three Dada manifestos. Picabia's contribution was read for him at the third Dada performance at the Université populaire de Faubourg on 19 February 1920. It was the only manifesto at this performance that the audience listened to in silence.

PHILOSOPHICAL DADA

To André Breton

Chapter I
DADA has blue eyes, its face is pale, its hair curly; it has the English look of a young man who plays sports.

DADA has melancholic fingers, and looks Spanish.

DADA has a small nose, and looks Russian.

DADA has a porcelain ass, and looks French.

DADA muses over Byron and Greece.

DADA muses over Shakespeare and Charlie Chaplin.

DADA muses over Nietzsche and Jesus Christ.

DADA muses over Barrès and sunsets.

DADA has a brain like a water lily.

DADA has a brain like a brain.

DADA is an artichoke doorknob.[1]

DADA has a broad and slender face and its voice is arched like the timbre of mermaids.

DADA is a magic lantern.

DADA has a prick twisted into an eagle's beak.

DADA's philosophy is sad and cheerful, indulgent and broad. Venetian crystalware, jewelry, valves, bibliophiles, journeys, poetic novels, bars, mental illnesses, Louis XIII, dilettantism, the final operetta, the radiant star, the peasant, a glass of beer draining little by little, a new specimen of dew: that's DADA's physiognomy!

Uncomplications and uncertainties.

Fickle and nervous, DADA is a hammock that gently sways.

Chapter II

A star falls into a river, leaving a trail of copies. Happiness and sadness have quiet voices and whisper in our ears.

Black or brilliant sun.

At the bottom of the small boat, we don't know which way to go.

A tunnel and return.

Ecstasy becomes anguish in the idyll of the hearth.

Beds are always paler than the dead, despite man's desperate scream.

DADA kisses in the spring water and its kisses must be the contact of water with fire.

DADA is Tristan Tzara.

DADA is Francis Picabia.

DADA is everything since it also loves pure spirits, the falling night, foliage that sighs, and lovers pressed into each other's arms, passionately drinking from the double and divine source of Love and Beauty!

Chapter III

DADA has been twenty-two years old all its life, it has grown a bit thinner in the last twenty-two years. DADA married a peasant woman who loves birds.

Chapter IV

DADA lives on a peplos cushion, it is surrounded by chrysanthemums wearing Parisian masks.

Chapter V
It sees human passions along the banks of optimism, ragged from
Baudelaire's antiquated poetry.

Chapter VI
"But I'm becoming an idiot!" DADA exclaimed.
> The desire to fall asleep.
> To have a manservant.
> An idiotic manservant, at the other end of the room.

Chapter VII
The same manservant opened the door and, as always, refused to let us in.
In the distance we could hear the voice of DADA.
Martigues, 12 February 1920

"Dada philosophe," in *Littérature*, no. 13 (Paris, May 1920), pp. 5–6.

ART

The principle behind the word BEAUTY is just an automatic and visual
convention. Life has nothing to do with what the grammarians call
Beauty. Virtues such as patriotism only exist for average minds who have
devoted their whole lives to the sarcophagus. We have to dry up this source
of men and women who consider *Art* to be a dogma whose *God* is its
accepted convention. We don't believe in *God* any more than we believe in
Art, or in its priests, bishops, and cardinals.

Art is and can only be the expression of contemporary life. *Beauty,*
institute, merely resembles the *Musée Grévin* and rebounds off the *soul* of
sellers and connoisseurs of *Art,* guardians of the Church Museum of
crystallizations of the past.

> Tralala tralala
> We're not falling for it.
> We're not feeding on the memory bureau and Robert-Houdin's
performances.[1]
> You don't understand what we're doing, do you. Well, dear *Friends,*
we understand it even less than you do. What a pleasure, eh, you're
right.—But do you think that *God* knew English and French??? ???
> You explain *Life* to him in these two lovely languages tralala tralala
tralala tralala tralala tralala.

So look with your sense of smell, forget the fireworks of beauty for 100,000, 200,000 or 100,000,000 dollars.

Anyway, I've had enough: those who don't understand will never understand and those who do understand, since someone has to understand, have no need of me.

"L'Art," in *Littérature*, no. 13 (Paris, May 1920), pp. 5–6.

[UNTITLED]

Dear revolutionaries your ideas are as limited as those of a petit bourgeois from Besançon.

Cannibale, no. 2 (Paris, 25 May 1920), p. 3.

With his typical brand of generosity, Picabia offered the following readymade poem to the uninitiated. As he explained above in "Art": "those who don't understand will never understand."

POETRY FOR THOSE WHO DON'T UNDERSTAND

FRIED CALF'S FEET, small entrée. Cook them *au naturel* (see page 201), bone them, and cut them into pieces; soak them in batter or coat them with breadcrumbs, and fry them (see Fried calf's head).

FRANCIS PICABIA THE ALCOHOLIC

"Poésie pour ceux qui ne comprennent pas," in *Cannibale*, no. 2 (Paris, 25 May 1920), p. 6.

"I Am Javanese" is one of Picabia's better-known poems; it was also published in Richard Huelsenbeck's *DADA Almanac*, and read at the Dada Festival at the Salle Gaveau (26 May 1920).

I AM JAVANESE

Whipped cream . . . what a taste . . .
Let's talk about serious things of the civilized world
That kind of poetry is made for Don Quixotes
I kiss all of you on your beautiful eyes dear lady readers
You cannot deny existence
Beyond-nature doesn't exist
We're going to chat
Where are you living?
My true feelings and an accurate printing house
A superb book condenses my faculties
Nonsense, isn't it?
Everything is nonsense—in America everything is DADA[1]
As for me I am Francis Picabia
That's my failing
The love of art is the greatest love of all
As I don't want my servants when I'm eating
All that isn't funny
I look at myself in a mirror
I have the air of a plant offered to Saint Anthony
That's what's important
Because I dress as a woman in order to dance
Some philosophical remarks
Steaks with brandy beer Egyptian chancres
A third of the world
Is a tattoo on some nanny goat's dung
Immense boredom is a pair of underwear
For elephants
Who walk bare-footed around the sun
Imagine that Negresses
Have mud-soaked asses
And breasts shaped like tongs
Their tinplate genitals are a nacelle
The birth of buttocks and that of Jesus is a balloon
If I had eleven cents I would go to the brothel
I keep a tight rein
And flit about sporadically

"Je suis des Javanais," in *Cannibale*, no. 2 (Paris, 25 May 1920), p. 7.

"Presbyopic–Festival–Manifesto" was performed at the Festival at the Salle Gaveau by Breton and Henri Houry (an actor and director). Picabia's "sodomist music,"

The American Nanny, was also performed at this festival by Marguerite Buffet (a piece consisting of three notes repeated monotonously on the piano).

PRESBYOPIC-FESTIVAL-MANIFESTO

The Speaker.—At my last cannibal manifesto, did I tell you that a piece of ass, a piece of ass represents life like French fries and is sold the way honor is? Well, tonight it's giving itself away for free: see how full this little theater is?

The Audience Member.—So, you're going to start again, with your coarse language and obscenities? Instead of expressing yourself in French!

The Speaker.—Obscenity only exists in your pathetic imagination: nothing is obscene. Is life an obscenity? Is making children an obscenity?

The Audience Member.—Life is what's beautiful.

The Speaker.—Ah yes! A beautiful marriage or a beautiful dowry, which is the same thing, or a beautiful victory achieved through shots from decaying carcasses.

The Audience Member.—It's impossible for us to see eye to eye, you reduce everything to materiality.

The Speaker.—I know what you like: official glory! Do you want me to tell you what you dislike most about DADA? It's that it doesn't like sales talk or hot air; you sense that it couldn't care less about you.

The Audience Member.—And why couldn't it care less about me?

The Speaker.—Because you're serious, and therefore an idiot.

The Audience Member.—I don't really see . . .

The Speaker.—This artist or bourgeois is nothing but a gigantic unconscious, he takes his timidity for honesty! Your charities and your admiration, my dear sir, are more despicable than all the syphilis or gonorrhea you distribute among your fellow men, under the pretext of sexual disposition or love.

The Audience Member.—It's impossible for me to continue compromising myself with an individual such as yourself, and I invite all of you, my fellow audience members, to leave this room with me; we cannot remain in contact with this character.

The Speaker.—Naturally, you're afraid that the wind is lifting your skirt and that we're seeing your genitals, which are fake; your hair is also fake, your teeth are fake; you have a glass eye and it's the only one

looking straight into mine, the other one's a chameleon from
Asnières, at 20,000 francs per carat, for idiots.

The Audience Member.—Sir, first off, I'm leaving, and second, I'm not
wearing a skirt, I'm a man!

The Speaker.—Oh, pants or skirt, it's the same thing, only the genitals
change, but with you and your kind they can't change since
they're fake!

The Audience Member.—But nothing's fake, or at least that's one of the
theories you've put forward.

The Speaker.—You're right, nothing's fake.

The Audience Member.—It seems to me that imitation . . .

The Speaker.—Imitation is real, a celluloid garden is real, a rock-crystal
parrot is real, an electroplated ware sheep is real.

The Audience Member.—You're not going to tell me that DADA is real?

The Speaker.—It's DADA that's telling you so: DADA is everything, it
understands everything, it is all religions, it can be neither victory
nor defeat, it lives in space and not in time.—But excuse me Mr.
Audience Member, of what nationality do you claim to be?

The Audience Member.—I am French from Paris.[1]

The Speaker.—From Paris.

The Audience Member.—Yes, from Paris.

The Speaker.—It's true, there are French from Marseilles, from Bordeaux,
from Besançon, from Paris; you're like certain inhabitants of the
Earth, who think they're Russian, American, German, or English; it's
true, it's true, you like traveling diligently.

The Audience Member.—You wretch [he fires a gun at the speaker].

"Festival–manifeste–presbyte," in *Cannibale,* no. 2 (Paris, 25 May 1920), pp. 17–18.

MAY DAY

For me holidays are always
cheerier the day after.
F. P.

No poetry, no literature, no antiliterature, write something for *Littérature* . . .
May Day, well-known Sunday atmosphere, with the hope for
revolution (very difficult to know at what point a revolution begins and
when it ends).

A charming lady comes over, wants me to visit an apparently delightful little hotel just a short distance from my place; there's no way I can refuse. My impression: the furniture and the other art objects look as if they have been sold and repurchased several hundred times; they seem to have acquired their value through traveling in moving vans.

Women don't understand the body's action. Oh, well, yes! perhaps you're right, you see; beautiful, soft, I'm nothing, I love lines . . .

Two floors to climb to find a pleasant room facing the South of France; from there I notice a vegetable garden, in the middle of which convent nuns are playing hide and seek! That makes me believe in May Day and I feel like joining the sisters, being a revolutionary. Back home, I tell Tristan Tzara the emotions of my stroll, and he too wants to play hide and seek . . .

But let us talk of serious matters: the conscience of Sardanapalus and that of Christ, who was a man of taste, made them prefer a coffin speckled with stars to the tears they were able to shed. But no! Jealousy, here's winter, the falling snow, the drama booed by a pitiless blackbird.

Verlaine gilded his genitals, he had syphilis, cirrhosis of the liver, rheumatism and genius.

Ribemont-Dessaignes is secretary to both Marthe Chenal[1] and the "Dada movement," which are the same thing.

I would really like to know what a poet is; I think I'm one because my vesicatory brain opens up to make a painting, beautiful patient things. Beautiful things, small operation, slight infection in the mirror, grotesque impressions: what taste the final drop has!

O annoyed altitude in the yellow and blue entrails of yawns.

Baudelaire had a suit made of billiard cloth. Lord Byron, leaving the Venice Opera in evening dress, swam back to his hotel.

Marthe Chenal gives as much a damn about the "Marseillaise" as she does the Dada movement—and how right she is!

You can see the countryside and the sea from my window; what a sickness this leprosy is: to love the boredom of the beautiful view that reflects the sadness of today. I do not share your opinion, all the plays currently up in Paris are absolutely idiotic.

At the end of May, there will be elephants in Paris as there are pipes, and also sublime monkeys.

Henry Bataille's painting is as stupid as his writing.[2]

Oscar Wilde used to walk about New York, along Fifth Avenue, in short trousers and socks!

I would like to smoke hummingbird tobacco.[3] No thank you! I never drink tea. Don't you think that Cocteau's modernism is like an invisible mending?

To play piano on the footbridge; humidity is odd, but we're chatting like mummy-boys. It's fond of boredom, of the dearth of news and of the doctor with the white ties. The bottom of the water looked fake, the diver shouted from the bottom of the water and his voice was fake. The madrepore shells give indigestion like broth on the eyes. I lift my head, men and women are fountains at the Palais Royal, repeated holders of diplomas.

André Gide, that empty fish tank, doesn't like Jews,[4] as if there were still Jews! What naivete, dear Sir.

Stupidity, like a ceiling of orange blossom, except in a barracks full of flowers in bas-relief silence, grows in the month of May. The rows of greenery about the trees, phenomenal landscape straps of clouds, descend into my chest like a drawing.

The crow of the cock frisking about in silver boots will make us dance in a lantern for a relatively long time. Erase! Nothing more to do, nothing more to see, newspapers are musty small decanters.

It's a dog's life, and he's always sad, running in circles around us. My eyes are moist, all along the road my blood is helpless against disdainful winks; take your lorgnette and contemplate the movement of a horse, it is really a public consideration.

The first of May is going to end in rain, just like last year.

"Le Premier mai," in *Littérature*, no. 14 (Paris, June 1920), pp. 26–28.

Jesus *Christ Rastaquouère* is Picabia's most accomplished literary work. Although the book finally saw publication through the aid of Breton, Breton declined to write the preface for it. Picabia thereupon broke off relations with him (relations that would later be renewed, albeit tenuously).

Upon its publication, Ezra Pound provided one of his typical plugs:

Francis Picabia . . . after a series of unequal works and the notable poems in Pensées sans langage, *has published the very vigorous* Jesus-Christ Rastaquouère, *which the publisher is afraid to put on sale openly in case he loses thereby his Russian clientele, though in fact the book contains nothing salacious or even, apart from the title, particularly blasphemous. The case is, simply, that Picabia has a pair of remarkably strong intellectual lungs that enable him to breathe and exist in the deserted heights of negation, those regions where the leading English writers and the French literary cliques suffer from vertigo or nose-bleeds.* (Quoted in Borràs, *Picabia*, p. 205)

There is no easy translation for the somewhat pejorative *rastaquouère;* a "flashy foreigner" is the best the dictionaries have to offer. Mark Polizzotti, in his translation of André Breton's *Anthology of Black Humor,* uses "carpetbagger," but Raphael Rubinstein and I have opted to leave the term as it is, especially as *Webster's* third edition includes it as such: "A foreigner whose claims to rank or wealth are under suspicion." Picabia had been going by the definition in the *Petit Larousse:* "A stranger living in grand style whose means of existence are not known." "Is this not precisely the case with God?" he declared (quoted in Massot, *Francis Picabia*, p. 27).

The word had already undergone some previous Dadaist usage, however. Walter Serner used it repeatedly in his *Last Loosening Manifesto:* "You see EVERYTHING is *rastaquouèresque,* my dear friends" (*Blago Bung Blago Bung Bosso Fataka!*, p. 155). The consummate moon-poet, Jules Laforgue, Duchamp's preferred poet (and admired by Buffet as well) referred to the sun as a rastaquouère.

Although this book has come to be considered one of the credos of the Parisian Dada movement, its opening "interlude" already demonstrates a distancing between Picabia and the Dadaists. Since the best-known translation of "Dada" is "hobbyhorse," Picabia's aversion to riding in this opening narration (as well as to his fellow travelers on horseback), his wooden horse (a more authentic "Dada" than its living counterpart), his subsequent imprisonment, and the presence of a cavalry leader who could conceivably stand in for either Breton or Tzara—all betray what would become Picabia's stance the following year: an opposition not to Dada, but to what the Dada movement had become. One of his only direct references to Dada in this book is his presentation of the Dadaists as "unclean animals" wanting to be baptized: an insult, even if taken ironically.

On a side note, this happened to be Serge Gainsbourg's favorite book (and Picabia his favorite poet). He owned one of the few copies of the original edition and referenced it in more than one interview.

JESUS CHRIST
RASTAQUOUÈRE

Translated by Raphael Rubinstein

I dedicate this book

to young girls everywhere.

FRANCIS PICABIA

Modesty hides

behind our sex.

F. P.

I knew a king struck by

dementia praecox whose madness

consisted of thinking he was king.

F. P.

**ONE MINUTE
INTERLUDE**

I took a trip on the most beautiful ship ever built; the strange thing was that the passengers and crew on this ocean liner were on horseback!

The captain, a highly skilled cavalryman, was on a thoroughbred racer, wore a hunting outfit, and sounded a horn to direct the maneuvers, whereas I, detesting riding, spent my days on the wooden horse in the gymnasium. We disembarked at a new land where horses were unknown; the natives took our ship's mounted passengers for two-headed animals and didn't dare approach, consumed with terror; only I, recognized as a fellow human being by these primitive people, was taken prisoner. It was in the prison where I was locked up that I wrote the lines that follow. This prison was an island completely deserted by day, but at night the inhabitants of a large continental city, in which marriage and free unions were both forbidden, arranged to meet there to make love. For this reason I was able to bring back from my exile the most splendid collection of women's combs in the world, from the saddest celluloid to the most transparent tortoise shell, covered in precious stones. I gave this collection to one of my uncles, a distinguished conchologist, and he displays them alongside a cabinet of Indian seashells in his house.

Chapter I

I am not talking about the cat, I am not talking about ears, I am not talking about corn, I am not talking about the sheep, I am not talking about women, I am not talking about men. I am not a painter, I am not a literary man, I am not a musician, I am not a professional, I am not an amateur.

The problem is, in this reject world all we have are specialists. Specialties separate a man from all other men.

Lyrical poets, dramatic poets, you worship art to escape from literature, and you are nothing but literary hacks. Straggling painters, the regions you explore are old anecdotes. Musicians, you are pebbles skipping on water . . .

> *A man these days*
> *Is a kind of mirror.*
> *When the curtain rises,*
> *The audience member's seat*
> *Is completely free;*
> *He has no faith*
> *And you impose prejudices on him,*
> *How can one have hope?*

Jealousy, love, hate, ambition: the audience member plays these ever-changing and solemn parts.

God, who rules over the problematic plot, is as improbable as providence or fate.

> *Extraordinary bliss,*
> *Necessarily impossible,*
> *In the sparse foliage*
> *Rainbow butterflies.*

Good vegetables, the strawberry plant, the heliotrope, etc. These are the excesses of love and the nothingness of Jesus Christ Rastaquouère.

LET US GO INTO THE
DESERT OF GOOD TASTE

Taste, something good, good wines, speeches, success, the incredibly grotesque spectacle of enthusiasm for one's nationality, for honor—*I only give my word of honor in order to lie*—are for me so many feelings of disgust, accompanied by nausea. A suckling pig is more sympathetic to me than a member of the Institute, and I feel a bitterness in my stomach when I gaze at the turkeys, peacocks, and geese that make up the upper crust of society. A real sense of duty, boiled by good education! There are people who live in its perpetual indigestion and that makes their breath stink since it can only be digested by some of the domestic corpses, in bronze or marble, from our public squares: Jesus Christ Stradivarius, Napoleon the pain in the ass, Spinoza the soporific, Nietzsche the onanist, Lautréamont the sodomite. Politics ends up dissecting lightness.—Hot air balloon of your so-called intellects, your brains are just so many little bells for camels and crocodiles, the sound of your sentences hangs from you like those bells cattle wear around their necks and which ring when they come down from the mountain of suggestions.

Superwomen, supermen, subwomen, submen, your hair will grow white and your thoughts will remain obscure.

The thoughts of the heart, the thoughts of the soul, the thoughts of the mind are just so many automatic chemical reactions; the current that drives them comes from you, from the sun, or from the Great Bear; the Great Bear recites, the sun recites, and we recite our digestions and indigestions. Your thoughts, dear lady readers, be they antireason or antitruth, are just so many conventions about an absolute, which is also nothing but a convention.

The sun is setting upon us and we carry it around so we can grow strong. Big mistake! Carpentier is no stronger than a two-year-old child,[1] space and time have the same duration, a woman—fat, thin, old, or young—they're all the same. You seek imaginary landings in the continual movement of resting places—what madness!

THE SUN HIDES
THE HORIZON

After long trips through America, China, France, and Germany, one returns even wearier of the game of moving around.

There are lakes and islands, which come to exactly the same thing.
Symphony that projects a brown color onto our stomachs:

"If you only knew how much I love you, what a beautiful romance we could have!" And they turn on the lamp to hide their nakedness, their nakedness trembling under the moonlight. There are hundreds of millions of these individuals, and their personality, whatever the language or costume, exists only to do the same thing.

Don't work, don't love, don't read, think of me; I have found the new laughter that grants you freedom. Live for your pleasure. There is nothing to understand, nothing, nothing, nothing but the value that you yourself will give to everything.[2]

One of my friends,[3] an agile and impassioned spirit, was telling me to seek out the differences between literary, visual, and musical works of art. I didn't agree with him and we had a long discussion on the subject; our delirium lasted almost an hour, until our brains, turned more or less into pulp, allowed us to note the emptiness of all physical and metaphysical theories!

In the course of the discussion another one of my friends intervened and his lucidity was suddenly obscured by the fact that he saw the outer light that he was projecting onto himself: the word light doesn't exist, but light exists, is it vibration or humidity? etc., etc.

"There are people who stand on their heads, like plants, and who look with their feet!": such was the conclusion of our conversation on the intellect and for a few minutes we had the impression of escaping from the madness of men who understand and explain

IN A GREAT
SILENCE

You tremble before Christ, you are all very good Jesuits.

EVERYTHING IS POISON
EXCEPT OUR HABITS

One should take communion with chewing-gum, that way God will strengthen your jaws.[4] Chew it a long time, without any ulterior motive;

since it likes your mouth, may it know what it's good for! Your warm tongues are not to be scorned, even for a God.

Think of those ridiculous illusions you all try to give each other; the corsets you wear are mousetraps. You are all pieces of ice and you want me to believe that this ice burns and consumes itself like the sun. All your heart does is melt, and all that the warm liquid coming from it is good for is to make that body float—that tiny, cold, dirty body you call the soul. Reality tosses your dreams onto the dunghill? You must straddle this dunghill and plunge straight into what I call Rastaquouère infamy.

I IMAGINE THIS:

Jesus Christ Jockey!

Yes, he becomes a curiosity for the mob, he sets off at a run, everyone bets on him. Result for those betting: zero.[5]

**ALL BELIEFS
ARE BALD IDEAS**[6]

Evil for evil's sake, the cerebral lobes of Joan of Arc, those of Marshal de Rais,[7] on the field azure or the gray matter, the Maid and the maidens, and finally the monks of madness: don't you think we need to leave all of that on some street corner? I much prefer the mystification of Jesus Christ Rastaquouère.

> *Then what,*
> *Train train for dying,*
> *It's all the same;*
> *Waves of thoughts*
> *On a word.*

FREAKS

Intelligence is official; institute, you want freaks: bearded ladies of painting, or little cyclops of literature. All artists are hunchbacked; music-box

humps, receptive to the rhythms of life-castanets. Barnum's freaks are unwitting, international Bolsheviks who are monstrously picturesque; they make us dream of evolution coming to a halt, of the hypertrophy of thought, provided more pleasantly by morphine or opium. All individual freaks want to be "opium" or "morphine," others, more practical, sell their charlatan-signature, like the ass-hairs of Mohammed or a piece of Jesus' cross, signed at the suggestion of snobs.

PHOTOGRAPHY AND GYMNASTIC RELIGIONS

Whew! I'm kissing you, dear lady reader, along your neck, we're in the sun, you have a sapphire on your finger, which you only think of giving to me, your right hand is scratching my back and my doctor told me that I was in magnificent health you can't ask more out of life; it was certainly Pasteur who in curing you of rabies restored you to life, but it remains to be seen which of the two is preferable? Pasteur was intelligent, I am nothing, freaks don't amuse me; Madame, I beg you, scratch me some more, keep scratching my back.

A QUESTION OF INVISIBLE CONTACTS

Infectious contacts, disinfectant contacts, society exists in part through invisible transmissions.

Love is an infectious contact that works by casting spells, it wants to first kill the loved one's entourage, then, very gently, the cherished ones themselves.

> *Black mass*
> *Lust*
> *To kiss the rump*
> *Demonism*
> *Etc., etc., etc. . . .*

Phalluses are exoteric in bed, and more often than not, esoteric in the street. If we don't poke our sisters, our mother, our friends, cute animals, it's because of our education, which finds a more convenient and healthier specialty: love with a lawful wife for the West, whereas the Orientals give us the spectacle of a farmyard whose cock is less evolved.

INTELLECTUALS
IN LOVE

It's exactly the same as with other individuals, what seems to transform it is that the two lovers act as voyeurs and arrive at the worst suggestions.

The superwoman represents the Institute.

The subwoman Dadaism.

As for men, they all want to become members of the cabinet. Lots of men sport the memory of their wife's love affairs in their buttonhole.

Church bells, the sound of waves, the still calm of the sea, moonlight, sunsets, storms, are all so much shampooing for the blind penis; our phallus should have eyes, with their help we could believe for a moment that we have seen love up close.

Platonic love doesn't exist.

Love is a closed shutter, painted dark gray!

Love is an opportunity passing by!

Love is a damp dwelling!

Love is a well on a cathedral!

Love is a tremendous fire! etc., etc.

Love is the logo of children manufacturers.

Love crushes you . . .

Love can be admiration or pity!

Love is often an economic commodity.

Love hypertrophies under the effect of cocaine, love is therefore a purely chemical reaction and expresses itself through contact with invisible currents, like the reflexes of a dead frog.[8]

SHIVERS
OF AN EMPTY HEAD

If you look inside yourself, all you'll be able to see is a library suffocating you; if you keep at it, you'll bring about the arrest of your faculties; keep at it some more and there'll be panic and delirium. Life is not your representation, but a representation; one finds the means of renewal, of sustenance, outside of oneself; well, it's the same thing as eating a steak.

> *From the heart of Jesus*
> *The sanctuary skiff*
> *Appears to me*
> *On a cross*
> *Of sorrel*
> *Singing the banal*
> *Ragtime*
> *Of money plants.*[9]

THE ROPES
OF MODESTY

Mineral symbolists, the ruby cabochon can pacify prudence, so keep your hats on. Impressionists, you must take out your watch. Cubists of Notre Dame's gutters, smoke fewer pipes and more cigarettes.

Dadaists, unclean animals, men shall baptize you, have no fear.

The Futurists are Italian—it seems that a honeymoon in Venice is marvelous!

> *The houses of Venice don't stand straight*
> *Lots of them are a mess*
> *And get our legs dirty*
> *One should change rooms*
> *The way one changes linen.*
> *The house windows*
> *Are so many anuses,*
> *But poetry is everywhere*
> *Don't you think?*
> *As for retaining the sorrow*

Of your rantings,
Suspended horizontal map,
I see nothing.

Old houses can no longer teach you anything, they are like old men who ramble on about youth.

**COMICS
AND HUMORISTS**

The psychologist nourishes himself exclusively on the conscience; personally, all I want is an unconscious that cannot be acclimatized.

Humorists are the comic's artificial flowers, they yield to the audience. Clowns are humorists.

Humorists are the worst kind of idiots, they can only amuse you, dear lady readers, if you're willing to wear a chastity belt.

THE COMIC

Bullfights make me want to laugh.

War makes me want to laugh.

The plays of Hauptmann and Ibsen make me want to laugh.

Capital punishment makes me want to laugh.

A reception at the Academy makes me want to laugh.

A king makes me want to laugh.

Jesus Christ Rastaquouère makes me want to laugh!

The cock, like Othello,
Resembles Macbeth,
Around the Olive trees.

KNOWN AND UNKNOWN

The unknown does not exist. Providence is known, it is not an enigma. There is only heredity.

The village sleeps,
Thoughts
Like animals,
Hide.

PALLORS

Disinterested souls live at the expense of others, celebrating the stupidity of work and the exquisite pleasure of revolutions, and all that without laughing, but cooing instead!

HOW OLD ARE YOU?

Under the linen, in a bedroom, today, right now, I'm making love with open hands.

Big daisies,
Like so many suns,
Enter my brain
Bristling with brambles.

Happiness sniffs at our shadow's debris. Life should be like a bath for stretching out its limbs; but the carpets of green grass blush under the flame of caresses, like young girls who show their hair. Toads leap into your mouth and little yellow flames enter through your ears. Soak your hands in silver and gold scented with balsamic plants, and arm in arm, heart between your legs, come find me on the horizon.

Chapter II

MY SMILE

"All the plants belong to me, that's why I don't like the country!"

It's a kind of bird, quite rare and hard to get to know, because it never settles anywhere; the female lays its eggs very high in the air and the babies are hatched before they've had time to reach the ground; they fly constantly, unaware of rest, and the flapping of their wings is like the beating of our hearts: to stop means dying. These birds exist everywhere, it seems they have always existed, but where do they come from, from what planet? The knowledge of their origins preoccupies many minds . . .[10]

And that brings to mind a curious story that I heard from a painter, half Norman, half Auvergnat, neo-cubist and neo–Don Juan:[11] the story of a man who chewed a revolver![12] This man was already old and had indulged in this strange mastication since birth; his extraordinary gun would have actually killed him if he had stopped for even an instant; yet he had been warned that in any case, the revolver would one day irrevocably go off and kill him; yet he continued to chew, without tiring . . .

**MAN'S MOST
BEAUTIFUL DISCOVERY
IS BAKING SODA**

All of creation's creatures are useless, their loves are like snow melting in spring.

Rainy days are like vacations.

I surpass amateurs, I am the super-amateur; professionals are shit-pumps.[13]

All the painters who appear in our museums are failures at painting; the only people ever talked about are failures; the world is divided into two categories of people: failures and those unknown.

> *Jesus Christ–Stradavarius*
> *was a failure,*
> *Buddha–crab*
> *was a failure,*
> *Mohammed–hairdresser*
> *was a failure.*

NO ONE IS UNKNOWN
EXCEPT FOR ME

The orangutans sing, they sing sugarsticks,[14] which other cabaret singers come to suck for ten francs.

> *It seems that we have to work,*
> *It's a debt*
> *A debt to stupid creatures,*
> *Evolution of white fish,*
> *Human aspirations,*
> *Peasant mouths,*
> *Wrinkling skin.*
> *One kilometer*
> *Or one hundred kilometers,*
> *There are no kilometers.*

Words are what exist, that which does not have a name does not exist. The word light exists, light itself does not.

WE ARE IN
A DIGESTIVE TRACT

And this digestive tract is getting bigger and bigger, it embodies space, whereas ours is only a shooting star, perceived by this space for one fleeting instant.

HUMAN JUSTICE
IS MORE CRIMINAL
THAN CRIME

Life's everlasting sleep is sitting on your bed, it is good and pleasant
company, its body is thinner than the air blowing in the same spot, on the
face of human majesty; isn't it true, dear philosopher, meditator, or
conjurer of dirty clouds, that when you fly away with these clouds, all that
remains is the buffoonery of fresh water? You alone are exempted from
the laws of gravity; so tell me, dear philosopher, whether your weight really
isn't like the razor of phosphorescent waves and whether Red socialism
is anything other than the crane in the mouth of the octopus, whose
phonograph-tentacles play the *very mustardy mercy* for you.

 Men's mouths are unconscious sex organs; the noise that comes out
of your foreheads reimmerses itself without a sound into the immobility-
circumference.

> *When someone speaks,*
> *I am ashamed*
> *For his lower jaw;*
> *The inside of his mouth*
> *Is a black sky.*
> *I can't love you,*
> *I detest myself.*

Girlfriend, you shine in the moonbeams.
 Girlfriend, I would like to be buried in an enormous lightning rod.
 Girlfriend, my friendship is indissoluble in school tra-la-la-tra-la-la.

Chapter III

THE COLD EYE

After we die, we should be placed in a ball, a multicolored wooden ball. It would then be rolled to the cemetery with us inside and the assistant undertakers assigned to the task would wear transparent gloves to help lovers recall the memory of caresses.

For those who would like to enrich their furnishings with the objective pleasure of the loved one, there would be crystal balls through which one could see the permanent nudity of one's grandfather or twin brother!

Trail of intelligence, steeplechase lamp; to the unblinking eye, humans resemble crows taking wing over corpses—and all the redskins are stationmasters![15]

SPINAL
EAU DE COLUMN[16]

Look, look at the gray matter boiling on the athletes; let me give myself an eau-de-Cologne rubdown all over, an eau-de-Cologne rubdown under the stars.

It's not feminine luxury that attracts the male, but masculine imbecility that estranges woman. The male sex always imagines himself as a hero or a seductive character because of the social standing he thinks he holds. Women prefer people like themselves—and how right they are to do so!

The prospect is so beautiful, isn't it dear Lady? A big stomach, a little bawling animal, the egoism of a cancer wearing you out! Then, when despite everything, you've become attached to this cancer, the good homeland takes it from you so that you can have the pleasure of thinking that after you die your very dear country will be able to tyrannize its neighbors a little more! . . .

In the name of the great, virile, fertile, and innovative future of the world, I sentence the idiocy that drives men to a supersaturation of their

equals, solely with the preservation of their masculine capitalism in mind. But my mind is quite at ease, the world is too stupid to end so soon.

Do you now represent a completely different universe, above the white clouds, rosary beads of the Eucharist?

Oblates, how are you? This is to heal your heart:

THE BLESSED VIRGIN
DANCES THE TANGO
WITH THE GREAT PIMP

I like this song very much; the Blessed Virgin is in fact the true proprietress of prostitutes . . . The Blessed Virgin is made of glass, the light passing through her leaves not a trace; Joseph is a little midday sun.

As you read these lines, won't you please suck the juice of a cherry.[17]

WE LIVE
IN A MUSSEL

> *The trouble of usage,*
> *The remorse that tears self-esteem apart,*
> *What pretension!*
> *"That's mine,"*
> *"That's not mine."*
> *It's enough to make you turn away! . . .*

"You're leaving already? Yes"—"You are very nice"—"Goodbye" "How did you manage to get here?"—"I got your letter from Zadig"—"You look like your photograph, dear Sir" "Goodbye" . . .

Chapter IV

PONS ASINORIUM

You always seek out the emotion you've already experienced, the same way you like recognizing an old pair of pants coming back from the dry cleaners, which seem new if you don't look at them too closely. Don't be fooled: artists are dry cleaners. True modern works are not made by artists, they are simply made by men.

"The public's mistake is to regard modern works as rebuses whose key they are supposed to discover.

"There is no rebus, there is no key. The work exists, its only reason for being is to exist. It depicts nothing but the desire of the brain that conceived it. Nature's inventions charm us without there being a question of reasoning or reasons for being.

"The artistic pleasure that modern works of art are able to give us is of the same order. We must look at them the way we would look at a tree, a flower, a landscape. Anything there is to understand is legible to everyone. The spectator feels an incredible letdown when he realizes how simple the process of understanding is. He's ready to find himself the victim of a practical joke, etc."

These lines were written by Gabrielle Buffet,[18] I am happy to quote them, the author clearly portrays the weakness of human judgment! This morning a young genius asked to do my portrait, a portrait that is supposed to appear in a book on modern artists. "Resemblance doesn't interest me" he declared. Maybe not him, but what about the public?

It seems to me that there are cases in which photography would be the best thing!

I want to make an "artistic" automobile in rosewood, mixed with Pink pills.[19] The tires would be steel and the bearings rubber; as FUTURISM it wouldn't be so bad! After all, at a certain point there's no reason why Rolls-Royces shouldn't be made like that.

Dear artists, screw off, you are a band of priests who still want to make us believe in God.

**GOD WAS JEWISH
HE WAS CONNED
BY THE CATHOLICS**

To dupe = Guillaume Apollinaire.

I much prefer Arthur Cravan[20] who toured the world during the war, perpetually obliged to change nationality in order to escape from human stupidity. Arthur Cravan disguised himself as a soldier in order to not be a soldier; he did as all our friends do who disguise themselves as honest men in order to not be honest men.

**AS FOR ME, I DISGUISE MYSELF
AS A MAN
IN ORDER TO BE NOTHING**

> *You give wise advice
> And ask peculiar questions;
> But why do you choose
> The past to judge nothingness
> Sound asleep?*

There are a thousand ways to pass the time and there is no way to pass the time.

What's the use of dying, what's the use of living?

Here we are in the infinite, which moves to become a meter of cloth at 99 francs 95.

And this meter of cloth is happiness, it reassures us, it makes us believe more and more that we are part of the universe. There is no acquired strength, there is only a single movement. Chemistry is only movement and movement exists only through our convention.

THERE ARE FAR FEWER THINGS ON EARTH THAN OUR PHILOSOPHY WOULD HAVE US BELIEVE

Nowadays it's a matter of the ever posthumous.

> *A deceased friend*
> *Takes the place of chance.*

SPINOZA IS THE ONLY ONE WHO HASN'T READ SPINOZA

But I am a child who learns to stand up straight, Bossuet[21] is a sad poet, priests make death unpleasant.—Let's chase the terrors away.

FIVE-MINUTE INTERLUDE

I had a Swiss friend, named Jacques Dingue,[22] who lived in Peru at an altitude of 4,000 meters; he had gone off to explore those regions several years ago, and had succumbed to the charm of a strange Indian woman there who drove him completely crazy by refusing to give herself to him. He grew weaker and weaker and soon could not even leave the cabin in which he was living. He was under the care of a Peruvian doctor who had accompanied him there, and who considered the dementia to be incurable.

One night a flu epidemic attacked the little tribe of Indians who were hospitalizing Jacques Dingue; they were all, without exception, infected and out of all two hundred of them, one hundred and seventy eight died in a matter of days; the terror-stricken Peruvian doctor very quickly returned to Lima My friend was also struck by the terrible malady and immobilized by fever.

Now, all the dead Indians owned one or more dogs, which soon had no other means of survival than by eating their masters; they tore the corpses to pieces, and one of them brought the head of Dingue's beloved Indian girl into his hut . . . He recognized her instantly and must have experienced an incredible shock, for he was suddenly cured of his madness and his fever; as his strength returned, he took the woman's head from

the dog's mouth and amused himself by throwing it to the other end of the room and calling to the animal to fetch it; three times the game was played with the dog bringing the head back by its nose, but the third time Jacques Dingue threw it harder and it burst against the wall; to the ballplayer's great joy, he was able to note that the brains that had spurted out showed only a single convolution and could be mistaken for a pair of buttocks! . . .

The interlude is finished, dear ladies, we continue with

Chapter V

THE SUMMIT OF THE LIMITLESS

Extraordinary, fantastic, amazing, outrageous, insane, crazy! . . . and no one mentions it anymore!

So everything must come to an end. Everything's finished in my opinion; if there was a performance, it's over, but you seek happiness, or at least the absence of moral and physical pain, don't you? Well, a few steps from there, you have the pond of the infinite, which gives you capillary refutation in a bag of chestnuts; buy it for five cents and you will see the sun move faster in space, you will live for hundreds of years; buy it for ten cents of chestnuts and the universe will whirl with dizzying speed, your fellow men will move so swiftly that you won't see them and the sun will seem like a bicycle racer going around a track.

But I'll stop there so that you won't call me insane, although individual insanity is a pretty rare thing! . . .

Thinkers want to prove everything, but I'm telling you: there is nothing.

One must adapt.

You all sacrifice yourselves, dear ladies, so as to keep a good reputation, but it's a sham, your ideals are false. So accept any destiny, you'll never be anything but imbeciles, transformed into intellectuals!

But there you are,
The doors close;
You didn't have
Permission.

BRAINWASHING
IS ALWAYS MORAL

Only brainwashing parents is immoral.

Go for a stroll, guardians of art school education and capitalist procedures; whether you intend to or not, you want to make life a cemetery for the newborn, you want people to be enslaved by your bad examples: it's all just the desire for property.

Fathers and mothers do not have the right to kill their children, but the Fatherland, our second mother, can sacrifice them as it pleases for the greater glory of politicians.

POLITICIANS
GROW
ON THE HUMAN DUNGHILL

No, I prefer to think of Ribemont-Dessaignes who wrote these lines:

"According to St. Jean Clysopompe

"What does it come down to in the end? You can't stick your head out without breathing in a pancake batter that solidifies on your face and suffocates you. These things are men? These creatures as soft as crabs when they're changing their skins?"[23]

or of Tristan Tzara TOTO-VACA poet
"i
"Ka tangi té Kivi
"Ki vi
"Ka Tangi té moho
"hi hi e
"ha ha e
"pi pi e
"ta ta e
"ta kou ta ka jou"[24]
or even yet "The Liquid Hanged Men"—Snakes no longer wear gloves, my dear Tzara![25]

You just left for Romania, you're going to pass through Switzerland, Italy, Pontoise—everything is Pontoise, everything is Paris, everything is me, everything is you, everything is nothing, even without suffering.

The priest's voice
Stretches out like a lawn
Of weeds,
Bordered by acids;
For a long, long time.
I know the consequences.

WHO IS WITH ME
IS AGAINST ME

Jesus said the opposite, only because he was a rastaquouère.
 Only the Jews are really energetic.

Chapter VI

THE REASSURING ASPECT

You're happy? Imagine that there is no tomorrow, life is today and today
doesn't exist.

"OH! THE SWEETNESS
OF LOVE
JUST BEGINNING . . ."

Love doesn't begin. Say instead that it's over as soon as you meet the man
with the pretty eyes, the man whose brain reflects the sky a little, my dear!
Or else the moon, or half moon, as you wish.

Alfred de Musset and Fanny, side by side, go for a stroll, greeted by
the countrymen . . .

Ah! So hide when you eat, but make love among the trees in the
winter, and in the summer, after a swim, at the seashore.

A man who is close friends with a married couple always becomes
the wife's lover, just as a woman who is close friends with a married couple
always becomes the husband's mistress. I see no explanation for this; it's
more funny than sad to think that novelty has a value that equals *value*, and
that's why there is no difference between a dentist and a painter.

The greatest pleasure is to cheat, cheat, cheat, always cheat. So
cheat, but don't hide it! Cheat to lose, never to win, because he who wins
loses himself.

Don't put a marble in a horse's ear, but a nightingale: the nightingale
will win the race and the horse will cash in the bet that he would have
placed on you.

Knowledge and morality are nothing but fly paper. My advice to flies is
that they live in confessionals, sins being much more agreeable nourishment
than caca.

The male is close to the woman
Stealthily he aims
And discovers her legs in their entirety,
He seeks the virgin corner.

That's good French mirth, the mirth of the Gallic Rooster.

In fear
Of electric lights,
Of waltzes,
Lace waltzes
Of monkeys,
Even more monotonous
But much more.

NEW HORIZONS

Paintings are made for dentists.[26]

So what! Let's get on with it! The overheated fumes of obstacles are just inexhaustible dramas; there are no obstacles, the only obstacle is the goal, so stride ahead without a goal. Analyze the blood of a hero and that of a coward and you'll see that they are exactly the same, your objectivity makes you prefer the hero only because you are snobs, the courage to be a coward is in my opinion infinitely more sympathetic; the art I love is the art of cowards. Cormons, Bernards,[27] those generals of painting, were made in order to paint Joffre, Mangin, or Lyautey.[28] As for Lyautey, who just made his victorious entry into the Académie Française, I quote this very beautiful period extract from his inaugural speech:

"I have said that one figure dominated this entire part of de Houssaye's[29] work, that of the Emperor.

"There is also one other: the soldier.

"Among all those he brought alive, there are none whom he gave a greater sense of real and intense life than Napoleon's soldiers, both old and young. The old are the 'grognards,' those who followed him into Egypt, into Russia, for whom he is god, who believe in no one but him.

"As for the young, I leave the floor to Mr. Henry Houssaye:

"'They were called the "Marie-Louises," those young soldiers suddenly torn away from home and a few days after their induction thrown into

the furnace of battle. They inscribed this name "Marie-Louise" with their blood on a great page of history . . .

"'It was the "Marie-Louises," those light infantrymen of the young guard who at Craonne stood for three hours on the crest of the plateau under the enemy batteries, a hail of bullets mowing down 650 men out of 920!'"

Poor souls have fallen by the hundreds for the glory of a ventriloquist. And to say that we've come to that! The men who lead the world make use of the vilest and emptiest of passions; Napoleon is the perfect example of the connective cell Forgive me for talking about such stupid things.

TOWARD THE INACCESSIBLE

Over there, to the north, to the south, to the east, to the west, the birds turn in circles to draw the sun in the wind.

Chapter VII

THE LAW OF PROBABILITIES

It is not certain that our thoughts are the product of chemical reactions. Assuming that there are several problems to solve, the Universe that you think you know is the mask of solitude; you are placed under the influence of epidemic values: the neurosis of Love, the neurosis of art, the neurosis of belief in a god.

The taste for the old is just a skeptical and occult synthesis that leads you to believe in the profundity of man; new evolutions are just enigmas for the sight and the ears.

Music is made for the ears and not the eyes; now I'm not saying that the opposite assertion isn't more accurate for nonalcoholics.

Artists are the result of nature's miserliness. The little wit they have they get through nastiness; Degas, the epitome of "success," is a perfect example of what I've just put forward. Besides, I heard an artist of great merit say that Degas was a failure!

THE SATYR
WITH THE TAIL OF A RAT

Noon in the skies, like a parchment, armed with a single hope, memories transformed. A single hope larger than two mouths touching each other; you can guess what's on my mind—one must find one's path and the paths lead nowhere!

You look at life with a paint brush and what you need is a gasmask, but there you have it, only money has genius; one must choose: live by genius or by good timing.

I am a motionless traveler, countries pass before me with their moving enigmas.

I flee from happiness so that it won't run away.

OUR HEAD
HAS TWO NEEDS
LIKE THE STOMACH

In a green light, your acts are illuminated under the sermons of honesty: it's the music of taste that gestures indelicately. Sing, sing. The rule has forgetful eyes, there is only refined violence, violence marks out moralists, moralists of yawns; our heart is barbaric and our stomach domestic, everything is different, it's marvelous, moral, or immoral; death signifies life just as much as life signifies death.

SNAIL
BITES

No body of work, be it painting, literature, or music, is a superior creation; all these works are the same. The most ideal work is the one responding more and more to certain conventions that seem new to you because you don't know them or because they have been more or less forgotten. There is neither error nor deviation in that: our brain is a sponge that soaks up suggestions, that's all.

All of man's works belong to a great tradition—or a minor one, if you prefer—there is no work that does not belong to this tradition, even those by the copyists in the Louvre, copying the paintings of the masters as closely as possible, just as Chardin[30] copied, as closely as possible, a hard-boiled egg or a coffee grinder.

You would do better, Messieurs, to paint the cliffs of Dieppe blue and red: nature is really no longer sufficiently modern!

So that no one misunderstands this book I end with this little poem:

> DADA *is imperceptible*
> *Like imperfection.*
> *There are no pretty women,*
> *Any more than there are any truths.*

Completed in Paris, 10 July 1920.

Jésus-Christ Rastaquouère, Au Sans Pareil (Paris), autumn 1920, with an introduction by Gabrielle Buffet, drawings by Georges Ribemont-Dessaignes.

[UNTITLED]

Paul Éluard always says
"Proverb" instead of saying shit[1]

Erik is Satierik.
Rachilde is treating herself with mercury.[2]
Trees have leaves in the summer
so as to guarantee themselves some sun.

I make love between two policemen
to keep my hands warm.

It is a very good thing to feel which way the wind is blowing by moistening one's finger.

391, no. 14 (Paris: November 1920), p. 1.

The next text was originally written in 1920 for Tristan Tzara's *Dadaglobe anthologie,* an ambitious project which never saw print.

SHE DOESN'T BLUSH

About twenty years ago, somewhere between Tétouan and Fez, I had a most curious adventure, which nothing now prevents me from divulging.

I had organized an excursion into the desert with one of my friends and his wife whom he had very recently married; some Moroccan servants accompanied us, we were traveling on horseback and camping out; in short, we were leaving behind the Ritz Carltons for a while for a return to a primitive life, one that tends to favor passionate states . . . and before

three days were up, I was madly in love with my friend's wife! I did not even try to conceal my fiendish passion, and great was my astonishment when I realized that she was responding to the suggestive looks I was constantly directing at her. My desire was heightened by this exchange, and the mute flirtation that ensued only exacerbated the passion to which we had become enslaved.

At sunset we would put our tents up side by side, but I was unable to remain in my own for long and came to lurk jealously in the vicinity of the conjugal shelter. As I was gazing at it one evening, I suddenly saw a white form slip along the ground, between the canvas and the sand, and a black patch appeared in the middle of this ivory: the body I had so desired was offering itself to me. I crawled over; I saw that the top of the young woman's chest had remained inside the tent, and I was amazed to hear a conversation taking place between the couple: a most mundane conversation that had to do with a question of some property that my friend had just purchased in Nice on the English Avenue, and the improvements it was going to need. They were discussing figures, but their voices were calm. I was unable to resist; I came closer and gently took that admirable female. And every evening the same pleasure resumed, and every evening the same conversation, or just about, was established between the husband and wife. The evening before our arrival in Fez, the night was so dark that I had some trouble getting my bearings and finding my mistress's body; I made it there after much effort, and as I was possessing her, I was stunned to hear, playing between my legs, on a guitar, the well-known tune of Santa Luccia.

I still have this guitar; now that I have disclosed my adventure to you, come have a look at it on the wall where it is hanging. Every now and then my desert lady comes to tune it.

"Elle ne rougit pas," in *Cahiers Dada* (Paris: Minard, 1966), pp. 133–134.

The next seven items are from the Tzara files in the Bibliothèque Jacques Doucet. Olivier Revault d'Allonnes has determined that they had also been written for the *Dadaglobe anthologie,* and were all first published in Belfond's edition of Picabia's collected writings.

"Antenna" acts as something of a companion to "She Doesn't Blush," particularly in the repeated manner in which a woman's body manages to lie both in and out of a dwelling.

ANTENNA

I cannot bear watching, relating, redoing the same things; to die a few times would be nice: three times, for example. In America you can get up to three tickets for speeding, after which they take away your driver's license; well, this one would be the last.

This opening is the trick of an artist who does not really know what to write, but I am like Atride Agamemnon, so I'm going to tell you the story of my first Goddess.

She arrived one morning in my antechamber, hidden under the stamp on a bill from Hédiard's;[1] her feet remained outside the house, resting on the sand at the seaside.

I showed her our future bridalroom and the bed where we would be sleeping—a bed sprayed every evening by the intelligence of friends—but her body was so stretched out that after visiting my apartment it was in pieces and her head came out of a window to smell the ass of a cunning dog passing by. This dog was the son of an immortal child, similar to an insolent divinity; the dog was the dog of a beggar who was roaming about and offering hospitality for one franc twenty-five to all those overly excited by the idea of God.

My goddess's body was soon no more than a thread and the idea that it could break filled me with terror. I gazed at it without daring to move; it was no longer getting thinner, but it was changing color, it became like gold and grew so hot that it was impossible for me to stay in the apartment. No sooner was I outside when a powerful whistling rended the air and the houses around me, and my goddess's body flew by and cut, like cheesewire, the buildings, the trees, etc. The Eiffel Tower was in its wake, I rushed over to see what had happened—had the Eiffel Tower been cut in two? But no, nothing of the sort had taken place. My goddess was simply hanging from it as the first wireless telegraphy antenna . . . A delightful song, comparable to ivory inlaid with silver, went off like a vagabond for New York.

Good night, dear friends.

AN AWKWARD AFFAIR

I was with the woman I had been desiring for months: we were side by side, trembling with violent passion, but my desire was such that it was impossible for me to prove it to her; I felt desperate, ashamed . . . Deciding to make use of a subterfuge, I left the room on the pretext of having to go

close a door, and took advantage of these moments of solitude to give myself over to a ritual that I felt sure would help me provide my partner with the tangible proof of my love; unfortunately for her, I took such complete pleasure in this game that I had nothing more to tell her once it was possible for me to go rejoin her—something I didn't dare do, quite honestly, so I got dressed again as fast as I could and left without a sound. All night I walked along the rue Tronchet and didn't return home until morning; passing through my apartment, I was surprised to note a slight disorder; I came to my room and there found the young woman I had left the day before. She was standing, completely naked, and next to her, just as naked, stood a tall blond man, their right hands joined in those of a clergyman who was wearing nothing but his detachable collar and tie. Seeing me come in, he uttered: "Ah! Finally, Picabia!" The young woman turned to me and added: "I hope, dear friend, that you'll act as witness to our wedding."

Picabia's assessments of individual artists in his next manifesto indicate a leaning toward a more conservative outlook, and a refocused attention on the classical paintings that would play a strong role in his later "Transparencies."

MANIFESTO PIERCED FROM BEHIND

Every artist has the head of a crucified man;
those who don't have such heads look like
grocery boys.
The crucified make art in order to sell it.
Grocery boys make art in order to get
the Legion of Honor.
Art = God = Bullshit + Mercantilism.
Piss off.
Rubens with his mythologies, Véronèse with his evangelical scenes, Rembrandt, Bonnat, Bouguereau[1] were people of genius: I call genius a marvelous worker; Cézanne's an artist like Henri Matisse, Picasso, etc., in other words, an incomplete man, a piece of merchandise for the rue de Beaume or the rue Richepanse.

It's exactly the same thing in literature and music—I'll come back to this question.

An idea is interesting if it isn't printed. Nothing has an ideal form, it just simply has a form; but we only perceive a tiny part of the universe; therefore, dear friends, don't believe in the forms that you see, these forms are just a detail, which itself is a form in a detail.

There is no subordination, any more than there are works of art.

Art is a game like love and sports.

RUMOR HAS IT THAT

Yes, I've read
I didn't write to you.
What could you be spending your time doing?
It's beautiful today!
What lousy weather!
Dying of boredom.
You—you're not like the others!
Rumor has it that . . .
Save time,
So you can spend it later.
That makes me dream of the future,
The future is beginning to wear me out
much more so than the past,
And much more than the present!
Kiss your mistress for me
Because I'm tired.

BAR

What love on each of your hands
What love on each of your buttocks
What love on each of your breasts
What a pity dear Madame
That all of it smells like money
Sleep soundly
You're rich
Yet who knows
The cold is poor in winter

And the summer warms up whoever perspires
I'm for pain from day to day
In the desert.

DRAT

1149 is 434 Leo 98624 sells
snail 00 000 10 Papa 2 the public
48 and 49 the wheel 24 caca 000 and
peepee 126 + 33 = 8
Leo 45 121 893 questions 21 but
I feel very calm today 25
in fashion 2222 + 333 = 0
 22 + 1 = 22
 22 − 1 = 22
 22 + 22 = 22
 22 = 22 = 44
34 987 6 is first the high cost of 30
like dancing 9 and peepee 10
 two times
 three times

DADA-MADRID

Spanish poem por: Pedro
por the Spanish Dadaist group

Bedside table stare away messieurs
77 shelves x Charlie Chaplin
Whiskey + dildo shelves X
 EY CARLOLLEIRA!
Himmennic Films
8 that makes 606 combs doctors.

"Antenne," "Une mauvaise aventure," "Manifeste percé par derrière," "Le bruit court que," "Bar," "Zut," and "Dada-Madrid," from the Tzara files in the Bibliothèque Jacques Doucet. First published in Picabia, *Écrits: 1913–1920*, pp. 261–262, 265–268.

The next poem dates from March 1921. Although it is contained in an altered form in *The Pilhaou-Thibaou* (see p. 273), it has been included to illustrate the disregard Picabia had for categories of poetry and prose. For the title, see p. 267.

SONG OF THE PILHAOU-THIBAOU

Crocodiles are my friends
There are no modern crocodiles
ancient neither
I am brother to the cherries
and to God
What is most beautiful in cemeteries
are the weeds
the weeds that grow on the tombs
the memories, guano for geraniums
Here the hotel rooms
have central cooling.
Our nose is the cemetery for millions of animals
Don't breathe if you have a heart!
But you only have a heart for what your eye sees!
The heart represents the beginning of walks.

"Chant du Pilhaou-Thibaou," originally published by M. Sanouillet in *Francis Picabia et 391* (Paris: Losfeld, 1966), p. 140.

In April 1921, the Dada group announced a "Grande Saison Dada," with plans for "visits, a Dada Salon, commemorations, operas, plebiscites, requisitions, denunciations, and trials," most of which were never realized, but all of which aimed, primarily through the efforts of Breton (who had been having misgivings over the adolescent pranks of the previous year's Dada events), at a more serious and directed Dadaist approach. The reticence Picabia expresses from his sick bed signals the beginning of the splintering of the Paris group. The first event consisted of a guided tour of the church of Saint Julien le Pauvre, and it is with this excursion that Breton takes the reins of Dada himself, leading a large segment of the movement into the Barrès Trial and, later, Surrealism.

The choice of this particular church was in line with the ambition of making excursions to places "that don't really have any reason to exist." Rain and lack of direction, though, made the event a failure.

The six-week illness Picabia refers to is the period of his "cacodylic eye."

THE DADAS VISIT PARIS

As we wanted to get some clarifications on the Dadas' visit to the church of Saint Julien le Pauvre, we telephoned M. Francis Picabia.

As I've been sick for six weeks, *he replied,* I've had no hand in the organization of this event. All I hope is that it presents nothing political, clerical, or anticlerical in character, because I will always abstain from participating in any event of that sort, as I consider Dada to be an individual having nothing to do with beliefs, whatever they may be.

"Les Dadas visitent Paris," in *Comœdia* (14 April 1921), p. 2.

The title of the next poem was the name of Picabia's dog.

NINIE

Perfumes, flowers, love, dance, music,
Sleeping under the stars,
Nude Aphrodite,
A child starting to walk,
Spartans,
Biting one's bottom lip with one's teeth,
The sound of the zither:
I am the man who invents new solder.
The brooks become rivers,
The inns luxury hotels;
The overexcited sensitivity of the underside,
Seeks out the chimneys, new elegance,
Whose oven aims to melt the chains of liberty.
Air is not white,
Rich men do not love war.
My dishes are golden, I eat off a platter.
The hilly countrysides do not resemble mountains.
Intelligence is Adam's apple
Stupidity William Tell's.

The game of dominoes was invented by Menander;
There are not enough dominoes for me to like this game.
The rump is always the same,
The sun is always the same,
The moon as well,
Art too.
Novelty is nothing but an exhibition masquerade;
There is the spirit,
But the spirit is Italian
And what is most beautiful in Italy
Are the mandolins.

P.S.—Don Quixote is an example.

"Ninie," in *La Vie des lettres* (Paris, April 1921), p. 395.

FRANCIS PICABIA
IS AN IDIOT

Anti-Dada, 1921–1924

Picabia made his public break from Dada shortly after Clément Pansaers (1885–1922, the sole Belgian participant in the Dada movement) informed him of his own. The event to bring things to a head was the infamous wallet incident at the Café Certà on 25 April: after finding a waiter's wallet, the Dadaists debated what to do with its contents. Pansaers (who wanted to return it) and Breton found themselves in opposition, and Éluard's anonymous return of the wallet the following day only heightened tensions. Pansaers related the incident to Picabia that same evening.

In his "Lecture on Dada" given in September 1922, Tzara claimed that

another characteristic of Dada is that we are always parting from our friends. We part, and we resign. . . . In actual fact, the real dadas were always apart from Dada. Those people to whom dada was still important enough for them to part from it with éclat, were only acting with a view to their own personal advertisement, and proved that counterfeiters have always insinuated themselves with filthy worms amongst the purest and most lucid adventures of the spirit. (Seven Dada Manifestos, p. 107)

M. PICABIA SEPARATES FROM THE DADAS

I approve of all ideas, but that's it, they alone interest me, not what hovers around them; speculations made on ideas disgust me. "One has to live," you're going to tell me. You know as well as I do that our existence is brief in regards to the speculation one can draw from an invention; we've been on earth since the day before yesterday and we'll die tomorrow! Cubism was born one morning in order to die that same evening, and then Dada appeared, which turned out to be just as ephemeral; the evolution continues, some person will find the name of the new casket for an already departed spirit, and so on and so forth.

The Dada spirit only really existed from 1913 to 1918, a period in which it did not cease to evolve, to transform itself; after that, it became as uninteresting as the output of the École des Beaux-Arts, or the static lucubrations offered by the *Nouvelle Revue Française* and certain members of the Institute. By wanting to continue, Dada retreated into itself. I regret that in writing these lines I may hurt some friends whom I like a lot, or worry certain companions who are perhaps counting on their investments in Dadaism!

To say what will now take place is impossible; I can only assure you that our frame of mind is no longer the same as it was from 1913 to 1920, and that consequently, it will express itself differently. Do not think for a moment that I am in my shirt sleeves at midnight in the month of July, gazing at the moon; fear not, I have all my common sense—if there is such a thing as common sense! One thing I'm sure of is that it is impossible to stop movement; money itself has a value—or has none;

paper would perhaps be worth more than gold if it was given to me to discover gold-bearing mines as sizeable as the coalmines of Cardiff! People divide individuals up into two categories: the "not serious" and the "serious." Up to now no one has been able to explain to me what a serious man is! I will here try to do so myself. I believe that he whom you call a serious man is a man capable of looking after his neighbors, his family, his friends, providing that to do so he employs the usufruct of capital. An unserious man is one who confuses usufruct with capital and who doesn't try to make dollars with his ideas; from an artistic point of view, the copyist in the Louvre will always be more serious than I am! Dada, you see, was not serious, and it is for that reason that, like a trail of gunpowder, it reached the world; if some people now do take it seriously, it is because it is dead! Many people are going to call me a murderer: these people are deaf and near-sighted! Besides, there are no murderers; tuberculosis, typhoid fever—are they murderers? Are we responsible for life? In my opinion, there would only be one murderer—the one who created the world! But seeing as no one created the world, there is therefore no murderer, and Dada will live forever! And thanks to it, art dealers will make a fortune, editors will buy themselves automobiles, authors will receive the Legion of Honor, and me . . . I will remain *Francis Picabia!*

You have to be a nomad, go through ideas the way you go through countries and cities, eat parakeets and hummingbirds, swallow living marmosets, suck the blood of giraffes, feed on the feet of panthers! You have to sleep with seagulls, dance with a boa, make love with heliotropes, and wash your feet in vermilion!

You have to camouflage church interiors as transatlantic liners and transatlantic liners as cream puffs, make statues come out of the sea and recite verses at passing liners, go for a walk completely naked just to put on a tuxedo back home; you have to hear confessors' confessions, never again see the people you know, in short, never put the same woman in your bed, unless it's to have a mistress who cheats on you every day with a new lover! All of that is much simpler than the faith of a coppersmith who always laughs at what is funny and considers black to be dark and white, light! The coppersmith warms himself in the sun because he's cold; don't be cold, you will then see how the sun resembles rain!

Life is really only tolerable provided you live among people who have no ulterior motives, no opportunists, but that's asking for the impossible . . .

Talent does not exist, masterpieces are just documents, truth is the pivot of the scales. Everything is boring, isn't it? The falling leaves are

boring, growing leaves are boring, warmth is boring, cold is boring. Clocks that don't ring are boring, those that do ring are boring. To have a telephone is boring, to not have a telephone is boring. People who die are boring, as are those who don't die. Since the world is badly organized, why doesn't our brain have the strength of our desires? But all that is of little importance: museum paintings are masterpiece-fossils; we say of a man that he has taste because he has the taste of others; life is a guitar on which you only like to play the same tune, endlessly.

"M. Picabia se sépare des Dadas," in *Comœdia* (11 May 1921), p. 2.

"**Francis** Picabia and Dada," Picabia's third declaration of his divorce from the movement, appeared in Le Corbusier's multiart magazine *Ésprit nouveau*. His break from the Dadaists was a theme that recurred frequently in his articles of this period.

FRANCIS PICABIA AND DADA

I parted from certain Dadas because I was feeling stifled among them, every day I was feeling sadder, I was getting terribly bored. I would have loved to live around Nero's circus; it is impossible for me to live around a "Certa" table, the scene of Dadaist conspiracies![1]

I have no wish to examine the full history of the Dada movement here; just a few words to settle things: the Dada Spirit really only existed for three or four years, it was expressed by *Marcel Duchamp and myself* at the end of 1912; Huelsenbeck, Tzara, or Ball found the Dada "name-case" for it in 1916. With this word, the movement approached its culmination, but it continued to evolve, each one of us bringing to it as much life as possible.

We were called madmen, phonies, funny guys, etc.—in short, it was a great success! This success, the pleasure of the game, lured several individuals in 1918 who were Dada only in name; then everything changed about me, I had the impression that, like Cubism, Dada was going to have disciples who *understood* and I soon had but one idea: to flee as far as possible and forget these gentlemen. But it's true, for a few hours I was amused—*me,* with the wind in my hair—to see them quietly profit from their opportunism in order to also fawn over serious people and the *Nouvelle Revue Française.*[2]

Now Dada has a court, lawyers, soon probably policemen and a M. Deibler:[3] it will become like Lenin's antimilitarism which, in order to do away with a general, turns him into a simple soldier and vice versa.

Dada makes me think of a cigarette that leaves a pleasant aroma around it. The cigarette brand is sold out, the tobacco remains, and I rely on the man of genius who will know how to give it a new name. But let's stop thinking of the past, despite this cigarette aroma; life is but a shadow, let us hold on to the illusion that our heads outshine it.

One must always look down, vertigo is more violent that way; we are all fellow travelers, physically worn out most of the time, we attend the tides; each low tide is new, just like each high tide—that's what men call evolution or progress and it is always the same thing. The sole strength that can aid us in taking this stroll is pride: our pride must be as infinite as the universe.

But this parabola is making me wander a bit from the aim of my article: I separated from Dada because I believe in happiness and I loathe vomiting; the smells of cooking make a rather unpleasant impression on me.

I'm ashamed of being so weak, but what do you expect, I don't like illustrations and the directors of *Littérature* are nothing but illustrators. I like taking aimless strolls, street names matter little to me, each day resembles the next if we don't subjectively create the illusion of novelty and Dada is no longer new . . . for the time being.[4]

The bourgeois represent the infinite; Dada would be the same if it lasted too long.

Paris, 13 May 1921

"Francis Picabia et Dada," in *L'Ésprit nouveau*, no. 9, Paris (June 1921), pp. 1059–1060.

Picabia dictated "Shingles" under the influence of the drugs he was taking for his eye: "a short story about his illness" was Everling's description for it. Regarding its postscript, she added: "despite his suffering, Picabia did not disarm, and his irony continued to exercise itself on his friends and colleagues!" (*L'Anneau de Saturne*, p. 141).

SHINGLES

There's only one system that's good,
and that's the Splendid System

That chases off the monotony of detachable collar opportunities! Zizi yaps various assessments, a yellow and white connoisseur. The day won't end; I dream that my great grandfather had discovered America, but not being Italian, he didn't tell anyone.

Eyes are fixed on my contracted eye—banal words, insensible words that weep.

What a scraggy landscape in the solitude of a bed! Zizi has stopped barking, the speed of my bedroom is making him tipsy. Fantastic and automatic turns furiously write "Shingles" in skillful curves on the still sensitive blanket.

I savor my eyelids and my reddened eye wants to seize the night. I'm mad! I have two hearts, one in place of my eye, the other flows and is going to die in a false breath movement.—No sleep, I walk on tiptoe, vague consolation of fraught nerves that bear the mask of fear, while smoking funny tobacco in little puffs.

It has been twenty-five days and the bedroom has gotten more and more confined, we're blocked in; danger can't get through, the days and nights enter the room, today is everywhere in the world.

At the end of the Earth, there is a church, and in this church an orchestra that revives the physiognomy of women and that of our scholar-cushions. Shingles is a doll that gently lifts my head, a peevish aurora borealis looking like a plucked fowl. Happiness walks, crushing the weak who fall, knocked senseless, in order to hamper the misfortune of bird inventions.

The bed—I have only to obey—and then the bed, great master of my tattoos, buttons, weak odor of umbrella. The vanished eye is a strange thing! Here's the peak of the mountain, but there is always a higher peak. Sleep wins, it is death, my eye seeks the door-satisfaction and I stay behind the stairs gilded with culinary talents.

You are a kind woman who peppers my life with painful secrets, your organism traffics in good companions from country to country. Barking wakes me up and your imagination as well; despite my politeness I am falling asleep on my feet and my eyes are wet with tears.

Legends, dreams, screaming, sunbaths, speed, all of that: groups of huts.

The sky is always gray—or is blue only in Spain. Let's change the subject: wisdom spits the blues, little honey-colored song—which bores the sun into our hearts while titillating the great Lucullan Table.

I'm drunk on milk, my hands touch nothing, I'm afraid of danger, everything sinks into a little nightmare in which harlequin gossip crowns the glory of a transatlantic liner.

This transatlantic liner is myself and I whistle to warn the passengers that we're leaving for Paris! My eyes prickle, an effort, I weep, weep over the mortality of hot water!

P.S.—I've just received Aragon's volume, I congratulate the *N.R.F.* for this book-grade crossing, between Anatole and P. J. Toulet.[1]

"Zona," in *La Vie des lettres,* Paris (July 1921), pp. 512–513.

The next seven items all appeared in *Le Pilhaou-Thibaou,* which was described as an illustrated supplement to *391,* no. 15, but actually constituted the issue itself. The title plays on the words *pilou* (flannelette) and *thibaude* (carpet underlay)—perhaps the use-value Picabia was suggesting for this supplement, the lengthiest of his *391* publications (as Sanouillet points out, the title *391* was undoubtedly too closely associated with Picabia's recently renounced Dada period for him to wish to use it in this instance). It may also be a play on Jean Crotti and Suzanne Duchamp's "Tabu" movement, announced in this same publication. Clément Pansaers had referred to this publication in a letter (see *Bar Nicanor,* p. 43), when it was still in a stage of preparation, as "Le Kangourou" (The kangaroo), which may have been an earlier title, or simply an error on Pansaers's part. One of Ezra Pound's contributions to this issue was titled "Kongo roux" (Red Kongo).

The issue was one of Picabia's more aggressive numbers and contained a number of attacks on former Dada colleagues and friends, and no longer featured any of Tzara's collaborations.

391

Cubism was invented by Picasso, it became of Parisian make.

Dadaism was invented by Marcel Duchamp and Francis Picabia—Huelsenbeck or Tzara found the word Dada—it became Parisian and Berlinesque in spirit. The "Parisian" spirit, which should not be confused with the spirit of Paris, consists of witty extravagances on the surface; it lives on people who "can't be fooled!" it holds the secret to transforming chicory into chicory, spinach into spinach and shit into caca. Obviously, shit and caca are the same thing, but a little spray of opopanax on the caca transforms this caca into a cream puff which madame la Ctesse Q . . .[1] is happy to eat and she makes her choice guests eat it.

These choice guests are: .

. and perhaps M. André Gide who doesn't eat cream puffs but casually slips them into his pocket where he forgets them and where they soon become caca again, illustrated by Roger de la Fresnaye.[2]

FUNNY GUY

Don't hide your secrets in your behind: everyone will end up knowing them.

F. P.

Offering one's hand is the first gesture for making children.

F. P.

"391," in *Le Pilhaou-Thibaou*, illustrated supplement to *391*, no. 15 (10 July 1921), p. 3.

[APHORISMS]

Luxury isn't a pleasure, but pleasure is a luxury.

THE ARCHANGEL GABRIEL

Nothing is more like a ladies' man than a gentlemen's woman.

SAINT JOSEPH[1]

Le Pilhaou-Thibaou, illustrated supplement to *391,* no. 15 (10 July 1921), p. 4.

The following semi-manifesto was
an open letter to Jean Cocteau.

--

MASTERPIECE

I have never written for myself, I have never painted for myself, I have never done anything for myself; my books are adventures, as are my paintings.

I displease artists because I am not an artist; I displease the poor, I displease the rich, because I am not poor and because I am not rich.

My metaphors, my dear Jean, irritate those around me and my "don't-give-a-damn" attitude scandalizes those who aren't around me.

You see, society people are always going to resemble daguerreotypes the way that Cyrano de Bergerac resembles Negro music. To make a long story short, what really makes living difficult is always having to be accompanied by dromedaries!

All our enemies talk about Art, literature, or antiliterature—and you're worrying as to whether your works are art or antiart? The only things that are truly ugly are Art and antiart!

God created man and woman; man created genius. Genius makes me think of Moses: only Mount Sinai perceived the rays surrounding his face. Only Mount Sinai was an individual of genius—at least it never asked for conclusions.

Those who gave the infinite's dimensions as being a meter were wrong: the infinite's dimensions are two meters fifty.

I think all books are beautiful; the only thing about them that displeases me is their bindings. Impressionism is a binding-frame the way cubism and Dadaism are binding-frames, and the same goes for Catholicism, Protestantism, Buddhism, etc.

The best religion is the one that doesn't exist; I will always find an empty apartment to be more sympathetic than when it is occupied. The Earth is a spherical apartment that should only house Bedouins.

We spend our time saying: "You are ahead, you are behind"; for me it's very simple: I just don't follow anything. By that I mean that I've never gotten any school prizes, I've never had my hands full of pride. Like a charming mortal I am stunned with obscene despair when I see my friends turn into artillery officers; it has been three months now and I still haven't had the courage to tell them that I find them terribly annoying.

Today, they're shooting at Barrès, tomorrow they'll shoot at the Gare Saint-Lazare or at market porters;[1] me, I shoot into the air and the bullets fall back into my pocket in the form of chewing gum, fried carp, or Rolls-Royces. Stupidity, equal to intelligence, is preserved in rubber jokes, like taking tobacco, and this tobacco, though very strong, can only make my artillery-officer friends sneeze.

Right now I'm orbiting the Earth and astronomers are watching me through their avaricious telescopes—this is an explanation like any other, which doesn't make it any easier when you've been invited to a friend's house.
FUNNY GUY

"Chef-d'œuvre," in *Le Pilhaou-Thibaou,* illustrated supplement to *391,* no. 15 (10 July 1921), p. 5.

[APHORISMS]

Chance is immobile.

F. P.

To those talking behind my back: my ass is looking at you.

G. F.[1]

All Jews became Catholics and all Catholics Jews.[2]

In America, they abolished alcohol and kept Protestantism—why???

The Dadas are quite ripe for Paul Poiret.[3]

I don't need to know who I am since all of you know.

FRANCIS PICABIA

The public needs to be violated in singular positions.[4]

Honor is the enemy of glory.

Morality is ill disposed in a pair of trousers.

It is only the debts that one can pay that are annoying.

Parisians ruin the French.

F. P.

It is easier to scratch one's ass than one's heart.

SAINT AUGUSTINE

The only tolerable uniform is that of a steam bath.

NAPOLEON

Le Pilhaou-Thibaou, illustrated supplement to *391*, no. 15 (10 July 1921), pp. 5–7.

[APHORISMS]

It's really only nonentities who have genius in their lifetime.

It's monkeys who make commonplaces.

F. P.

Favorable wind has blue feathers.

F. P.

Georges Ribemont-Dessaignes became Romanian, Tristan Tzara Parisian, that's what makes friendship.[1]

F. P.

"To say: 'Pierre de Massot is too young to write' is the same as saying: 'This child is too young to be born.'"[2]

F. P.

Le Pilhaou-Thibaou, illustrated supplement to *391*, no. 15 (10 July 1921), pp. 9–11.

THE PILHAOU-THIBAOU

Appended to *391*, the *Pilhaou-Thibaou* will remain unique: this is its first and last issue. Pilhaou represents the sign made by the left hand, which being confirmed by Thibaou, a sign made by the right hand, indicates that all is

well. And so the sky is beautiful today, I have the impression of living among palm trees, it is twenty-five degrees in the shade, I'm wearing a white suit with wonderfully polished yellow shoes; I have a lot of money in my wallet, which I got from a collection of mummies that I sold. All of a sudden I have the feeling that Bérenger [sic] shall go down as the greatest French poet ever![1] But it is 11:30, I have to go take my bath. Thoughts during the bath:

Crocodiles are my friends, there are no modern crocodiles, any more than there are ancient ones, I know this because I am brother to the cherries and to God. God told me that what he loves most on Earth are cemeteries, and in the cemeteries, the weeds that grow on the tombs. The memory of the dead is just guano for the cultivation of geraniums. God guarantees central cooling at the Père-Lachaise. Noon: time to get out of this bath, it has gotten completely cold. My nose lengthens in the water, our nose is the cemetery for thousands of animals, so don't breathe if you have a heart, but you only have a heart for what your eye sees; the heart represents the beginning of walks, now you never go out, you are all sons and grandsons of shopkeepers and you live for yourself in your egoism as if in a shop. Can't you sense that what you call your personality is just a bad digestion that poisons you and conveys your bouts of nausea to your friends? A man once bragged to me very arrogantly and claimed that he had attained the greatest egoism; I showed him my little dog Zizi and was able to assure him that this dog was even more of an egoist than he; in my opinion it is those people closest to animals who are also closest to perfect egoism. What you take for "temperaments" are only illnesses, which would be better to try to cure than to praise. Snobbery buys little pieces of these illnesses in the hope that they end up being good deals. As for so-called serious people, they are sterilized by death—and what a death! Green death, blue, pink, or death as a hero (very pretty costume!) or the death of the poet "just as he was producing his most beautiful verses." So what remains? On the one hand, contagious illnesses, on the other, death! Nero is really the only one I can see who presents some interest, he was one heck of a Dada, as much of an egoist as my friend, true, but at least *he* didn't look like he had just left a watering hole like all of those little Dadas from Certa! You have to climb up lighthouses if you want to throw light on the world! I myself installed a farmyard on a lighthouse and my mind has not grown deranged because of it.

In New York the Statue of Liberty throws light on the world, this woman comes from Europe and does not know what she is doing. I climbed onto her head and made her up as an old general; she seemed satisfied, but that won't last long—she was asking for a pearl necklace; not having any big enough, I made her a necklace with the balloons of the Louvre.
FUNNY GUY

The more one pleases, the more one displeases.
F. P.

"Le Pilhaou-Thibaou," in *Le Pilhaou-Thibaou*, illustrated supplement to *391*, no. 15 (10 July 1921), p. 13.

[UNTITLED]

The only lawful union is between people who don't love each other.
THE BLESSED VIRGIN

Le Pilhaou-Thibaou, illustrated supplement to *391*, no. 15 (10 July 1921), p. 14.

ALMANAC

> *It was my great-grandfather who*
> *discovered America, but as he wasn't*
> *Italian, he didn't tell anyone.*
> **F. P.**

The Vaseline of eloquent hackneyed expressions,
In the pale gleam of newspapers,
Marinates my friends in oil.
Modern style is an art that has to be abolished—old modern style too;
In painting, Primitives are the dying lights of canticles.
The ideal would be a conflicting work in pure regions.
Stray thieves seem to walk surrounded by star performers wrinkled
 with publicity.
When the miracle of reflection is evoked, life doesn't disgust me.
My heart is hung from the wire that commands crimes.
My passion is the idleness of disgust.
Les Houveaux, 3 May 1921

"Almanach," in *New York Herald Tribune* (Paris, 12 July 1921), p. 3.

In October 1921, *Le Gaulois* addressed an open survey to some prominent painters. The questions: "In your opinion, is there a crisis in French painting? What are its causes? . . . What needs to be done?" Picabia offered the following response.

[UNTITLED]

I know nothing and I understand nothing.

Le Gaulois (Paris, 29 October 1921), p. 3.

FUMIGATIONS

I would like to visit plant interiors and also people interiors, the way one visits church interiors; to reduce my little self in such a way that I could slip into, sit, lie down in a friend's heart, enter his bladder, and with the help of a little pirogue, block up his urethra canal so as to facilitate the mortal floods; to go climbing in his liver, roped up with other hikers who would also have the pleasure of living among the bacillus of his digestive tract, and go vacationing on kidney beach![1] But we have to be content with the terrestrial outskirts and go camel racing in the desert. I must here restore the camel's good name: this animal has never given anyone seasickness — that is something completely invented by naval officers. But what was the original idea behind this article? That's what's important, and try as I may, I can no longer recall what this idea was; anyway, I had the feeling that it would come to me when I began writing — so let's continue with whatever.

One of my friends told me the other day that I was a bad European! He probably thinks of himself as a good European because he filters everything, like a Pasteur filter; he filters clowns, he filters Negroes — filtering, that's all Europe can do after wearing itself out trying to conquer the Alsace-Lorraine! Filtering the Alsace-Lorraine would be pretty strange; we would quickly have the pleasure of hearing a pretty love song from Berlin! I am a bad European the way I am a bad American, the way I am a bad painter, a bad writer, a bad husband, but . . . I drive automobiles very well! I would so like to paint the way I drive an automobile, 130 kilometers an hour without running over anyone — in Paris, of course. Anyway, my friend the good European is a good writer, a good draftsman, a good poet, but he doesn't know how to drive an automobile. Perhaps I don't either! It would be very amusing to drive an automobile in two directions, one forward, the other backward, especially if this car were painted pink and black. Enough, this is already getting old . . .

I would like to find an engineer who would be able to realize my latest invention; this invention consists in assembling circles around the Earth, circles that would remain fixed through a centripetal attraction; palaces would be built on these circles which would spin round and round. In this way, we could go round the world without having to leave our rooms, or rather we could see *it* go round in twenty-four hours! There's Cairo with its vision of the pilgrims of the Mecca, Upper Egypt, then New York, Brooklyn, and Riverside Drive, there's Paris, the Seine, etc., and throughout this incredible procession, young girls would play Reynaldo Hahn's melodies on the piano![2] There would be no more voyages, no more missed trains, no more night, and thus much less danger of catching chills; anyway, putting my discovery into practice could offer serious advantages. If an American engineer ever gets an idea reading these pages, I would be very obliged to him if he wrote me so we could discuss the possibilities of fleshing it out. Of course it's understood that the inhabitants of these circles would benefit from "anationality."

There are people who are passionately fond of nature, they gaze at animals in adoration, at plants in exaltation, they experience voluptuous sensations when seeing the sun set or rise; simpletons tend to love these people very much; as for me, my only desire would be to attract madmen, which is a little like what Napoleon did!

Aha! Aha! Imagine a person followed by all the madmen of the world, by all those who believe in the Blessed Virgin, or Joan of Arc, by those who think they are Nero, Charlemagne, William II, Edward VII . . . or myself! By those who think they are horses, lions or tigers, monsters or hummingbirds! Don't you think these people are also close to nature? They don't participate in the joys of family life and often lack that ruthless curiosity.

There are people who read nothing, who think about nothing, who do absolutely nothing, but who meticulously take care of their head cold when they have one. They sometimes go to the cemetery to bring some flowers to beings that they knew and who are conscientiously rotting; their flowers will rot, they too will rot, you can see very well that there's no cause for worry. Nature takes care of everything; there is nothing to do but let it do its thing, it does what it does very well. Ideas rot like flowers and people and there are people who want to mummify ideas the way the Egyptians mummified corpses.

I am for incineration, which conserves ideas and individuals in their least cumbersome form.

Dear friends of all countries of the world, renew and liven up, burn and drown, kill, rob, everything and everybody . . . except myself.

"Fumigations," in *The Little Review* (London and New York, autumn 1921), pp. 12–14.

Picabia exhibited two paintings at the Salon d'Automne (1 November–20 December 1921), which ended up being two of his most controversial: *The Hot Eyes* and *The Cacodylic Eye,* both titles referring to Picabia's eye ailments from a few months earlier. The latter painting consisted for the most part of the signatures and inscriptions of the friends who had come to visit him during his convalescence.

Controversy turned to scandal when *Le Matin* published an article accusing Picabia of plagiarism. Picabia's response is now perhaps the most important of his various artist statements.

THE CACODYLIC EYE

Le Matin took great pride in showing on their front page my painting from the Salon d'Automne, *The Hot Eyes,* printing a diagram below it of an air-turbine brake published in a scientific journal from 1920. "So Picabia invented nothing: he copies!" I'm afraid so, he copies an engineer's working drawing instead of copying apples!

Copying apples, anyone can understand that; copying a turbine: that's stupid. In *my* opinion, what is even stupider is that *The Hot Eyes,* which was inadmissible yesterday, now becomes, through the *fact* that it represents a convention, a painting that is perfectly intelligible to everyone.

The painter makes a choice, then imitates his choice, whose deformation constitutes *Art;* why not simply sign this choice instead of monkeying about in front of it?[1] There have been quite enough paintings accumulating, and the approving signature of artists—who are merely that, approvers—would give a new value to those works of art intended for modern mercantilism.

Temperament? You have to be kidding me! Anyone who really has "temperament" uses it in other ways than by making all those faces we call painting, sculpture, etc. I myself would like to establish a "paternal" school for the discouragement of young people from what our good snobs call Art with a capital A. Art is everywhere, except among the Art dealers in the Art temples, the way God is everywhere, save in churches, because I imagine that if there is a God, he must prefer life to unleavened bread!

The paintings at the Salon d'Automne and their creators are unleavened bread; I prefer this journalist who believed he had distressed me by reproducing the air-turbine.

My paintings don't pass for very serious works, because they are made without any ulterior motives toward speculation and because I work on them by enjoying myself, the same as when one plays sports. You see, boredom is the worst of illnesses and my great despair would be precisely in getting taken seriously, in becoming a great man, a master, a man of wit whom one invites because of his decorations, of his relations, and because he does well at dinners, where the people who eat the most are the people without any guts! You see what I mean: the artist-minister, the artist-deputy. Now, me, I've often written it: I am nothing, I am Francis Picabia; Francis Picabia who signed the *Cacodylic Eye,* along with many other individuals who were even so kind as to inscribe a thought on the canvas. This canvas was finished when there was no more space on it, and I find this painting to be very beautiful and very pleasant to look at, and harmonious: it *may be* that all my friends have a bit of the artist in them! I had been told that I was going to compromise myself and compromise my friends; I was also told that it wasn't a painting. I consider nothing to be compromising if, perhaps, one doesn't compromise oneself; and I think that a fan covered in autographs does not become a samovar! That is why my painting, which is framed, made to be hung on the wall and looked at, can be nothing else but a painting.

I'm planning on exhibiting some white mice at the Indépendants—living sculptures.—A guard will be by them to sell bread to the public, to keep alive these little animals who are so indispensable to my work.

Le Matin will discover that I took these mice from a bird seller, which even so won't keep me from being very pleased with my idea.

"L'Œil cacodylate," in *Comœdia* (23 November 1921), p. 2.

At the same Salon d'Automne, Picabia handed out large quantities of a leaflet, continuing what was becoming a touchy exchange over the origination of the Dada word, spirit, and movement. The handout was specifically a reply to *Dada au grand air,* the *Dada* issue put out by Tzara in response to Picabia's attacks in *The Pilhaou-Thibaou.* ("Funiguy [sic] invented Dadaism in 1899, cubism in 1870, futurism in 1867, and impressionism in 1856. In 1867 he met Nietzsche. . . .")

[HANDOUT]

FRANCIS PICABIA

IS AN IMBECILE, AN IDIOT, A PICKPOCKET !!![1]

BUT

HE SAVED ARP FROM CONSTIPATION**!**

THE FIRST MECHANICAL WORK WAS CREATED BY MADAME TZARA THE DAY SHE BROUGHT LITTLE TRISTAN INTO THE WORLD, AND YET SHE DIDN'T KNOW

FUNNY-GUY

FRANCIS PICABIA

is an idiotic spanish professor,[2]

who was never dada FRANCIS PICABIA IS NOTHING !

FRANCIS PICABIA LOVES THE MORALITY OF IDIOTS

ARP'S PINCE-NEZ IS ONE OF TRISTAN'S TESTICLES

FRANCIS PICABIA IS NOTHING **!!!!**

IS POOR
IS RICH
IS NOT SERIOUS
IS A PROFESSOR
IS A SPANIARD
IS AN IMBECILE
IS NOT A MAN OF LETTERS
IS NOT A PAINTER
IS A CLOWN
IS AN IDIOT
IS A FUNNY GUY

FRANCIS PICABIA

BUT : ARP WAS DADA BEFORE DADA

AS WAS BINET-VALMER[3]
AS WAS RIBEMONT-DESSAIGNES
AS WAS PHILIPPE SOUPAULT
AS WAS TRISTAN TZARA
AS WAS MARCEL DUCHAMP
AS WAS THÉODORE FRAENKEL[4]
AS WAS LOUIS VAUXCELLES
AS WAS FRANTZ JOURDAIN[5]
AS WAS LOUIS ARAGON
AS WAS PICASSO
AS WAS DERAIN
AS WAS MATISSE
AS WAS MAX JACOB
ETC... ETC... ETC.....

EXCEPT FOR FRANCIS PICABIA

THE ONLY COMPLETE ARTIST **!**

FRANCIS PICABIA RECOMMENDS SEEING HIS PAINTINGS AT THE SALON D'AUTOMNE

AND OFFERS YOU HIS FINGERS TO KISS.

FUNNY-GUY.

Men covered in crosses bring cemeteries to mind

shirts like them change ideas, dirty want don't you If

Distributed in large quantities on the occasion of the Salon d'Automne of 1921.

Picabia's comments on plagiarism and copying in the next piece merit attention, particularly his implication that plagiarism takes instinct.

MARIJUANA

The Mexicans have found a way to experience all the pleasures of the cinema without having to leave their homes and with minimal expense. They settle down in front of a white wall, take a small quantity of marijuana paste, and soon, under the influence of this marvelous drug, they see animated characters loom up before them, expressing their desires in the manner of actors in Rio Jim's most beautiful films.[1]

This preamble is to make the lines that follow more comprehensible . . .

Art has but two dimensions: height and width; the third dimension is movement—life—represented by *the evolution* of art: it is the arm of the cameraman shooting the film in the cinema. This evolution is the only thing that should interest us. Guillaume Apollinaire liked the fourth dimension because he was a poet! The fourth dimension is the "sublime," which means the unknown; it is Rimbaud, whose work is more poetic owing to the fact that he died young, after having destroyed almost all of it. Forain,[2] who professes so much admiration for the author of the *Drunken Boat,* would be less enthusiastic if the poet were still alive.

Right now, the third dimension serves as an excuse to ruin everything: ruin American music and Negro sculptures, ruin Michelangelo, Greco, Goya, Paolo Ucello—in short, to plagiarize without instinct anyone who has created something. Now while one may copy a man of genius, one cannot *imitate* him. It is true that you only concede genius to others so that you can attribute it to yourself! These days, *there are no more men of genius* and their works make me think of the construction of graceful Machin cars.

Talent does not exist; I can remember a mathematics instructor from my youth who had been a toreador!

I would like artists in the foolish sense of the word, but all we have now are intelligent people! They paint the intellect and end up expressing themselves the same way as those marijuana lovers who project themselves onto the wall-screen by dint of cerebral onanism. I prefer "idiots" with their mystical ideals, when they paint virgins surrounded by angels; alas! our virgins today are Kahnweiler[3] and Rosenberg, and the

angels Picasso, Derain, or Guirand de Scévola[4] . . . Nearby, a pianist plays an *Allah's Holiday*[5] Parisianized the way a fish is taken out of the ice after a year and prepared for some snobs by a skilled cook who names it: "Dream in mackerel cream." There are also those lovely articles written by influential critics to facilitate mercantilism for the dealers—a mercantilism that will soon collapse and bury the half-geniuses of the rue de la Baume and the geniuses of the rue d'Astorg[6] for a very long time: Germans have stopped buying because it is too expensive, and that leads the Norwegians and the Swedish to lose interest in this so-called modern merchandise, which I find to be more old-fashioned than a fashionable fashion designer, and more old-fashioned than certain Dadas, those sons of the Merry Widow. Picasso's the only one really worth anything; provided his bourgeois associates don't eventually spoil the charm of his nomadic mysticism.

You see, the more I live, the more I want to live; not live in the sense of duration, but in the sense of pleasure. When I'm faced with the stillness of the countryside I get so bored that I feel an urge to eat the trees; in the cities, in Paris, for example, I feel capable of carrying the Obelisk to the Olympia! "That's not a pleasure," you'll tell me. Well, yes it is, and it's a pleasure greater, in my opinion, than taking marijuana and looking at a wall. A day will come when great drug addicts will prefer a white canvas over any painting, and this white canvas will not speak, but its signature will influence people through suggestion to the point at which they'll see the contents of their own minds on this canvas. But, let's see now, there is one thing that is even more beautiful: suicide![7] Dear friends who consider anyone who does anything to be stupid, why don't you destroy yourselves once and for all? You'd then get the chance to escape the supreme punishment, since society cannot punish the crime of suicide with the death sentence—however much it may equal other crimes, since killing oneself and killing one's neighbor are the same thing: murder is murder!

It's better to love the struggle, to not fear long visits at the homes of friends who make you forget "serious" appointments.—There is nothing serious, there is nothing comical, but it is no longer possible to live in the shadow of conventions; so live in the sun and avoid stagnation if you don't want to rot.

"Marihuana," in *Comœdia* (21 December 1921), p. 1.

Breton announced the formation of the Paris Congress at the beginning of 1922. Although his intention was to establish a "defense of the modern spirit" among artists and writers, he somehow managed to ensure Picabia's participation. Picabia's uncharacteristic adherence to such a goal was no doubt encouraged by the fact that Breton's first action was to launch an attack on Tzara, whose aim was to keep the Dada movement alive. By malevolently situating himself in the middle, Picabia sharpened the antagonism between Breton and Tzara, and the conflict quickly escalated. *The Pine Cone* was Picabia's one-shot double-sheet in support of the Paris Congress and against those in opposition to it (Tzara, Ribemont-Dessaignes, and Satie, among others).

In a letter to Breton (17 February 1922), Picabia wrote: "In *The Pine Cone* . . . there are some pretty blunt things. . . . Don't let them shock you, that's how I talk when I've really had enough of a man" (in Sanouillet, *Dada à Paris,* p. 555).

Tzara would respond to *The Pine Cone* with the publication of *Les Dessous de Dada* and *Le Cœur à barbe.*

The title, according to Christian (Georges Herbiet), derives from a pine cone equipped with a pelican's head and feet that was in Christian's bookstore. Picabia's drawing of this object figures on the front of this publication. The layout of this broadsheet is, typographically, one of the more chaotic-looking Dadaist publications, resembling (both in appearance and invective) a wall of graffiti. A reproduction can be found in Motherwell, *The Dada Painters,* pp. 268–271.

THE PINE CONE

My very dear friends Tzara, Ribemont, and Company, your modesty is so great that your works and inventions only attract flies.

to Jeanne Lecomte du Nouy[1]

I knew a young woman who granted every favor to her lover except that of taking off her hat, on the pretense that it looked so good on her.

THERE IS ONLY ONE ALMOST ABSOLUTE THING
AND THAT'S
FREE WILL

Hello Pansaers

Hello Pound

OUR HEADS ARE ROUND TO ALLOW OUR THOUGHTS
TO CHANGE DIRECTION

PRIESTS SPONGE UP SINS THE WAY HANDKERCHIEFS SPONGE UP TEARS, THE LIQUID OF REPENTANCE.

THE IDEAL

When you face a Painting by Vélasquez, and turning your back to it, you see a Picasso, can you notice the difference between these two Paintings?

You stop seeing the Vélasquez when you turn away from it. But you subjectively retain the Vélasquez image and you perceive the Picasso objectively, from which ensues a critique that is the root of the ideal.[2]

The negative pole is as necessary as the active pole and the two ends of a straight line touch each other at the circumference.

Cubists who are all for prolonging cubism resemble Sarah Bernhardt.[3]

Tristan Tzara the traitor has left Paris for La Connerie-des-Lilas;[4] he decided to put his top hat on a locomotive: that's obviously much easier than putting it on the Winged Victory of Samothrace.

One day when he was in his birthday suit, Ribemont-Dessaignes put on a top hat so that he could look like a locomotive; the result was pathetic.[5]

Vouxcelles took him for a *tuyau de poil*[6]—not even, my Dear Friends, he simply looked like an Idiot!!!

ITINERARY

To go to Fréjus : BUS
" " to Cannes : COASTAL ROAD
" " into Yourself : ELEVATOR
" " beyond : LIFE

What augments our personality represents good, what can harm it represents evil; this is why God has no personality.

ERIK SATIE IS BECOMING DADA WITH HIS FRIEND TZARA HE INTENDS TO MAKE AN OPERA, GEORGES DESSAIGNES WILL TOUCH UP THE MUSIC IN THIS WAY WE WILL HAVE A VERY MODERN WORK.

Picabia has discovered a gyroscope for brains against the vertigo of celebrity.

My Dear Cocteau, everything I've had to say about you I have written; whatever people are telling you right now is a pure lie (take note Tristan and dear Ribemont).

DEATH
doesn't exist
there is only dissolution.
Beauty is relative to the state
of interest it creates.
LOVE is the adhesion to

all the ways and means in perfect
 relations.
Passion is solely the
desire for strength without
foreign and objective influence.
We are not responsible for
what we do, for we only
see our actions once they
are carried out.
There is no ideal without passion and
passion is not an objective ideal.
Men are more imaginative
when killing themselves than when saving themselves.
Heredity is exclusively objective.

 OZENFANT is very shrewd?
 THE PARIS CONGRESS
 is fucked, Francis PICABIA is taking part

I would like someone to invent
for my own personal use
a pocket electric curling iron
and a phosphorescent pencil.

If I wasn't big, I
would be small and people
who like me now
would not like me.

PICASSO is the only
painter I like.
 F. P.

 CUBISM
 IS
 A CATHEDRAL
 OF
 SHIT[7]

La Pomme de pins, "Le Bel exemplaire" (Saint-Raphael, 25 February 1922).

The *Revue* *de l'époque* ran the following survey, soliciting the opinions of forty artists and critics, including Picabia. His response headed the list, and it echoes a statement made the previous year in *Dada Stirs Everything* in retaliation to Filipo Marinetti's claim that Dada had descended from Futurism: "Futurism has died. Of what? Of Dada" (Borràs, *Picabia,* p. 205).

REPLIES TO A SURVEY

Do you think that Cubism is really dead?

Cubism is dead.

If yes, what did it die of?

Cubism.

Revue de l'époque (Paris, March 1922), p. 644.

In the spring of 1922, *The Little Review* devoted an issue to Picabia. "Francis had become French editor of the *Little Review* in 1922," Margaret Anderson later wrote, "but we never had anything from him except a Picabia number" (*My Thirty Years' War,* p. 255).

HURDY-GURDY

The laughter of alfalfa drinks my laughter
innocently, like another
and the shadows fountains
in blue, red, green,
reflect the colored glasses
adorning my heart.

To be cheerful together, like water,
makes for an ambitious and stupid dream
I just saw a different beauty,
a substantial serial
in which someone clambers up afternoons
slowly, like a man
with a scratched finger.

Imagine a man bothered
by the improvement of roads
by the victory of the Marne,
and who would like nothing but the ceilings
in the Palace of the Doges!
an artist stamping his feet,
an artist worn away by his weight
big and skinny.

Each day resembles the one before,
each day is a little balcony
each day is a little feather duster
—or a polar bear,
relatively easy to read;
whipped cream
in the clouds of the civilized world,
I am happily a poet, Don Quixote
of applause.

I look at the sky,
the sky looks like cemeteries
I would like a cemetery
on a boat,
the crosses would be sails
and the helm placed in front
would look like an Egyptian mummy.

I would like to have a new friend
to whom I could tell incomprehensible things
my brain is so big
and the world so little!

The gaily melancholic moonlight
flutters around the enthusiasm
of nations;
it is a pleasant mirage,
the sun colors the skin,
the moon the heart.

I ended up believing
that a beautiful mouth
shines
like a sh . . .[1]
fed at a good table.

Bandits have a taste for slow trains,
Narcissus loved cider,
but I love the Bois de Boulogne.
The books we love most
are those we don't read
Leeches, cupping glasses,
I hope you get everything you could want,
a terrible sorrow
and all of that to the sound of hurdy-gurdies.

"Orgue de barbarie," in *The Little Review* (London, spring 1922), pp. 3–4.

Albert Einstein's arrival in Paris on 28 March 1922 caused quite a stir. Among the numerous accounts of his visit in the papers was Charles Nordmann's anecdotal article, which appeared in *Le Matin* on 29 March 1922. The following article was Picabia's response.

UP TO A CERTAIN POINT

When I was a child, my father gave me a pair of scales as a present. After using it to weigh eau de cologne, coal, hairs, and flies, I had the idea of placing my pair of scales on a window in the sun, and to place a sort of screen in front of one of the pans so that this pan remained in darkness. I wanted to know whether light was heavier than shadow. The scale was apparently incredibly precise, because the needle tilted to the side of the screen. My conclusion was that night was heavier than day. It was Einstein's arrival in Paris that brought this childhood memory to mind.

Rest assured that I am not going to do as M. Nordmann does, who talks to us about Einstein the way that poets talk about the moon! That is, by making literature, by telling us that he has a large forehead and eyes that are blue . . . or black, and this out of sympathy for his readers whom

he's afraid of tiring by leading them into a more abstract realm. In this way he gives us the impression that he alone is capable of understanding Einstein, and "to understand is to equal," no?

Someone told me the other day: "If a Swiss man had come to Paris with a new invention for regrowing hair, he would probably find no success with the scientists who received Einstein; yet his discovery would prevent thousands of individuals from catching head colds, and would be worthy of attention even from an aesthetic point of view."

I share this opinion, but M. Nordmann is probably endowed with a full head of hair.

I have a friend who likes Einstein the way he likes the cinema, Dada, or Lenin, the way he would like a new illness and would be flattered to be its first victim, because this illness would be described as a modern illness! My friend doesn't like Parisian life, he likes Germans, although he didn't see any during the war and he's never been to Germany.

He likes Germans the way certain people like high game or ungutted fish. It shocks others who are more tender-hearted.

My friend also likes his wife's lovers—but he doesn't like me, he doesn't think I'm modern enough! It's true that my French and Spanish origins derive from old Latin races, which will soon be disappearing to make room for the children of Einstein, good-looking Israelites . . .

"The Germans are great thinkers, and great artists," some say, "they proved it by buying the first Cubist paintings." But it was not the Germans who bought these Cubist paintings, it was the sons of Israel, and they bought them in Paris, in New York, throughout the entire world, as well as in Berlin, thinking that these paintings, which are unverifiable, could become the perceptible expression of an era in which nitric acid replaces love. These paintings, moreover, were indeed made for them, since it was easy to buy them at low prices and sell them without regret.

This spirit I'm bringing to your attention is part of what contributed to making Dada unbearable: Dada, which I presented to you four years ago and which we were forced to throw out the door because it didn't know when to leave! It is now loitering about like a nuisance in certain taverns, and hopefully my friends the "modernists" will soon be accompanying this character to heaven, where we'll try to join them as late as possible.

You see, I consider Maurice Barrès to be a thousand times more intelligent than the parasites of La Rotonde and infinitely more likable than them, although *he* never wrote that he was likable![1]

Léon Bloy, who is still covered in silence, is ten thousand times more likable and more intelligent, for example, than a certain pale, greasy-haired "modernist" . . . If Bloy had been Jewish, he would probably be a god . . . Indeed, my growing impression is that all gods are Jewish! But, you'll tell me, haven't they made a god of the Douanier Rousseau? "Probably, but he had a Jewish spirit." I remember what Apollinaire once said to me: "Rousseau works less well when he's getting paid more!" That's also in the Dada spirit, isn't it?

Now they're going much further than Dadaism did; teachers in certain schools are starting to give the best grades to the students who don't know their lessons; the first prize in dictation is bestowed on the one who has the most spelling mistakes! It obviously takes a personality to make spelling mistakes, and it seems to be more personal to do so than to not make them; a teacher can tell a student who knows something: "You don't make mistakes, you have no imagination." Madmen have even more imagination; when they're incapable of writing a word, they trace out numbers, and this means of self-expression, which until now had interested no one except psychiatrists, impresses certain individuals who pride themselves on their new spirit.

The last thing I want is for you to see an anti-Semitic attitude in my article, but I consider current developments to be empty of real effort, empty of interest, an outright nuisance made for snobs and invalids of the Tchoukine and Marosow sort, and I fear that Einstein's calculations are not accurate: in six months they'll be declared false by another Einstein!

They talk about Einstein the same way they talked about Dada; I do not have the honor of knowing the former, but as Dada used to be my friends, I'm a bit wary. But they attribute to the German scientist a thought that pleases me very much.

Someone once asked him what he thought of the infinite: "If you want to see it," said Einstein, "get some opera glasses, but I'm afraid that you'll only be looking at your rear end!"[2]

"Jusqu'à un certain point," in *Comœdia* (Paris, 16 April 1922), p. 1.

With the new series of *Littérature* and the departure of Philippe Soupault (who disliked Picabia) as coeditor, Breton, in addition to having Picabia illustrate the covers starting with the fourth issue, extended him an open invitation to contribute as much writing as he wanted. *Littérature* would now become Picabia's primary literary outlet, as Georges Casella, who had given Picabia free rein in his journal *Comœdia,* had died several months earlier, and his successor (Gabriel Alphaud) would feel less generous in this respect. Picabia would demean the new *Comœdia* the following year in a brief note in *Littérature.*

THOUGHTS AND MEMORIES

Personality is the use of reason. In nearly every modern work we've seen, there has been nothing but individuality. Individuality is what characterizes the animal.

The first time I stayed in America, I had the honor of being presented to President Roosevelt. When in the course of our conversation I asked him what had struck him most in Paris, he replied that it was the Eldorado![1]

There is no law, every law being a convention, and convention a law of tendency.

I was one day showing the sea to a young girl who was seeing it for the first time; she declared that a potato field was much more impressive!

Only men possessing a rotary movement within them can attract other men.

As Carrière[2] was trying to explain to a student how to paint one day, he said to him: "Close your eyes and paint what you see!"

Many people try to imagine the infinite. Imagine two mirrors with the same form and dimensions placed in front of each other: the infinite is the reflection they throw back.

"Pensées et souvenirs," in *Littérature,* 2nd series, no. 4 (Paris, September 1922), p. 13.

EASY EFFECT

What is flat on the Earth becomes round when we look at it from the sky; I have a thousand mathematical images in my imagination for measuring the infinite and providing me an answer.—Answer: a little drizzle on the

sand from which I like to gather shells at low tide; these shells are the sun's caresses, my eye absorbs them like aspirin.

WHAT THE HELL DOES THAT MATTER!
Gymnasium literature! I loathe works that smack of the furniture mover, I loathe polished literature, waterproof literature.

We should walk with bare feet and only put boots on when entering the literary mosque, we should vomit, not varnish, we should wear Chinese slippers when looking after the toes of our spread feet, we should sport a name embroidered in rose petals under our soles, and a cat carved on a phallus for a spur!

IN THE LAST ISSUE
We should forget our sex the way we forget our homeland, and love nothingness, for souls and cows have the same smell.

WE'RE ALL LIKE THAT
We should look at men and women from below; the tremendous sympathy I have for life is like fatty rice on a new straw hat!

WE WERE MADE FOR EACH OTHER
The moonlight mastodon, enormous poetry, shit or rose, rose or shit, makes me uneasy.

My head turns me and I turn with my head. Whipped cream, pocket knife blades of numerous opinions, dizzy spells and discouragement, to die like a colossus, groping along, back turned to the sun, to explode like an air balloon.

ME, I'M THE SKY'S PROTÉGÉE
What's the good in discussing! The man of breeding, actresses, the kitchen, museums, the construction of a wall: they all charm me like clear water, like the ancient East, in the stupidity of commanded miseries.

UNDER HIS LITTLE TROUSERS
The inside, the outside: they look like a tortoise. Solitude is comparable to a lamp that turns down low. Goethe sums up his work: reflection and slowness, in the middle a LADY and a GENTLEMAN who don't sleep together when they're alone!

Politeness is the opposite of the picturesque, the picturesque is the opposite of art, art the opposite of life, life the opposite of God. Memories are melancholic and the moon smiles at me.

"Un effet facile," in *Littérature*, 2nd series, no. 5 (Paris, 1 October 1922), pp. 1–2.

[UNTITLED]

For a man to stop being interesting, it is enough to not look at him.[1]

Littérature, 2nd series, no. 5 (Paris, 1 October 1922), p. 10.

MY HAND TREMBLES

The church towers are singing their heads off
We go our way, lost in the crowd;
like birds on a plain,
trees, flowers, animals are people
more sensitive than men.
But me, I have a blindfold on my eyes
so as not to see the sunsets;
sunsets are not beautiful enough
and would make me weep;
the moon is not beautiful enough,
women are not beautiful enough;
I only like gunsmith shops,
I like them because I don't like hunting,
I don't like war,
and I'm afraid of dying.

One day my grandfather said to my father:
it is as hard to part with death as it is with life;
I found this thought so beautiful
that it made me shrug my shoulders,
and I changed the subject through discretion.
life is insane;
spring is in autumn
autumn in spring,
summer in winter and winter in summer;

I prefer my tears
and my new hat.
Under my feet I trample
the guilloched butterflies with their pretty colors
for all beauty is a vice of nature
But the church towers are singing their heads off
like birds on a plain.

"Ma main tremble," in *The Little Review* (London, autumn 1922), p. 40.

HISTORY OF SEEING

Years pass, the shops have muslin curtains. Hysteria is squatting on its heels, clenching a wooden viper in its hands; a ring is hanging from its tail and a diamond is embedded in this little snake's nose; when you look at this diamond up close, you can see a woman kneeling, she speaks and says to us: "Tomorrow will be less beautiful than a secret, less beautiful than a bad piece of advice, tomorrow is a promontory of stones, of dead leaves and pools of water where melancholy with slow steps and without light, without warmth and without color tries to turn the windows of Christian sentiments blue."

My heart barks and beats, my blood is a stationless railroad that leads to Barcelona. My body is a jar of excellent opium that helps charm my leisure activities.

Paris is bigger than Picabia but Picabia is the capital of Paris; Breton is a great river of Turkish tobacco and the sea plunges into this river to rise to the infinite.

Duchamp is making faces in the mirrors of the South Pole as if we were there! Marcel, you have to dye the icebergs blue, pink, green, and red, then cover them in saliva; Gabrielle Buffet will ski on their multicolored slopes while dreaming of her boulevard correspondence, and all over the world bellboys will be disguised as magistrates.

It is easier to swim in dirty water than clean water; dirty water is heavier, there's no point in knowing how to swim in kitchen water; old men lap at it happily and all the cretins float on their backs. Canudo[1] is head swimmer of the Greasy-Waters! Gonzague Frick[2] plunges his head in to find out if it is actually written in good French; *we're* swimming in the wonderful crystal of the horizon's springs.

Between my head and my hand, there is always the face of death.

"Histoire de voir," in *Littérature,* 2nd series, no. 6 (Paris, 1 November 1922), p. 17.

PITHECOMORPHS

The Mohammedan is aroused by the nudity of the feminine face, the European by her calves; the shrewd artist arouses the public in the same way.—He doesn't want his works to be copied, but he doesn't hide.—In the other case, he hides himself but exhibits his works. The better of the two is the one that was of less use to him.

I dedicate this thought to my good friends Brancusi and Marcel Duchamp.

FAMILY FEELING MADE MAN CARNIVOROUS.

"Pithécomorphes," in *Littérature,* 2nd series, no. 6 (Paris, 1 November 1922), p. 20.

TYPERAVINGS

An idea came to me, just like that, simpering, mouth in heart, chloroform on table:

Little Jesus came down my chimney one Christmas Eve on a cow to take away what I had in my bootees! He was rather disappointed to find nothing but his portrait. There was no decent way for him to bring it back, because of the Blessed Virgin.

I live next to the Casino; you need an appetizing production to not get bored "here below," but I am not like others, I don't like the Tango; yet energetic rumps are so many caresses, and my brain flexes on my sex; I grant minuscule talent to my friends, and the idea of sensual pleasure makes its copper shine.

I don't like life's false passengers, women who cross their legs the way men cross their arms, I don't like changes in the program, hard months, silk fabric scratched by fingernails, makeup, taking a taxi, front doors; but madmen, the avenue Henri-Martin,[1] midnight, cold water— those are my friends.

At this moment a woman next to me is caressing her breasts, their tips are red; there is a portrait on each breast: on the left, Foch, and on the right, the Unknown Soldier. Her belly is painted white, her legs yellow— alas! she's dancing the tango! Her buttocks are held in a box of candles, the bottom of the box is cracked open just like a piggy bank, blue pearls slip out of this crack and I thread them. This woman's arms are plaster, without joints, and she spreads them apart in a cross. All of a sudden she stops dancing and I am overwhelmed by vertigo in the impressive silence.

The lights go out, the gramophone plays "Rose," I drop to my knees, and suddenly feel the morning coolness . . . There are no risks to enjoy, inferiority comes from resignation; one must love murderers and despise victims;[2] ridiculousness does not exist.

I like candor, hypocrites disgust me, one should prefer physical enjoyment over everything and only abandon oneself to oneself; effusion divided is like two autos face to face, each one trying to make the other back up.

I just sneezed, a short vacation in the infinite; now I'm listening to a distant song, the song of spermatozoa, attracted by the lure of my soul.

The girl with the white belly brushes against my leg and arouses in me a sincere emotion, listen to me:

To be in the doldrums or to be in the newdrums, it's all the same; don't you have a vague feeling of light? No one is tricking you, you're no longer jealous; don't think of cemeteries, of misery, live like Little Jesus, completely naked but with a parasol to keep your sex in the shade.

Spiritualism and *theosophy* make people look a little as if they're in an *opium den,* but time passes more quickly.

Now, lovely tango dancer, put some lipstick on my lips; how lovely you are! She blushes through the rouge of her makeup and says to me: "Aren't you ashamed?"

12 October 1922

P.S.—Through discretion, bury your family and friends around cemeteries.

Natacha was living on the bridge of the superman; Jean Cocteau lives on the Pont de la Concorde.

The only essential things are useless things.

"Dactylocoque," in *Littérature,* 2nd series, no. 7 (Paris, 1 December 1922), pp. 10–11.

Germaine Everling describes in *L'Anneau de Saturne* the incident at the root of the first part of the following "Travel Souvenirs." Breton and his wife accompanied the Picabias on a trip to the South of France one winter (Everling's date of 1924 would appear to be erroneous):

Breton had borrowed from Jacques Doucet a magnificent pelisse lined with squirrel fur for the occasion. He wore a leather aviator's helmet on his head, from which his poet's hair escaped. . . . In Marseilles, we came straight into the Colonial Exposition. Breton purchased a stuffed armadillo there. He visited the city, including the red-light district, carrying the animal under his arm, and in this array achieved an unbelievable success. As he was not responding to the advances of the prostitutes and was looking at them them uncomfortably, one of them came up to him and, by way of a joke, took off his headgear. Breton was quite bothered and beseeched Picabia to intervene, not having the authority to do so himself. (L'Anneau de Saturne, p. 161)

TRAVEL SOUVENIRS: THE COLONIAL EXPOSITION OF MARSEILLES

"Ah, if the Negroes were still there."

We have roamed from country to country, wearily examining those bookmakers' bindings; not a single woman to be seen, men selling stuffed animals at a reduced price: a little armadillo for twenty francs, kingfishers for fifteen francs. André Breton buys an armadillo. As if it were a dog, he puts it under his arm, pets it, warms it under his magnificent pelisse; and then, the only miracle since the beginning of the world: the armadillo comes back to life, jumps to the ground, goes to sniff at the feet of an indigenous watchman in a large red, green, blue, yellow, violet, and black suit. A gentleman present at this scene, tremendously interested, offers to buy Breton's armadillo for five hundred francs; Breton hesitates, but his wife urges him to accept, saying that she only likes animals when they're "stuffed." The gentleman grabs the docile armadillo and we are then dismayed to see that it is still stuffed! The gentleman is furious: he arms himself with a knife and brutally opens the animal's stomach; hundreds of dollars spill out, as well as little white butterflies, on the wings of which one can read printed by way of advertisement: *Mills and Co. Bank.* Imagine our alarm!

Mme Mills, who is with us, explains the phenomenon to us by the fact that her husband is named Gascon!

Recovering rather quickly from this initial fright, we continue traveling through this loathsome cemetery whose corpses we are.

Indo-Chinese lanterns light our way under an umbrella. Soon, following a tremendous rain shower, we see the palaces of Conakry and

Ziguinchore, the Moroccan souks, the Annamite shops and the merchant of Turkish Delight all disappear under the sand; there remains nothing before us but an immense velodrome in the center of which, a little to the right, a small restaurant stands, from which the resounding music of a jazz band can be heard.

Four head waiters offer to serve us and persuade us to have dinner, maintaining that only there will we be able to taste the specialties of the country.

We are puzzled by a coming and going of cyclists in black outfits; these are, apparently, waiters who serve on bicycles going at top speed.

We are the guests of our friend the American banker; during dinner, he tells us the story of his life, his work, and his future. He also says to the lady sitting next to him: "How young you are!" To me: "I am French," and to Breton: "I've been all over the world." And all of us think to ourselves: the world is like the Exposition of Marseilles, it is only beautiful when seen in *L'Illustration*.

A friend had told me: "Since you are going to Havana, I would love it if you brought me back one of those birds they call parrots. I live alone and it would be like a companion."

In Cuba, I forgot the bird and tried to make up for this absent-mindedness when I arrived at Barcelona, but I was dumbfounded by the prices they were asking for the "loritos" and abandoned the purchase.

As my friend had never seen a parrot, I had the idea of buying an owl for a modest price and made a present of it to him. He was delighted and immediately asked me if the bird talked: "Not yet," I told him, "but he listens, he listens wonderfully . . ."[1]

Paul Morand[2] writes on Sundays for avant-garde reviews—I really like this weekly inspiration; all week he belongs to the rearguard but on Sunday . . . Dear Monsieur, you would do better to have a little more imagination the rest of the week and use Sunday to pray in the company of Léon Daudet[3] so that your fame lasts forever, which would greatly surprise me.

"Souvenirs de voyages," in *Littérature*, 2nd series, no. 8 (Paris, 1 January 1923), pp. 3–4.

[UNTITLED]

It is the blind who have found that fortune is blind.

Monsieur Philippe Soupault is an aristocrat who doesn't like the smells of food he is not afraid to eat.

They've just created an order for the dead. Every ten years a commission will open the coffins and the corpses best preserved against maggots will be decorated with the white cross. They'll pin it in place of their nose.

Littérature, 2nd series, no. 8 (Paris, 1 January 1923), p. 13.

The title of "Thank You Francis!" ("Francis Merci!") continues the joke from Picabia's painting *Chapeau de paille* (described in the note to "Hurdy-Gurdy").

THANK YOU FRANCIS!

We should get to know everyone, except ourselves; we shouldn't even know what sex we belong to; I've stopped bothering to know whether I am male or female, nor do I hold men in higher esteem than women. As I have no virtues, I am assured of not suffering from any. Many people seek the road that can lead them to their ideal: I have no ideal; the individual who parades his ideal about is simply a social climber. I'm probably a social climber as well, but my social climbing is my own invention, a subjectivity. Objectivity would consist of getting myself decorated with the Legion of Honor, of wanting to become a minister or of aspiring to the Institute. Whereas for me, all of that's shit!

What I like is inventing, imagining, creating a new man out of myself at every moment, then forgetting him, forgetting everything. We should secrete a special eraser, rubbing out our works and any memory of them as we go along. Our brain should just be a black and whiteboard, or better yet, a mirror into which we look at ourselves for a moment so as to turn our

back to it two minutes later. My ambition is to be a sterile man for others; any man who collects a following disgusts me, he gives his gonorrhea to artists for nothing and sells it to art lovers for as much as possible. Writers, painters, and other such idiots have passed the word around to fight against "monsters," monsters that don't exist, naturally, since they're purely invented by man.

Artists are afraid, they mutter words into each other's ears about a bogeyman who could very well prevent them from making their bits and pieces of garbage! In my opinion, there has never been an era as stupid as ours. These gentlemen want to make us believe that nothing more is going to happen; the train is apparently moving backward, it's very pretty to look at, the cows gaping at it from the pastures are no longer enough! And the travelers aboard this retreating Decauville are named Matisse, Morand, Braque, Picasso, Léger, de Segonzac, etc., etc. The funniest part of it all is that they accept Louis Vauxcelles as their stationmaster: the man whose swollen black briefcase holds nothing but a fetus!

Ever since the war, a feeling of heavy, stupid morality has been prevailing over the entire world. Moralists never make out the moral facts of appearances: for them the Church is a moral like the moral of drinking water, or of not washing one's ass in front of a parrot! All of it is arbitrary, moral people are not well informed, and those informed know that others will not get informed.

There is no moral problem; morality, like modesty, is of the utmost stupidity. The fundament of morality should take the form of a chamber pot: that's all the objectivity I ask of it.

This contagious illness we call morality has managed to contaminate all so-called artistic circles: writers and painters are turning into serious people, and soon we will have a Minister of Painting and Literature—and I expect there will be even more appalling bullshit than that! Some poets, not knowing what to say anymore, turn Catholic, others become believers; these men manufacture their pieces of tripe the way Félix Potin manufactures cans of cold chicken; it has been said that Dada is the end of romanticism, that I am a clown, and they cry out long live classicism, which has to save pure souls and their ambitions, modest souls, so dear to those suffering from delusions of grandeur.

Even so, I still have hopes that nothing has yet ended; there remain myself and a few friends who have a love of life, a life of which we know nothing, and which interests us for this very reason.

"Francis merci!" in *Littérature*, 2nd series, no. 8 (Paris, 1 January 1923), pp. 16–17.

In regard to the subject of the following (undoubtedly fictitious) dream account, Aragon mentioned in *Paris Peasant* that Picabia "occasionally puts up at a hotel for transients, in the Rue Darcet, basing his affection for it on the fact that shoes are never to be seen standing outside the bedroom doors" (p. 16).

ELECTRARGOL

Sixty-four pairs of boots! Two pairs at each door, one feminine, the other masculine! My dream had led me into a long corridor, with a red carpet and white walls . . .

Given the order of these boots, which seemed immutable, I was unable to resist: I piled them all up, any old how, and carried them into a big building where every evening I mixed up the order of the pairs of shoes in front of each door; sometimes four men's boots would be in front of a bedroom, further on two little patent leather shoes, side by side with satin shoes, further on, slender golden buskins teamed up with heavy foul-smelling hunting boots made of fake leather; the following evening lent itself to another combination, and so on. The next morning, I was walking along the balcony onto which all the rooms of the building opened, and I was surprised to breathe in wonderful fragrances through the closed shutters. I thus had the illusory impression that I'd created a bit of happiness around me.

The idea finally came to me one evening to put the shoes and boots back in the same order that I had seen them the first time in the hotel corridor; I was not surprised, when I took my morning walk along the balcony the following day, to detect amidst the subtle fragrances emanating from the rooms the sickly smell of chocolate. The sweet silence of the previous days was disturbed by the sound of belligerent voices endlessly discussing numbers . . . Irritated, I gathered the shoes together again and when I passed by a river, quickly hurled them into the water. Some plunged in courageously, whereas others just floated like dead dogs, and still others clung to the shore. The first ones to reach the sea were placed on the end of poles and now serve as landmarks for fishermen. They look like the great men of public monuments.

There are now sixty-four people throughout the world who walk with their feet bare, who shall never be able to put on either shoes or boots. I run into some of them from time to time and they look at me with much love in the depths of their eyes (but even so a bit of reproach), and they seem to say to me: why did you hurl our happiness into the water after letting us taste it, why did you stop caring about us?

The curious part of this little story is that I dreamed it in a brothel in which I was living with my wife and in which I never once saw, the entire week we were there, a single pair of boots outside the doors!

"Electrargol," in *Littérature,* 2nd series, no. 9 (Paris, 1 February–1 March 1923), pp. 14–15.

[UNTITLED]

There is only one way to save yourself: sacrifice your reputation.

I met a man the other day claiming to be an aviator; I've since learned that he was an elevator attendant.[1]

Littérature, 2nd series, no. 10 (Paris, 1 May 1923), p. 13.

The second-to-last issue of *Littérature* was devoted to poetry. Although Breton included three poems by Picabia (including "Blind Man's Bluff" and "Irreceptive"), he did not include the drawings he had asked Picabia to submit, nor Picabia's poem on his uncle's death. Tensions between the two would escalate as Surrealism began taking form.

BLIND MAN'S BLUFF

Chance is a cigarette
that makes you hungry.
Friends gesticulate
like wrinkles.
On a hearse passing by
I read:
he's dead
because he didn't drink enough,
he's dead
on one leg
made from a billiard cue;

when he was alive
we put chalk
on the tip
to keep him from slipping;
he died
during vacation
at the end of a rope
signed "report";
between the Azores and Lisbon
an American schooner
carries his fortune
over the dead calm
of experts.
The future is a monotonous instrument.
Hôtel de la Bertha, 23 June 1923

"Colin-Maillard," in *Littérature,* 2nd series, nos. 11–12 (Paris, 15 October 1923), p. 22.

IRRECEPTIVE

In the mouth a prodigality,
for no one,
surface, appearance at any price.
Why speak in a popular manner?
I am always at the door,
at the bottom of the earth;
the universe of morality, of morals,
for free at the tip of a creeping cereus;
what is most difficult is not understanding;
the idea in favor
is not a revelation,
history has always marched,
we cannot break its charm.
The modern idea,
Is worth: "I understood all over again";
pastries and fruit get mixed together.
Half of the world for the others,
the other half for me.

"Irréceptif," in *Littérature,* 2nd series, nos. 11–12 (Paris, 15 October 1923), p. 23.

Picabia finished his only attempt at a novel at the beginning of 1924, a sarcastic and unsuccessful *roman-à-clef* entitled *Caravansérail* (Caravansary). The loose narrative included an assortment of potshots at Breton and his friends and satirical depictions of the still nascent Surrealist movement. With typical nerve, Picabia went so far as to ask Aragon to write a preface for it. The preface was never written, and the manuscript remained unpublished until 1974, more than twenty years after Picabia's death.

Also unpublished from the same time was the following short poem. In its original version, "Tambourine" was the first line of verse, and the dedication had served as a title. Picabia had sent it to Breton for inclusion in *Littérature*, but it was not included.

TAMBOURINE

To Jacques Doucet[1]

Customs have a crafty eye
Like the stitches of a fine thread
the drunkard goes from village to village
Seeking friends
flies flutter about before dying
Like little missiles
Music passes by in the street
Our ear follows it
One must go to the end of the world
But the end of the world is bleached by the sun.
Le Cannet, 21 January 1924

"Tambourin," originally published in *Francis Picabia et "391,"* ed. Michel Sanouillet (Paris: Eric Losfeld, 1966), p. 152, note 1.

The following interview was signed by "R. J." Although of interest given its citations of some of Picabia's personal tastes at this time, this short interview is also indicative of the storm that was to soon follow the "lull" mentioned at the start of the piece. Picabia's indication of an approaching "movement" to be taking place "apart from those who are trying to fabricate it" refers to the nascent Surrealist movement that he would attempt to take over in his next issue of *391*—an ultimately fruitless effort that would do little more than seal the end of his friendship with Breton.

His tastes here are typically conflicting and self-serving: his roots in abstraction are still evident in his citation of Kupka, and the status of several friendships are evident in his dismissal of Cocteau and his former collaborator (and possible mistress) Laurencin. Pierre Benoit, a prolific and popular novelist in his

time, though forgotten today (and not to be confused with Pierre-André Benoit, who would in later years become Picabia's devoted publisher), gets a thumbs down, whereas Breton (whose activities Picabia is almost certainly intending to sabotage at this point) gets a thumbs up. The fact that Breton's *The Lost Steps* contains an essay devoted to Picabia, of course, probably helped to get this book's title included in the favored list.

Picabia's concluding statement on Lautréamont cannot be taken seriously, and is only meant to one-up Breton and company's passion for the poet. The same can be said for his dismissal of Saint-Pol-Roux: Breton had dedicated his recent collection of poems, *Earthlight,* to the Symbolist poet, whom the Surrealists as a whole admired both for his mastery of the image and for his self-exile to a castle in Brittany.

Also worth noting is the formal address of "mon cher maître" on the part of the interviewer; though this may have been added after the interview had taken place, it still betokens an unrelenting spirit of contradiction: a few years earlier, Picabia had stated "I don't belong to the group of imbeciles who have themselves called *mon cher maître*" (*Écrits: 1921– 1953 et posthumes,* p. 33).

WITH FRANCIS PICABIA

What think you, mon cher maître, *of the current lull?*
I don't consider it to be so much a lull as general impotence. Some people have a desire for love, and when they don't find a trade in a young mistress, they return to their previous "collage."[1] With an artist, it is his ascending element alone that interests me, his scandalous element . . .

Is there not precisely a certain fear of this scandalous element among younger artists today?
No, but they've attained success and have no more need of scandal. They are immediately carried off by editors and art dealers and presented as new geniuses. Artists nowadays get married right away and have children who have nothing monstrous about them.

Is there a new movement brewing?
Inevitably! There is always a movement, but it is impossible for me to be more specific about it for you. What I can tell you is that it will take place apart from those who are trying to fabricate it. Artificial eggs don't produce chicks.

Would you name for me, mon cher maître, *the painters you hold in esteem?*
With pleasure: Kupka; Marcel Duchamp, although he is no longer painting; Man Ray. With Braque, there is an aspect to his nature that I like tremendously. Metzinger isn't lacking in interest either. Marie Laurencin

was once able to be interesting, but all the high society, nobility, silk stockings, and furs made her lose her way.

May I also ask who your favorite musicians are?
There are only two: Erik Satie and Stravinsky. I love Auric's wireless telegraphy. Milhaud seems to be OK. Yvain and Christiné are great. One thing that would please me would be if jazz replaced organs in churches. That would be amusing for a couple of hours.[2]

At the risk of bothering you, I'm eager to ask who the writers are that hold your attention?
I will name for you those I find to be dreadful: Paul Morand, Jean Cocteau, Radiguet, Pierre Benoit, Giraudoux, Delteil, etc. A writer I do like is Gustave Le Rouge.[3]

I like *The Lost Steps* by André Breton, who would interest me anyway since he is my friend. I also like Pierre de Massot and have decided to give him a lot of credit.

Don't you like Lautréamont, Nouveau, Saint-Pol Roux, etc.?
I read Lautréamont when I was nineteen and it bores me to talk again about a man whom my friends have discovered twenty-six years later. As for Saint-Pol Roux, I detest what he was able to do and he was right to shove off to Brittany . . .

"Chez Francis Picabia," in *Paris-Journal* (Paris, 9 May 1924), p. 5.

Less than two weeks after the preceding interview, Picabia put out the first issue of *391* to appear in three years (the last one had been the *Pilhaou-Thibaou*). Starting with this issue, Picabia would henceforth use it as an instrument against the rising Surrealist movement. The next three pieces, published together, were intended to mock the parlor games in which the Surrealists were then engaged: their chain games in the case of the first and third, and the acrobatic wordplay of Robert Desnos (and, by implication, if not intention, Duchamp) and Roger Vitrac in the second.

The titles, although evoking Picabia's earlier reference to "isotropic" poetry, seem also to hearken to a phrase from Tzara's 1919 "Unpretentious Proclamation" (a piece contemporary with his first meeting with Picabia): "Hypertrophic painters hyperaestheticised and hypnotized by the hyacinths of the muezzins of hypocritical appearance" (*Seven Dada Manifestos*, p. 15). The adjective form of the word "hypertrophy," it should also be noted, is very evocative of the vocabulary of Jules Laforgue, who associated the word with an aggrandization of the ego, but whose poetic-scientific vocabulary was also an influence on Duchamp, and hence possibly on Picabia as well.

POETIC HYPERTROPHY

The dog left the house, but my parents are sick.

The piano's out of tune, but my uncle lost his handkerchief.

The silverware is finished, but there's no more jam.

The fish is fresh, but my aunt's eyes ache.

One should say that the toilet is in the house and not that the house is in the toilet.

The gorgeous maid just arrived, but my father was not appointed minister.

The boat is not repaired and the bike is in the lake.

The lentils are cold, but I don't have my underpants.

TOBACCO

Armor is the lard of saying art.

The peace sign pissed on Passy.

·The taboret is tobacco like a tableau.

The powwow had Paul on the pole.

Herbs are hermetic in Erblay.

The oak oath is ok.

The pendulum pants pound the peacock.

The soupy soutane smiles under the table.

The follicular photography is frisky.

The carpet carpets the pets of the lazuli tapir.

The glycine glistened in the glycerin.

TROPHIC HYPERPOETRY

Mom drained the cesspool, but she refilled the tooth glass.

The tooth glass is pink, but Dad is no longer constipated.

The child is constipated, but the clock is right.

The clock is constipated, but the child is late.

The late train bothers me, but the airplane circulates.

The airplane is high up, and the policeman holds back the crowd.

The crowd is black, but I'm going off on a trip.

A ton of aunts taunting so many tawny awnings . . . to flee.[1]

Hey, I ate a date a day . . . of greenish hue.

CATTAWI-MENASSE[2]

"Hypertrophie poétique," "Tabac," and "Hyperpoésie trophique" in *391*, no. 16 (Paris, 20 May 1924), p. 3.

The next issue of *391* announced the end of Picabia's friendship with Breton. Page 4 contained a letter from Breton entitled "A Letter From My Grandfather," which read as follows:

Paris, 5 May 1924

My dear friend,

I am leaving Paris for a few days, but could not help but tell you right here and now what a surprise it was for me to hear of 391*'s reappearance and how I perceive the terms of your communication to the papers.*

I have no intention whatsoever of distracting you, or advising you; you know what reservations I have on your recent activities, on the very meaning of this activity (Montparnasse, the Ballets Suédois, a rather boring novel, Paris-Journal, *etc.). I would abstain from expressing myself so clearly on this subject, in view of the profound respect and affection that I shall hold for you despite everything, if this morning's* Journal du Peuple *had not inflicted your latest little ranking on me. I see no point in telling you that I decline your cordial invitation with all my heart, as I shall urge all my friends to do. May the old posturings of Satie, you have thus found Huelsenbeck, bravo Rigaut, etc., compensate you for our refusal.*

Your friend:

ANDRÉ BRETON

Picabia's announcement of *391*'s reappearance had been a blatant effort to get under Breton's skin: declaring the journal's consecration to Surrealism, the "master of the house" invited Breton and his cohorts to contribute to it. (In the previous issue of *391*, Picabia described himself under his signature as "Director of André Breton's Surrealism.")

Breton's reference to the "Ballets Suédois" is to Picabia's involvement with *Relâche*, and the "boring novel" refers to *Caravansérail* (a boring novel indeed).

Picabia's reply followed directly on the same page.

[REPLY]

REPLY: "When I smoke cigarettes, I'm not in the habit of keeping the butts."

391, no. 17 (Paris, 10 June 1924), p. 4.

TWO of the aphorisms also included in this issue would crop up again twenty years later in the first stanza of the first poem of *Thalassa in the Desert*. Given that Nietzsche's *The Gay Science* would play such a predominant role in Picabia's writing twenty years later, it is noteworthy to see him borrowing phrases from it this early on.

391

Our genitals should always be casting a shadow on our stomach.

Jews have their noses in the air, Christians have them down.

I am a monster who shares his secrets with the wind.[1]

Men earn diplomas and lose their instinct.

The only way to have a following is to run faster than the others.[2]

The most beautiful book would be one that could not be considered as a book.[3]

What I love least in others is myself.[4]

The impotent always grovel before the past.

I like pederasts, because they don't make soldiers.

The unknown is an exception, the known a deception.

The first phallus was Adam's rib.

The other evening, as a friend and I were leaving a little restaurant in Montparnasse, we saw the moon in the sky, shining with a most intense brightness: "That's my star," said my friend.[5]

"391," in *391,* no. 17 (Paris, 10 June 1924), p. 4.

L'Ésprit nouveau devoted an issue to Apollinaire. Contributors apart from Picabia included Pierre Albert-Birot, Paul Dermée, Picasso, and Tzara. It is typical that Picabia was unable to pay homage to Apollinaire without first taking a few stabs at his expense (not to mention utilize him to make others such as the Delaunays look ridiculous).

GUILLAUME APOLLINAIRE

We were very close, very close friends, Guillaume Apollinaire and I; if our friendship cooled a little at the very end of his life, that was solely due to a question of "uniform."

Everyone has their weaknesses. Guillaume Apollinaire had let himself get a little carried away with his official side, the side of the "stripe." The prospect of a possible Legion of Honor haunted him; he had confided as much to me and asked if I couldn't find some support among my connections that would aid him in obtaining this distinction. I replied that I would do everything possible to ensure that he never be awarded it!

We were together a lot those last two years preceding the war; we met almost every evening to go smoke opium with friends; in those days it was quite amusing to hear gallant Guillaume engage in interminable discussions with little society women, or particularly Montmartre and Montparnasse women, on the charm of literature or love!

We often went out by automobile, he adored that, and one evening when we were at the Bar de la Paix, in the company of Claude Debussy and P. J. Toulet, I suggested to Apollinaire (who had imbibed, as had I, numerous cocktails), that we leave for Boulogne, and from there embark for England; we arrived at the port just in time to catch the boat, which was leaving at first light. I had no anxiety about the trip, as Guillaume had assured me that he spoke English wonderfully well; but once on board, when I asked him to have them serve us some breakfast, he found it impossible to make himself understood: he then confessed that he only spoke "old Irish"!

We stayed five days in Hythe, and thanks to his extraordinary memory, when we came back he was speaking English as well as . . . myself!

This trip remains one of the good memories of my life, I've never had a cheerier, wittier companion, or one with as much spirit as Apollinaire.

Another time, when we were dining together, he told me he was in a great hurry as he had to give an important lecture that evening; I, on the other hand, felt a desire for the open air: "Come on," I told him, "don't be stupid, forget your lecture, we're going for a drive." He began to laugh like a madman; I can still see his elegant hand in front of his mouth and his little round finger, slightly separated from the others. His laughter was an acceptance, but even so he said to me: "Delaunay is going to be furious, I promised I would talk about him, and say that his wife embroidered some little 'simultaneous' curtains, you know, the ones that decorate my study! . . ." We went to Chartres; he was delighted to have played this trick on the audience, like a schoolboy who plays a practical joke on a supervisor.

Some time after, Guillaume Apollinaire came to spend several days with me in Etival, in Jura, in the company of Marcel Duchamp. All three of us made the trip there by automobile, at night; the whole way Guillaume sang a nice song that he had thought up:

> *Tanguy du Gana*
> *N'as-tu pas vu mon gas*
> *Qui jouait de la trombona,*
> *Qui jouait de la flûte à mes gas*
> *Qui jouait de la flûte!*[1]

We spent two weeks there; we discussed cubism, the possibilities of a new evolution. Apollinaire would certainly have been Dada, like Duchamp and myself, if he hadn't died so prematurely.

He had an amazing talent for jackstraws. We spent hours playing it almost every evening and he beat us regularly. We also took several walks. One day, in the midst of a small uphill climb, Guillaume was overcome by such vertigo that he lay down on the ground and declared that he was unable to move forward or go back! What finally induced him to make the necessary effort to get back to the house was our absolute assertion that he was only going to die of hunger if he stayed there. His appetite was tremendous, but he would never accept such a remark from his friends— he would claim that it was theirs that was bad!

He had extraordinary knowledge in botany and was even capable of inventing new names for plants if he needed.

Like a child, he enjoyed everything without ever seeing the bad side of things; I remember once going to see him and finding him in a furniture mover's outfit in the company of Raynal;[2] they were both endeavoring to get large pieces of furniture into a room whose doorway was too small. Guillaume didn't hesitate to break the furniture apart so as to insert them "in little pieces"!

This same evening, he was to dine at the home of Victor Margueritte;[3] at the last moment, he was running late: impossible to find his dress tie! After looking everywhere, we saw all the ties, together in a bottle! Guillaume had stuffed them in there so as not to mislay them. Both of us took turns trying in vain to remove them with the help of a corkscrew: the bottle was precious and Apollinaire didn't want to settle on sacrificing it, so I painted a pretty bow on his shirt in Indian ink; he was delighted by it.

My memory of him is of a great purity of heart, of a great simplicity that really bloomed only in the intimacy of his friends, outside any "gallery."

As for his work, I consider it to be at once full of inventiveness and most intelligent. He is a friend whom I deeply miss; he had the incomparable charm of never committing himself to being compromised.

"Guillaume Apollinaire," in *L'Ésprit nouveau*, no. 26 (Paris, October 1924).

The final issue of *391* announced Picabia's long-awaited (and short-lived) replacement for Dadaism. "Instantanism," however, proved to be little more than a sarcastic attack against Breton's Surrealism, and Picabia's proclamation was about as far as the movement went, although he would designate *Relâche* as an "Instantanist ballet." "For the sake of future historians of the theater," René Clair later commented, "I must add that no one has ever known exactly why this ballet was 'instantanist'" (Clair, *À nous la liberté*, p. 109).

Picabia signed an aphorism by Nietzsche in this same issue as "An Instantanist." Raoul Hausmann had proclaimed his own post-Dada activity in 1921 as "Presentism": "an elevation of the so-called sciences and arts to the level of the present" (Benson, *Raoul Hausmann,* p. 195). Whether Picabia had kept himself up to date on the former Berlin Dadaist, though, is uncertain.

DADAISM, INSTANTANISM

Journal of Instantanism
FOR A WHILE

THE INSTANTANIST IS AN EXCEPTIONAL, CYNICAL,

AND INDECENT BEING

THE ONLY MOTION IS:
PERPETUAL MOTION!

INSTANTANISM: IS FOR
THOSE WHO HAVE SOMETHING TO SAY.

In its next issue "391"
will provide a list of foremost
Instantanists, exceptional men.

THERE IS ONLY ONE MOTION:
AND THAT'S PERPETUAL MOTION!

INSTANTANISM : DOES NOT WANT YESTERDAY.

INSTANTANISM : DOES NOT WANT TOMORROW.

INSTANTANISM : LEAPS ABOUT.

INSTANTANISM : DOES PIGEONWINGS.

INSTANTANISM : DOES NOT WANT GREAT MEN.

INSTANTANISM : BELIEVES ONLY IN TODAY.

INSTANTANISM : WANTS LIBERTY FOR ALL.

INSTANTANISM : BELIEVES ONLY IN LIFE.

INSTANTANISM : BELIEVES ONLY IN PERPETUAL MOTION.

"Dadaisme, Instantanéisme," in *391*, no. 19 (Paris, October 1924), p. 1.

[UNTITLED]

Vices are dignified, virtues undignified.

Leaders always have bad manners.

It is necessary to do something, but not to think about doing something.

Idiots think that memory is a part of knowledge and life.

391, no. 19 (Paris, October 1924), pp. 2–3.

Entr'acte was a two-part film intended to both introduce Picabia and Satie's ballet *Relâche* and serve as its intermission. The film was directed by René Clair, with accompanying music by Erik Satie (who created for it the first "shot by shot" musical composition for the cinema). When Clair later restored his film, he joined the "prologue" (which he had formerly believed to be lost) to the main body, and the two parts are now shown as one. The original scenario remained unpublished until 1968.

SCENARIO FOR *ENTR'ACTE*

Curtain rises
Satie and Picabia load cannon in slow motion, the shot should make the biggest noise possible. Total duration: 1 minute.

During the entr'acte
1. Boxing bout with white gloves against a black screen: duration, 15 seconds. Projection written for the explanation: 10 seconds.[1]
2. Game of chess between Duchamp and Man Ray. Stream of water maneuvered by Picabia sweeps away the game: duration, 30 seconds.
3. Juggler and père Lacolique: duration, 30 seconds.[2]
4. Hunter fires at an ostrich egg on a stream of water maneuvered by Picabia, who sweeps away the egg which lands on the head of the hunter; a second hunter fires at it and kills the first hunter; he falls, the bird flies away: duration, 1 minute. Written projection: 5 seconds.
5. 21 people lying on their backs display the bottoms of their feet: 10 seconds. Handwritten projection: 15 seconds.

6. Female dancer on a transparent sheet of glass, filmed from below: duration, one minute. Written projection: 5 seconds.

7. Inflation of balloons and rubber screens, on which faces will be drawn, accompanied by inscriptions: duration, 35 seconds.[3]

8. A funeral procession: hearse pulled by a camel, etc.: duration: 6 minutes. Written projection: 1 minute.

"Scénario pour *Entr'acte*," in *L'Avant-scène,* no. 86, November 1968, p. 11.

Relâche was performed by the Ballets Suédois, with music by Erik Satie. Cendrars's original title, which figures on the original manuscript and is crossed out by Picabia, was "After Dinner." As one can tell from the notes for the film and the presence of Cendrars's name on the backdrop, not everything here had been finalized. There are also a few details that have carried over from Cendrars's original conception, such as the use of a revolving door. The fact that a good deal of the music takes place when dancing has ceased betrays the influence of Satie's "furniture music," previously ridiculed by Picabia.

RELÂCHE

White curtain, flat. Film projection to be decided, around thirty seconds or thereabouts, accompanied by music. The curtain rises; the stage appears like an ovoid archway, completely covered in big white balloons. White carpet. A jointed revolving door in the back. The music lasts another thirty seconds after the curtain rises.

A woman gets up from the orchestra stalls; she is grandly dressed in an evening gown; she climbs onto the stage with the aid of a gantry. Music: 35 seconds. The moment she appears on stage, the music stops.

The woman halts in the middle of the stage and examines the scenery, then stands still. At this moment, the music resumes for about a minute or so. When it stops, the woman begins to dance. Choreography to be determined. The music resumes for a minute and a half; the woman returns to the back of the stage and makes three passes through the revolving door, then comes to a halt, facing the auditorium.

During this time, thirty men in black dress, white tie, white gloves, and hat applaud and leave, one after the other, their spectator seats, climbing alternately onto the stage by means of the gantry. Duration of the music: a minute and a half.

The music stops the moment, through a dance to be determined, they surround the woman who has returned to the middle of the stage; they turn around her while she undresses and appears in a completely skintight pink silk leotard. Music for 40 seconds. The men move away, line up against the scenery; the woman stays motionless a few seconds while the music resumes for 35 seconds. Some balloons burst in the back.

General dance; the woman is carried away into the arches.

CURTAIN

NO INTERMISSION, strictly speaking; the music lasts five minutes with film projections of the authors seated face to face, engaged in conversation, the text of which is inscribed on the screen for ten minutes. No music during the written projection.

SECOND ACT

The curtain rises. A minute of music. Luminous and intermittent signs are set against a black background, on which the names of Erik Satie, Francis Picabia, and Blaise Cendrars stand out, one after the other, in color.

Two or three powerful, very powerful, projectors are directed from the stage to the auditorium; they shine down on the audience and produce black-and-white effects with the aid of disks pierced with holes. The men come back one by one and stand in a circle around the woman's clothes, placed on the ground in the middle of the stage. Twenty seconds of music.

The woman comes down again from the arches, still in leotard; she wears a crown of orange blossoms on her head; she puts her clothes back on while the men undress in turn and appear in white silk leotards. Music for twenty seconds. Dances to be determined.

One by one the men go back to their places where they find their overcoats. Thirty seconds of music. The woman, alone, takes a wheelbarrow, heaps the clothes left by the men into it and goes to tip them into a corner in a pile; then, approaching the proscenium as closely as possible, she takes off her bridal crown and throws it to one of her dancers who will go to set it on the head of a well-known woman in the auditorium.[1]

Music: fifteen seconds.

Then it is the woman's turn to return to her seat; the white curtain is lowered, before which a petite woman appears who dances and sings a song.

Music: 45 seconds.

First published in *Francis Picabia et "391,"* ed. Michel Sanouillet (Paris: Eric Losfeld, 1966), pp. 256–257.

INTERVIEW ON *ENTR'ACTE*

"Current cinema doesn't interest me: calendars, postcards, Henry Bordeaux,[1] André Gide's antiquated psychology, wishes for the new year, sentimental speculations for sickly adolescents or misshapen virgins! Not interesting.

"What I love are races across the desert, savannas, horses bathed in sweat. The cowboy entering through the windows of a bar-saloon, breaking windowpanes, the glass of whiskey emptied at a right angle into a hearty gullet, and the two brownings aimed at the villain: all of that punctuated like a gallop, accompanied by whip crackings, curses, and gunshots.

"Or else the image in freedom, the intrinsic value image, leaping on the screen: that's what we've tried to do for the Ballets Suédois, who are going to insert into *Relâche* (a ballet by Erik Satie and myself), a film directed by René Clair entitled *Entr'acte*."

"You say that they're going to hiss? All the better! I'd rather hear them cry out than applaud."

Comœdia (Paris, 31 October 1924), p. 4.

INSTANTANISM

Bankers are artists and artists are bankers; grocers are writers, writers are grocers; the cinema is theater, the theater is cinema; doctors are patients, patients are doctors. Doctors pass on their contagious diseases to us just as the theater has unfortunately given the cinema its inveterate diseases. The theater is to the cinema what the candle is to the flashlight, the ass to the automobile, the kite to the airplane.

In my opinion, we have to forget what was done yesterday, our behinds can contemplate the respectable past on their own! The public loves the cinema, it loves it more and more, through disgust for the theater and for the banality of life; really, once we emerge from the idiocy of politics and the useless cruelty of wars, our present-day life seems terribly sad and monotonous; love itself, the only belief left to us, becomes more and more a question of money for the majority and there will soon be no one but those living the "high life" who'll take an interest in it, for such people love life and prefer the fever of baccarat to the dullness of the savings bank and the *Crédit Lyonnais*.

The cinema should also give us fever, should be a sort of artificial paradise, a promoter of intense sensations exceeding the airplane's "looping the loop" and the pleasure of opium; for that it should turn to the spontaneity of invention, which will always be more alive than the stupidity of a beautiful photograph, thanks to which unfortunate actors manage to resemble characters from the *musée Grévin*[1] exhumed by official convention . . .

The cinema must be not an imitation but an evocative invitation as rapid as the thought in our brain, which has the faculty of transporting us from Cuba to Bécon-les-Bruyères, of making us leap onto a bolting horse or from the top of the Eiffel Tower . . . while eating radishes! The film that makes us stay seated for two or three hours just to recount to us the loves of a young chaste girl and a well-mannered, literary, pimping hack, or to show us some religious, military, or political procession in the rain, or even a cloudy sunset—that film is a dead leaf, let's speak no more of it, it is an evolution from the magic lantern. The cinema is only now about to commence, it is going to commence with men like René Clair, for example, who has understood all its new possibilities, like Daven, who will be an invaluable assistant; I hope in this way that five or six of us (all the better if we are more numerous) will manage to make films that will not be American, nor Norwegian, nor French, but international, and by that I mean films expressing all the evolutions of our era, its desires, its needs. We don't go to the cinema looking for our bedside table, our slippers, our stove, or our checkbook; we go to forget all of that to whatever degree possible and in that way take the kind of indispensable rest that only distraction and laughter provide.

There have been many amusing films in America, very few in France; Germany presented *The Cabinet of Dr. Caligari* to us as a masterpiece—a pretty stupid film to my mind. In Spain, in Italy, the only things they put on the screen are knives, tuberculosis, and poison—what a drag it all is!

But it seems to me that I've said enough; to be understood, it is still best to show something; at the risk of this passing for publicity, I feel no compunction in asking all those interested in the cinema to go to the Théâtre des Champs-Élysées and see the film *Entr'acte,* which is showing in the middle of the ballet *Relâche.*

"Instantanéisme," in *Comœdia* (Paris, 21 November 1924), p. 4.

Picabia conceived the following cinematic sketch for the stage as a sort of follow-up to *Entr'acte,* and it shares a number of elements with that work: the dancer Börlin disguised as a ballerina, the hunting rifle, a madcap chase scene, and a group vanishing act as a conclusion. Very little is known about this work, as it was performed only once, and little documentation of it remains. In a letter to Marcel Lévesque (who would play a role in the sketch), Picabia described the work as follows:

My dear friend, the sketch will be the story of a man driven mad. (Marcel Lévesque) (my apologies!!!) enters every house at night, hoping to find his wife who has left him for another lover. One evening, just by chance, he enters the house where the lovers are—the entertaining aspect of the event is that the wife's lover is a sleepwalker. The lover and the madman find themselves face to face and the latter is utterly mesmerized by the sleepwalker, who is naturally unaware of the effect he is having and is just following his own crazy, obsessive notion, which I will mention in the scenario. There will be nine characters, two of which will be important roles for women.

The idea behind this sketch is a parody of the cinema, transposed to the theater and made up of "slow motion," "speeded-up motions," simultaneity, lightings that I'll indicate later on. . . .

SCENARIO FOR *CINESKETCH*, 1924

SCENERY
A long hallway running from a bedroom on the right to a kitchen on the left. In the bedroom: a bed, a wardrobe, chairs, tables, armchairs. In the kitchen, the usual furnishings plus a large wash tub.

CHARACTERS
> A lady
> The lady's husband
> The lady's lover
> The lover's lawfully wedded wife
> A maid
> A thief
> A police officer

These characters will have to wear four costumes to allow for as much simultaneity as possible.

Black-and-white city costumes, providing as much of a photographic appearance as possible; these costumes will have to be comical, with exaggerated makeup. The thief will wear a mask with a black velvet eye mask over it.

At the beginning of the sketch a lady is lying on the bed reading, and then falls asleep. The thief enters through a door in the back and advances cautiously, revolver in hand, all the way to the door of the kitchen, which

he opens very slowly; the light turns on and the thief shows dismay at finding himself in the kitchen.

The woman, having heard some noise, wakes up; she thinks that it is her husband come home, she powders her face and then seems to be waiting for the door to the bedroom to open. The thief slowly enters the bedroom; the woman sees him come in. She takes a revolver from under her pillow and shoots six times at the thief, who is not in the least frightened and continues to approach on tiptoe. The lover comes by the same hallway and sees through the half-open door what is taking place in the bedroom; he shoots six times at the thief, who again is not in the least frightened but makes a little jump at each shot. The woman loses her head, runs about the bedroom in every direction, and takes refuge in the kitchen, where she grabs hold of an enormous cake, a kind of wedding cake, and prepares to throw it at the thief's head; but while the latter is in the bedroom reading the book the woman had started, the lover's lawfully wedded wife (who had followed her husband) enters the kitchen, gets the cake right in her face and is literally covered in cream. The lover then enters the bedroom and starts to shake all over as the thief starts reading aloud to him from the book, *The Daughter Born without a Mother* by Francis Picabia. The lover faints . . .

Men walk through with signs saying: End of part one.

The characters in the bedroom are still in the same positions: the lover passed out, the thief now reading in a low voice and showing signs of mental disturbance. In the kitchen, the woman scrapes the cream off of the lawfully wedded wife with a spoon and both start eating the remains of the cake.

The woman's husband arrives via the hallway, in a driving outfit, followed by a policeman who is writing him a ticket. The police officer is armed with a hunting rifle, and is wearing a cartridge belt.

The thief, hearing some noise, enters the hallway, and is followed by the lover who has come to. A frenzied chase scene takes place throughout the three rooms, with everyone chasing the police officer.

Börlin then appears as a ballet dancer dressed in a pink tutu in the worst possible taste; he makes a few quick dance moves without noticing what is taking place around him—but he finds himself face to face with the police officer, who for no reason whatsoever arrests him. At that moment the maid enters, the police officer's girlfriend; she takes Börlin for a woman and flies into a jealous rage, but the latter takes a pipe out of

his bodice and starts smoking. The maid realizes her error and rushes to the police officer's arms, but Börlin disappears and is replaced by an actual woman. The maid doesn't understand any of it, loses her head and runs around in a circle, followed by all the others.

The husband, having the horn of his Citroën in his hands, starts sounding it without letting up. The maid takes down a guitar—or some other musical instrument—hanging from the wall as she passes it, and leads the circle while playing it, but the policeman manages to get in front of her and, to escape the maid, disappears into the washing tub, which is filled with soap suds. Everyone follows him and disappears into the tub, which has no bottom and is set over the stage trap door—black out—a clock strikes midnight, the room lights up, the woman is in her bed, she wakes up from a restless sleep, picks up the book sitting on the bed and reads a poem in a distraught voice.

END

"Scénario pour *Cinésketch*," in *Francis Picabia,* Galeries Nationales du Grand Palais, Paris, 1976, p. 133.

PICABIA TOLD ME . . . BEFORE *CINESKETCH* AT THE THÉÂTRE DES CHAMPS-ÉLYSÉES

Yes, my dear, I, Picabia, have written a revue, a sketch to be precise, to end the year on a happy note, or at least try to . . . What got into me? Well, it's very simple, here's how it started: until now, the cinema has taken its inspiration from the theater; I've tried to do the opposite by bringing to the stage the methods and the lively rhythm of the cinema.

Will there be a theme?

Yes, a little story, but decorated with lots of colorful details. I reconstructed a painting by Cranach, the only painter I find bearable these days: you'll see his evocation of Adam and Eve come to life in a kitchen. The characters will be fully nude. I'd rather tell you so right off the bat so that there is no misunderstanding. Marcel Duchamp and Francine Picabia, one of my psychic children, will bring that charming painting to life.

You will see a burglar: Marcel Levesque . . . A very elegant lover, Marcel Bain. A baroness, the baroness Doubles. That graceful person you see over there, in the first row in the orchestra, next to Jeanne Pierly and Maria Ricotti, will be for this occasion a very nice cook. There is even a husband . . .

There always is . . .

Yes, he's M. Fournier . . . Jean Börlin will be a policeman and Mlle Bonsdorff, a nude woman . . . All of it accompanied by the first-class New York jazz band, the Georgiews . . . A spraying of light over all that . . . People disappearing under showers of green, pink, and yellow lights . . . For scenery there is a kitchen, a hallway, and a bedroom, whose walls will be covered in chalk . . . There you are, you now have a very clear idea of what *Cinesketch* will be . . .

"Picabia m'a dit . . . avant *Ciné-Sketch* au Théâtre des Champs-Élysées," in *L'Action* (1 January 1925), p. 4.

SLACK
DAYS

After Dada, 1925–1939

In 1925 Picabia and Everling and their son Lorenzo moved to Mougins. His years of socializing along the Riviera were accompanied by a renewed and often intense reabsorption into painting. His writing, on the other hand, came almost to a stop during this period, and it would not be until the outbreak of World War II that he would turn his hand back to poetry.

The following snippet comes from an article entitled "Hôtes d'été" by Paul Gordeaux.

[ON LAND SPECULATION]

I, too, want to indulge in speculation. I'm going to build a fake cemetery in my garden! The neighboring plots of land will immediately depreciate in value and I'll be able to buy them at a good price. I would then only have to demolish my fake cemetery and go start the process again somewhere else.

L'Éclaireur de Nice (Nice, 6 September 1925), p. 3.

Between attending frivolous society events and working at his studio, Picabia took the time to issue the following "Profession of Faith"—a significant, if naive, statement of his individualism that switched his sights from bourgeois mercantilism to socialism.

The socialist newspaper, *L'Humanité*, would soon after launch an attack on both Picabia's "profession" and his art (in their 26 February 1927 issue).

PICABIA'S PROFESSION OF FAITH

Cold Light

Having never been a believer, I was compelled to fabricate a soul for myself because I love to love. My soul believes in me and I . . . in whatever I want!

They always told me that I was a painter—I know nothing of it; as a child I made use of colors, these colors formed a picture, then another one, and still others, but it has always been the same one. It's *Little Dog, The Carburetor Child,* it's *Parrot* or *Martigues,* it's *Seville,* it's *New York,* it's *Paris, London, Monte Carlo* or *Bécon-les-Bruyères;* it's *Udnie,* it's *Dada, Oliviers, Spanish Women;* it's the sea, the sun, a joke.

Everything can be, or not be, a joke, isn't that so? Things only have the value one gives them. All the same, we shouldn't confuse force and fashion; force rises up, fashion stays small and petty, petty like Communism,

therefore idiocy. Mussolini may be a dangerous madman, he may be disturbing, but he will always be more sympathetic to me than the effigy of a Lenin, sculpted in such a manner that men divide it up among themselves like the little lumps of sugar one gives to dogs!

I fabricated a soul for myself so that it would resemble no other, and in this way I avoid the distressing impression that I get from mass meetings, which they hold on holidays, for another ambition—also in the cellars where rats make their nests . . .

Poor revolutionaries, made in series, they carry their advertising-label like a flag; their kennels are too narrow for my wolf's soul.

Francis Picabia
11 December 1926 at Mougins A.-M.

"Lumière froide," in *Le Journal des hivernants* (January 1927), pp. 20–21.

Written on 1 February 1927, the next essay was originally titled "Rats et Papillons" (Rats and butterflies), and retitled "Une crise artistique" (An artistic crisis), before taking on its final title. "The Return to Reason" was the title of Man Ray's 1923 Rayographic film, but it is hard to say whether Picabia had intended to refer to it or not. It proved to be the last article Picabia would publish in any significant Parisian review, and was a determining factor in his coming ostracism from the Parisian avant-garde.

This article, with the preceding "Profession," constituted Picabia's farewell to the avant-garde. His physical absence from Paris (he was now in Cannes) and the conservative outlook expressed here were accompanied by his absorption of classical motifs in his "Transparencies": a signal to many that Picabia was thenceforth irrelevant in the world of painting.

PICABIA VERSUS DADA, OR THE RETURN TO REASON

A mere nothing agitates the universal bedlam that
takes on the aura of modernity.
Haven't you noticed that the world's taste
has degenerated into drunkenness.
CHRISTIAN

To my friend René Clair

Houses of reinforced concrete, the food at the Tip, rabbit-chinchilla, artificial pearls, celluloid tortoiseshell, pasteboard automobiles, camelskin

crocodile, pegamoid camelskin, fake pegamoid pegamoid: that's our era for you!

The taste, the need perhaps, for going fast, without knowing where to, with a maximum of appearances, the desire to equal and equalize, led us to the abolition of differences, to the negation of the qualities of beings and things; sensitivity disappeared, smothered under tinsel. More and more, understudies are taking over leading roles, women are assessed by the weight of their jewelry, and fake pearls weigh the same as real ones! It's the absolute reign of ersatz. But suddenly neurasthenia has appeared at its sides and it holds sway over the world; men are sad, let down by their hopes because they no longer put any ideal into them.

In their ancestral need to believe in something, they ask money to give them the illusion of love or glory. Now in my opinion, money is the best culture medium for breeding bad faith, boorishness, and prostitution, and that is because it has spread everywhere, because it is handled by clumsy hands, too weak for its strength.

And there's the wound of equality. Instead of trying to belittle the strong to aid the masses, we should facilitate their means of making the most of themselves: it's the only way of defending what is most beautiful, most sublime in life: loving.

Socialism was only invented by the mediocre and imbeciles. Do you see socialism, do you see communism in love, in art? The threat of suffering the consequences would make us double up in laughter.

The men who invented these ridiculous words were just ambitious moneygrubbers; they opened the doors to useless characters, plunderers, shameless prattlers. These days, any country in which a clan of nonentities tried to cut off the heads of those who represent force and intelligence, who represent an aspiration to something better, would be a finished country; maybe later, when the world has cooled down a lot and it's eighty-six degrees below zero! . . .

Believe me, I have no intention of talking politics, that's something I absolutely loathe, but our lives have reached this comical point at which everything is mixed up with everything else, and the arts are no exception to this law.

I invented Dadaism the way a man stands amidst a blazing fire and starts another fire so as not to get burnt, and there were several of us who gave the best of ourselves in the center of this infernal circle; now we're nearing the end of the drama, and certain people, who were only late spectators and understood nothing about it, stupidly try to imitate those

who risked everything in order to save themselves from the democratic peril of popularization; they shout themselves hoarse on the still red embers, but the fire quickly goes out, for they have no spark of inspiration.

Art cannot be democratic: do you think that the worker, who knows what democracy is, wants a democratic mug to decorate his bedroom? No! He dreams of beautiful women, of Versailles, honor and property. One must indeed aim at something higher than oneself, otherwise what good would effort be, and without effort, how establish a selection?

Mountains cannot be turned upside-down: what rises ends in a peak and there's not much space on this peak; to reach it, one must be elevated by the love one bears in oneself, which is nothing other than the desire to love; to maintain it, one must believe in one's own force. On the arid slopes leading to the summit, one shouldn't have to fear crushing reptiles, shooting the jackals following the caravan in the hope of devouring it, or at least of gorging themselves on the provisions that it has brought for the difficult journey . . . looking down from above, we can already see the clowns, dressed in black clothes, fighting over the remains we left behind us, they go fiercely and unrelentingly at the corpses of cubism and Dadaism; starved by the emptiness of their brains, they're afraid of dying of hunger . . .

They've made vices out of love, love has become a whore . . . there are also whores of art . . .

Ideal, Love: this era was a bad choice for uttering such words, the public is beginning to grow accustomed to ugly things, to acquiring an unhealthy taste for them!

Yet perhaps this is the moment to tell it the truth, to warn it; it must learn to discern the true from the false, gold from rolled gold, it must make an effort to look with new eyes, it must acquire proper control, outside of all influence, it must relearn what a beautiful form and a beautiful conscience are. Then it will rediscover the joy of living.

Your little caravan will survive, for we are all believers, we reject those who would like to pass for what they are not, those who love, paint, or write the way one guts a fish and tries to trade in its innards!

Our little caravan climbs with courage and holds its hands out to men of good will.

Mougins, February 1927

"Picabia contre Dada ou le retour à la raison," in *Comœdia* (Paris, 14 March 1927), p. 1.

THOUGHTS

The lizard without power and life, the ass that was once charming, cover the immense place of endless destiny . . .

Spring came like the wind or the way water grows destinies Pierre or Jean . . .

Heaven is savage, the key to heaven is blind, kisses seek the secret of life . . .

A morning manhandled justice in the vast desert of young girls . . .

I found everything in the root of pieces . . .

If youth was able, if old age knew how.

I only distrust honest people.

It is more dangerous to do good than evil.

One can only talk badly about one's friends.

The mind of a scholar is in his ear.

Morality and good taste are an old couple; their children are stupidity and boredom.

Beware of friends who reflect upon you in order to "invent" that which they've seen you do.

There are people who kill you by defending you . . .

"Pensées," in *This Quarter,* vol. 1, no. 3 (spring 1927), p. 304.

[UNTITLED]

It is impossible for me to know what painting is; painting is not learned; genius lies in ignoring others.

From the catalog to Picabia's exhibition at the Galerie Fabre, in Cannes, 20–25 February 1928.

The success of *Entr'acte* encouraged Picabia to envision this next screenplay, a more ambitious, but in the end, unrealized project. When asked the preceding year whether he was considering another venture into the cinema (in an interview with Christian that appeared in the same issue of *This Quarter* cited above), he replied: "Yes, if I found a sponsor who wasn't interested in making a commercial film, because there is no film more anticommercial than one that has commerce for a goal."

Because of such details as a dream sequence arising from a slumber on a toilet, Borràs describes this screenplay as "a satire aimed at the Surrealists" (Borràs, *Picabia*, p. 336). Its satirization of religion and morality is even more obvious. Picabia's subtitling this piece with an inspiriting "Sursum Corda" would serve only to quicken the plunge of any elevated feelings on the part of his audience.

THE LAW OF ACCOMMODATION AMONG THE ONE-EYED

"Sursum Corda"

(Film in three parts)

CHARACTERS

THE LEGLESS CRIPPLE
THE AMERICAN
THE PRIEST
THE SELLER OF TRANSPARENT CARDS[1]
THE CYCLIST
THE PAINTER
THE SECURITY AGENT
 and THE MANICURIST

Employees, agents, judges, mannequins, crowd, etc.

Preface

Only madmen really know what they're doing, they're absolutely conscious of their gestures: the madman invents nothing, he imitates. What about the raving lunatic, you ask? Well, I rather like him: his ravings have no point to them.

Nations, too, are sometimes overcome by raving lunacy; they have their outbursts from time to time, but for acts that would merit the padded cell—those people get awarded medals of honor! . . .

This little preamble may seem to have nothing to do with my film; it is, however, intimately connected to what is about to follow—container and content, space and time—as you please! . . .

THE LAW OF ACCOMMODATION AMONG THE ONE-EYED is a crime story, but there are no crimes, not even a crime against reality; there are some very absurd little conventions that move about by hopping on one leg, from the left to the right, and from the right to the left.

So I am going to ask you to be so kind as to give yourself up to my cinema for a few moments; all the seats in it are good, and it's easy for you to get the best one; you can settle into your bed to watch the filming! . . .

I've heard it said that screenplays are nothing . . . That's the reason I'm asking each one of my readers to direct it, to film it for themselves on the screen of their imagination, a truly magical screen, incomparably superior to the pathetic white and black calico of the cinemas, whose orchestras make me think of dogs barking at the masks of mi-carême! . . . mi-carême . . . a break from abstinence shared by the stupidity of sanitary conventions.

Do the filming yourselves as you read THE LAW OF ACCOMMODATION AMONG THE ONE-EYED: *the seats are all the same price, and you can smoke without bothering your neighbors.*

First Part

Presentation of the characters by a photographer visible on the screen, who will arrange them in a group, one by one (posed as a family group).

The Card Seller, who is at the same time a professor of theology at the Sorbonne, arrives in university clothing and will dress to pose as a peddler (a view of his tray of licentious cards: animated nudes).

Presentation of an entire building in Paris, central quarter, an apartment building on the corner.

Details of the first floor:

A beauty parlor looking onto two streets, with outer shop windows in which one can see revolving dolls, turning from women into men, and vice versa; these dolls will make inviting gestures to the passersby, wink their eyes, and smile the very moment the latter stop to look at them. Animated posters, of the Palmolive type, composed in tableaux.

The jeweler's shop on the side: dazzling shop windows, glittering with precious stones that draw the passersby into a sort of halo, like a lure, luminous advertising, of the Citroën type, etc.

On the sidewalk around the two shops are the Legless Cripple and the Card Seller (the latter, despite his miserable appearance, will remain very distinguished in attitude and gestures). Both are going back and forth. The Legless Cripple is trying to see what is happening inside, while keeping an eye on the entrances and exits; the Card Seller, almost ecstatic, continually paces around the parlor because, through the shop windows, he sees the Manicurist.

Interior of the jeweler's shop: great luxuriousness, with a special counter of jewels for animals. Ladies enter accompanied by cats, dogs, monkeys, tamed sheep, and buy sparkling jewels for them. The American, highly regarded in the store, has just purchased a diamond rivière which he intends to give to the Manicurist (vision of her adorned with the piece of jewelry).

Interior of the beauty parlor: some extremely old, ugly, and deformed people come in. They come out again ravishing. The Manicurist is

dressed as a nurse, but, behind only, she has a V-neck down to the waist, with a very short skirt that stops above the knees, almost a tutu. Very pretty, blonde, she goes from person to person, gives advice, makes adjustments, directs her assistants with authority: everyone wants her attention; the American enters, he asks to have his nails done; as she does them, he woos her—coquetry.

The Cyclist comes to have a massage; the Manicurist displays a fond preference for him. The Priest comes to buy some perfumes, he asks to try them out first on the hands of the Manicurist, which he then inhales with voluptuous pleasure.

The Painter comes in and asks for a false beard to be crimped; he would like to buy a handbook on "The Art of Makeup." He is mad about disguises.

The Security Agent comes in and asks for some pastel makeup, which he would like to use to "restore" some faded paintings . . .

The Card Seller, who can always be seen in one of the windows gazing at the Manicurist, takes her for a Sister of Charity; he has visions of a free clinic, he offers his merchandise to a passerby, all while reeling off his grievances, then he buys a white rose and enters the parlor to offer it piously to the Manicurist, whose dress he kisses. *He sees her* as a white sister.

Every time the door opens, one will catch a glimpse of the Legless Cripple on the lookout, taking notes. Seven o'clock, the shop empties, and gradually there remain only those characters who are regular customers and who know each other, as they all live in the same building. The Manicurist brings some cocktails; the Card Seller acts as if he is receiving communion with his.

The American announces that he is going to give a big party at his home in honor of French sports and on the occasion of the Six Jours race; he invites all of them and tells the Manicurist that she will be crowned queen of sports that evening; he wants her to make herself up very beautifully with this ceremony in mind, as he will present her with a considerable surprise, in memory . . .

The Cyclist gets touchy, but the American creates a diversion by informing everyone of the celebration's program, which appeared in an evening paper as follows:

1. Reception for a delegation of the Club of Sports and Games of Chance, and of a delegation of the L.U.S.V. (Lawful Union of Sports Victims);

2. Grand athletic ballet—modern dances;

3. Crowning of the Manicurist;

4. Dinner.

They accept the invitation.

The American, on his way out, hires the Card Seller to hand out the programs, and he invites the Legless Cripple to precede the delegation of the L.U.S.V., as a jogging victim of wear and tear . . .

He then goes up to the second floor of the building to a fashion designer's where he attends a fashion parade: extravagant dresses and bathing suits "inflated" by Deauville, a series of "nude suits" (nudes painted on leotards).

The American will have the dress that he ordered for the Manicurist shown to him; it is a sumptuous and low-cut dress in which one can recognize elements of a tamer's outfit.

At times it seems to him that he recognizes the one preoccupying him in such an absolute manner in the models presenting the styles. He leaves and goes up to his place, on the floor above.

A very luxurious and whimsical apartment: the armchairs are suspended from the ceiling, like gymnastics apparatuses, at different heights, to which a pulley, operated by a servant in livery, allows one access. The American goes to his study in which the only piece of furniture is an enormous empty safe; there he puts away the piece of jewelry bought for the Manicurist; then he gets himself up into the highest armchair and falls asleep reading "La Vie de Bohème."

Floor above: The Priest's apartment—the priest comes back home; there is a great number of statues of Saint Sulpice to which the Priest will give a military salute; they will then take on the appearance of the Manicurist. He lays out his parcel of perfumes, pours them out at the feet of the statues; with the last one he hesitates, then swallows it in one gulp, after which he begins to furiously beat a punching ball.

Floor above: The Agent's apartment; there are paintings everywhere, "modern paintings." The Agent dreams of nothing but painting and his collection, the way his friend the Painter dreams of nothing but detective novels, intrigues, crimes, etc. The Agent hangs up his latest acquisitions; the moment he puts the last painting, which depicts fireworks, into place—this painting explodes and covers him in rubble! The Painter enters and helps his friend extricate himself; the Agent, in order to replace the destroyed work, would like the Painter to make him a portrait of the Manicurist as the Queen of Sports; the painter accepts on condition that the Agent lends him all his

police papers for a time and entrusts him with the first criminal case to come along.

The Painter returns to his place, the floor above, a very sparse studio with not a single painting; the moment he opens the door, he remains dumbfounded, for he is witnessing an actual theatrical rehearsal: characters are acting out sketches reproducing the covers from the famous "Fantômas" novels; seeing the Painter, they stop and very slowly come to a standstill, shrink, and are soon nothing more than the characters appearing on the covers of the scattered volumes; the Painter rubs his eyes, he must have been dreaming . . . but a single little shrunken character, the coachman of *The Night Carriage,* is still walking about, even fluttering about the room. The Painter finally catches him with a butterfly net; at that moment, he vanishes. The disappointed "hunter" makes sure that the Policeman's papers are indeed authentic and in place in his portfolio; he picks up one of the volumes from the ground, settles down to read, and falls asleep. The coachman returns in his dream, teasing him . . .

Floor above: three doors on the landing (since the third floor the staircase has been narrowing, and as the building grows impoverished, the climb becomes steeper and stretched out). The Manicurist is going up; reaching room no. 1, she takes out her key and enters: a very squalid and disorderly room; on the walls are prints cut out of *Le Petit Parisien Illustré,* stockings to be mended are lying about everywhere, she lays down her coat, her outfit, slips on an old-fashioned and worn-out dressing gown, takes off her wig and ridiculous little pigtails are revealed: she is very dark-haired. She puts on very worn-out old slippers, her stockings fall, she greases her face, gets into bed, dreams of the American (jewelry, luxury, Rolls-Royce), then of the Cyclist (love, tandem, picnic on the grass). The two individuals merge, are superimposed upon each other, and like jugglers, climb onto each other's shoulders; they collapse at the same time, and are nothing more than scattered pieces which the Legless Cripple gathers up into a pile in his cart, and then drags off at full speed; everything dims . . .

Room no. 2, that of the Post Card Seller, is very virginal; muslin curtains on the bed, a large crucifix and a box-tree branch, pious images, an impression of austerity; the Card Seller prepares his theology lecture for the following day, then takes inventory of his cards; he puts his profit into a moneybox and explains to his dog that this money is intended for the purchase of a life-size equestrian statue of Joan

of Arc. He sits down at the table after reciting the Benedicite, and prepares, while eating, his pornographic collection for the next day.

Room no. 3: The Cyclist's room, also very poor, but in order, cycling accessories, inner tubes, striped shirts, etc.

The Cyclist is playing "patience," losing each time. Someone knocks at his door: a messenger enters and delivers a letter from the Priest. This messenger is dressed half like an angel, half like a messenger. With this letter, the Priest asks the Cyclist permission to attend his training at the velodrome the following day; the Cyclist gives an affirmative reply. He reimmerses himself in his patience, the queen of hearts has the face of the Manicurist, but she is never in the game, she turns about the Cyclist; tired, he throws away the cards and falls asleep while pedaling in the air.

Second Part

The next day at the velodrome.

The Cyclist, in order to get into the habit of having an audience, has placed about forty very ordinary mannequins into the stands, similar to those one sees in department store windows in the provinces: brides, policemen, children of all sizes, people taking their first communion, a general in full uniform, a sailor, an academician, a chauffeur, etc. When the Cyclist passes before them, they automatically raise their arms. The Cyclist is soon showing signs of effort, then of fatigue. The Priest, who is the only one alive amidst the mannequins, hurriedly takes off his cassock, appears in shorts, snags the kepi of the mannequin-general and puts it on, then leaps onto a bike and paces the Cyclist at full speed; the mannequins applaud. They go several laps in this manner, soon followed by all the mannequins on roller skates; they finally leave the velodrome and crossing through Paris, arrive (finally) at the American's, where things are in full swing, still escorted by the mannequins. These latter guests will come to a halt among the party's guests, whereas the Cyclist and the Priest will end their momentum through several laps around the lounge.

The American's Party

The American is entertaining with the Manicurist dressed in all her finery at his side. Procession of the Delegation of Sports Victims, with the Legless Cripple at their head: monstrous professional deformations, all their heads are too small for their bodies, a few bodies without a head, abnormal thoracic developments in comparison to bony legs, or vice versa, etc.; lastly, a pregnant woman followed by ten children from 10 to 1 years of age.

The Seller of Transparent Cards, a few steps away, gazes at the Manicurist. He seems bedazzled by her, but he *sees her* as the Blessed Virgin, he wants to offer her a pious image and chooses one from his portfolio, but as soon as it passes into the hands of the Manicurist, it turns into a licentious card. The Manicurist bursts out laughing; the Card Seller doesn't understand.

Infernal jazz, blinding light: the servants pass out dark glasses and special cotton for the ears on trays, intended for those indisposed by the noise and the light.[2] Another, at the sideboard, pours about twenty bottles of champagne into a large receptacle, which he then serves to the consumers with the aid of a sponge that he squeezes into their glasses. The American is constantly at the side of the Manicurist, who is really playing the hostess; she reminds him about the promised surprise: he is waiting and will present it to her shortly, at the close of the celebration. The Cyclist lurks jealously around them; the Legless Cripple doesn't miss anything of what is happening or of what is being said among the six characters. The Painter, who is very much the plain-clothes detective, is making the most of the authority conferred to him by his papers and stops the dancing couples at every instant, asking the men to show their driver's license, failing which he reports them . . . The real agent, very interested in the paintings, cannot resist several modern canvases, which he takes down surreptitiously and puts aside for his collection; he will be taken by surprise by the Legless Cripple, who goes from one guest to another, always on the lookout.

Grand athletic ballet in which every whim will be able to prevail; the bustle is at its height, they're drinking enormously at the sideboard, and the tired American tries to isolate himself, in vain; he goes to his bedroom, but the sportsmen have set up a boxing match there. In the study, the sports victims are holding a meeting,

demanding the right to incest as no woman is able to bear their disabilities, apart from the women in their families . . .

In the kitchen, the Priest, completely intoxicated, absolutely insists on saying mass on the stove.

The Card Seller is trying to sell his pornographic collection, by assuring each buyer that they will be entitled to plenary indulgence.

The Legless Cripple goes to the sideboard and grabs a knife, which he sharpens against his wheel.

Everybody is drunk.

The discouraged American can find no solitary spot except for the W.C.; he goes into it, collapses onto the seat, and falls into a deep sleep, neglecting to close the door.

Here, a sort of intermission—the American's slumber: sights of America, harbors, factories, animal farms, oil wells, Negro jazz, Lincoln's portrait, etc., etc.

The Manicurist, as a ghost, walks across all of these landscapes . . . then, very gently, everything disappears . . .

Finally, in the apartment, it is dawn. A great disorder reigns: overturned chairs, the enormous safe is open and empty, the broken case for the piece of jewelry intended for the Manicurist is on the ground, the guests have left, only five or six individuals are still there, asleep, surrounded by mannequins, all in horrified poses, perhaps because of what they've seen . . . The Legless Cripple, on the other hand, is wide-awake and turning about the furniture and the sleepers like a madman, drunk with joy. He collides with the Priest, however, who is now wearing his surplice and his stole again; he shakes the others, who start to wake up in turn: Where is the American? They have to take their leave and thank him! . . . The Manicurist would very much like the piece of jewelry that she's still waiting for . . . "You'll have it soon," whispers the Legless Cripple, "if you don't talk . . ." They look for the American everywhere, without success; in front of the door, now closed, of the W.C., they wonder: they think that the American may be in there; perhaps he's unwell? On the door, a sign: "Private bathroom"; it doesn't matter, the Legless Cripple suggests they break it open, because there's no

response to their knocking; acceptance, but the door doesn't give, the Legless Cripple has a board brought, on which he hoists himself, and which they tilt toward the door, the cart rolls and smashes it in. Horrors! . . . The American is on the ground, his throat cut, bathing in his blood, dead. The Manicurist starts laughing like a madwoman, the others are dismayed, the Legless Cripple weeps and takes the American's handkerchief to wipe his eyes. They carry the corpse onto his bed following the painter's orders, and on the presentation of his policeman's papers, he directs the Legless Cripple to the police captain's; while this is happening, the Manicurist does the dead man's nails, the Priest lights some candles, the Painter writes up a report, the Card Seller prays, his rosary in his hands, the Agent makes a sketch of the corpse, the Cyclist plays a game of patience—all out of professional habit.

The Legless Cripple arrives at the captain's after a wild journey. He asks to be heard; he recounts the crime and makes a statement on the individuals still there. He produces damning charges against the Painter, the Card Seller, the Priest, and the Cyclist; in fact, he can assert, with proof to support, that:

The Priest was seen racing in shorts at the velodrome.

The Post-Card Seller leads a double and shady life.

The Cyclist was certainly jealous of the American.

The Painter is holding false papers.

The Security Agent stole some paintings from the American.

The captain betakes himself to the scene of the crime.

Interrogation, inquiry on the scene, the facts put forward by the Legless Cripple are found to be accurate, arrest of the pseudo-guilty parties; the Manicurist makes eyes at the captain and is let free.

Third Part

The Assizes

The Agent and the Painter, after the witnesses are examined, which include the Legless Cripple and the Manicurist, are sentenced to death, and the others to hard labor. The Legless Cripple is very elegant, he attends the trial on a deluxe motor cart; behind this cart is a platform with a seat for the Manicurist, whom he has married.

Coming out of the Law Courts, he gives her, in memory of this day, the diamond rivière the American had once bought for her, and which the Legless Cripple had stolen, for he is, of course, the one who did the deed, who committed the crime; the Manicurist knew this, but the appeal of money was stronger. She is now a very elegant and distinguished lady. As they leave, the Legless Cripple suggests a trip to Deauville.

The Three Roads

The road to Deauville: a magnificent Hispano flies by, holding the President of the assizes, the lawyer for those sentenced, and the one for the plaintiff claiming damages whom one will have to recognize without any doubt. This car is overtaken by the Legless Cripple's cart, and waves and smiles are exchanged.

The road of "La Nouvelle" on which those sentenced pass along, among whom figure the Cyclist, the Priest, and the Card Seller. All three think of the Manicurist with different visions.

Finally, the road to heaven, which the Agent and the Painter are ascending. The Agent carried off his paintings under his arms. At the end of the road is a large crucifix; on their arrival, Christ comes to life, bursts into laughter, undoes his arms, applauds vigorously, and unites them upon his heart . . .

END

La loi d'accommodation chez les borgnes, Éditions Th. Briant (Paris, 15 May 1928).

Picabia responded to the critics of his previous year's conservative articles by adding more fuel to their fire. If he didn't actually repeat his preference for Mussolini over Lenin this time, he did offer a confused conflation of capitalism and socialism.

Picabia would appear regularly in *Orbes* hereon, along with Duchamp and Cendrars.

SLACK DAYS

What is most difficult
is learning how to whistle in English.

Little nasty things sometimes result from a lot of kindness!

This is how the trifling, disgusting things that are written about me every day must, when I think about it, come from very decent people who are just not up to it, and miserable!

Not up to it! By that I mean people who, having taken a third-class ticket on the express train of life, are thrown out the door when passing through Villejuif, thinking that they've arrived; perhaps they didn't have enough luggage to go further.

Dear friends, Life has no stations, Life does not admire, Life does not criticize, Life does not own your stupid little scales on whose pans you put a name, then another, in order to know the weight of genius! Be careful: it sometimes happens that these weights are so heavy that they break the scales and the pans come back down on you . . . because you're looking from below! There is nothing left for you to do but hate, but spew your bad-smelling bile; it gives you relief, doesn't it, to detest? It fills existence . . . it would be easier to smoke a cigarette, smoke is so delicious! . . .

The *Venus de Milo?* very pretty; Jesus Christ? him too; Dreyfusard? Antidreyfusard? charming! The department of births where one registers geniuses, the department of deaths where one removes them? Handy!

Delightful little critics, who foretell the coming weather, it is to you that amateurs must turn if they are to know whether they need a straw hat or an umbrella, it is to you that we must turn for permission to paint, write, or make music! We are supervised by these gentlemen, and if there is an artist too different from the others, a poor wretch who shows off, there is nothing to do but bully him, cut him down, cut off his . . . ears, and if they grow back, well, they'll punish him even better: they'll stop talking about him!

This little game has had its day, like Jazz, it's over; the man who wants a book or a painting follows his own personal bad taste; his criticism is much more certain, because it is only influenced by the work itself.

The man who follows the taste of others is an impotent man, a voyeur; it is only in a brothel that he will find what he needs to revive his virility!

It is our senses that can make us believe in an appearance of truth and it is not truth to try to make love with a vise, a lamp glass, or sandpaper! It is obviously new enough but our tactility makes us quickly understand that it is idiotic and quite disagreeable!

The École des Beaux-Arts, so disparaged these days, perhaps represents the most abstract evolution; that's why our senses are indispensable for us to transmit this evolution to us, but those who judge and decide have no more senses, no more life, their brains are weakboxes in the service of young, strong people! There is as much life in a Beaux-Arts student as in a cubist student or a Dada student; where life stops is at the prix de Rome, as at the prix cubist or at the prix Dada. Every individual who believes in *prizes*—or in the *prices* of his works—has nothing more to do than rent a hearse to finish off his journey; he can make a little hole at the top of his coffin: with one eye he can see each person salute him as he passes: there's nothing more to fear from dead men, one can respect them!

One of my friends once told me that concubinage had been corrupted by marriage! One man is corrupted by literature, another by painting or music. This means that only man himself is in life; the rest is just a speck of dust that one can buy with another speck of dust: money. Yet a person can acquire a work through love, he can be jealous of it, want to be the only one to possess it, but those who deal in the painting trade, the way others deal in the white slave trade, are poor rich men, deprived of many joys, whose hearts beat only when faced with high prices, highly paid prices, highly sold prices.

Always the same immense void, always the same aridity: what a feeling of sickness, what tediousness this artistic socialism, this desire to reduce the lungs of some to the profit of others: what rubbish!

I read in a paper that the only great artists now are those who, working at whatever during the week, free themselves on Sundays to practice Art. They are called Sunday painters . . . it's a whole program . . .

Always this imbecilic sentimentality: one loves an artist because he only works one day a week—or a month, once a year would be better (what a light would shine on that day!), or even yet because he is tubercular or homosexual. Poor carton-mâché revolutionaries, if you

absolutely must overthrow something, overthrow yourselves and go sleep with life!

She couldn't care less about republics and those poor in spirit who want to serve Society. Society, especially good society—what a fraud! No more a coward than its defenders, whatever their etiquette may be.

There is no school, school signifies death.

Nobody is well known. Look at the Unknown Soldier: everybody knows him!

Paintings get more expensive the more boring they become.

Admiration, like denigration, is always grounded in the wrong reasons.

Not everyone is given a strawberry mark on their face; to expose it is to risk selling it.

I know a man who influenced our entire age by hiding.[1]

Enemies can only become friends and vice versa. What are you afraid of?

True Frenchmen dye their beards green to invite the crickets to come sing in them.

One cannot know why evolution exists; investigations are too small next to culminating moments.

To ease one's conscience, one must change one's conscience: put two fingers down your throat!

Ugliness is the decadence of a convention.

One need not be afraid of one's immorality, but to show it is to want to trade on it.

To encourage mediocre people in their mediocrity is a pleasure that belongs to society people.

The weak are friendly with anti-Semitic Jews.

Civilization invented crime.

The sunbeam is cruel, but the moon is charitable to the imagination.

The atheistic man who is about to die asks for a priest—he would do better to ask for a woman!

A man who resists his instinct grows numb to become communist, which is to say, reasonable—reasonable like someone sleeping.

You probably think all that doesn't have much to do with the beginning of this article, but why the devil would an article have something to do with itself from one end to the other? And then, if you look closely . . .
Painting, Music, Literature: these three magic words can still remain alive for those who forget their role as painter, musician, or man of letters, and see in these means of self-expression only the joy of being alive!
They say: "he does nothing, he lives the high life!" Well, all the better!

"Jours creux," in *Orbes*, no. 1 (spring–summer 1928), pp. 29–33.

The following prescription had been addressed to Cocteau, and written out on Picabia's writing paper, whose letterhead read: "Doctor Francis Picabia, Laboratory Director aboard the yacht *L'Horizon*, port of Cannes, everyday from 5 to 7, nighttime, by appointment." Picabia and Everling had separated by now, and he was living for periods of time aboard his yacht with Olga Mohler.

GENERAL PRESCRIPTION NO. 555

I recommend:
1. *2 galas a week,* for two months if possible, every Tuesday and Saturday.
2. A cup of tea at the *Ambassadeurs* every day after golf, tennis, yachting.[1]
3. Play a few games of baccarat to maintain the heart's rhythm. Same exercise in the evening, rest and dancing at the *Brummel.*
4. *Tonight's diet:*
Cups of Cacodylate Borscht Koof
Aiguilettes of *ambassadeurs* sole strychnine

Mans Maryland Coca fattened chicken
Phytin hazelnut apples
Phosphoric asparagus of Laures
 Virgin sauce
Iodide Neapolitan cassata
 Bedroom antics

Cannes, 5 March 1932

"Ordonnance générale n° 555," in *Empreintes,* Brussels: Éditions de l'Écran du monde, May–July 1950, p. 68.

[UNTITLED]

Life doesn't like magnifying glasses—that's why it holds out its hand to me.[1]

From exhibition catalog, Léonce-Rosenberg Gallery (Paris, 1–24 December 1932).

NOTICE

To trust one's heart is to
obey one's grandfather.

Spiritual alcohol decimates and corrupts humanity.

The English dominate the Indies,
the Communists want to dominate the Bourgeois . . .

Surrealism . . . Communism . . .[1]
 white That makes gray . . . black

red excites bulls . . . it would seem . . .

"Avis," in *Orbes,* no. 4 (summer 1935), p. 20.

I AM A
BEAUTIFUL
MONSTER
1939–1949

Picabia and Mohler were in Switzerland visiting Mohler's parents when war was declared on 1 September 1939. They stayed in Switzerland, and the following year, for practical reasons, Picabia married Mohler. The "slack days" had ended, and the times had caught up with Picabia. Caught away from his studio, Picabia began to write poetry again, but in a very different manner from his earlier years: sarcasm had given way to melancholy lyricism. Though *Poems of Dingalari* would be Picabia's first book of poems in nineteen years (since 1920's *Unique Eunuch*), it would not see print for another sixteen.

POEMS
OF
DINGALARI

I need air to breathe
before me Switzerland with its sunken eye-sockets
looks at me
I hear the word war uttered
the ground is soft
I feel like I've fallen
and it won't be possible to stand back up
I am so distraught
I banged into the exit door
but when it opens
it will be too late
I am worn out
my head gently collapses
what a horrible thing
there are still cigarettes
but my lighter has stopped working
and every match in the world
is about to be drenched in tears.

Since September 1939
the sun seems to have set
everything has grown suspect
everything has grown older
events are nothing more than rumors
all this debris
all this destruction
all these ruins
are only darkenings
as for me I am of the century to come
the century I shall not see
I'm hopeful
that my birth will be tomorrow
but all the venomous powerless men
will be powerful
as always.

My thoughts grow pale
despite the rooster's crow
my ideas are of no use

for the time being
and it's raining
I would like it if tomorrow
during breakfast
the world of idiots
stopped being of any use.

I have a spider for a girlfriend
she hopes that the moon
will come and get caught in her web
I prefer this girlfriend
to the eternal hourglass
or perhaps to love oneself
to avoid desiring something else.

The rings of the telephone
live off their private income
the telephone is the gentlest
young man on earth
he is unmarried
his feminine weakness
has disarming charm
there you are, informed
but that isn't the important question
my concern is in knowing the future
I also have a question to ask you
can ice melt in the sun?
a voice trembling with impatience
answers me
everything is going to be all right.

I know nothing of happiness
having never been warm enough
how would I not guess
its hiding place?
perhaps in a game of dice.

Intelligence and stupidity
shall never be friends

intelligence is without a dress
stupidity is a dress
on a garage door.

The more I sing every song
that I know
the more I suffer
and the more I sing
on the road covered in frozen snow.
There is no news
but I love the night
among the statues lying
on the flagstones of the churches
my girlfriend is in the way
and also her heart swells
on the kitchen table
did you know that
I am always at the intersection
of two roads
you guess
one has to keep friendship alive
without changing places
but what a pretty foot you have.

His eyes are like rats
rummaging about another world
on the table a round loaf of bread
a pair of socks
and tubes of colors
I knew nothing about him
she says to me do you like what he does?
having forgotten where we were
I tell her
he could be worse
you know painters
are almost all Don Quixotes
especially these days
and yet yesterday and tomorrow
resemble each other.

I rubbed my love
with sandpaper
to forget my long wandering life
my heart is lying down
on a pile of shavings
it was born of a well-known father and mother
naturally I am its child
I am my heart's son
but where did you learn
your painterly skill?
I learned it by looking elsewhere
forgive my asking.

The large kitchen lamp
was not lit
and yet I saw that my girlfriend
had a crooked nose
one more that's all.

Great loud laughter everywhere
everywhere the laziness of shaving
I am obliged
to put my thoughts under lock and key
the farmers are all dead men
who spend their time
going to their funeral.

Why fear barbarism
my dear friend
it is so good to be happy
without knowing why.

The sign the true sign
you are going to see it
I looked out the window
the sun was shining
Beneath this sun
the village was already

as good as new
no one had seen it
and all was forgotten.

I sought new light
tortured light
of universal literature
explorer of the sublime
in the ugly and the hideous
my virtuoso thought perhaps
well beyond my talent
expresses itself to charm me
and wanted strange and exotic
to make me love the monstrous
my thought has come to shatter
at my feet
why?

Don't ask me questions
let's talk about something else
let's talk about dead eyeglasses if you like
Botticelli Piero della Francesca
or Vélasquez
or about a raped girl
whom a bunch of idiots think
they should pity
do you recall the varnish on my paintings
they were like mirrors
in which at any moment
something can suddenly appear
to merge with the oscillations
of my weary heart
which no longer knows how to love
or hate
or even transport itself
beyond personal misfortunes
I've reached the height of suffering.

Today I am thinking of men
those amphibious men of the capital
who search in the nooks and crannies
of houses in ruin
those men burn incense
for humanity
give me some air
open the windows
stop looking at those anemics
they're noxious
more noxious than illness
that at least can be
a feeling
they—are rattlesnakes
who draw little children
closer to them.

Do you think that at this moment
lots of men are pronouncing
the name of their love
if that's what you're hoping for
you bunch of cretins
you'll be sorely disappointed
they are simply saying
my little Jeanine or Marie
or Louise or Germaine
or give me a cigarette
besides it's the last gift
one gives to the condemned man
he's given the gift of death
and a cigarette
one probably helps the other settle
yet I knew
a condemned man
who had asked for a toothpick[1]
he must have been a poet
it surprises me that they don't bury
executioners
at the Bank of France

scram off to the savages
those who still believe
in civilization
or stay all alone together
with yourselves
or commit the crime
of killing yourselves.

A mirror before me
begins to laugh
the same laughter as me.

I am rid of my youth
rid of its unbearable oppression
all that remains in me
is hashish
women now
are delightful pianos
yet today I still
vainly seek in all the arts
a work equal to
the women I've loved
my painting
was never anything but a reflection
of my life
for me I consider it
to be a source of happiness
of the first order
to live exclusively
for women
the world is poor
for him who has never loved
I am using a mystical formula here
nothing will prevent me
from loving their immodesty
I think that women
are the repositories of my liberty.

They do not value feminine life
therefore they make their wives
into common women
whose suppressed hatred
makes them powerless
their so-called love
is nothing more than a caricature
drawn by their children.

I am quite innocent
it seems to me
yet those among you
ladies and gentlemen
who are not dwarves
will think that these poems
are cynical.

The drawn-out strength
of seriousness
makes me think
of All Souls' Day.

I am not made for solitude
but I despise happiness
I need to hear
music
especially in autumn
you know the moment
when everything withers.
In my country
there is but one season
that of love
without music.

Supersaturation of an impossible era
I found the way to amass my strength
in order to forget events
a joyous delirium sweeps through me
for the first time

in two months
my individuation
like a salutary balm
arouses the unprecedented of a dream
whose dazzling splendor
will give me metaphysical
comfort
far from all these horrible tragedies.
My satyr's heart
metamorphosed
under the bay tree of the virgins
in the immeasurable joy
of inexperience.

My nerves are strained
I'm half-dead
how spur on
the new poison
the exquisite pleasure of the sky
mystical love
I think that I know better
than anyone
what wonders
my body is capable of
rapture of my dreams
in which the devil is its wife
me its lover.

The multitude makes me suffer
solitude makes me suffer
I don't know my destiny
I loathe everything official
I don't want to be taken
for an artist
the rastaquouèrian idea
is not to my disliking.

For the love of madness
I became the wife

of my mistress
we are dancing the night away
on the tips of our toes.

Better to stay in bed
and in your well-locked
bedroom
than to see the woman you love
walking naked in the rain.

Now it is the boat
that steers the helm
my porcelain dolls
hear the distant echo
of the waves.

A halo of spiritual grandeur
begins to pity me
but I'm surrounded by the negation of life
I am pagan and immoral
I always need
several women
to hang upon my every word.

A stroll in the forest
among the pine trees
one Sunday
I was full of rapture
especially as I was far from men
but my martyrdom
had to begin again that evening
the soldiers
were on leave.

Instinct for self-destruction
against fatality
fatality
wants to make me vanish
why leave corrupt people

just to fall
into a corrupt climate?
the fog
is outside my window
and surrounds the house
my poor room
whose only life
is the tick-tock
of a little Swiss cuckoo clock
that takes on
a thinker's expression
the electric heater
warms my feet
but my shoulders are cold
my thoughts not being inclined
destructively inclined I think
I've stopped trusting anything
save chance
and nonsense.

Outside my window
there is a madhouse
one of the guards
lives in my building
I like this man
he doesn't speak French
but it might be the madmen that are guarding him.

My newspaper is an instrument
without mercy
my newspaper is a tyrant
my newspaper wins victories
my newspaper leaves to others
the trouble of proving
that my most important thing is a newspaper
that can only be read
by the moonlight
well that's life.

The ugliness of certain eyes
is appalling
they want to fascinate
but they fascinate themselves
in front of mirrors
they think they can do the same
with life
fascinate life
and find the key
to the wealth of others
and help themselves generously to it
the cleverest among them look like
they're doing you a service
they talk
all that is just dupery.

One can perfect
one's instinct
for one's ascending life
but instinct
does not perfect us
in the eyes of morality.

To pass one's time
in making promises
to try to be less miserable
to hope for a bit of pleasure
there is only one way
instinct
must kill our memory.

I am so lonely
I've the impression
of being in a crowd
that would like to find
the door to heaven.

I became the one who can no
longer give

my dream is to steal
stolen things
must have more taste
to steal a bread roll
and to be able to give it
to him who is dying of hunger
I am certain that he would tell me
that he had never eaten
anything better.

Often two great blue eyes
look at me
they want to drive the clouds away
their hope is in Paris
and even in the Gulf of Juan
for me these places
are infinitely far away
these eyes look like they're telling me
are you not my sun
she would like through her cloudless
smile
to make me believe in the sun.

The hours speak to me
nine o'clock says hello
ten o'clock says good evening
but my sorrow
is so profound
that the rest of the hours
pass by without sleep
I await the hour that will say to me
come we're leaving
we're going back to your place
my place oh yes
that wonderful country
where there are no hours
where there are no days or nights
that wonderful country
where one sleeps without knowing it

tears come to my eyes
when I think that in my home
hunger is insatiable
in satiety.

One can imagine
a long-range shooting
an exceptionally long one would be needed
for the bullet
to remain in my head
and serve me as a quill
to write this book.

Rubigen, 1939

Poèmes de Dingalari, Alès: Pierre-André Benoit, October 1955.

Some of the poems in *Thalassa in the Desert* were probably written in the winter of 1939–40. The title was derived from the pink pages of the *Petit Larousse:* "Thalassa! Thalassa!" ("The sea! The sea!") was the cry of joy uttered by Xenophon's battle-weary troops in his *Anabasis* (IV, 8). (Picabia had played on this phrase as early as 1915 in his mechano-portrait of Marius de Zayas, whose title, *De Zayas! De Zayas!* appeared over a simple representation of the sea.) This sea leads us to Nietzsche's *The Gay Science,* in which he speaks of building a house into the sea: "I should not mind sharing a few secrets with this beautiful monster" (214:3:240; see also 247:4:310).

"My Girlfriend," "The Child," "Poem of Hope," and "On the Other Side" all appeared, accompanied by a fifth poem, in *La Révolution surréaliste* (Paris, 15 December 1929) under the general title of "Des perles aux pourceaux"

(Pearls before swine). "Bacarrat," "Spinner," "Oasis," "Swimming," and "Final Song" were published in *L'Usage de la parole* no. 3 (April 1940), a review edited by Surrealist dissident Georges Hugnet. Given that the editor of the "L'Age d'or" series in which this book was published was Henri Parisot (who worked closely with a number of Surrealists and even cosigned an occasional declaration with them), the Surrealist ties to these poems are striking. Equally striking is the range in time of the composition of these poems, which is belied by the consistency of their mood (a portion of "Swimming" dates back to 1920).

The first poem is arguably one of Picabia's more accomplished, and encompasses a good number of his most recurrent terms and themes: egoism, sin and virtue, New York and Paris, velodromes, and transparent cards.

THALASSA
IN
THE DESERT

BACCARAT **STARTER** OASIS **SPINNER** DOMINOES **MY GIRLFRIEND**
THE HAND'S GESTURES **WAVE** THE SKY **THE CHILD** SENTIMENTAL POEM **TEARS**
FIVE O'CLOCK **SWIMMING** I AM MY TRUTH . . . **PLANS** POEM OF HOPE
ON THE OTHER SIDE CONVALESCENT **RAINBOW** FINAL SONG

BACCARAT

I am a beautiful monster
who shares his secrets with the wind.
What I love most in others
is myself.[1]

I am a beautiful monster;
I have the sin of virtue for support.
My pollen stains the roses
from New York to Paris.

I am a beautiful monster
whose face conceals his countenance.
My senses have only one thought:
a frame without a picture![2]

I am a beautiful monster
with a velodrome for a bed;
transparent cards
populate my dreams.

I am a beautiful monster
who sleeps with himself.
There are only seven in the world
and I want to be the biggest.

STARTER

Finger raised to sample the rain,
breathe in my resounding silence.
Transparence is beautiful only in cards,
in front of a tamed light.

Put on your running slippers,
take off lined up with yourself;
don't go to the stars,
a run around the table is enough.

Don't forget the revolver
which is loaded only with reason
and take your courage in hand
like a waterproof female.

My dog is never in the same spot,
he scratches his collar's hope;
just like my friends,
he still believes in doors!

OASIS

Explorer of the undiscoverable Self,
I take a walk in a palanquin;
the bluebirds are my friends,
the rings on my fingers my nourishment.

For a companion, I have the present
and for guides the Further-Off hours . . .
My wife is the thirteenth wonder
of a harem in the form of a star.

My messengers are named forgettings;
they sing a water-colored song,
which enters my eager heart
through a sensitive door of gold.

My dogs, Caress and Falsehood,
are always at my side
and drag a pink scarf,
all that's left of an incestuous love.

And I take the easy road,
The same as any other,
which strays from the eleven pains
and draws closer to the End.

SPINNER

One must take time by the hair,
connect the subconscious propellers
in the space of the secret.

One must caress the probable
and believe in the impossibility
of crossing paths.

One must learn to weigh up
ten grams of white, five grams of black
in the hope of scarlet red.

One must know how to fall from below
so as to favor the zenith
of privileged mornings.

One must love the four mouths
floating about the silky doubt
of dead principles.

DOMINOES

To the catechism of offerings, I sung of life,
waffle cloth, from which forces escape,
castle of concentrated odors.
I looked under the shutters at the aroma that kills.
The spiraling aroma
tangible only to the heart.

But my heart is masked in black,
ever since your fingers touched it
and I can brave without fear
the bite of the bird-fairies;
I am stronger than life,
I left a long time ago.

Clutch to your chest what men call sweetness;
you shall see your mouth weep
for sweetness and honey
are the pale pink dominoes
trimmed in black lace
and lined in the silk of sorrow.

MY GIRLFRIEND

Thank you, I'm preparing a cyclone
to make my girlfriend's eyes laugh.
It's easy for her to fear nothing
you have to scare her
to not be afraid . . .
Under normal circumstances
I go dog hunting
in the plains
where the prairie crabs
have stopped going to mass!
My girlfriend spits on the ground
and that's all there is to it.

THE HAND'S GESTURES

I'm trembling with love
watching the beautiful American women walk
as beautiful as swans.
They are the actresses of this love,
wandering ghost, in the shape of an arrow.
The music laughs, boredom disappears.
It is midnight to the taste of honey,
but these favorable conditions are useless.

WAVE

The red enchanted clover
melted by the magic spell of the little bell,
in the land of isles and adventures.

In the blue and yellow seas,
wisdom or madness,
men throw themselves into their swimming.

THE SKY

Paris with its head in the clouds
shines up in the sky.
The streetcars pass by,
like death.
Death is a little road
that everyone takes.
Death is a statue.

The best families
have the age of reason.
I prefer the cocoa
of beggarwomen
who no longer make the sign of the cross
in fear of death,
churches no longer being virgin.

Always take the side door
to go up to the sky.
Luckily for me, the sky
is at the end of the world.
God lives in a safe
the key to which the poor will never have.

THE CHILD

Autumn has faded,
through the child
whom we love.
Just like a vulture
on a decaying carcass,
he diminishes his family
then disappears
like a butterfly . . .

SENTIMENTAL POEM

Blue skies streamed along our mouths,
like love scented with crimson buds.

Stars are the petals of our thoughts
when the sun goes down.

This evening, closing my eyes, standing next to you,
my hymns shall ripen, bathed by the moon.

If you wanted, completely naked, I would grow old
with your smile, hands on your breasts.

Whatever you do, don't throw me into the void!

TEARS

Sprawling flowers of the eye,
like the panther
with magical teeth,

freshen my eyes
and calm my heart
senses on top below!

In this way my happiness,
in gentle words, uttered
its desire to blossom.

Wonder of wonders! I shall dance
like the smoke,
woven into a satin blue dress.
My body inside out
implores you
to give me your innermost thoughts.

FIVE O'CLOCK

The enormous lions,
like timid lambs,
have thoughts of little girls!
My heart is rusty
for it no longer sees
your beloved gaze.

Just like your hands,
the hues of your eyes
are caresses
and give me shivers.

SWIMMING

I am the mirage beyond the literature
of bourgeois absinthes.
Loving supposition of an alcoholic blotter,
ghost author of a new work!
The path is discreetly wild,
cut off from illuminations.
Death, a unique opportunity
for invisible splendors,
is lying upon a couch.
Like an irregular poet,
I am the author of bad manners.[3]

I AM MY TRUTH . . .

I am my truth . . .
Cruel enemy of enemies
and of executioner friends.
Tortures saunter about my home
feet bare,
so as not to make any noise.
What ruins
these paradises of the world!

PLANS

Take jam by the hand
on the tray of abstractions.
For a necklace, you'll put on Love;
not the barren love of virgin children,
nor the kodak love of prostitutes,
but the only love that counts,
the Love of me.

Let's go to the central land where the cruel helots sing;
bring your weaknesses for luggage
and the memory of Benares in your eyes.
I will be dressed in costly rags
and shall offer you every evening
a dark and transparent mirror
in which you won't recognize yourself.

POEM OF HOPE

Her gaze amuses me
like a gate pushed open
onto a rusty park.
Lemon of the falling sun,
she passes by like a hedgehog curled up in a ball,
every evening along the sides of the brook.

At night the crows
are black stars
and make a heartrending music audible.
I would like to smell an aroma
similar to the caress of spring,
far from the green and white mountains.

ON THE OTHER SIDE

Sitting in the water's shadow
the melancholic idea carries me off
to the age of the left hand.

Birds only stop to weep!
The great fear is that you will die in little pieces
in the unpleasant place of life,
head in hands, without purpose.
Take a glass of color,
throw in three drops of cold,
you will have the aroma that follows.
Feel gratitude toward no one;
those who survive are assassins.
Death is the horizontal extension
of an artificial dream,
life not being verifiable.

CONVALESCENT

I'll have to go
through the cramped hope of your dwelling;
the house and the stairs,
as if on a steamship,
dance the secret of voluptuous pleasures.
Climb on, lukewarm love
through the perfection of happiness.
I squeeze my sadness
to the sound of invisible bells,
but the trains pass
over my diminished sorrow
the way love
passes over my thoughts every day
with its hat cocked over one ear!

RAINBOW

Birds from the sky
fill the air the way mosaics do
on the golden sun.
She is in love with my eyes,
there's nothing left for me!
We were short of breath,

like cats before meat.
Distracted from my appetite,
I recognized my road,
and now I suffer
before the cunning beast.
Our senses make us believe in chastity,
roguish consolation,
like money,
which is at the bottom of the abyss
overlooked by the open window
of the mad rainbow laughter.

FINAL SONG

Guess what's behind the blue hill:
a king in a wickerwork castle.
And behind this frail castle,
guess what there is.
By a pink tree,
a messenger talking to the moon.

Guess what's behind the yellow moon:
a gnome made of wire
blowing into a wooden horn.
At the end of the horn, the soul of a bird
summoning the spring from which dreams drink;
dreams that sleep during the day!

Guess what's behind the golden dreams:
a body of silk,
hair made of the shadow's dust,
a mouth for arid thirst,
arms to hide my sadness.
Behind my dreams there is you.

Thalassa dans le désert, Paris: Fontaine, collection "L'Age d'or," 3 September 1945
(with illustrations by Mario Prassinos).

Explorations went beyond even Picabia's early poetry in its reduction of language to pure abstraction (a similar shift had already taken place in his painting at this time). The poem accompanied a series of ten equally abstract lithographs by Henri Goetz (whom Picabia harbored, along with Christine Boumeester, from the Gestapo in 1944), which are linked to each other in a similar manner as Picabia's blocks of words: like a zoom lens, each lithograph focuses on a detail of the preceding image, and opens it up for exploration, moving through landscapes of shells and blobs reminiscent of Yves Tanguy's paintings. Picabia here performs something of a linguistic equivalent of this, taking the last phrase of the preceding section and "opening" it up, as it were, for further exploration. This zoom lens movement also moves us nicely from the similar lens of "Final Song," the final poem of the preceding collection.

EXPLORATIONS

I

Apparition for touching the smell of my heart, amidst the world encompassing the boundless memory of the hand on the fist of other objects; all that to awaken in me the freedom of love in the caress of desire.

II

Caress of desire, which invites desire, for the exquisite woman, who in my eyes, along the road of the caress, slips toward the world of myself; my throne against my flesh with the movement for forgetting the presence facing each other, which is to say, the new sadistic synthesis of blurred memories.

III

Blurred memories of contents outside the present; hypothesis of others, similar to each other, to come convince the psychoanalyst of my circular life of the opposite, the image of the design in the sentence of the stars.

IV

The sentence of the stars, like the alienated limit, to freely seize the windings of basic intuitions. My body's liaisons in the failure doomed to failure; the bad faith of years in the world of all hope, succession of the infinite, uncommon essences, the logical necessity that rejects the freedom of nothingness.

V

The freedom of nothingness to not be in oneself, as simple as the well-considered form, exclusion of the consciences of signification for the slightest affair; you have had many affairs, Madame? The existence of the world, the existence of others is assessed as the intuition of an absence.

VI

The intuition of an absence, for the existence of my experience leaning over the shoulders and tight buttocks of your conversations, on the photo of the village and the nobility swelling my heart to its bursting point. Something new, some affairs, something new to sculpt the second nature of black eyes beseeching the monstrous, to the sound of the tom-tom of stomachs for lips that know how to travel.

VII

Lips that know how to travel, incredible progress of the self along the terrain of truths of unconsidered existence in the illusion of the same things for the universal moment of intentions in the chiseled life of happiness.

VIII

The chiseled life of happiness is the gentleman of leather distinctions for students with goose-feather faces, poor simple appearance of the light roast outmoded by the plurality of the universal concept of my knowledge.

IX

The universal concept of my knowledge is to grab hold of others who end up in cigarettes along the big hands that change place, the way the sea carries away the blue of the years in order to speak with this serene sweetness of the concern for the self that concerns no one. Life without purpose, pessimism of purposes that have no reason to exist in the original contingency.

X

The original contingency on the level of permanent objectivities, intuition of expectation, social realities, carburetor of his heart in the crippled world to touch the back of a humpback with the beautiful chest, but his pain is bagpipes, in the caress of desire, my destructive sickness of my body's apparitions doesn't make more than one along the dream's road.

Explorations, Éditions Pro-Francia (Paris), 30 July 1947.

The next text comes from an exhibition catalog. Its title was composed of the initials of the exhibiting painters: Hartung, Wols, Picabia, Stahly, Mathieu, Tapié, Bryen. The subtitle alludes to Nietzsche: "Mystical explanations are considered deep. The truth is that they are not even superficial" (*TGS* 182:3:126).

The show "was an attempt to bring together the different aspects of what was then called psychological abstraction and was later to become more generally known as lyrical abstraction, to differentiate it from geometrical abstraction" (Borràs, *Picabia,* p. 453). Picabia's paintings would be predominantly abstract from here on.

As the catalog was printed by Pierre-André Benoit, this publication marked a starting-point for the collaboration between Picabia and Benoit, even though they would not actually meet until October 1949, after Benoit had already published a number of Picabia's works, many of them (such as *Three Little Poems*) "micro-books" of extremely diminutive size and limited printing.

H W P S M T B

Antimystical Explanations

Paintings and their execution are different for different painters: one has gathered together in a Painting the bright ideas that he was able to steal away from the radiance of sudden knowledge and carry off with all possible speed: someone else only provides shadows, pastiches in gray and black of what, the day before, was constructed in his thought.

My painting is a woman who does not want to make love with her husband.

I don't like this fashionable way of making paintings; it is only etiquette that makes them important.

My thought tells me where I am: but it does not tell me where I am going.

Ignorance of the future is my life, my life that can only live in anticipation.[1] I am failure's success.[2]

I desire neither result, nor goal.

"H W P S M T B," from the catalog for the exhibition "H W P S M T B" at the Colette-Allendy Gallery, 22 April 1948.

THE FUTURE-CHILD

One quite simply
needs the absolute blood of life
for the effusion of illusion
one needs the assimilation of the imagination
which produces the opinion
of great dreams
that sleep
in a world
sheltered from the world
before the impatience
of the painting that is to come.
Francis Picabia
Basel, 27 October 1948
(unpublished, to Marguerite Hagenbach[1])

"L'Avenir-enfant," in *Panderma* (Basel), no. 1 (1958).

Three *Little Poems* **was the first in a substantial series of "bibliophile editions" that Benoit would publish of Picabia's writings.**

All three poems consist of Nietzschean themes that can be found in *The Gay Science* (e.g., "Star Friendship," logic's dependency on illogicality). From here on, allusions to and appropriations/quotations of Nietzsche will be prevalent throughout Picabia's writing.

THREE LITTLE POEMS

My friendship
is a star
always harder to please
in regard to myself.[1]

Happiness in Renunciation[2]

Love deceives me
it is in this way that
the mushroom grows
which from your mouth
adorns
your memory for me.

Logical

Logical
illogical
to deduce
otherwise
seems
more
and more
true.[3]

Trois petits poèmes, published by Pierre-André Benoit (PAB), at Alès (Gard), 1 January 1949,
in an edition of 49 copies.

In March 1949, Picabia had a retrospective at the Drouin Gallery. The catalog (entitled *491* and subtitled *Fifty Years of Pleasure*) contained a mishmash of aphoristic writings. The first text has not, for obvious reasons, been translated. Letters, and perhaps words, seem to have been removed from a source text that remains obscure. (A number of words are discernible, though: the "explanations" open, for example, with a reflexive verb conjugated in the first person plural.) In execution, it bears resemblance to an earlier text that Duchamp had inscribed on his 1916 work, "With Hidden Noise," as well as to his 1939 text, "SURcenSURE."

For the title, see the "antimystical" "H W P S M T B." This piece is something of an illustration of Nietzsche's definition of a mystical thought: it doesn't even say something banal—it simply says nothing at all. The fact that Picabia assigns the text to his Dada period implies either that the original text he manipulated dates from then, or that his retrospective assessment of Dada hasn't changed since then (in that it all meant "nothing, nothing, nothing").

MYSTICAL EXPLANATIONS

NS—NS—STONS—TOP—BIN—DEDU
EN—CE—PR—SA—TESE—PR
SA—PE—PR SA—PUM—PR—L'HADE
TS—CES—GRS—QD—IS NS—RASNT
NS—DCENT—NE—FAISSE—NS—RASNT
NS—DCENT—NE—FAISSE—NS—AIMS
DE—DOER—SR—EE—SS—SECS—SS
PACE—EE—ET—NE—TEE—PACE—MS
OU—COUNT—LS—SEDNS?

FRANCIS PICABIA, Dada period

I'd rather others chose for me, so as not to be the victim of my fair play.

Materialism likes abstract art; abstract man simply likes art.

"Explications mystiques," in *491* (4 March 1949).

In the next text, Picabia is, for the most part, copying out phrases from Nietzsche. See *The Gay Science:* The title comes from 123:2:60 (Picabia replaces Nietzsche's "women" with "painters"); lines 1–15 are from 144:2:88; lines 16–18 from 144:2:89 (Picabia replaces Nietzsche's "festivals" with "love"); lines 23–29 from 145:2:92 (replacing "prose" with "painting").

PAINTERS AND THEIR ACTION AT A DISTANCE

TO TAKE TRUTH SERIOUSLY!
BUT IN HOW MANY WAYS?
THESE ARE THE SAME OPINIONS
THE SAME WAYS OF PAINTING
THAT A THINKER CONSIDERS AS ZERO,
WHEN THEY PUT THESE WAYS INTO PRACTICE,
HE DIES, IN THIS SENTIMENTAL MOMENT.
THE OPINIONS THAT CAN MAKE AN ARTIST HAPPY,
WHEN HE BEGINS TO LIVE WITH THEM,
BELIEVING IN THEIR PROFOUND GAIETY,
DISAPPEAR IN ORDER TO SURPRISE HIM
IN WHAT IS OPPOSED TO APPEARANCE.
WE ARE BETRAYED BY THE SERIOUSNESS
THAT MEN GIVE TO INVENTION
AND BY WHAT WE ATTACH IMPORTANCE TO
WHAT DOES ALL OUR ART MATTER IN ARTWORKS,
IF LOVE, WHICH IS LIFE,
BEGINS TO FADE AMONG US!
NOWADAYS, WITH PAINTING,
MANY MEN HAVE THE SUDDEN
AND HASTY KNOWLEDGE OF ENLIGHTENED TOUPEES
IN THEIR HEADS.
BUT DON'T FORGET THAT THE GREAT MASTERS
OF PAINTING
WERE ALMOST ALWAYS POETS
IN SECRET, AND FOR THEIR PRIVACY:
ALL CHARM CONSISTS
IN ESCAPING IN ORDER TO CONTRADICT ONESELF MALICIOUSLY
WITH REGARD TO POETRY.
27 August 1948

"Les peintures et leurs effets à distance," in *491* (4 March 1949).

The remaining phrases in *491* are probably all taken from Nietzsche. I have been unable to locate all of their sources, however; what I have found is given in the notes.

[UNTITLED]

Knowledge is an old error that thinks of its youth.[1]

 Illogicality invented logic.[2]

 Men who aren't good-looking or noble want to become men?

 The shadow of God is a man in the moonlight.[3]

 Loyalty can only result in suicide.

 Love forgives even lovers.[4]

 Women are more skeptical than all men, especially old women.[5]

 Prayer was invented by men, for women and their sex.[6]

 Mystical explanations are the most superficial.[7]

 Men invented the worship of error, nontruth, and falsehood.[8]

 Malcontents and the weak make life more beautiful.

 Laws are against the exception; as for me, I only like the exception.[9]

 The devil follows me day and night, because he is afraid of being alone.

 It is raining and I think of the poor people for whom it is not raining.[10]

 The clear conscience of laughter gives me a rest from serious people.[11]

 Must I start thinking over a serious outcome.

 All women are full of subtlety, especially when it is a question of exaggerating their weakness.[12]

 Many artists devote their time to their painting; I wonder why these people are so fond of bad company.[13]

·Art is the worship of error.[14]

To fear the senses is to become a philosopher.[15]

 The love of hatred is the most beautiful love of all.[16]

 The end is new; I am the new means.

 To play the voyeur is to go beneath existence!

491 (4 March 1949).

PRECAUTION

Her heart claims to like only
intelligent people
they aren't
but she believes
that they are
she looks for stories

comparable to those that she would like to have
and in her heart
are rosy-colored thoughts
the approbation of which
her stupidity makes her record
like a feeling of mathematical
progress for the equation of dreams

Précaution, published by PAB in Alès, March 1949, in an edition of seven copies.

IN A CHURCH

In a country church
I saw in place of the Christ
a photograph
of a very pretty woman
in Renaissance clothes.
A curious ornament
for a church.
I was pondering over it
when a door opened
and a priest
holding a flower in one hand
and a bag of candy in the other
said to me:
You wish to speak to me?
Yes Father
if it's not an inconvenience.
He made a vague gesture
and said to me sweetly:
I love you
do you want to sleep with me?
Then he remained silent
looking through the window
at the Holy Ghost passing by.

"Dans une église," in *K. Revue de la poésie,* no. 3 (May 1949). This issue was entitled "From Humor to Terror, Homage to Kurt Schwitters."

OR ELSE

Either in a placid position
or else good or bad memories again
or else intentions and hopes
or else sweet pleasures of our bitterness
or else lies
or else in one way or another
or else being in love
or else suffering and misfortune
or else the labyrinth
or else chaos
or else nothingness
or else ?

A MATTER OF TASTE

Our opinions demonstrated by our actions
are wonderful plants,
you know happiness,
evil and good
are pederasts,
who don't love life
because life is a woman
who thinks of life in a practical way
and in no other!

I hate what is good
as much as what is bad.[1]

I never ask questions
because I run after the sun.

Faithful to my nature
I paint what pleases me
But what pleases me?
That which pleases me.[2]

I look at the ceiling
on which there is nothing.
Why?
I know that there is nothing there,
But I'm not completely sure of it.[3]

Give me colors to grind
Picabia to grind
don't look for meaning
in what has none.

CLOAKROOM

Archway lit by the night
you hang over multicolored men
over ghosts and hermits.
The wind chases away the clouds
to sweep away
the melancholy of the sky
also to show myself
my memories
hung like flowers
from the stars.

"Ou bien," "Affaire de goût," and "Vestiare" originally published in *L'Art abstrait*
(Paris: Éditions Maeght, 1949).

I'VE NEVER
BELIEVED
IN MYSELF
Late Writings, 1950–1953

Benoit took great care in preparing *Chi-lo-sa,* creating a special typeface and an elaborate page layout, as well as a different graphic design for each cover.

The title translates from the Italian as "Who Knows?"—another phrase from the pink pages of the *Petit Larousse.* It may also allude to a passage from *The Gay Science:* "But the ability to contradict, the attainment of a good conscience when one feels hostile to what is accustomed, traditional, and hallowed—that is still more excellent and constitutes what is really great, new, and amazing in our culture; this is the step of steps of the liberated spirit: Who knows that?" (239:4:297).

The book itself is a lengthy collage of passages from *The Gay Science* spliced with Picabia's own, often sentimental, verse. I have traced the origins of most of the Nietzschean passages and titles, but a number have doubtlessly slipped by me. But even those that I have not traced directly back to Nietzsche echo with the philosopher's ideas. Picabia's own verse is often discernible by the presence of a woman.

The aphoristic format of Picabia's / Nietzsche's verse hereon finds a visual echo in the series of "pocket paintings" that Picabia executed in the 1940s. Wartime rationing had limited supplies for everyone, and the practice of mini-painting can be found among a number of artists during this period, including Joseph Sima and Max Ernst. Picabia's literary production at this point, then, indicates an effort toward the reformation of the "pocket poem" (a term going back to Pierre-Albert Birot's first book of poems in 1917): economic and recycled literature.

The book's preface was by Jean van Heeckeren, a friend and lifelong supporter of Picabia's work who as coeditor of *Orbes* published a number of his articles. It bears quotation:

When writing, [Picabia] works somewhat in the manner of a painter who starts by slapping paint on the canvas and then extracts the painting from it. He had actually shown me a very voluminous, dense, confused, and formless first draft, from which some phrases emerged. When I saw the finished manuscript, it was barely recognizable. Its volume had been greatly reduced, everything had been cut into little pieces and clarified with the utmost lucidity. It is a curious fact to take note of because in reading it one can get an impression of improvisation, owing to its frivolity (frivolity of profundity), which ponderous minds will not grasp. This book, which gives an insight into Picabia's mind in 1949, is a perpetual rejuvenation; one has the joy of discovering an intelligence-sensibility in him that is entirely gratuitous, without any preconceived goal, and without purpose; he enjoys writing everything that gives him pleasure one moment, and it is, as in his paintings, a perpetual invention.

Chi-lo-sa? Are these poems? Are they aphorisms? They're neither one nor the other. This is a book. A book the likes of which you have never read. And this book will fail to delight either the fools, or the incomplete, or the indoctrinated, or the blind—which is to say, the majority of people.

To call a mass of unattributed quotations a "book the likes of which you have never read" is ironic to say the least; Heeckeren was apparently unaware of the nature of Picabia's "writing," though. (Or was he? An article he wrote in the 1930s on Cendrars in *Orbs* was supposedly copied straight out of Balzac. See Bochner, *Blaise Cendrars,* p. 260, n. 13.) "Postmodern," however, would be an equally problematic description of this book. *Chi-lo-sa* (and some of the writings to follow, such as *The Masked Saint*), could be construed as a literary anticipation of Sherrie Levine, or Michèle Bernstein and Guy Debord's Situationist "novels," save for the fact that Picabia calls no attention to his impudence, and for the most part seems to have no thoughts of "detourning" or manipulating his source material (Nietzsche's philosophy had by now, more than ever, become his main reference point). The very fact that he opens this work by putting his own name to its epigraph immediately announces an uncomfortable reading experience. It is indeed, if for reasons other than those implied by Heeckeren, a book without precedent.

CHI-LO-SA

To those who now have ideals,

these ideals often bring on remorse: for ideals are a virtue

of a time other than that of honesty.[1]

Picabia

Resting in the shadow of the fir trees
I saw my heart shrug its shoulders

NO ILLUSIONS

A bird
teaches a fish
how to swim
without hatred
and without any hard feelings.[2]

MADNESS IS A GAME

But what's the beauty in that
nothing is proven
intelligence
diminishes in clarity
in order to vent the passions
close to the one who provides them.[3]

PLEASURE

Pleasure keeps to itself
and doesn't look
at what takes place behind its back.[4]

TO HANG FLOWERS UP
SO AS NOT TO SEE THEM ANYMORE

Might morality not have
its origin in error.[5]

INNOCENCE

Why not sleep
in a flower
eyes in hands
and dream
of everything that sways
and squats
why don't you come over here
into my arms
so you don't have to see me anymore.[6]

LOVE

I compare you
to the amorous fish
who would be jealous
of the intrigues of birds.

INTERPRETATION

Everywhere I come across morality
I look for instinct.[7]

SHRUG YOUR SHOULDERS

Would you like to paint
in a bidet of bugs.

AND THERE YOU HAVE IT

For hours without talking
she looks at the color of her skin
and every part of her body
she's as amused as a child
we were pressed against each other
but my mouth no longer knew
how to join hers
I'm going to bed
she told me.

THE MOON WENT DOWN
INTO MY CHAMBERPOT

My heart is the greatest
mystery
It whispers to me the tune
of the aimless mind
on the divan
of my thoughts
racked by the uncertainty
which kisses me.

I EVEN SAW HER HAND

Since I need her
I have to continue
believing what she tells me
but the light breeze
of all possibilities
overcomes me to distinguish
the sacrifice of my desire
for her reason.

LAUGHTER

I laughed all day long
it seems that my laughter is
the sound of my tears
to stop laughing
when gazing at
her whom I'd like to know.

WHAT DOES IT MATTER

I seek silence
amidst the noise
by playing deaf
to the point at which
I become so.

COLLOQUIUM

And now
we must devour distances
to find out what no one
knows:
where happiness is.

AROUND NINE O'CLOCK

You have to and you don't have to
so begins the day
for the uncertain future.

WHERE AM I

Dark sea is humanity
it is quite a
melancholic story
for the boat
that wants to cast
its anchor into the sky.

FOR MY REPUTATION OF NOT
BEING SERIOUS

Better to do nothing
than anything.[8]

NEW REALITY

Their pride only comes
from what they don't have
poor new reality

as if I give a damn
a friend used to tell me
as morality
for his own
instinct.[9]

MEDICINE

You long for glory
take my advice
renounce time
and freely
renounce troubles.[10]

Yes sometimes
I paint
it distracts me
from the paintings
of others.

INSTINCT

Morality is a way of living
off others for others.

TO CHOOSE

I will never make a choice
because I'm afraid of making a mistake.[11]

A BIRD SINGS

Daylight comes after a sad night
a millstone rests
nothing happens
a bird sings
a desire urges me on

but where to
and then it's over again
for today.

TAKING TRUTH SERIOUSLY MAKES ME LAUGH

This mountain makes the region
charming if you climb this
mountain you will be disillusioned
it is the same for men
you have to look at them from a certain
distance.[12]

PREJUDICE AGAINST IMBECILES

Ideals cannot survive
without the insane.

HUMANITY

A man
full of strength
love
tears
laughter
is probably
that which men
call humanity.[13]

THE MOON

I'm going to sleep
the moon told me
she closed an eye
and again said to me
you know it takes more

than beautiful moonlight
to surprise me.

I must eat my bread
by the sweat of my brow
but I'm never hungry
when I'm sweating
I'm thirsty.[14]

THE SHADOW TURNS

The hours are short
the shadow turns
about a spire
in the sky
it took my hand.

SADNESS

The remedy for sadness
is called sadness.[15]

SUCCESS

The age in which we find ourselves
is as agreeable
as the one in which we don't find ourselves
for causing trouble
what uncertainty
in success.

THE TOAD WITH THE YELLOW EYES

We were in the garden
one afternoon
Suzanne[16] suddenly
closed our book
to listen to a musical tune

that didn't exist
and threw me a wide-eyed look
through a curious vision
that of a toad
with yellow eyes.

AN ARTIST

An artist seems to me
like an inadequate
antiquity.

NEUILLY FAIR

I love this woman
because she reminds me
of merry-go-round horses.

Pity is the virtue of prostitutes[17]

MY MEMORY

From your mouth falsehood ensues
but your stupidity
effaces its features
now I have only to
clean out my memory
until the very last trace of it
has disappeared.

I'M AFRAID OF FLOWERS

I care as little
about being respected
as of going to heaven
but I can't see very well
there is a screen

between you and me
perhaps the darkness
which is all to your advantage.

ANNOYANCE

Everywhere I come across
a moral standard
I come across a function
for others.

THE PRIEST

Calmness and fear
without expression
without ears
without words
without thought
that's the parish priest for you.[18]

DURATION OF THE DREAM

The sleepwalker must
keep on sleeping
in order not to dream
and his lifeless face must
have the irony of itself
like a little will-o'-the-wisp
dreaming
for the duration of his dream.[19]

DISDAINFUL WOMAN

We went
all the way to Aar
and there we threw away
your pants

along with the book
you had brought.

The only way
of being the strongest
is to fight
on the side of one's adversaries.

Pain asks for reasons
pleasure couldn't care less.[20]

MONKEYING ABOUT

Farewells seem to come apart
through the heart's tired fluctuations
and want to nestle
far from our innermost pains
like monkeying about.

PETRIFIED LIFE

What a petrified life!
But my intention
is to not feel
bad enough
to feel bad.[21]

SCENT OF ACACIA

She held her cheek
against her hands
her eyes were blurred
with blue with green with purple
she let her mouth
her gloves and her handkerchief
drop
do you remember
that scent of acacia.

YOUR EYES

I admire your eyes
your name
your voice
your body
come with me
to your place
you will be my aid
for thinking about you.

Disgust among refined minds
is a new concupiscence.[22]

Do you want to go
to where I'm coming from
to look at the whores.

EGOISM ---

MADMAN'S UNCERTAINTY

The labyrinth tries to leave the labyrinth
like a rhinoceros without horns
must I look at it as a nightingale.

THE MIND CAN BE AN EVERLASTING REALITY

I seek the cord that binds
all things
by astonishment's orders
to discover the significance
of the appeal of illusion
which wants to become the reason
for boredom
and for the daydream
of hope.

ISN'T IT CRUEL TO LET LIVE?[23]

To know how far existence goes
to know whether existence possesses a
character
without explanation and especially without
reason
for our curiosity
in wanting to understand
this unknown perspective.[24]

CONSEQUENTLY[25]

The icy realm of ideas
is more dangerously seductive
than the senses
the philosophy and vampirism
of the enigmatic idealism[26]
which takes after the wisdom of the sages
in order to contemplate itself
and trace out the line of hope
along the horizon of its desires.

CONTEMPT ALWAYS BUT
WITH THE HOPE OF ADMIRATION[27]

Nature glitters
I hear its call
to dance
to attack a happiness
hung from my desire
which is without hope.

FAITH DOESN'T SAVE

Tonight the stars
are dead
for the ghosts

who is it that pleases them
that's what I don't know.

JOY IN MADNESS[28]

Dirty and pure
madwomen and wise men
doves and serpents
neither good nor bad
I still have to run . . .[29]

INTELLECTUAL'S CONSCIENCE

Among certain men
I found the reason
for their bad conscience
that's what amuses me.[30]

TAKING TRUTH SERIOUSLY[31]

It's coming down in torrents
even into the water
but it would be crazy
to stop pissing because of that.

ONE MORE STEP
INTO PESSIMISM[32]

When one loves
faults stay hidden
with the exception of that of loving
and even so truth
only begins at three.

QUESTION MARK[33]

A well-organized society
only knows how to put to sleep
those who are falling asleep
so as to sow evil
in the same way as good
on one foot
or on two.

MYSTERIOUS SUZANNE

You whose heart wants to break the mirror
to see yourself
always more beautiful
move away
so I can look at you.

EVERY WOMAN'S HONOR
IS PUT IN HER ASS[34]

Why believe in what is well
especially in what is well said
I don't like men of taste
they make me think of game
that's been hung too long.

JOY

Eternal consciousness of the moon
where memories are lost
in my shifting furrows
to the point at which line by line
gradually as in measure
in my eternal unconscious
a new desire urges me on
into the night.

CHURCHES GIVE AMOROUS IDEAS[35]

Everything around me
changes into darkness
it is the knell
in the desert
the Buddha's shadow
is no longer visible
but I still want to see
and eat the hashish
that looms up from nothingness
to console me for nothing
and for the memory of his shadow.[36]

THE WISE MAN ALWAYS SMILES

The problem of consciousness
only presents itself to us
when we begin
to understand to what extent
we could do without comprehension.[37]

BEWARE OF THINKING[38]

I am afraid of my room
because a woman
is its smoke
without fire
but perhaps that is
what I'm looking for
I'm looking so as not to find
the experience of inexperience
which goes to the brain
to speak to me of passion
and especially of nothing at all.

GO FOR A WALK WITHOUT ME

Now go for a walk without me
into what happens
and even into
what will never happen again.

TO LOVERS WITH THEIR HANDS FULL

Children are the penitence
of love
must one be indulgent
toward women
who yield to the penitence
of such customs of maternal love
as contemplative patience
in order to have their true reason.[39]

TO THINK ALONE

You have nothing more to seek
since you've found everything
except your stupidity
which others will find.

JUXTAPOSITION

Your mouth cannot
make me forget your ass
which has the reflection of your heart
wet from my kiss
which thinks about what it already knows.

MUSIC OF SOLITUDE ···

LOVE DOESN'T FORGIVE
THE LACK OF DESIRE[40]

People don't know
far-off expeditions
placing in their thirst for the already seen
all the novelty of their personal infinity.[41]

PERHAPS

Her heart makes eyes at me
clever magician
singing passionately
of the glory of her sex
kindled in my hands.

TO A NEW SEA[42]

Guess what I'm asking for
a memory against boredom
which bears the image of the unknown
so I can be closer to myself
and see the world at a greater distance
by navigating with the four points of the
compass
having a horror of dead calm.[43]

BOREDOM

Gold turns into lead
for the one
who doesn't like boredom.[44]

SHE LEADS ME
INTO THE LABYRINTH[45]

She asks me to wait
then she disappears
I learned from her charming past
that she had been the wife of a Spaniard
who lived on his memories.

She seeks
so as not to find
the reason for her search.[46]

A LEAF FOR
A WREATH

I learned to find
by not seeking.[47]

DECLARATION OF LOVE

The recollection of thoughts
is only a little bouquet
for our illusions.

A TORRENT OF DIAMONDS

I want to open the eyes
of those who have
the same eyes as me
to make them believe
in the eyes
that I myself have.

I SAW THE ROSE THAT CARRIES ME

The apple falls from the tree
to sow other apples
which shall also fall from trees
in the hope that these apples
become stars
like the sun
which makes the apples grow.[48]

SUBLIME INSANITY

What marvel
does she still see
yes she arises
and her wings
are round me
but then what is she carrying
perhaps myself.

NEED OF CERTITUDE [49]

A desire urges me on
I'm thinking of you.

BECAUSE OF THE WIND

Faced with existence I occupy
the sleepwalker's continuity[50]
in favor of one thing
or another.

BELIEF IN LINE
WITH THE IMAGINATION

There you are
take off your dress
take off your pants
I want you completely naked
so I can rest
in your shadow.

WORRIES

My happiness wants to sleep with me
but wouldn't it be dead
it isn't alive
I want to go beyond existence
far from the undertow of my memories
to find the dream of illusion
and no longer have to forgive
those who cannot be loved
for not loving them
and have nothing more to simulate the
 image
in the manner of images
and to have nothing more to defend oneself
 with
against oneself
against them
against everything
and even against memories.

ON ONE OR ON TWO LEGS

Take this memory's
legacy
and throw it very high
so that it hangs from
the crescent of the moon.

AND CONSEQUENTLY

But I already no longer know your name
you who passed through

my arms
like the shadow
of a forgotten love
poor actress of your imagination
who wants to stand on her head
with her eyes at the tips of her toes
to know the price of life
without knowing its value.

MUSIC OF FORGETTING[51]

To come out of nothingness
to find consolation
for everything (nothing).

UTILITARIANS ARE
RARELY RIGHT[52]

I've understood nothing
nor sensed the coherence
of illogical deductions
against instinct which is logical
but false (is it true).

CONDITION FOR EXISTENCE

Eternity's star
intends its light to be had
by the one who can believe
and find.

PRECISION OF ABSENCE

She wants to sleep with me
at all hours of the day
I wait like an idiot
but nothing happens.[53]

THIS IS MY TYPE
OF INJUSTICE[54]

My heart is unsettled
I also have a grudge against it
All my happiness
is a sweet and desperate
torment.

THE FLY

I would like to be alone
on a cloud
catching flies.

I THROW HER UP THERE

She who comes from below
smells musty
she who comes from above
also smells musty.

TIMELY BAD INSTINCTS

One girlfriend became two
love passed away
next to me.[55]

COMMUNISTS THINK
FIRE WAS MADE FOR THEM

To invent the worship of illusion
as a condition for invention
is not an invention.

AGAINST THE MISTRAL[56]

To forget is best
and to recover at random
the roses of my life
which turn
incessantly about me.

AMERICAN BELIEF

Imperfection
as a rule
for perfection
on the cloud of certitude.[57]

SOME KIND OF MADNESS

I see again the gulls of Cannes
the sea is calm
evening is going to rest upon it
perhaps that was happiness.

MY ATMOSPHERE[58]

NEW SKY

The painter must learn
to recover his silence
so as not to die of impatience
and remain on the road
where the thick clouds part
to let the sun shine.

INTERPRETATION

You see she flees from men
to show them to us

by running before them
so that they'll follow her.[59]

PHYSICAL JUDGMENT

Hands unite
better than mouths
even so they have the same goal
to do the same thing.

DESCENT

You are at the bottom of the stairs
where you could find
more than you desire
if you only knew how to find
the bellpull.

WHILE DRINKING WINE

I wanted to go
into the heights
and now I'm going to disappear
and for whom?

HAPPINESS

Where does happiness come from
from near
or from afar.

COMEDY

Who has seen it
its name is friendship.[60]

REASON IS A LIGHT
THAT MAKES ME SEE THINGS AS
THEY AREN'T

TO MY HEART THE WATCH
THAT MARKS THE MIRAGES

People arrange their lives
with a view to appearances
and bedazzlement.

AND PERHAPS THIS IS THE WAY IT IS

The nightingale has a flute
my wife some shoes
of red morocco leather
and skin that makes
the jasmine flowers blossom.

THIS LAST ONE IS OF ONLY
SECONDARY INTEREST

Your smile is a moon crescent
for my testicles.

UNCONSCIOUS VIRTUE[61]

I would like to throw
some empty ideas into the air
so that they fall
toward the sky
but go to our rendezvous
so that you can bring me your virtues
those also fall
through your asshole.

He who knows how to confess
can forget.[62]

THE SPIRIT
IS THIS SORT OF THING

Radishes fall from the trees
why not.

SOLITARY

I think of the darkness
of the needle that turns
upon the piece of charcoal wandering about
pitying
that which is not
a sin for me.

CONSERVATIVE FAMILY

Matisse has a Persian eye
Picasso paints like a chameleon
Braque like a woman from Normandy.

THE DREAM'S DURATION[63]

The years only get thinner
that's why I tell my heart
to drink the philter of dreams
whose flower is about to open
to receive me.

I ATTRACT YOU AND I LOVE YOU
DON'T FORGET ME

I like the defrocked priest
the freed convict
they are without a past
and without a future
and thus live in the present.[64]

IN THE SOUTH OF FRANCE

Prose full of haste
poems in a hurry
me I'm rocking
upon the surface of the sea
last night
when everything was asleep
the sigh of the wind
for an hour
maybe two
took pity on me
and said
I know a woman
who loves you
why don't you go find her.[65]

PERHAPS APPEARANCE IS LIFE[66]

The optimist thinks that a night
is framed by two days
the pessimist that a day is framed
by two nights.

PAIN OF ERROR

He's a good man
so he passes for an idiot.

SOMETIMES THROUGH THE STREETS SOMETIMES IN A BED

Jean Van Heeckeren Marcel Duchamp
one more than less
the other less than more
navigate with golden sails
without hatred or joy.

MASKED MONSTERS

I was dreaming of the women
on Fifth Avenue
in New York
those street sweepers of the steel
sky.

AMERICA

Set out to take the Devil's ladder
which they lean against the stars
everything sparkles
and looks at me
the wind makes me
lose my hat
I no longer have to greet the goal
that stretches out before me
now a new life
for a new game
I'm going to greet this life
but without my hat.

TO MY LADY READER

Now my hand
in your bed
can no longer find yours.

BETEL-CHEWING[67]

One must drop one's anchor
into the vagina
of one's ideal.

A FEW DAYS IN SWITZERLAND

Long as a day without sorrow
a friend was saying to me who was bored
of no longer being bored.

For feeling desire it is enough to be a child.

Loquacity is a pleasure of noise and sentiments.

We are often mistaken about women
it is not they who have a taste for purity
that's a man's taste.

To have faith in oneself is a useful blindness or a partial darkening.[68]

To love life is to repel those who want to die.[69]

The conscious person is a late evolution, and consequently that which is least strong.[70]

Superior men distinguish themselves from inferiors
through the fact that they think they see and hear
what others do not see and do not hear.

Women love to exaggerate their weaknesses.[71]

Men let themselves be seduced by discreet tenderness.[72]

His fame benefits from the fact that he never reached his goal.[73]

Now I can no longer recall how
I was able to feel such happiness
from catching a little bird.[74]

Our thoughts are the shadows of our actions.[75]

I fear that very young women are greater skeptics than any man.[76]

One must lose one's lasting habits for the sake of one's health.[77]

The problem of consciousness only presents itself to us
when we begin to understand to what degree
we can do without consciousness.[78]

We are nothing more than building material for society, but what society . . .[79]

And I hope to continue traveling ahead of the greatest sorrows and my
highest spaces without feeling ashamed of myself.

Oh ideal little bird.

All men are in sum only a single man for multiplicity is just appearance.

I feel something like pleasure when I incorporate knowledge into myself
and render it instinctive.[80]

Women should not have this poverty of spirit when offering their virtue
or their modesty.[81]

What do you know of the character of existence to be able to decide on
suspicion or trust?[82]

It is such a joy to make a Swiss Protestant sin
because she cannot get herself absolved.

Vulgarity was invented in Southern France.[83]

I met God
he was equipped with a divine microscope
for studying our unconscious virtues.[84]

They knew it was me; I wonder what people really mean by knowing?[85]

People who talk a lot have nothing to say.

The most convincing eloquence is that of silence.[86]

New moral events cannot exist
not even in the sensual realm.[87]

Is it hunger or abundance that produces the desire for destruction—
maybe the two together.[88]

Carry on as you began, constantly ready to say anything.

Dancing gives you illusions
praying makes you lose them.

Many men are fetuses
who think they're the Unknown Soldier.

Bravery loses its right through lack of experimentation.[89]

Death is the goal of existence
but the deceased leaves behind his magical influence
for vices are easy to imitate
and have no need of long practice.

Oh! how little you need
because beings bring to light
the heart of their grandparents
who are only the enlighteners of their father.

REASON

It is enough that my life
has a reason
for me to regret
this reason.[90]

SADNESS OF MADNESS

My sadness
wants to sleep with me
so as to find me in my imagination
and to no longer have
to simulate its image for me
so as to no longer defend myself
against myself
against life
and also against memories.

DURING THE RAIN

I don't want to know anything more about it
take some chocolates
no one's eating them
and they're going to get stale
then she took my head
put it on her sex
and seemed struck
by an extraordinary happiness
which made her lose the time
she needed to go to the hairdresser's.

STABLES

The smell of stables
makes the lovely ladies
swoon

what do you think of that
my darling.

She looks as if she's waiting
for the caress of a new hand
what do you think ought to be done
lift up her dress
it was a young crystal girl
she had the voice of a mandolin.

WHAT THE FLAMES
REVEALED TO ME

We shall meet again
and not recognize each other
even if it means
we have to be friends.[91]

The comedy of existence
is not conscious
men imagine
they know why they exist
laughter is the wisdom
of sublime unreason.[92]

I saw a gorilla in a circus
leap at a spectator
whom he had taken for a woman
which had made him furious.

THE BED

That night
I again
had a bit to drink
enough
to tell

stories
she put her head
in her hands
and cried.[93]

THE JOY OF HELL[94]

Wherever I may be
think of me
I'm at your feet
but below
it seems
is always hell.

BOREDOM

I have given a name to my boredom
and call it Bern.[95]

VRÉNELI

Vréneli's bedroom
where we were staying
had pink drapes
a bed padded with peach damask
a small clock was showing noon
or midnight since yesterday
she undressed
a little like an Englishwoman
her dress had diagonals
and diamonds.

KNOWLEDGE

Like a rolling ball
I turn about myself
to seek
what no one has found.

MATTER AND IDEAL

A fat woman
was walking near me.

She was smelling the grass
wore a sack on her head
and was casually holding an umbrella
dark and sad
with the tips of her fingers
in green gloves.

THE CANDLE

She leaned against the bed
slightly bent over
a candle
also bent over
was dripping on her dress.
Rubigen, 25 August 1949

Chi-lo-sa, published by PAB (Alès), 1950, in an edition of one hundred copies.

I'VE NEVER BELIEVED

I've never believed in myself, I've never believed in my actuality, and I've never known how to see myself in the future, like a child who believes that he will truly be himself, when he will become something else, when he will be the man able to be something beyond this life, I'm thinking of an imaginary self that cannot exist.

Je n'ai jamais cru, published by PAB (Alès), May 1950, in an edition of three copies.

"**For** and Against" is a bizarre text, at least half of which is composed of snippets from *The Gay Science*, arranged into dialogue form and focused on the theme of homosexual love. This is not an issue discussed in *The Gay Science*, although one section (68) entitled "Will and Willingness" alludes to the theme: a male sage delivers one of the book's less misogynistic statements on women to a youth who has been "corrupted" by them. Nietzsche follows this somewhat sympathetic statement by what seems to be the sage's Socratic and unsuccessful attempt at seducing the boy.

Picabia's intentions with this text are difficult to ascertain; it comes a bit late to be a response to Breton's renowned aversion to homosexuality. That he may be working something out on a personal level seems hinted at by the opening "Concealed from myself" (Nietzsche may lurk even there, however: "When we are in love we wish that our defects might remain concealed" [*TGS* 218:3:263]). Is there a more concrete dialogue between Picabia the artist-writer and Benoit the artist-publisher carrying over into the text? Any motivation will probably remain opaque until more context for this piece is found.

FOR AND AGAINST

Concealed from myself.[1]

I am writing these lines in the corner of a house in ruins; but it is too vain to know it.

This is a conversation between two friends, one who loves women, the other men.

On that day X planted himself before his friend Y and asked him this banal question: "What do you know about love?" Y, not wanting to answer rashly or with insolence, laid his hands flat, and finding nothing to say to him, spoke reluctantly: "I am naively humble, and rather frequently at that, and when you are so, you become, once and for all, unsuited for following the moral standard

that tells me: you're wrong—where are your senses! that can't be true: loving men, yes, men, men—but do you mind if we don't talk about it?"

I do,

went X.

And a strange conversation ensued: truly X, skilled at improvisation, especially in regards to his life, was never mistaken, although he constantly played a curious game. He made me think of those female improvisers whom the audience would like to think of as immoral, but wrongly, for every man and woman is more and more idealist, through the luck of their unexpected whims. Homer may have perhaps lost his taste for life because of these whims, thought X.

Riddles are a danger, moreover here's the reason:[2]

If you love men, Y, it's through disgust, perhaps a disgust for moral standards, which spend their time telling us: "don't do such and such a thing," although thirty-year-old women, in the innermost recesses of their hearts, are more skeptical than men, and end up believing in the superficial side of life, as if it was the very essence of their life[3]—and then wouldn't it still be love that advises them not to love?

Y exclaimed, with the voice of a contralto: "Everybody agrees that young girls are to be brought up in ignorance in the matters of love,[4] and perhaps that's the reason I love men.

"And then," he tells us, "I love men because they are the point to which women strive, for which men are nothing but apology and penitence."[5]

That's not bad, thought X, but Y resumed: "It seems to me that with lions the masculine sex is looked upon as the fair sex?[6]

"Because for me a woman is a paradox, it seems to me that a woman has no sex.

"Aristotle might have said the same thing; what do you think X?"[7]

"To think that it's common is much less the effect of a better understanding than the effect of separative tendencies, that's all.

"And since the strength of young men is immobilized in their need for life, you shouldn't be surprised to see how sensitive they can be; just as many decide in favor of men. As to what attracts them, it's the spectacle of the ardor surrounding

the male sex, that's why the subtlest seducers are very good at making them catch a glimpse of happiness, rather than persuade them through social reasons: one cannot be happy or win through arguments. That's what we've arrived at: abstract love, like abstract painting. Do you want to reply, Y?"

"Well, it's very simple: it's because nature was parsimonious with regard to women that she didn't really make them shine, one more so, another less so in accordance with the abundance of their money, that's all. Also, why don't women have, in their rising and at the end of their life, as beautiful a visibility, even as that of the moon? As if there's something less equivocal in living with a man! That's what I think."

My own opinion is that X is right. All while being perhaps an idiot to remain a bird who doesn't want to wander away from its cage by becoming the object of its contemplation in order to transform itself into this very object, without forgetting the affirmations. And then the only rival of love is the feeling of friendship, which for me is even more sacred.[8]

Pour et contre, published by PAB (Alès), May 1950, in an edition of eighty-four copies, with four double lithographs by Picabia and five lithographs by Benoit.

Benoit did not typeset "The Least Effort," but rather published it as a lithograph, reproducing Picabia's original manuscript, cross-outs and all.

Picabia's rejection of the "weighty and serious" attitude again draws from Nietzsche's *The Gay Science,* but his simultaneous dismissal of abstract art is puzzling, given the amount of abstract paintings he was churning out in his later years (many of which—his polka-dot canvases in particular—indeed seem to have been executed with minimal effort). His withdrawal from the Salon des Réalités Nouvelles around this time, though, is reflected in this artist's statement.

Equally striking, if not necessarily puzzling, are the parallels in this text to his various statements from the 1920s: "Everything wearies us, especially commonplaces or repetitions, which . . . lead us . . . little by little toward the least effort, lethargy and death" ("Fight against Tuberculosis"); "I consider current developments empty of real effort, empty of interest, a nuisance" ("Up to a Certain Point"); "One must indeed aim at something higher than oneself, otherwise what good would effort be" ("Picabia Versus Dada").

THE LEAST EFFORT

I am writing these lines for P. A. Benoit, one of the very few men who has understood what the least effort means. Loving is always done with the least effort.

For us, the least effort is to rely on others and on ourselves so that we can look at ourselves from above, and laugh and soar.

The least effort is essential if one is to remain joyous. It is precisely because we are weighty and serious men that nothing can do us as much good as the least effort, for we have need of a lively, childlike, happy art if we are not to lose the freedom that we place above everything, our ideal demands it, and it would be a retreat to fall, eyes closed, into this stupidity of abstract art, because of the demands of its stupidity, and all that just to end up becoming a monster, a supposed scarecrow for being modern and in life? What absurd inflexibility!

One must play very far from all these idiotic academics. And not be ashamed of oneself, in anything, to practice the least effort, we have especially had enough artistic overexcitement, which has nothing to do— quite the contrary—with art for art's sake, as far away as possible from all these hideous profiteers.

Le moindre effort, published as a lithograph by PAB (Alès), in December 1950, in an edition of one hundred copies.

The issue of *La Nef* in which the next collaged text appeared was devoted to the subject of poetic humor. A good portion of Picabia's contribution is composed of extracts gathered from his earlier writings (plucked out in the same manner that he plucked out phrases from *The Gay Science* to compose *Chi-lo-sa*, or some of the small books to follow); rather than do any plucking myself, this sampling has been kept intact as one piece, despite some of its fragmentary repetition.

POETIC HUMOR

I've always loved to amuse myself seriously.

What do I matter, what do my arguments matter—if they are the worst, so much the better.

Where art appears, life disappears.

I like to paint and write, I like going to the Folies-Bergère, to Tabarin, to the Bal nègre. Gallery openings make me melancholic, as do marriages and burials. There's love, but if my heart brushes against it, it reacts impatiently, and my heart hurls its contempt on the person who is not exactly of my nature, love makes me reach heights without my realizing it, thinking that I am completely safe, but I am always amidst waves, waves that come to wash my feet; strong and weak are relative concepts. Life is obviously not an argument, because it is in living conditions that one must find error far from knowledge, but this must be more than a means. Painting in order to stop thinking pleases me; thinking in order to paint is only an antic of the spring tide of the spirit.

What good would a church be if it wasn't the tomb of God?[1]

Humor is the cannibalism of vegetarians.

Humor swallows men like mussels.[2]

It was a dead woman who wanted to inherit a living man's estate.

A woman kisses a rabbit,
I ask her why?
she tells me
tomorrow Sunday I'm going to kill it.

Beds are always paler than the dead.

I left paradise one Sunday to go see the roses one Friday at the seaside.

All I've ever been able to do is water down my water.

Morality is ill disposed in a pair of trousers.

Those who talk behind my back are gazed at by my ass.

Very pleased with your nomination, am delighted to send you all my congratulations.[3]

I tell myself that I've had enough of women, it is now impossible for me to digest them and yet I've an empty stomach. What drove me to swallow women? Perhaps a lack of oysters.[4]

One day I showed the sea to a young girl who was seeing it for the first time; she declared that a potato field was much more impressive.

All beliefs are bald ideas.
 Our phallus should have eyes: thanks to them we could believe for a moment that we have seen love up close.

The world is divided into two categories: failures and those unknown.

I disguise myself as a man in order to be nothing.

Spinoza is the only one who hasn't read Spinoza.

Men covered in crosses bring cemeteries to mind.

Nature is unjust? All the better, inequality is the only bearable thing; the monotony of equality can only lead us to boredom.

Get it into your head *that one doesn't make progress.*

Making love isn't modern; even so, it is still what I like to do best.

One must never forget that the greatest man is never anything but an animal disguised as a god.

Everything for today; nothing for yesterday, nothing for tomorrow.

What men lack is what they have, which is to say: eyes, ears, and ass.

Where did God go? To the loo.

> Evil,
> is the traveling lady,
> when without knocking
> she entered my room
> to ask me
> to accompany her
> into my bed.
> She was a painfully
> unique woman,
> I loved Naomi.

I STRETCH OUT ON HER

Theft or suicide
to love before understanding
April fool
to knock on the door
to buy a hat
to close one's eyes
to open one's mouth
and she delicately started
to play "he-loves-me, he-loves-me-not"
as if I were a daisy.

For the love of madness
I became the wife
of my mistress,
we are dancing the night away
on the tips of our toes.

Ns ns stons Top bin dédu
en ce pr sa Tese pr
sa pé pr sa pur pr l'hade—

ts ces grs qd is ns rasnt
ns dcent ne faisse ns rasnt
ns dcent ne faisse ns aims
de doer sr ee ss secs ss
pace ee et ne tee pacé ms
où count ls sédns?

I rubbed my love
with sandpaper
so I could forget my long wandering life,
my heart is lying down
on a pile of shavings,
it was born of a well-known father and mother
naturally I am their child;
but I am my heart's son,
where did you learn
your painterly skill?
I learned it by looking elsewhere
forgive my asking.

I'm going to buy a pierced sou
I burst into tears
without knowing if it was over her
or over me.

DEARIE ME!

A poet, proud of his role,
stretched out on his back
pursues his death rattle.

THE EYELESS MOON

We left side by side
I stopped listening to you
my little one
but I remember half
of your words
and the others I spit out

breath against breath
our heads bow.

Sincere enemies
are essential
everything whose depth
they cannot see becomes
their thoughts and shadows
always darker
and emptier.

FOR THOSE WHO MUST ALWAYS COME

A world I could possibly live in?
Without reactionary barbarity
Without monuments to God
Without bombs
Without tombs
Souls are completely selfish
I am the only one to tell myself
That isn't good.

I get lost in my cage
Full of tears and laughter
But forced to stay on my own road
And live with known joy.

At noon I was lying down
At the attack
Of a ladder
which led to heaven
In order to see the red rocks
which led to the sea.

MY ATMOSPHERE

As nasty as a good conscience
eternally dying.

Wisdom on the throne of illusion
in a Spinoza's heart
looks for work
for the sake of a salary.
Me I have a remedy
for remedies
it's called remedy;[5]
Let's always try!

SADNESS

I saw the cloud carrying you
I even saw the wind propelling you
I saw you come down
like a golden ray
and go through my heart
you call yourself happy
Me I am
the wind
that knows how to dance
to chase away the dust
of the roads.

Alas! What I painted on canvas and wood
With my heart and my hand
Should adorn my heart and my life
But you say my heart is a madman
And the canvas and wood should be cleaned
until every last form has disappeared.
But I'm going to give you a hand—
I learned to live alone
As a painter and as a heartless man.
When my life ends,
I would really like to see you, great idiots that you are,
Soil life and love with your wisdom.

Tuesday at 9 o'clock

Faithful to my nature
As to my paintings
I paint what pleases me
But what pleases me?
That which pleases me.[6]

Eyes to the sky
Like an insolent fellow
Poor hornless bull
You are always falling behind
In a hook-nosed
world.[7]

It is raining and I am thinking
that the poverty
of the poor
doesn't prove
anybody right.[8]

"Humour poétique," in *La Nef*, nos. 71–72 (December 1950–January 1951), pp. 116–123.

WHAT I DESIRE IS A MATTER OF INDIFFERENCE TO ME, WHETHER I CAN GET IT THAT'S WHAT COUNTS

Love my amateurish paintings
tomorrow you will find them to be very beautiful
　　admirable the day after tomorrow[1]
they will give you courage
ever since I tired of searching
　　I've learned to find nothing[2]
I live with little hope
wherever I am I find the ground
but below my feet
is always disgust
in short he who doesn't think
is perhaps in good health
that's a lot.

Ce que je désire m'est indifférent, que je le puisse voilà le principal, published by PAB (Alès), April 1951, in an edition of twenty copies.

SUNDAY

To think differently than is customary is much less the result of a better understanding than the result of strong inclinations, of separative, mocking, and perhaps perfidious inclinations. Heresy is the compensation for sorcery, and is also not at all innocent or even venerable in itself.[1] In short, I don't like Sunday, which is not a holiday but a day of totalitarian boredom.

Dimanche, originally printed on a card 10 × 14.5 cm; several copies published by PAB, Alès in 1951 (probably in May).

"The Masked Saint" is a poem composed of snippets taken from Nietzsche's own short poems that make up the prelude to *The Gay Science.* Nietzsche's poem of the same title casts a different light on what would otherwise seem to be a rather melancholic affair for Picabia: "Lest your happiness oppress us / Cloak yourself in devilish tresses / Devilish wit and devilish dress. / All in vain! Your eye expresses / Your angelic saintliness" (*TGS* 53:Prelude:31).

THE MASKED SAINT

My life has passed by
I seek and haven't found
It was sorrow and error
The reason for my search
Is what I seek
But don't find[1]

*

Starting today
I'm hanging from my neck
Everything that time once proclaimed[2]

*

I must eat my bread
By the sweat of my brow[3]
But I'm always cold

*

All happiness on Earth
Pleases me[4]
But it comes too early
Or too late[5]

*

What do I care what the world says
I'm here for good[6]

*

The greatest happiness
Is a misfortune

*

I go my way
And always over people[7]
May all keys
disappear
In a skeleton key[8]
A man just lost his reason[9]
Now sun
Now cloud[10]

*

He who is himself
Is a skeleton key[11]

Le Saint masqué, published by PAB (Alès), September 1951 (with ten lithographs by Picabia),
in an edition of thirty-three copies.

591

It's sunny
I hear happiness
in my brain
I'm going to give it
a hand

but the wind
puts out the sun
so that the stars
can sleep.

I would like to be the urge
to soar
in a wood
and to think alone
so that eternal desire
blends me
with the shadow of the trees.

*

In sadness
there is just as much pleasure
it's even pain
that provides me
with sublime moments
through distaste
for this sort of pain
whose stars
refuse to follow
the road
into the labyrinth
of existence[1]

A man's truth lies in his errors.[2]

Perhaps men are only separated from each other by the degrees of
their misery.[3]

A free spirit takes liberties
even in regard to liberty.[4]

There are always simpletons,

idiots who get bored when doing nothing.

For me that's the only good thing there is: doing nothing.

I find life to be
from year to year
more mysterious,

It is not
a duty nor
a dupery,

The only way to
find one's absolute
is to kill oneself.

one must
also laugh
with pleasure![5]

*

Reason! Here I am, hanging
from a new day

but I detest all reasons

when suddenly what happened?
nothing happened
one desire after another flowed by,
and already the moon has gone to sleep
in the sanctuary of night.

This woman is like a cow
who sees love pass by[6]
she invents weaknesses
of virtue and modesty
what a melancholic business.

*

A painting doesn't exist

What I do is never understood, even by myself!

Painters are painters,

nothing more

and that's what interests me

paintings.[7]

if it doesn't know how to transport beyond all

I am the anti-artist *par excellence*, a monster damn it.[8]

Is there something to understand?

591, published by PAB (Alès), 21 January 1952 (with five lithographs by Picabia), in an edition of seventy-four copies.

[UNTITLED]

The breaks in my life
the frequent contact of sublime hazards
to become a simple reagent
in another form.

I don't want to get confused
by the randomness of the world
to explain the originality
of my experience.

At night the cry of lovers
awakens all the women
for the divine tenderness
of the most beautiful destiny.

When you want to tear yourself apart
you need cocaine
I'm still at it, looking for cocaine
or the voluptuousness of hell.

To still believe in the ideal of the modern idea
in order to retie civilization's knot:
a characteristic symptom of the decay
of sick life.

Fixe, a publication of the review *Dau-al-set*, Barcelona, August–September 1952: a special
issue published on the occasion of the thirtieth anniversary of the Picabia exhibition at the
Dalmau Gallery.

**DON'T THINK BADLY
OF ME ANYMORE**

He who stands on
his own life bears
his image with him
into the sky

Ne pensez pas plus mal de moi, published by PAB (Alès), 1952, in an edition of twenty copies.

MOUNTED FLOWER[1]

Where critics admire infinitely
the author doesn't agree with himself

I wander amidst a world
A world that has stopped loving life

 *

A new life
That alone matters to you
Through new sensation
To play a part
That could elevate you
Above yourself
But nothing of all that
Vanity
Hypocrisy of a new mask
Monstrous being
Miserable loves
Which give luck
In a farandole of flowers

 *

To suffocate love
In the gardens
The birds sing
They smile at flowers
A faint echo
That comes from memory
Like a sober kiss
On the lips
Many times in exhilaration
Just like poetry
The cypress trees are alive
Under the domes of superstition
In the vermouth

 *

New times
Love affairs
Now there's a rather empty pursuit

Able to trouble children
Over there the moon shines
But the way the dead
Shed light on the living
I rely on you
Today the inner pleasure
That sheds light on my dream
Is a hoopoe
Blowing into an instrument
Which doesn't emit any sound

 *

The birds swim
In the purple water
Then fly away
To make a telephone call
Nothing more than the memory of a dream
Beauty lifts itself up
You know all about it friends
At the distressing sight
Of a heartless face
Which age is going to ravage in a cowardly way
To accuse it
To tear it up
Its only merit
Is to not have any
The woman of this music
I am hearing
Is only an old Viennese waltz
Recess the following day
This dream would have no charm
If it had no end
Distressed affections
If I dared agree
To caress your hand
Rope ladder
Which we'll have to climb down
She gave me her hand
Now I can move
She's gone

You know who it is
A portrait forgotten
By those who knew it
Forgotten by men
Who owned it
The vertigo one experiences
When thinking one summer evening
About a form of insensitivity
Let's put ourselves here
Do you want to
A blue paper orchid
In the ear
And like a naked ampulla
Go tell him that I'm here
May she come
To go to Cousserans
Poor castaway
Of lace and rosy fragrance
Do you really want me that much
My mind is quite weary
To go visit the future
Look at my face
Why not carry out your mission
The mission of the miracle

 *

I am tormented by doubt
This doubt which I still love
What a beautiful engraved picture
In traveling clothes
In my memory
Happiness is an enigma
In a chest of diamonds
For the garden of the Hesperides
But there is a shadow upon my face
It is my sadness
For I know by heart
The distressing appearance of faces
One must feel content
That they are alive

I tremble when
I need to understand
My memory
Which would like
To be examined
Bit by bit
When the treachery of love burns
Lighting up the horizon
But is there a place in it for me
A place for suffering
Happy days
Vain modesty
Of my misfortune of hoping
From a long branch
I swing my fatigue
A bird becomes my friend
It is completely black
Go to sleep around it
You seem to be made for this pastime
But we'll see later
Whether the odious future
Inflicts us with remorse
Fragile happiness
He who grounds himself in happiness
Inextricable hotchpotch
Of innumerable cogwheels
More than a doubt
A certitude can show
Without decision and without remorse
The nerve cells of life
To repel a logical certitude
Is the refinement of the intelligence
Of things
Sensed truth
Of the first days of our love
All that one summer afternoon
When the olive trees rose to the sky
With new fingers
So sentimental

And full of tenderness
At eleven o'clock
I went back to the castle
Under a moonlight
Of flirtatious remarks
When one doesn't have the cinema
One has
The indestructible need for
Or the indestructible faith in
The indestructible madwoman
Constantly
In an improvisation
Of poor taste
That is my secret
And her stupidity
But there are still
Other ways
You can try
By holding out your hand
To her
You will not succeed in taking hold of her
For I am the merry posthumous
Boy who dances
On the solitary mountains
Where at a lonely spot
Almost round
I can blush in the penumbra
There is nothing to change in that
Everything has too high a price
Everything that is thought
Studied
Built
Developed
Is an art before the others
You know it well
The great moderns
Suffer from their conscience
But what a miracle

*

She is still there
What is her goal
Her road her little road
I think of you
I am in bed I hear the wind
The day is rising
It is completely dark
I would like to smoke
And not see your eyes
Far too uneven
But with the regret
That no longer touches
My heart
Let's talk about something else
Must we be interested in
Men who have
A very bright future before them
Or speak of women
Who have a very great past
The present of women
Is found in the youth
Of the past
And that of men
In the old age of the future
To slowly gather
The lawful sorrow
Now gilded
Like a useless art
When the world began
All was good
Today taste
Has a haggard look
Without scruples
Like an artist
With dyed hair
And a face lightly
Rouged
I began to sleep
Like a clock

Awaiting its hour
I dedicate this long poem
To the woman
Who doesn't know how to go to bed
Without emptying her heart
Into the chamber pot
Of her bedside table
And who can live
Without the kiss
Of our joined lips
Terrifying business
If she isn't real
But who can I talk to about it
Cousserans, 3 September 1947

Fleur montée, PAB (Alès), November 1952, "poem by Francis Picabia, planimetric sculpture by Jean Arp"; an edition of fifty-five copies.

The title of the next piece is from *TGS* 144:2:88. The titles within are also taken from Nietzsche; the poems, however, are Picabia's. This manner of titling was reflected in Picabia's paintings throughout this period as well.

**ARE WE NOT
BETRAYED BY
SERIOUSNESS**

INCAPABLE INTOXICATION[1]
I fear that your memory
is going with you
your lips
are going to leave
my lips

your heart
left
just like the rest

HAPPINESS
when the sun turns black
only then
shall the woman of my nightmares
become happiness
for that she will have
close-cropped hair
a flat chest
skin stained yellow
hairy arms
then I will see
her beauty
as in a mirror
but I am afraid
of having chosen badly
for her eyes
are black
like money
it is a woman
passing by
or a memory
that is not my own
before me
life goes by
come under my arm
and dry your tears

THE ABYSS OF PERFECTION
how pretty you are
maybe
more than you believe
maybe less
than you think
you are a pretty girl
all the images of women

are not
as beautiful as you
but don't be sad
if I'm unfaithful one day
an overwhelmingly voluptuous pleasure
will secretly awaken me
in a new
dream

I'M RELYING ON FORGETTING[2]
I no longer dare
open my eyes
if my arms
must never again
embrace you

AGAINST THEATER[3]
all is good
for him
who knows how to see
against conjugal injustice
the pleasure
of the period

ABYSS OF PERFECTION
it is a woman
reading these lines
she is very far away
in the forest
but I see her
I hear her
and I feel her
as if she
were touching me
what does
everyone else matter
who compares her
to what they
would like to know

I CAN HARDLY REMEMBER
HOW I WAS ABLE TO FEEL
SUCH HAPPINESS[4]
give me your hand
and hold mine very tightly
for our hands
like our mouths
know how to unite
and their passion
has no equal
but above all
don't speak
and listen to the wind
which is less gentle
than your hands

I SEIZED THIS THOUGHT
IN PASSING
kneel down
without speaking
for long hours
breathe softly
like a little girl
so that my mouth
may join yours
and be happy

CATCHING A BIRD
I dream of the past
in the forest
but I would like
to go to Cannes
and look at the sea

STOP THINKING SO MUCH
one can ask a woman
anything
when she is naked

and when she's thinking
of her remote destiny

TRIALS AND EXPERIMENTS
my tongue knew her tongue
and eyes closed
she joined her heart
to my own

ONE MUST CREATE FOR ONESELF
A LITTLE SUN[5]
why look outside
since love is within
as I was sitting
in the forest
a woman had just passed by
she looked at me
she spoke to me
I took her
for a bird

I AM NOT
A SLANDERER
I watch a crow passing by
in the round shadow
of a fir tree
it speaks to me
then
stepping back a bit
I started
to smile
uneasy
thinking
that I was
nuts

TO NOT KNOW
I want to choose
from the entire forest

a tree
to whom
I will confide
a secret

MORE THAN I HAD WANTED
he is not a pleasure seeker
nor a dying man
he is nothing
but he knows how to laugh
all day long

IN BED UNDER THE SAME MOON
my glance
reminded me of her own
but I don't have
black marks
on my eyes

LANDSCAPES WITHOUT A FUTURE[6]
love me
not
with smiles
but with your heart
so that your life
touches mine
my hand
in your bed

IT IS A MATTER OF TASTE
she's the one who looks after me
in the evening instead of making love
she gives the red fish
something to drink

MY THOUGHTS
ARE THE SHADOWS
OF MY LIFE[7]
the white veil falls
let me see

your naked belly
so I can gather
the flowers of your body
do you want some

NOTHING MORE
the stars move off
oh how sad and alone
I am here!
sad as the dawn
if it's cold
maybe there will be
fire this evening

I'VE HAD ENOUGH OF MY COMPANY[8]
this is the fifth summer
that I've seen die
upon these mountains
the leaves are going to fall
softly like the snow
it is time I went missing
laden with years
for they weary me

THE FEELING OF NATURE
SHOULD BE DIFFERENT[9]
I don't call for help
because this little game amuses me
but I am
in less good form
to prove
my desires
to myself

I ALWAYS FIND MYSELF
IN BAD COMPANY
MY OWN[10]
don't pass by
without looking at me

my autumn is warmer
than your spring
I am like you
a child

EVERYTHING SETS
am I not quite the idiot
to believe myself a child
branded by wrinkles

IT IS PERHAPS IMPOSSIBLE FOR ME
TO STAND STILL[11]
I am old
that's why
I don't want to do anything
the only disgrace
is to grow old
today
tomorrow
will not awaken me
for life has worn out
my hope
and no longer amuses me
Rubigen, 19 August 1950

Ne sommes-nous pas trahis par l'importance, published by PAB (Alès), 1 March 1953, in an edition of thirty copies with an original gouache by Pierre-André Benoit in each one.

A survey on socialist realism appeared as a supplement to the review *Preuves,* a review that focused on "Problems of contemporary art." The series of questions concluded as such: "In conclusion, do you reject or accept socialist realism?" Picabia's response was prefaced as such: "Picabia sends us several lines which pose the problem of art and the artist in the world and in this way replies in an indirect manner to our survey. Is Picabia's life and painting not the best example of nonconformism one could offer?" Picabia's noncomformist response was again assembled from *The Gay Science.*

[REPLY TO A SURVEY]

—Do you believe that a man can
learn to be hungry and thirsty?
—Where art ends,
where life begins,
I am the poet of my life,[1]
alchemists
astrologers
sorcerers
hunger and thirst
of my own life
to fortify myself[2]
do you think that this interests me
whether man can learn
what others know?
A poem must be what
does not yet exist,
what has no value
like nature
which is valueless by itself.[3]

My ideal prevents me from seeing society's accepted standards
of behavior.

Success in failure is a success.[4]

Life has neither goal nor result.

My painting is a woman who does not want to hear her husband talk
about making love.

What is painting?

To do something that has no name, even should it happen to be
before one's *eyes*.

Now with this way of making paintings, it is only etiquette that
makes them important.

An original man is a man without a name.[5]

My thoughts tell me where I am: but they don't show me where I
am going.

Ignorance of the future is magnificent; I don't want to die from
seriousness, nor from impatience, above all to believe through an
anticipation of impossible things . . . ?[6]

Supplement to the review *Preuves,* no. 29 (July 1953), p. 34.

According to Carole Boulbès, "Yes No" was written at the same time as *Poems of Dingalari,* around 1939.

YES

 NO

YES

 NO

YES

 NO

Painting music literature
hothouse flowers
yes no

*

One must distrust
picturesque beings
one must distrust
antique-dealer painters
one must distrust
distrusting
even painting
painted without distrust

*

Serious people
have a faint odor
of carrion

*

Skepticism
cynicism
the infinite
what a fashionable spectacle
but nature
has a little declaration
to make to you my dear sir

it doesn't borrow fire
from the conflagration

*

Perhaps I made
painting sick
but what a pastime
to be doctor[1]

tomorrow I am counting on painting
to be my doctor

*

Right from the start of my life
the public cast
its sentence on me

he's making fun of us

what has always amused me
is this public
who knows me
but who doesn't know itself

*

I'm only working against my interests
I don't know any other way
of dealing with myself

*

The profound mediocrity
of painters
depresses me

*

Old mediocrities
are in fashion
new ones too

knowing my strength
I am tolerant of myself
and nothing more is forbidden

*

I experienced painting
as an object of passion
my paintings are acts of love
that's my way of working

> *

My painting is a contradiction
between life and sleep

> *

Success is a liar
the liar loves success

> *

People want others to talk about them
because they're only interested in the people
whom others talk about
others hide behind
a mask
which they think they've chosen
seducer
seducer like . . .

> *

Gestures are silent
they rely on noise
and noise relies on gestures

> *

Those who shine like the sun
have no need of noise
all these poor idiots who think
that noise
can make them shine

> *

People always talk
about little things
they cannot talk about great ones
their hearts being too small

> *

For many people
happiness
lies in imitating

> *

To understand everything
makes life monotonous
to love everything
without understanding
lots of people
understand that

 *

Is the sky beneath
or above us
one has to guess
if you could see me
my smile would tell you

 *

I love the sea
the mountains hide the stars
if only the sun could make
the mountains melt
like snow

 *

I hate clouds
their ridiculous forms
they don't even have
the beauty of tigers
on their prey
these idiotic clouds
which live only on the sun
and which spend their time
hiding it

 *

Cats that look at birds
have eyes that meditate
birds that look at cats
have eyes that doubt
my own close
to think of miracles

 *

In the near future fables
and lovely fairy tales
will come back into fashion

 *

Only the contemplators
of constellations
can still
move us

*

Now if you like
let's talk about my painting
for I am perhaps
my own disciple

*

1939

Oui non oui non oui non, published by PAB (Alès), 1953, in an edition of one hundred and eleven copies.

Picabia died 30 November 1953 of arteriosclerosis. The following poem was the last work of his to appear during his lifetime.

A MADMAN WHO GOES MAD

The moon goes down into a chimney
it is cold in the street
I hear the rain
I am sitting waiting for nothing
I found one
I am looking for two
two leafs for the wreath
of the legacy
of the solitary ghost
who drags himself after love
so as to empty my heart.

"Un fou qui devient fou," in *Caractères,* nos. 7–8, 1953.

MY
PENCIL
BUCKLES

Posthumous Writings

Picabia's posthumous writings have of course been included in chronological order throughout this collection. This last section comprises some writings whose dates of composition are a little uncertain.

The title "Alarm Clock" of the following unrealized ballet refers to two early Dada drawings of 1918 and 1919: Picabia had dismantled an alarm clock, dipped its parts in ink, and pressed them onto a sheet of paper. The results became the cover for *Dada*, no. 4–5 (1919).

Something of a performative equivalent seems to be at play here, although the ballet's use of rubber scenery and inflatable costumes also echoes the scenario for *Entr'acte*. The theme of the roulette wheel evokes Duchamp's usage of it in his attempt to master chance, and the luminous boxing gloves come straight out of Duchamp's *Notes* (no. 197): see notes to "Scenario for *Entr'acte*" (p. 314).

ALARM CLOCK

Notes for a ballet

Scene 1

The scenery, made up of different corridors, starts dancing for 2 minutes. This same scenery, being taut rubber on stretchers, stays motionless, but people behind press against it and form curious shapes; this scenery has to be under a dazzling light.

Scene 2

In this same rubber scenery: dancers in black leotards appear with boxing gloves that are luminous, as are their shoes.

Scene 3

Metallic scenery in copper and iron.

Five dancers, two men and three women, in silver and gold leotards that must cover the skin simply, and silver and gold shoes in contrast to their leotards.

Scene 4

Roulette wheel dancers, male and female, in black and red leotards, a female dancer in a white leotard.

Scene 5

Male and female dancers in black and white leotards with little round mirrors all over their bodies.

Scene 6
Very elegant evening dresses. (*2 minutes*)

Scene 7
Green costumes dancing in the air, some male and female dancers dance on the stage. (*2 minutes*)

Scene 8
Costumes that inflate and deflate.
 The costumes will be black and red. (*2 minutes*)

Scene 9
Male and female dancers lying down at each other's sides in white costume. (*2 minutes*)

Réveil-matin, published by PAB (Alès), February 1954 (written in 1950), in an edition of thirty-three copies.

TOMORROW SUNDAY

Tomorrow Sunday in Rubingen
there will be no newspapers
nor letters
tomorrow I will reread my newspapers
and my letters
so as to read between the lines

Tomorrow Sunday
the most ancient spirits
put on new clothes
in Switzerland like anywhere else

A woman kisses a rabbit
I ask her why
she tells me
tomorrow Sunday I'm going to kill it

Tomorrow Sunday
we will eat chicken
measure of things

Demain Dimanche, published by PAB (Alès), March 1954.

Most of **"I Must Dream" can be traced to** *The*
***Gay Science:* line 1 from 116:1:54; lines 2–3 from**
51:Prelude:26; lines 6–7 from 51:Prelude:27;
lines 9–10 from 51:Prelude:26.

I MUST DREAM

I must dream
I must climb
to listen to you speak
you wanted me to
it's time

you are lost
if you believe in danger

come on it's time
but there's no one
you can use for a step

"Il faut que je rêve," in *La Carotide,* no. 1 (November 1956).

SONG CARESSED
BY THE DESPERATE SCENT

The lake, an absolutely Swiss mirage
 Is not a dream
It is my companion
 Through my window the horizon
 Imprisons my heart separated from you

My bedroom that loved your face
too much
 Is a robe of memories
 Under the reflections of the sky.
Your lips, like the caresses
 Of thrilling flowers,
About me, brush against my nights.

"Chant caressé par le parfum désespéré," in *La Carotide,* no. 4 (February 1957).

MY PENCIL BUCKLES

My pencil buckles with sadness
big eyes heavy with melancholy
look at sinister names
I think of my murder
between conqueror and conquered
the choice is too easy
strange mixture of suffering

Around me everything sways
with the most grotesque ineptitude
of feet and fists bound painfully
on my bed to the colors of opals

I've forgotten nothing of your hands
revolver holster of high society's
stand to attention at full tide

What are you doing what do you hear
for several weeks
I have known the bracelet
of happiness

Mon crayon se voile, published by PAB (Alès), 1957, in an edition of six copies.

[UNTITLED]

There is only one thing that counts
and that is the celestial
everything seen from this height shrinks and fades
into contempt

691 PAB (Alès), summer 1959, in an edition of one hundred copies. This publication was an homage to Picabia and *391*.

The next group of aphorisms, and their title, are all from Nietzsche, altered so as to seem to be in reference to an unnamed woman. For the title, see *TGS* 212:3:232: "Either we have no dreams or our dreams are interesting. . . ."

OR ELSE ONE DOESN'T DREAM

Of what importance is a woman who doesn't know how to transport us beyond all women?[1]

Today I am poor: but it is not because it was taken from me, but because I have rejected everything far from me. She will never understand my voluntary poverty.[2]

Her thoughts shall always be emptier, she so loves to stand still.[3]

She has this poverty of the rich, but with the beautiful madness of truly prodigal poverty.[4]

I recognize women who seek peace and quiet through the great number of imbeciles they place about them.[5]

And what makes them waste away most rapidly? The bourgeois narcotic.[6]

What, in the last analysis, are the truths of a certain little woman? Her irrefutable errors.[7]

She who isn't busy is always in a predicament.[8]

That one's an envious one, you shouldn't wish her children: she would bear them envy because she can no longer be a child.[9]

It is better to suffer than to be surrounded by scarecrows.[10]

Ou bien on ne rêve pas, published by PAB (Alès), February 1960, in an edition of thirteen copies.

This next poem is composed entirely of several of Nietzsche's rhymes from *The Gay Science:* lines 1–4 from 65:Prelude:55 (this time Picabia changes the subject of painting to writing); lines 5–10 from 65:Prelude:57; lines 11–12 from 65–67:Prelude:59; lines 13–14 from 67:Prelude:60; lines 15–17 from 69:Prelude:63.

In regard to this manner of literary collage, perhaps we may conclude these writings with Nietzsche on the "Poet's Vanity": "Give me glue and in good time / I'll find wood myself. To crowd / Sense into four silly rhymes / Is enough to make one proud" (*TGS* 65:Prelude:56).

LET CHANCE OVERFLOW

Faithful to nature and incomplete!
In the end I write what pleases me
But what pleases me???
That which I think I know how to do!
If I was allowed to choose freely
I wouldn't choose anything
Perhaps a little spot for myself
in the midst of happiness
and for me still
and more willingly before its door
My quill scrawls
Who then reads what I write?
But you are from above
for you live even above praise
Predestined to your orbit
you acknowledge only a single law
Be pure!

Lassez déborder le hasard, published by PAB (Alès), 19 March 1962, in an edition of twenty-nine copies.

References to Friedrich Nietzsche's *The Gay Science* have been abbreviated to *TGS*. The numerals that follow refer to page number, book, and section (e.g., 106:1:38 would be page 106, book 1, section 38). Book and section numbers are to allow references to other editions and translations of Nietzsche. I have chosen to use Walter Kaufmann's translation, to which my page numbers refer.

All other translations, unless otherwise noted, are my own.

I AM LOOKING FOR A SUN: Pre-Dada, 1917–1919

To Douxami

1. "Pharamousse" was one of the pseudonyms Picabia used for *391*. According to Olga Picabia (Sanouillet, *Francis Picabia et "391,"* p. 53), he took it from his childhood nickname, *Frimousse* (Little face). The alteration, however, evokes other words: *pharamineux* (mind-boggling), and the marine evocations of *phare* (lighthouse) and *mousse* (foam).

2. Another pseudonym: Picabia's grandfather, Pedro Martinez della Torre, built the first Spanish railroad and was made a marquis by Queen Isabella.

Fifty-Two Mirrors

1. The French title (*Chicot*) can refer to a tree stump, but more commonly refers to the stump of a tooth. "Mack" is my rendition of *poisson*—literally, a fish, but also slang for a pimp; "septum" for *cloison*, although it is also slang for the hymen; and at the risk of stating the obvious, "hosed" is for *arrosée* (also slang for "ejaculated") and "garden" (*jardin*) is also slang for the woman's pudendum. The likely context is a night spent with a prostitute (a personage who will reoccur throughout these *Mirrors*).

2. *Canities* is more Latin than English, which has no common equivalent; like *canescent*, but a whitening applying specifically to the hair.

3. Picabia left New York for Barcelona on 20 September; he had most likely not seen land at this point.

4. "Fifteen years today" may be referring to Picabia's first visit to Spain in 1902; if so, that would date this poem at 1917, and perhaps it was composed shortly after the previous poem, in Barcelona. Because of the ambiguity in phrasing, though (*quinze ans aujourd'hui*), it could also be giving the age of the prostitute's client.

5. This poem reads almost like a brief musing over Picabia's marriage, perhaps an egoistic effort at tenderness. If that reading was to be taken, though, for Picabia to have his wife follow the preceding poem's streetwalker would point to problems.

6. This poem would seem to offer something of a defense (or at least an explanation) for Picabia's actions in his relations with women: an egoistic celebration of eros and the present. The title (*Guichet*) can also be French slang for the entranceway to the vagina.

7. Picabia's children were in boarding school in Gstaad, Switzerland, during the war. Gabrielle Buffet went to see them at the end of 1915, and left New York again to join them 16 September 1917 (see the poem "Departure"). One is tempted to assume that the last two lines refer to Buffet, since the title gives an indication as to where his thoughts are.

The *Manuel Calvo* was the boat Picabia took back to France, via Barcelona.

8. For the title, see "Gstaad."

9. Mme Picabia left for France on this day, after spending it with Duchamp, Roché, and the Baronne del Garcia. Picabia would leave New York only a few days later (see the previous poem, "Land Ho"). He was in the midst of being treated for his opium addiction at this point, and their marriage was in bad shape.

10. This poem and the three that follow ("Yesterday," "Soldiers," and "Ascetic") originally appeared in *391*, no. 7 (New York, 1917), p. 2.

11. It is tempting to see a reference here to the performance of Raymond Roussel's *Impressions of Africa,* which Picabia, Buffet, and Duchamp attended several years earlier, and which was to have such an influence on both artists' work. Its most infamous scene involved a hopping, zither-playing worm.

12. "Half Asses" and the following "Inference" originally appeared in *391*, no. 6 (New York, July 1917), p. 4.

13. "Somersaults" and the second poem following ("Cereal Joy") appeared side by side under the title "Isotropic Poems" in *391*, no. 5 (New York, 1917), p. 5.

14. "1093" originally appeared in *391* no. 6, p. 4. According to Sanouillet (*Francis Picabia et "391,"* p. 80), the title to this poem refers to the Lexington Avenue address of the Special Medical Board's offices in New York, to which Picabia was supposed to report.

15. "Horror of the Void" originally appeared in *391*, no. 4 (Barcelona, 25 March 1917), p. 2. According to M. Sanouillet (*Francis Picabia et "391,"* pp. 41–42), this poem may allude to Marie Laurencin, who was a fellow exile with Picabia in Barcelona at this time; indeed, one of her drawings faces the poem in the issue of *391* in which it appeared. She had married a German, Otto von Wätjen (perhaps the "barbarian" of the poem), two months before France's entry into the war. The two were soon put in a French

concentration camp, but got out through the aid of friends. Their relations were subsequently strained during their exile.

Given that it is likely that an affair had taken place between Picabia and Laurencin in Barcelona, the "elusive egoism" would seem to refer to Picabia.

16. "Cottage" originally appeared in the same issue of *391* as the previous poem, "Horror of the Void" (p. 7), and the two seem linked, both through their proximity in publication, and their allusions to an extramarital affair (Sanouillet, *Francis Picabia et "391"*). The odd "Cocoa" concluding the poem (*Cacao* in French) might allude to Laurencin's dog, Coco, whom Picabia references in the mechanical portrait he made of her at this juncture.

17. "Magic City" originally appeared in *391*, no. 4 (Barcelona, 25 March 1917), p. 8. As Sanouillet points out (*Francis Picabia et "391,"* p. 65), "Magic City" refers to Luna Park, a Parisian amusement park. It was here, as the poem suggests, that Picabia picked up the opium habit that was to become a problem for him over the next ten years.

Duchamp references Luna Park / Magic City in several of his notes, describing it as a "background" to his *Large Glass*. In the context of Duchamp's bride and her bachelors, the poem makes for an interesting read, given its elements of "sublime nihilism," "sterile passions," and "silent ulterior motives."

The last line of the poem originally read "1914–1915" when it appeared in *391*, and Sanouillet describes the poem as evoking "the final moments of joyous liberty that Picabia had spent in Paris in 1914–1915" (ibid.). But as the facsimile edition of *391* no. 4 that I've been able to consult has the years corrected in pencil (possibly by Picabia's hand), I have opted to go with the dating as it appeared in *Fifty-Two Mirrors*.

18. "Singular Ideal" was originally published in *391*, no. 3 (Barcelona, 1917), p. 3.

19. "Frivolous Convulsions" was originally published in *391*, no. 2 (Barcelona, 1917), p. 2. This rather unflattering portrait of what seems to be a woman in the throes of a mating ritual was accompanied by a semi-cubist drawing by Otho Lloyd when Picabia first published it in *391*. The drawing depicted a woman using a sewing machine (a machine whose erotic convulsions the Surrealists, after

Lautréamont, would make much of in the coming years). It is this drawing that helped me decide on the gender of the poem's subject, as it is much more ambiguous than English allows for, and could conceivably even be describing the throes of a sewing machine. Picabia's original coupling of image and text makes for a fairly dark allusion, though, and a less frivolous reading of his mechanical drawings and paintings of this period, especially as Lloyd's geometric abstraction turns the scissors on the sewer's lap into a stand-in for genitals (of uncertain gender).

20. "Metal" was originally published in *391*, no. 6 (New York, July 1917), p. 2. According to Sanouillet (*Francis Picabia et "391*," p. 79), this poem was written after an evening spent in Manhattan's Chinatown. One is tempted to see an opium dream lying at least partially behind its inspiration.

21. "Revolver" was originally published in *391*, no. 1 (Barcelona, 25 January 1917), p. 2.

22. An approximate quotation (perhaps from memory) from part four, section two, of Nietzsche's *Thus Spoke Zarathustra* ("The Ass Festival").

23. "Ideal Gilded by Gold" was originally published in *391*, no. 5, p. 2. The only prose piece of the collection, this poem was also probably the earliest written. Gabrielle Buffet dates it at 1910. Picabia would sometimes have her finish a page that he had started, and this piece was an instance of this. Given the second paragraph's announcement of a halt, it seems safe to surmise that Buffet's input begins with the third paragraph. Picabia's sexist opening thus gives way to a rather complicated bi-gendered text.

24. Evident irony here, given that Santo Domingo is possibly the oldest continuously inhabited settlement in the Western hemisphere. Its "environment" was drastically altered when a hurricane destroyed the city in 1930.

25. For Picabia, this would have been in 1914.

26. The title of this poem ("Les vieux ont soif") is a pun on Anatole France's 1912 novel about the French Revolution, *Les Dieux ont soif.* At the time, the phrase was dismissive of those clamoring for war.

Poems and Drawings of the Daughter Born without a Mother

1. Picabia dedicated "Pneumonia" to his elder son, Pancho Gabriel François (although the dedication was not printed). Pancho had been ill mid-March;

when checking for pneumonia, a French doctor would put a hand on the patient's chest and have him or her repeat "33."

2. The manuscript for "Electric-Light Globes" is dated 25 February 1918; Picabia and Buffet had joined their children in Gstaad on the sixteenth. The title possibly alludes to the electric light advertised by the Park Hotel, their temporary domicile at this point.

3. According to Everling, Picabia wrote "Reseda Bird" for her and it concerned their "honeymoon" in Martigues.

4. "See" was later reprinted horizontally in *391*, no. 12 (Paris, March 1920), p. 4, without a title.

5. This poem seems to refer—particularly through its implied ménage à trois—to Picabia's juggling act with Buffet and Everling during this period. The asexuality implied by the title forestalls any easy reading, though.

6. Picabia was to use this title, "Cacodylate," on several occasions. Its appearance this early on is prescient: in 1921 he would contract a painful eye disease, with a prescribed remedy involving cacodyl, a vile-smelling arsenical radical that would have unpleasant side effects. His need for and dread of this medicine accounts for the recurring "Cacodylic Eye" in his works.

7. "Male" was later retitled "Cynicism without Scale" for the cover of *391*, no. 11 (Paris, February 1920).

8. "Narcotic" was later reprinted in the *Pilhaou-Thibaou* (*391*, no. 15 [Paris, 10 July 1921]), p. 16, under the title "Monument à la bêtise Latine" (Monument to Latin stupidity).

9. "Philandering" in the second-to-last line is my translation of *bagatelle.* The sexualized door (*porte*) getting nailed shut and broken open, and framing this poem, affects the reading of this word: to be *porté sur la bagatelle* is to be a philanderer, and the *bagatelles de la porte* can be summed up as "heavy petting" and a prelude to sex.

"Failed" seems to be concerned with some goings-on in Picabia's hotel room; the apparent secrecy, and his reference to his "fiancée" (rather than "wife") indicates that Everling is involved. The afternoon stroll described is probably symbolic: his sweaty rummaging in the bushes is most likely taking place within his room.

The Mortician's Athlete

1. Walter Conrad Arensberg (1878–1954), with his wife Louise, put together one of the earliest and most important collections of modern art (now at the Philadelphia Museum of Art), which included about forty works by Duchamp and many by Picabia. Their artistic salon in New York helped gather together most of the individuals who are today classified under the rubric of New York Dada.

2. The preceding five lines compose the poem "Easel Wife" from *The Daughter Born without a Mother*, with a few (intentional?) alterations: *étranger* (foreign) has become *étrange* (strange), *parasite* has been pluralized, and the *noyer* (walnut tree) has become a *noyau* (kernel).

3. *Forkscrews* is an unmotivated pun: *Tire boutons* (something like "buttonhooks") is a play on *tire-bouchons* (corkscrews).

Georges Ribemont-Dessaignes (1884–1974) met Picabia in 1912, and soon after turned his hand to writing. He was an active member of the Parisian Dada movement, as well as the group's secretary. In Duchamp's words, the "deepest a-metaphysics of Dada were in great part the contribution of Ribemont-Dessaignes" (*Writings of Marcel Duchamp*, p. 158).

Platonic False Teeth

1. With World War I having only ended a month or so prior to this poem, this is a phrase that had been very prominent in the media. Apollinaire's *Mamelles de Tirésias* of the preceding year had made repopulation its central theme.

2. *Bibendum:* The Michelin tire man remains an active mascot to this day. Picabia seems to be using him here as an adjective.

3. *Which of the two wheels . . .:* Picabia's many drawings and paintings of two connected gear wheels came to symbolize the interdependent sexual relation between male and female; the positioning and size of the wheels, though usually ambiguous, is nonetheless significant, as evinced by their possible transformation here into "prostitution."

4. This postal address evokes, and perhaps explains, the puzzling first line of Picabia's earlier poem "Pneumonia."

5. Marius is probably a reference to Marius de Zayas (1880–1961), a Mexican author and painter

who cofounded *291* with Alfred Stieglitz and was part-owner of the "Modern Gallery" in New York with Picabia.

6. *Unhappy mother:* Buffet had given birth to their fourth child a few months earlier; Everling's second child (her first with Picabia) would arrive in January. It is tempting to see the outside world peeking through in parts like this.

7. *The Lost Steps:* a literal translation of *les Pas-Perdus* (a title Breton would use a few years later); the expression refers to a train station waiting room.

Purring Poetry

1. *Cocido:* A Spanish dish, something of a stew.

2. *Novio:* Spanish for "fiancée" or "sweetheart." The word (along with "fiancé") figures in the titles of a series of studies Picabia made in 1916–1918, depicting a pair of wheels, one smaller than, and presumably propelling, the other. In the painting *Machine Turn Quickly* (ca. 1916–1918), Picabia labels the small wheel as "woman," the larger one as "man."

3. The City-Hotel is where Picabia stayed in Switzerland. The printer mentioned two lines earlier is probably Heuberger, who printed the eighth (Zurich) issue of *391*.

4. The Château d'If, an island in the sea of Marseille, was formerly a prison. Alexandre Dumas made the name legendary by imprisoning the Count of Monte Cristo there.

5. Among the numerous possible "meanings" of the word "Dada" (hobbyhorse, nanny, etc.), one unearthed by the newspapers at the time was from the Kru Africans, for whom the word refers to the tail of a sacred cow. Whether Picabia is willfully enlarging the animal or not is uncertain; *queue* (tail) is, however, also common slang for the penis.

6. "Moët et Chandon" is a make of champagne, but *moët* might also be a play on *mouette* (gull).

7. Picabia's advice echoes one of Duchamp's notes (*Notes*, no. 66) for an unrealized "round book" edition of the notes for his *Large Glass*.

YOU BUNCH OF IDIOTS: Dada, 1919–1921

Thoughts without Language

1. The Modern Gallery was founded in New York in 1915 by Marius de Zayas. Picabia was involved in its conception, which was to be a more commercial version of Stieglitz's 291 Gallery.

Tombs and Brothels

1. According to Sanouillet, this "unknown artist" is Albert Gleizes, a lesser-known (but certainly not unknown) cubist who shared Picabia's exile in Barcelona and New York. Picabia published an article by him in the fifth issue of 391 in New York in 1917. Their friendship was uneasy at best, and with the advent of Paris Dada, it became openly antagonistic ("*Francis Picabia* pétrit la terre gleize," Paul Dermée would later announce in the Dada magazine *Projeteur* [Paris: 21 May 1920]). Gleizes wrote one of the more considered attacks on Dada the following year, "The Dada Case," which can be found in *The Dada Painters and Poets* (Motherwell, ed.). Picabia would, however, publish another article by Gleizes the following month in the tenth issue of 391.

Manifesto of the Dada Movement

1. This was a standard Dada byline, and appeared on the Paris Dada movement's stationery.

2. Picabia would incorporate these four lines into his poem "Swimming" (in *Thalassa in the Desert*) twenty-five years later.

Doctor Serner's Notebook

1. As the eighteenth century was the "age of reason," this would probably count as an insult for Picabia.

2. "Spanish guy," though, is a definite compliment coming from the Spanish-born Picabia.

3. "French guy," however, would qualify as an insult for the Spanish-born Picasso (although for Picabia, not as bad a one as "Parisian").

4. Picabia would frequently disparage the rage to be "modern" over the coming years: "Making love isn't modern," he says elsewhere; "even so, it is still what I most like doing."

Metzinger first exhibited at the age of fifteen; Louis Vauxcelles was the art critic who came up with the monikers "fauve" and "cubist" (both of which he had intended to be disparaging).

5. A nose-thumbing to both Braque and Picasso, but given Picabia's regard for cubism, not exactly a hat-doffing to Gleizes, either.

6. Intelligence aside, these other comments on Tzara and Ribemont-Dessaignes cannot be taken seriously (although there is a hint of challenge in Picabia's assessment of Tzara's Dadaism that betokens their future antagonism). Ribemont-Dessaignes had just been challenged to a duel by Vauxcelles the month before after his scabrous attack on a range of artists in the previous issue of 391.

7. Arp would in fact arrive in Paris at the end of the year.

8. Given Nietzsche's influence on Picabia, this remark could read sarcastically; see *TGS* 106:1:38: "When one considers how much the energy of young men needs to explode, one is not surprised that they decide for this cause or that without being at all subtle or choosy"; or 210:3:218: "I do not love people who have to explode like bombs in order to have any effect at all."

9. Jean Crotti (1878–1958) was a Swiss painter and a marginal figure on the New York and Paris Dada scenes. He was the husband of Duchamp's sister, Suzanne.

10. A somewhat puzzling statement given that Suzanne Duchamp did in fact paint (see William A. Camfield's article in Sawelson-Gorse, ed., *Women in Dada,* for a summation of her contributions). Picabia's remark, in the guise of snubbing painting, is either denigrating her work, or providing an indication as to how detached she and her husband were from the Dada movement (a detachment apparently more of their own choosing than enforced by others).

11. Juliette Roche (1884–1980) was married to Albert Gleizes, but was also a poet and painter in her own right.

12. The reference is to Revelations (3:15–16): "I know thy works, that thou are neither cold nor hot: I would thou wert cold or hot. So then because thou art lukewarm, and neither cold nor hot, I will spue thee out of my mouth."

13. Jacques-Émile Blanche (1861–1947) was living on the street named after his father, Doctor Émile-Antoine Blanche (whose claim to fame was having treated Gérard de Nerval). He was not exactly

a fan of the Dada movement, however, even though he was the first to write on the Zurich Dadaists. He had a cardiac arrest on his way to the first Dada manifestation in Paris: "Dada's first victim," as Aragon put it.

Jacques Rigaut, who would come to be known as the "Dada dandy," was Blanche's secretary.

[Statement by F. P.]

1. Picabia is borrowing Apollinaire's observation from *The Cubist Painters:* "Just as there are very thin people named Legros and very dark people named Leblond, so I have seen canvases entitled *Solitude* featuring several human figures" (Apollinaire, *Cubist Painters,* p. 11, translation modified).

Unique Eunuch

1. From Wilde's letter to the *Daily Chronicle,* 28 May 1887.

2. From Nietzsche's "Posthumous fragments" to *Thus Spoke Zarathustra.* This is fragment no. 12.

3. Gabriele D'Annunzio (1863–1938): Italian poet, novelist, soldier, and, ultimately, fascist. His novels, and their disregard for bourgeois morality, were strongly influenced by Nietzsche. The Berlin Dadaists sent him a "Dada-Telegram" offering their support in his "Dadaist" annexation of the Dalmatian port of Fiume. His dictatorship there would end the following year, 1921.

4. *Lama* can translate as either "lama" or "llama."

5. Gabrielle Buffet and Picabia had lived on avenue Charles-Floquet in Paris. Floquet (1828–1896) was a politician best remembered for wounding General Boulanger in a duel.

6. Henri Bergson (1859–1941): French philosopher whose influence in the early twentieth century was enormous—significant enough for Picabia to have come across his ideas on vitalism and intuition in 1910–1911.

7. Ferdinand Foch (1851–1929): French general and marshal of France.

8. Enrico Caruso (1873–1921): Italian operatic tenor, whose fame would outlive his death the following year through recording technology.

9. *Picaflor:* Spanish for "hummingbird"; the word must have been appealing to Picabia with its "pica" (which on its own means a spade or a picador's spear, referring to the hummingbird's beak), but

even more, "picaflor," in America, refers to a womanizer or a Casanova.

10. As "Germaine" would seem to refer to Everling, one would then assume that the other names refer to other women in Picabia's life; what he seems to be doing, though, is feminizing the given names of some of the men in his life at this point: Louis Aragon, André Breton, Marcel Duchamp.

11. *Shining Vagina* is the title of a painting Picabia finished around May 1918 (later retitled *Shining Muscles*).

12. This newspaper had published two protests by Picabia toward the end of 1919; one in regard to the manner in which his and Ribemont-Dessaignes's paintings had been hung in the Salon d'Automne, the other to the unauthorized censoring of the titles and inscriptions of his paintings at the Cirque d'Hiver. The paper was on the whole about as far left as the Action Française (mentioned two lines later) was right—which, for Picabia (who made no distinction between left and right), amounted to the same thing.

13. One can only make guesses here, as the names are not united in any obvious way; since Picabia seems to be addressing these people with some contempt, one would lean toward identifying "Paul" as someone like Paul Cézanne, rather than one of his colleagues such as Paul Éluard or Paul Dermée (although as already stated, attacking friends was not uncommon for Picabia, and he was fond of employing ambiguity to this end). Some possibilities, then: Jacques Émile Blanche, Henri Matisse, Georges Auric; Paul Cézanne, Maurice Denis, Jean Cocteau.

Dada Manifesto

1. Picabia would a few months later add his first name to Ingres' signature at the end of a letter, and reproduce the whole on the cover of *391,* no. 14 (Paris, November 1920), with the title "Copy of an autograph by Ingres by Francis Picabia."

2. "Viens Poupoule" (Come darling) was a very popular and flighty song in Paris in the early 1900s.

[Untitled]

1. Léonce Rosenberg had just published his study *Cubisme et tradition* (although Picabia is here quoting from an interview between Rosenberg and E. Teriade). With his brother Paul, he ran the L'effort

moderne Gallery. An occasional target for Picabia's Dadaist attacks, he would nevertheless become Picabia's enthusiastic and supportive dealer during the latter's "Transparencies" period in the late 1920s and early 1930s.

2. *Mort-dorée* (gilded death) refers to the Section d'Or, at which Picabia was, in typical contradictory style, displaying several paintings.

3. Picabia may have been making this up, although making such a statement would not be completely out of character for Jacob (*The Dice Cup* was published in 1917); in either case, the remark is intended to be malicious.

[Untitled]

1. This is a follow-up to Picabia's previous comment on Jacob. Jean Moréas (1856–1910) wrote the first Symbolist manifesto.

Chimney Sperm

1. This comment indicates that Tzara's role in the Dada movement had already undergone an attack of some sort. Picabia's assertion means little, though, given that he had not been present in Zurich at Dada's origins. His comment on Tzara's nationality is in response to the media's accusations that Dada's origins were Germanic.

[Untitled]

1. See note 1 to the "[Untitled]" before last.

2. Erik Satie (1866–1925) had just introduced his "furniture music" at an art gallery opening. This "music not to be listened to" is now generally regarded as the first instance of conscious "ambient music" ("muzak," in its vulgar form). Although the tone of this note is derogatory, Satie and Picabia would become collaborators a few years later.

3. Alexandre Archipenko (1887–1964): a Ukrainian sculptor who had connections to early Dada. The joke is lost in translation: Archipenko is *fermé* (inscrutable, but literally "closed") as a *maison close* (brothel, but literally "closed house").

4. André Favory (1888–1937): a fauvist, and then cubist painter; André Lhote (1885–1962): a fauvist turned cubist who later synthesized pure color with cubist form to make what he called "Synthetic Cubism"; Roger Allard (1885–1961): French poet and critic who proclaimed the advent of the new school

of painting that would become known as Salon Cubism. In one sentence, Picabia puts down two artists and two critics.

5. This line is from Tzara's "Dada Manifesto on Feeble Love and Bitter Love" (*Seven Dada Manifestos*, p. 45).

6. *Zizi* is a childish name for the penis (like "willy" or "peter"); the occasionally cited "Zizi de DADA," though, was also the name of Picabia's Pomeranian dog. One act survives of a Dada play written by Ribemont-Dessaignes in 1921 with the same title.

7. Picabia is presumably referring to the wife of U.S. President Woodrow Wilson, who had suffered his debilitating stroke the previous year, and had also won the 1919 Nobel Peace Prize.

8. Edgar Varèse (1883–1965): the avant-garde composer. The two knew each other in New York, and even lived together after Picabia's wife left for Switzerland. Picabia would periodically poke fun at Varèse's alleged ambition to compose a "Dance of the Cold Water Faucet."

[Untitled]

1. The reference is to the removal of Brancusi's "Princess X" from the Salon des Indépendants that same year on grounds of obscenity. A manifesto in protest was published in *Le Journal du peuple* (25 February 1920), and Picabia was among those who signed it. Paul Signac was president and founder of the Salon, which would reject two of Picabia's three submissions the following year.

2. "ABC" refers to Aragon's Dadaist poem "Suicide," first published in this same issue of *Cannibale* and later collected in his *Mouvement perpetuel*. The poem consists of a simple listing of the alphabet.

3. A response to an unsigned notice that had appeared the week before in *Carnet de la semaine* (18 April 1920), p. 9.

4. In a letter to Picabia (March or April 1920), Cocteau wrote: "I know now why we differ so much and are able to approach each other even so. You are the extreme left, I am the *extreme right* . . ." (Sanouillet, *Dada à Paris*, p. 585). The comment on music alludes to Cocteau's involvement with the music group Les Six (whom Cocteau helped officially announce in January 1920 in the pages of *Comœdia*).

A Silly-Willy's Notebook

1. Picabia's joke doesn't translate; *gratte-cul* translates literally as "ass-scratcher," but it is also French for "rose hips."

2. Duchamp was a great consumer of whiskey for a period of time in New York. When criticized for his drinking, Duchamp declared: "If I didn't drink so much alcohol I would have committed suicide long ago!" (quoted in Naumann, *Making Mischief,* p. 191). Prohibition in America was established on 16 January 1920.

3. André Dunoyer de Segonzac (1884–1974): French painter and graphic artist, and member of the Section d'Or. The Symbolist artist Gustave Moreau (1826–1898) was one of Breton's favorite painters.

To Be Seasick on a Transport of Joy

1. "Watercress closet": *Cresson de pissotières* — literally, "urinalcress." In French, watercress is *cresson de fontaine* — literally, "fountaincress." This pun was Philippe Soupault's stage name for the Dada performance at the Salle Berlioz on 27 March 1920. The play on fountain/urinal evokes Duchamp's infamous 1917 *Fountain.*

It is an odd dedication, given that relations between Picabia and Soupault had always been strained, at best.

Philosophical Dada

1. "I'm sending you *Philosophical Dada,*" Picabia wrote to Tzara (12 February 1920), "dedicated to André Breton, he'll understand why (the artichoke doorknob)" (quoted in Sanouillet, *Dada à Paris,* p. 531). Indeed, Breton wrote Picabia three days later: "DADA is an artichoke doorknob. Nothing could move me more than this intention of yours" (ibid., p. 543). A private joke seems to be at play here, as this potentially surreal object could, after all, be found in many bourgeois homes. One is struck by Breton's essay a few years later, though ("The Disdainful Confession"), in which he states: "Desire . . . the man who said, 'Breton: sure of never having finished with his heart, the knob on his door,' was certainly not mistaken" (*The Lost Steps,* p. 2). Whether or not this man had been Picabia, the connection would seem to be the "artichoke heart," especially in that according to French idiom, a man having such a thing ("il a un coeur d'artichaut") falls in love with every woman he meets.

Art

1. Jean Eugène Robert-Houdin (1805–1871): the French father of "modern magic." Ehrich Weiss later drew his own stage name, Harry Houdini, from that of his "foster father." Robert-Houdin was a best-selling author in his time, and it is worth noting that the book he had been writing when he died, *Magie et physique amusante,* carried an anticipatory echo of Duchamp's later pataphysical notion of "amusing physics."

I Am Javanese

1. An observation that would be subsequently verified by Man Ray in a letter to Tzara (8 June 1921): "Dear Tzara—dada cannot live in New York. All New York is dada, and will not tolerate a rival . . ." (Naumann, *Making Mischief,* p. 143).

Presbyopic–Festival–Manifesto

1. "Je suis français de Paris"—a remark attributed to Jean Cocteau during one of his offended nationalistic reactions to the Dada movement. "Parisian" was for Picabia an adjective even more pejorative than "French."

May Day

1. Marthe Chenal (1881–1947): An opera singer and possibly Picabia's mistress at one point (Marcel Jean claimed this to be the case). She was famous for her rendition of the "Marseillaise" (wrapped in a French flag) on the steps of the Opera on 11 November 1918: a rendition she repeated, bizarrely enough, at the audience's request, to conclude the Dada Festival at the Salle Gaveau. She would later marry René Char.

2. Henry Bataille (1872–1922): a French dramatist and poet. Although he did have artistic inclinations, he is not remembered for them.

3. A desire probably stemming from Apollinaire. When describing the poet's astonishing erudition, Buffet mentioned hummingbird tobacco among the range of topics he once introduced to her (along with the one-winged bird, a subject he had wanted to use for a poem). See Buffet-Picabia, *Rencontres,* p. 70.

4. A reference to Gide's article on Dada (and his attack on Tzara); see "[Aphorisms]," p. 197.

Jesus Christ Rastaquouère

1. Georges Carpentier (1894–1975): French boxer. He was middleweight champion of the world in 1920 when Picabia was writing this, but would be beaten by Jack Dempsey in 1921.

2. This is one of Picabia's classic passages, which begins with an anticipation of what would be the slogan, entirely unconditional, of May 1968: "Never work!" Picabia's apolitical egoism, of course, proffers a different slant. The translation of this paragraph follows that of Sanouillet's transcription from the manuscript, which makes a few small corrections to the published text.

3. Picabia told Sanouillet that this section was written after a lengthy conversation with Breton.

4. According to Gabrielle Buffet, Picabia borrowed this observation from his eight-year-old daughter, Janine.

5. Picabia's imagined scenario evokes a prose piece by Alfred Jarry, "The Passion Considered as an Uphill Bicycle Race."

6. Undoubtedly a nod to, or a quote by, the very bald Ribemont-Dessaignes, who provided three illustrations for the original publication of this book. Better a bald head than a bald idea.

7. The infamous Gilles de Rais, lieutenant to Joan of Arc and subsequent occult necrophile who ritually slaughtered hundreds of children.

8. Echoes of various poets can be discerned in Picabia's list of love definitions, and this section could be read as a Dadaist attack on various conceptions and expressions (or to Picabia's eye, destroyers) of love, starting with his dismissal of Plato. Love as an "opportunity passing by" evokes the ironic melancholy of Jules Laforgue; a "well on a cathedral" echoes Rimbaud's hallucinatory visions, as in "L'Enfance" (with its descending cathedral and ascending lake); love as a "purely chemical reaction" smacks again of Jarry, and of *The Supermale* in particular; and the concluding (and rather brutal) "reflexes of a dead frog" could have easily found a place in Lautréamont's *Maldoror*. All these authors were key figures for the future Surrealists, with the exception of Laforgue, who was nonetheless important to Duchamp.

9. The French name for the herb *Lunaria annua* (also known in English as "honesty") is *monnaies du pape*—literally "pope's money." This marriage of

religion and money makes for a symbol of obvious appeal to Picabia; but furthermore, the plant belongs to the *cruciferae* (or mustard) family. The latent pun between crucifix and mustard explains Picabia's emphasized "mustardy mercy" further on in the poem (see p. 237).

10. A few birds fit this description; one is the martlet (or martin), a footless (and sometimes beakless) heraldic device that according to medieval wildlife writers spent its entire life in the air.

Another possibility is the *Manucodiata,* or "bird of paradise," which was thought to be born footless in paradise, find sustenance in the dew of heaven, and drop to the Earth upon its death. Its scientific name is in fact *Paradisea apoda* (without feet), as the specimens brought back by the Europeans had all had their feet, skin, and sometimes skull removed, and were stuck on a stick.

Along this same line is the hummingbird (*picaflor,* in Spanish), which also was once thought to have no feet, and to be in continual motion. See note 8 to *Unique Eunuch* on the picaflor for its Picabian resonance. Among other things, Mayan legend had it that the hummingbird was the sun in disguise. Given the picaflor's skirt-chasing, sun-loving, "pica"-rooted resonance, Picabia had probably intended this short anecdote as something of a self-portrait, with the one following it as a portrait of his antiart comrade-in-arms.

11. This is undoubtedly Duchamp, who was born in Normandy and whose grandparents ran a café in Auvergne. To label his friend a "neo-cubist," though—given the continual insults Picabia directed at cubism as a whole—seems odd. "Neo–Don Juan" is more in character.

12. In a letter to Tzara, Picabia referred to a recent collection of poems which he considered to be his best yet: *Le Mâcheur de pétards.* No trace of this manuscript has been found, but given that its title could be translated as *The Gun-Chewer,* one is tempted to think that Picabia may have incorporated this missing work into *Jesus Christ Rastaquouère.* The (for Picabia, typical) ambiguity of *pétard,* though, allows it to also take on the slang meaning of "ass," presenting the pun-like possibility of an ass-kisser at the origin of this anecdote.

Duchamp also makes an intriguing, if mysterious, allusion to a "revolver-chewer" in the notes

of *À l'infinitif* (*Writings*, p. 101). Given his other inventions such as the "Chocolate Grinder" (who grinds his own chocolate), one is led to view this revolver-chewer as another onanistic, self-fellating personage.

13. The shit-pump is a device found in Alfred Jarry's works. Whether Picabia is actually borrowing the phrase from Jarry here, though, is uncertain.

14. At the risk of belaboring the obvious, *sucre d'orge*—"sugarstick"—is also slang for the penis.

15. Possibly a snide reference to Rimbaud, whose "Bateau ivre" starts its journey with "Redskins" nailing bargemen to posts.

16. This pun works a bit better in French ("Eau de cologne vertébrale"); it is also borrowed from Picabia's daughter Janine.

17. This is one of Picabia's more quoted phrases; it evokes the simpler one that French students put at the head of their papers when they want their professors to read it: *Lege, quæso* (Please read: a phrase included in the *Larousse* pink pages).

18. Taken from her essay "L'Art ne s'explique pas" (Art does not explain itself), a preface for Picabia's 1918 show at the Galerie Moos in Geneva. (See Gabrielle Buffet-Picabia, *Rencontres*, pp. 225–226.)

19. Pink Pills (*Pilules pink*) were advertised all over Paris at the time with a poster of an elegantly dressed masked man scattering the pills over Paris; the image was appropriated and altered so as to replace the pills with a concealed dagger, to create the first cover image for (and best-known representation of) the master of evil, Fantômas.

20. Arthur Cravan, born Fabian Avenarius Lloyd (1887–1910?): boxer, poet, nephew of Oscar Wilde, and general adventurer, Cravan to this day represents Dadaism incarnate. He and Picabia knew each other in Barcelona when both were escaping the war. Cravan's disappearance at sea remains a mystery, and has become something of a Dada legend. His avoidance of the war and any form of nationalism was as akin to Picabia's attitude as it was in contrast to that of Apollinaire.

21. Jacques-Benigne Bossuet (1627–1704): French prelate and writer.

22. *Dingue* could be translated as "nut case."

23. From Ribemont-Dessaignes's "Manifesto according to Saint Jean Clysopompe," which appeared in *391*, no. 13 (Paris, July 1920), p. 2. *Clysopompe* (which translates roughly as "Enema-pump") is a play on "Chrysostom."

24. Tzara described this poem in a letter to Jacques Doucet (30 October 1922) as an abstract poem, "composed of pure sounds invented by myself and containing no allusion to reality" (*Dada à Paris,* p. 624). It had appeared two years earlier in Richard Huelsenbeck's *Dada Almanac* (p. 58), however, in a different form and in its original context: it comes from a Maori work song for hauling trees.

25. Picabia is referring to two of Tzara's poems, both of which would later be collected in *De nos oiseaux* (Of our birds). "The liquid hanged men" is from "Ange" (Angel), first published in Raoul Hausmann's *Der Dada* (Berlin), no. 1, 1920, but the poem dates from 1916. The comment on gloved snakes refers to a verse from Tzara's "Monsieur AA fait des signes sténographiques à Monsieur Tzara" (Monsieur AA makes stenographic signs at Monsieur Tzara), in which he claims that "snakes now wear gloves." Picabia himself published that poem in *391*, no. 14, in Paris, November 1920. There would appear to be a private exchange between the two given the line that follows in Tzara's poem: "javanese passion in a Rolls-Royce"—alluding to Picabia's poem "I Am Javanese" (see p. 218), and to his passion for automobiles.

Tzara would incorporate his glove-wearing snakes into his "Chanson Dada" (Dada song) the following year, which he sang, to Breton's chagrin, as a conclusion to his testimony at the Barrès Trial (see note to "Masterpiece").

26. Picabia published Duchamp's "Dada Drawing" (better known as the "Tzanck Check") in the first issue of *Cannibale* (April 1920): a drawing of a check which he gave to his dentist for services rendered. Picabia also made his own drawing with this title. This statement follows from his comment on the equivalency in value of dentists and painters in the previous section.

27. Fernand-Anne Piestre Cormon (1845–1924): a master of academic painting. Picabia was a student in his studio, and it was there that he claimed to have contracted his "Cézannaphobia."

Paul-Albert Bernard (1849–1934): muralist, notably at the École de Pharmacie.

28. Joseph Joffre (1852–1931): French general, commanded the French Army at the beginning of World War I.

General Charles Mangin (1866–1923) earned his nickname "The Butcher" in the early stages of World War I.

Louis-Hubert Lyautey (1854–1934): France's Minister of War from 1916–1917.

29. Henry Houssaye (1848–1911): son of Arsène Houssaye, was elected to the Académie Française in 1895, from which he carried out an attack against naturalism.

30. Jean-Baptiste-Siméon Chardin (1699–1779): French painter whose still lifes and everyday subject matter were against the rococo grain of his time.

[Untitled]

1. Picabia is misquoting, to say the least. He may be parodying something Éluard had written in a letter: "I only say Proverb behind mirrors."

2. Mercury was used for treating syphilis, but here, "Mercury" also refers to the famous publishing house, Mercure de France. Rachilde was married to its editor, Alfred Valette.

Antenna

1. A top-quality delicatessen founded in Paris in 1854.

Manifesto Pierced from Behind

1. Paolo Véronèse (1528–1588): Italian painter of the Venetian school, influenced by Titian.

Leon Bonnat (1833–1922): an academic, realist portrait painter, and friend of Degas.

Adolphe-William Bouguereau (1825–1905): worked from the models of Véronèse and Titian, and steeped himself in classicism.

FRANCIS PICABIA IS AN IDIOT:
Anti-Dada, 1921–1924

Francis Picabia and Dada

1. The Café Certa at the place Blanche (famously described by Aragon in *Paris Peasant*) was the locale chosen by Breton and his friends to be their regular meeting place. It thus served, along with Germaine Everling's Louis XV drawing room, as the meeting place for the Parisian Dadaists. After a certain point, it started to take over as a meeting place, something which was probably not to Picabia's liking.

2. The *Nouvelle Revue Française,* through the agencies of André Gide and Jean Paulhan, had encouraged the growing rift among the Dadaists by opening their doors to Breton and company, while summarily dismissing Picabia and Tzara.

3. Picabia is referring to the Barrès Trial; M. Deibler was the last of a family lineage of executioners.

4. "For the time being" hints that Picabia may not have been seeking a definitive end to Dada, but was leaving the door open to the possibility of his regaining control over the group and the movement.

Shingles

1. "Aragon's volume" is *Anicet ou le panorama,* published by the *N.R.F.* in February 1921.

Anatole France (1844–1924): member of the Académie Française, whose state funeral the Surrealists would later attack with their infamous *Un Cadavre.*

Paul-Jean Toulet (1867–1920): a French dandy, poet, and novelist who remains little known in English. *Les Contrerimes,* the slim volume of poems that would establish his fame, was to have originally appeared in 1913, but because of the war it did not actually see print until 31 December 1920, after his death. His best-known novel, *La Jeune fille verte,* appeared this same year. Picabia's sarcasm is rooted in the fact that Toulet's rigorously classical verse was quite against the currents of the time.

391

1. "Ctesse Q" might not be referring to anyone specifically; "Q" sounds like *cul* (ass) in French.

2. Fresnaye had just illustrated a deluxe edition of Gide's *Paludes.*

[Aphorisms]

1. The attributions throughout this issue are, of course, fictitious.

Masterpiece

1. Picabia is referring to Breton's orchestrated "Barrès Trial," from which Picabia made a noisy exit (an exit that could have been anticipated, since he had already publicly renounced Dada a few days before). In this overly serious mock trial, Barrès was tried in absentia for his "Crime against the Security of the Mind." Breton, as Presiding Judge of the Court, pushed for a death sentence.

Picabia's reference to the Gare Saint-Lazare is to one of the planned "Dada excursions," which was never realized. Guns were not to play a part in the event.

[Aphorisms]

1. *G. F.:* Although these initials have been previously attributed to "Guy Funny" (which is to say, to Picabia himself), this is a rare instance in which he is providing an actual, if half-veiled, attribution. One of Gustave Flaubert's wittier "pensées" runs as follows: "As far as insults, silly and stupid remarks, etc., go, I've found that one needn't get angry unless they're said *to your face.* Make all the faces at me that you want to behind my back: my ass is looking at you" (see Flaubert, *Les Pensées,* p. 50).

On the subject of Flaubert, his ironic definition of art from his *Dictionary of Received Ideas* makes for a good application to Picabia: "ART.—It leads to the hospital. What good is it, since it can be replaced by mechanics, which does it better and more quickly" (Flaubert, *Les Pensées,* p. 147).

2. Picabia is probably referring to Max Jacob, a Jew who converted to Catholicism.

3. Paul Poiret was a Parisian fashion designer; he would use designs by artists as backdrops for his models. Picabia himself proved to be ripe, as his painting *The Cacodylic Eye* was employed in just such a fashion.

4. *L'Intransigeant* had claimed the previous year, in reference to Dada (and in a phrase parodied by Éluard in *Proverbe,* no. 2) that "one must break [*violer*] the rules, yes; but to break them, one must know them." The context Picabia places on the verb

changes its nuance. Picabia's preceding aphorism may also have been a response to this article.

[Aphorisms]

1. Ribemont-Dessaignes and Tzara were now looked upon as enemies by Picabia.

2. Pierre de Massot was a young writer who had just put out, through Picabia's financial aid, the first study on Dada. Picabia made him managing editor of *391* starting with this issue, as well as private tutor for his children.

The Pilhaou-Thibaou

1. Picabia is presumably referring to Pierre Jean de Béranger (1780–1857), a French folk poet and lyricist, best remembered for his pro-Napoleon political verse. This would be supported by Picabia's assignation of one of the earlier aphorisms to Napoleon.

Fumigations

1. In the French there is a play here on *rein* (kidney) and *Rhin* (Rhine).

2. Reynaldo Hahn (1875–1947): French composer of incidental music, and a conductor. He became director of the Paris Opera in 1945.

The Cacodylic Eye

1. This "monkeying" phrase evokes Picabia's Dada painting of the previous year (reproduced in *Cannibale,* no. 1), consisting of a stuffed monkey attached to a board, gripping its tail between its legs—an alleged "portrait" of Cézanne, Renoir, and Rembrandt.

[Handout]

1. Tzara had called Picabia a "literary pick-pocket" in *Dada au grand air,* probably in response to Picabia's claim that Dada had more or less started with Duchamp and himself.

2. Speaking in Tzara's defense, Arp stated in *Dada au grand air:* "I am convinced that this word [Dada] has no importance, and only imbeciles and Spanish professors could be interested in dates" (*Dada à Paris,* p. 301).

3. Jean-Auguste-Gustave Binet (known as Jean Binet-Valmer) (1875–1940): a patriotic and once popular novelist, and editor of *La Renaissance Latine.*

4. Theodore Fraenkel (1896–1964): Breton's childhood friend, and one of the few participants in

the Dada movement to have left literature alone (he pursued a career in medicine). He did, however, participate in most of the movement's performances in Paris.

5. Frantz Jourdain was President of the Salon d'Automne. Picabia's submission of *The Hot Eyes* to the Salon this year bore the inscription "Hommage à Frantz Jourdain." To avoid the scandals of the preceding year, Jourdain had Dadaist entries displayed in plain sight (rather than tucked away, as they had been the time before, which provoked an outcry from the Dadaists). Needless to say, scandal was not avoided.

Marijuana

1. William Surrey Hart (1870–1946), an American actor and director, and one of the earliest stars of the cinematic western, was known as "Rio Jim" in Europe.

2. Jean-Louis Forain (1852–1931): French painter and satirist, and an associate of Paul Verlaine and Arthur Rimbaud.

3. Daniel-Henri Kahnweiler (1884–1979): art dealer whose gallery was instrumental in championing Picasso and Braque.

4. Lucien-Victor Guirand de Scévola (1871–1950): French painter best remembered for his works of symbolic idealism.

5. A tune composed by Rudolf Friml (1879–1972), a pianist and composer of operettas and musicals, and an early film composer. He was enormously popular at this time.

6. The Kahnweiler Gallery was on the rue d'Astorg, the Rosenberg Gallery on the rue de la Baume. Both were cubist strongholds.

7. Suicide had been an ongoing obsession for Breton and his associates; Breton had repackaged Jacques Vaché's drug overdose as a suicide, and Jacques Rigaut, who would later succeed in his third attempt, claimed to wear suicide "in his buttonhole." The Surrealists would print their well-known inquiry on suicide in 1924.

The Pine Cone

1. Not to be confused with the French painter and sculptor Jean-Jules-Antoine Lecomte du Nouy. George Baker has pointed me to the inscription Picabia made to Jeanne Lecomte du Nouy on his 1913–1914

work *Chose admirable* à voir (most likely some years after painting it). She also starred in *Cinesketch*.

2. Picabia seems to be "subjectively retaining" a passage from Nietzsche here: "As soon as we see a new image, we immediately reconstruct it with the aid of all our previous experiences, *depending on the degree* of our honesty and justice" (*TGS* 173–174:3:114). This passage also complements Picabia's comments on the effects of taking marijuana while looking at a blank wall in the preceding essay.

3. Sarah Bernhardt (1844–1923), the famous French actress, had made many "farewell tours" after her leg was amputated in 1915. This comment, then, relates indirectly to Picabia's comments on prosthetics in "Presbyopic–Festival–Manifesto."

Tzara's response in *Le Cœur à barbe* was: "As long as there are painters like Picasso, Bracque [*sic*], Gris, sculptors like Lipchitz [*sic*] and Laurens, only an idiot would talk about the death of cubism" (in Sanouillet, *Dada à Paris*, p. 356).

4. *La Connerie-des-Lilas:* A play on the Closerie des Lilas (connerie means, roughly, "bullshit"), where Tzara and others had a public hearing on the Paris Congress and the attacks Breton and the Congress had made against Tzara after his refusal to participate. This hearing proved to be a major factor in the Congress's undoing.

5. The references to top hats and locomotives come from two of the questions the Paris Congress put forward after they had been accused of being too ambiguous in their intentions: "Has the modern spirit always existed? Among so-called modern objects, is a top hat more or less modern than a locomotive?" Breton's opinion on the matter is evident in the fact that Man Ray's drawing of a top hat adorns the covers of the first few issues of the new series of *Littérature*. Tzara, however, replied: "Faced with the honor the Congress committee does me in taking such an intense interest in my person, I have only to remove my top hat and put it on a locomotive which will go off at full speed into the unknown lands of criticism" (in Sanouillet, *Dada à Paris*, p. 342).

6. *Tuyau* is slang for penis; a *tuyau de poêle* is a stovepipe, but to be *à poil* is to be naked (although *poil* on its own is "hair," so a sort of hairy penis is also suggested).

7. This is a response to the Italian Futurist Boccioni's claim that cubism was the "cathedral of the

future." An earlier leaflet (*Dada Stirs Everything,* January 1921), cosigned by Picabia, described cubism as a "cathedral in *pâté de foie gras.*" As Marc Dachy points out in *Dada et les dadaïsmes,* artistic cathedrals were abundant during this period of the avant-garde: Hugo Ball had already designated abstraction as the cathedral of the future, Kurt Schwitters named his first *Merzbau* the "cathedral of erotic misery," and Oskar Schlemmer spoke of constructing a "cathedral of socialism." A Dada manifesto attributed to Walter Conrad Arensberg ("Dada Is American," a text which Arensberg denied having written, and which may actually have been written by Picabia), stated, after a brief dismissal of cubism, that Dada's religion "doesn't come out of a cathedral like appendicitis." And one of Duchamp's intended readymades, the Woolworth Building in New York, was known in its day as the "cathedral of commerce."

Hurdy-Gurdy

1. *Comme une m . . . :* I've made the assumption that "m" is for *merde,* especially given the controversy that had arisen at the beginning of the year over Picabia's submissions to the Salon des Indépendants—one of which bore the inscription "M . . . à celui qui le regarde" (a phrase more commonly found scrawled as graffiti in latrines than on a work of art in those days). Despite Picabia's claim that the phrase was to read *"Merci* to the one who looks at it," he proved to be alone in this reading. With that in mind, however, allowance could be made for the possibility that this line should be translated as "like a th . . ."

Up to a Certain Point

1. Picabia is again referring to Breton's orchestrated Barrès Trial, and also alluding to the phrase Tzara reiterated throughout his "Dada Manifesto on Feeble Love and Bitter Love": "I consider myself very likable."

2. Tzara often told people that he had known Einstein, and would relate this anecdote; whether Einstein had actually said such a thing is questionable.

Thoughts and Memories

1. The Eldorado was a huge and elegant *café-concert* on the boulevard de Strasbourg.

2. Eugène Carrière (1849–1906): French painter and lithographer.

[Untitled]

1. A Nietzschean statement: see *TGS* 223:4:276 (*"Looking away* shall be my only negation").

History of Seeing

1. Riciotto Canudo (1877–1923): Italian Futurist poet and essayist, and an early champion of the cinema, which he named the "seventh art." He became an ardent French patriot and lived in Paris for the second half of his life. The Ballets Suedois performed an adaptation of his 1920 work *Skating Rink* the year Picabia was writing this.

2. Louis de Gonzague Frick (1883–1959): anarchist critic, poet, essayist, and dandy, and one of Apollinaire's most devoted friends.

Typeravings

1. The avenue Henri-Martin was a few blocks down from Everling's house.

2. This is probably a quote; it echoes a phrase that had haunted Unica Zürn from this same time period (a period somewhat notorious for its rash of *Lustmord*): a Berlin defense attorney had claimed (during the trial of a sex murderer) that "not the killer but the victim must be blamed." It had only been a year since Landru had been accused of seducing, killing, and incinerating eight women in his oven.

Travel Souvenirs: The Colonial Exposition of Marseilles

1. This joke must have made the art circle rounds at this time: Salvador Dalí recounts this same *"marseillais story"* in *The Secret Life of Salvador Dalí* (p. 208), as it was told to him by Joan Miró.

2. Paul Morand (1888–1976): A writer whose best-known work, *Ouvert la nuit* (translated by Ezra Pound as *Open All Night*) created a bit of a furor at the time. Picabia renamed Morand "Pierre Moribond" ("Moribund" in English) in his novel *Caravansérail: Morand* sounds like *mourant* (dying) in French.

3. Léon Daudet (1867–1942): son of Alphonse, was a journalist, writer, and editor of the anti-Semitic *L'Action Française.*

[Untitled]

1. Duchamp mentions the same joke in his *Notes:* "the elevator boy—or the indoor aviator" (*Notes,* no. 233).

Tambourine

1. Jacques Doucet (1853–1929): couturier, collector, and sponsor of the arts, on whom Breton and Aragon relied for a period of time as a source of income, Breton as a "librarian," Aragon as a "literary advisor." Breton was responsible for Doucet's acquisition of several important works by Picabia.

With Francis Picabia

1. Picabia is alluding to a cubist technique, but *collage* is also a pejorative term for a romantic liaison.

2. Georges Auric (1899–1983): the youngest member of Les Six, he wrote scores for numerous films, including several by Cocteau. Henri Christiné (1867–1941) and Maurice Yvain (1891–1965) brought innovations to the operetta-revue, introducing jazz and dance rhythms into the format. Both are remembered as being very Parisian music-hall artists.

3. Gustave Le Rouge (1867–1938): a pulp writer who would most likely be all but forgotten if not for the friendship and admiration of Blaise Cendrars; his "Mysterious Doctor Cornelius," though less remembered than other fictional characters by his contemporaries (Fantômas, Nick Carter), was the focus of his best-known series of adventure novels (although Cendrars considered Le Rouge's cookbook to be his literary masterpiece). This citation by Picabia, however, is interesting given this connection with Cendrars, in that it brings up the possibility that he was aware that Cendrars had collaged phrases from Le Rouge to create the poems of *Kodak* (though this was also a method employed by Hans Arp in his early poetry).

Poetic Hypertrophy Tobacco Trophic Hyperpoetry

1. *A ton of aunts . . .*: In French: "Nathan m'attend tant de temps tentant tant de tantes . . . à fuir." See Desnos's "21 Heures le 26-11-22" in *Corps et biens* for the target of Picabia's satire.

2. Cattawi-Menasse is another of Picabia's pseudonyms. "Menasse" sounds like "Menace," but Picabia's intentions here are obscure.

391

1. This would become the first verse of Picabia's poem "Baccarat" (see p. 362). The phrase is from Nietzsche, the "monsters" being the waves of the sea,

with whom he identifies (see *TGS* 214:3:240 and 247:4:310).

2. A rewriting of Nietzsche: "He is running away from people but they follow after him because he is running ahead of them . . ." (*TGS* 206:3:195).

3. Cf. Nietzsche: "What good is a book that does not even carry us beyond all books?" (*TGS* 215:3:248).

4. Cf. Nietzsche: *"What do you love in others?—* My hopes" (*TGS* 220:3:272).

5. The friend Picabia mentions is undoubtedly Blaise Cendrars, whose collection *La Formose* (The Formosa) was published by Au Sans Pareil this same year. (This collection would later become the first part of his *Feuilles de route* [Travel Notes].) Perhaps the best-known poem from this collection is "Orion," which opens: "C'est mon étoile . . ." In this poem, Cendrars relates the star to the hand he had lost in the war.

Cendrars and Picabia had been neighbors a couple of years earlier in the suburbs of Montfort-l'Amaury. At this point, Picabia had taken over, unbeknownst to Cendrars, the writing of the scenario for what would become *Relâche*. The project was originally to have belonged to Cendrars, who was at that point traveling to Brazil. The producers, at Erik Satie's suggestion, approached Picabia to do the decor and costumes, and ultimately, the scenario itself. Cendrars's original script was to commence with a drunken man emerging from a restaurant, which also finds an echo in this brief (and probably invented) anecdote.

Guillaume Apollinaire

1. I have been unable to ascertain what the singular and plural usage of *gas* refers to, save perhaps what it means in English, replacing the French *gaz* in order to keep the singsong rhyme. The pluralization makes this seem unlikely, however; the most likely possibility may be that Apollinaire was just using it as a nonsense word. The first verse is also troublesome: *Gana* cannot refer to Ghana (it was not even a country at that time), and *Tanguy* does not refer to the Surrealist painter (who was not on the scene at the time of this anecdote). That said, an approximate translation would be: "Tanguy of Gana / Have you not seen my gas / Who played the trombona / Who played the flute to my gas / Who played the flute!"

That the song is licentious, though, seems certain: *flûte* is French slang for the penis, and "playing" this instrument is slang for the act of sex (fellatio in particular); I am not aware of a similar formulation in French for the trombone, but the verb form *trombonner* is slang for having sex (and *trombiner* slang for a French "Wham bam thank you ma'am"), as is the phrase *jouer à trombinarès*.

Given the significance of the Jura–Paris trip for the work of all three men, this song is of more consequence than one might at first think, particularly as it coincides with Duchamp's conception of the *Large Glass,* and its mixture of the mechanical and the erotic. (On the same note, it may be worth mentioning that *flûte* can also have mechanical applications, and *trombe* refers to a waterspout.)

2. Maurice Raynal (1884–1954): an art critic of the cubist years.

3. Victor Margueritte (1866–1942): French author best remembered for his 1922 protofeminist novel *La Garçonne.*

Scenario for *Entr'acte*

1. This scene may have been influenced by Duchamp. Compare this with note 197 in his *Notes:* "(slow motion) / Boxing fight— / take a film / of a real boxing / fight—done with / white gloves / and blacken all the / rest of the picture so / that one only sees / the white gloves boxing."

2. The "père Lacolique" is a small figurine, usually made of clay or papier-mâché, of a squatting man with his pants down. By inserting a cylindrical pellet into its bottom and setting it on fire, one can make the figure defecate. This curio seems to have Belgian origins and dates as far back as the 16th century.

3. This is also echoed in Duchamp's *Notes.* See his note 196: "—Screens in rubber, canvas and other / materials / rubber so that it can \ be deformed— by blowing it up. Pressing at certain places / from behind—"

Relâche

1. This ended up being Marthe Chenal (see note for "May Day").

Interview on *Entr'acte*

1. Henry Bordeaux (1870–1963): French Catholic novelist and historical biographer. His book *Yamilé sous les cèdres* (The gardens of Omar) had come out the previous year.

Instantanism

1. A wax museum in Paris that depicts scenes from French history.

SLACK DAYS: After Dada, 1925–1939

The Law of Accommodation among the One-Eyed

1. The editors of the Pléiade edition of Alfred Jarry's works identify Jarry's reference to "transparent cards" as being to a trade in pornographic watermarks; the fact that this commodity has been forgotten might be explained (inadvertently) by the relevant passage from Jarry: "The taxpayer, who salaries a branch of the police force so that they may pursue dealers in transparent cards . . ." (Jarry, *Adventures*, pp. 227–228). Picabia will mention these cards again in his later writings ("transparent cards / populate my dreams"); what makes them interesting is that they may very well have played a role in his lengthy series of "Transparencies"—a possibly licentious framework to his painterly exploration of classicism.

2. The same was provided to the audience at *Relâche.*

Slack Days

1. A reference to Duchamp and his withdrawal from painting.

General Prescription No. 555

1. The President of the Cannes Casino asked Picabia to take on the organization of the "galas" at the *Ambassadeurs,* which Picabia did starting the winter of 1930–31.

[Untitled]

1. This is possibly a play on Nietzsche: "This artist is ambitious, nothing more. Ultimately, his work is merely a magnifying glass that he offers everybody who looks his way" (*TGS* 214:3:241). This allusion would make this an antiart statement, then, in line with Picabia's "carpe diem" articles of this time.

Notice

1. Breton's association with the Communist Party began in 1926, and he briefly joined in 1927. His political convictions led to a number of exclusions from the Surrealist "party," although they weakened considerably by the time Aragon left the Surrealists to join the Communist Party in 1932. Breton finally broke all relations with the Party this year, 1935, when he was denied the right to speak at the Congress of Writers for the Defense of Culture (a bit of a complicated affair that also helped precipitate René Crevel's suicide).

I AM A BEAUTIFUL MONSTER: 1939–1949

Poems of Dingalari

1. Legend has it that while on his deathbed Alfred Jarry asked for a toothpick; when the doctor returned with one, Jarry held it, smiled beatifically, and died. According to William Copley, though, Jarry is an author whom Picabia "systematically refused to read" (Martin and Seckel, *Francis Picabia,* p. 16).

Thalassa in the Desert

1. Cf. Nietzsche: *"What do you love in others?—* My hopes" (*TGS* 220:3:272).

2. This evokes Picabia's late Dadaist work *St. Vitus' Dance* (1922), which consisted of a frame empty save for some cords and a few inscriptions.

3. Four of these last five lines first appeared with Picabia's "Manifesto of the Dada Movement" twenty-five years earlier (see p. 179).

H W P S M T B

1. Cf. Nietzsche: "'My thoughts,' said the wanderer to his shadow, 'should show me where I stand; but they should not betray to me where I am going. I love my ignorance of the future and do not wish to perish of impatience and of tasting promised things ahead of time'" (*TGS* 230–231:4:287).

2. Cf. Nietzsche: "I do not know whether I do not have more reason to be grateful to my failures than to any success" (*TGS* 243:4:303).

The Future-Child

1. Marguerite Hagenbach, also known as Marguerite Arp-Hagenbach: Hans Arp's longtime friend and second wife.

Three Little Poems

1. Nietzsche has a section in *The Gay Science* entitled "Star friendship": "Let us then *believe* in our star friendship even if we should be compelled to be earth enemies" (226:4:279).

2. Picabia is probably using the term "renunciation" the way Nietzsche does in *The Gay Science* (319:5:363): a woman loves through renunciating her rights, a man through possession of them. This isn't Nietzsche at his best, though; nor does it help much to illuminate this minimalist poem.

3. Cf. Nietzsche: "How did logic come into existence in man's head? Certainly out of illogic. . . . Innumerable beings who made inferences in a way different from ours perished; for all that, their ways may have been truer" (*TGS* 171:3:111).

[Untitled]

1. This seems to be Picabia's own phrase (particularly in its hint of nostalgia), but one extrapolated from *TGS* 169:3:110: "Over immense periods of time the intellect produced nothing but errors. A few of these proved to be useful and helped to preserve the species. . . ."

2. Cf. Nietzsche: "How did logic come into existence in man's head? Certainly out of illogic" (*TGS* 171:3:111).

3. In a variant of the relevant section of *The Gay Science* (167:3:108), Nietzsche concludes with the comment that God's shadow is also called "Metaphysics."

4. Cf. Nietzsche: "Love forgives the lover even his lust" (*TGS* 124:2:62).

5. Cf. Nietzsche: "I am afraid that old women are more skeptical in their most secret heart of hearts than any man" (*TGS* 125:2:64).

6. Cf. Nietzsche: "Prayer has been invented for those people who really never have thoughts of their own and who do not know any elevation of the soul or at least do not notice it when it occurs" (*TGS* 184:3:128); the comparison makes Picabia's version particularly misogynistic.

7. Again from *TGS* 182:3:126.

8. "Error, nontruth, and falsehood"—otherwise known as "truth," i.e., "the weakest form of knowledge," according to Nietzsche. See *TGS* 169:3:110 for his elaboration on these terms.

9. Nietzsche describes the "severity of science" as something in which "doing things well is considered the rule, and failure is the exception; but the rule always tends to keep quiet" (*TGS* 235:4:293). If Picabia is indeed referring to this passage (which would be supported by the fact that he refers to it again in *Chi-lo-sa*), then it would enrich his frequent usage of the word "failure" as self-description during his Dada years, but only through a confused reading of Nietzsche, as the philosopher's usage of the terms "rule" and "exception" in this instance are, in the context of

science, the reverse of how he uses them elsewhere (when discussing "herd" morality, for example).

10. Picabia's rewording of Nietzsche makes for an ambiguous statement: "It is raining, and I think of the poor who now huddle together with their many cares and without any practice at concealing these: each is ready and willing to hurt the other and to create for himself a wretched kind of pleasure even when the weather is bad. That and only that is the poverty of the poor" (*TGS* 208:3:206).

11. Cf. Nietzsche: "Laughter means: being *schadenfroh*, but with a good conscience" (*TGS* 207:3:200).

12. Cf. *TGS* 125:2:66.

13. More than one critic at this time chose to use Picabia's phrase against Picabia himself. He is again borrowing from Nietzsche: "This artist offends me by the manner in which he presents his ideas, although they are very good; his presentation is so broad and emphatic and depends on such crude artifices of persuasion, as if he addressed a mob. Whenever we give some time to his art we are soon as if 'in bad company'" (*TGS* 204:3:187).

14. Cf. Nietzsche: "If we had not welcomed the arts and invented this kind of cult of the untrue, then the realization of general untruth and mendaciousness that now comes to us through science . . . would be utterly unbearable" (*TGS* 163:2:107).

15. This is taken out of context from Nietzsche: "Formerly philosophers were afraid of the senses. Have we perhaps unlearned this fear too much?" (*TGS* 332:5:372).

16. This seems to be derived from Nietzsche, although it does not exactly follow its meaning: "If one would hate the way man was hated formerly . . . with the whole *love* of hatred, then one would have to renounce contempt" (*TGS* 341:5:379).

A Matter of Taste

1. Picabia seems to have reversed Nietzsche's sentiment (Nietzsche hates that which is neither); see *TGS*, Rhyme 18: "Narrow souls I cannot abide; / There's almost no good or evil inside."

2. From *TGS*, Rhyme 55: "They paint what happens to delight their heart. / And what delights them? What to paint they're able."

3. This stanza evokes Picabia's short, Nietzschean, explanation of the "ideal" from *The Pine*

Cone: turning from a Vélasquez and toward a Picasso, one's subjective memory of the Vélasquez enables an "objective" viewing of the Picasso. Given that, throughout his career, Picabia never refuted any period of his work for the simple reason that he claimed to not remember any of them, one would think that such a "subjective" image of "nothing, nothing, nothing" would enable an "objective" viewing of nothing. Picabia's lack of certainty here on the matter indicates a certain faltering in his attitude.

Another possible allusion is to the Surrealists' oft-repeated reference to Leonardo da Vinci's advice to his students to look at a wall and paint what they saw in its cracks.

I'VE NEVER BELIEVED IN MYSELF:
Late Writings, 1950–1953

Chi-lo-sa

1. A slight rewriting of Nietzsche: "Anyone who is unyielding nowadays will often have a bad conscience due to his honesty; for being unyielding is a virtue that does not belong to the same age as the virtue of honesty" (*TGS* 198–199:3:159). The fact that Picabia signs this quote with his own name makes for a marked contrast to his Dada years, when he would sign his own, often scandalous, aphorisms with other names (Confucius or St. Augustine, for example).

2. Picabia is playing with the Latin phrase (to be found in the *Larousse* pink pages): *Discem natare doces* (to teach a fish how to swim), i.e., to teach someone their specialty.

3. Cf. Nietzsche: "Of these two speakers, one can show the full rationality of his cause only when he abandons himself to passion" (*TGS* 131:2:76).

4. Cf. Nietzsche: "pain always raises the question about its origin while pleasure is inclined to stop with itself without looking back" (*TGS* 86:1:13).

5. Cf. Nietzsche: "Even if a morality has grown out of an error, the realization of this fact would not as much as touch the problem of its value" (*TGS* 285:5:345). The title of this one again alludes to Picabia's image of the ideal: a hung painting, remembered rather than viewed, which serves as a comparative model for other paintings. Hung, unlooked-at flowers, then, become idealized flowers: an ideal like morality. This goes along with Picabia's earlier statement: "For a man to stop being interesting, it is enough to not look at him" (see p. 293).

6. This poem was first published on its own in November 1949 by PAB in an edition of four copies.

7. A basic Nietzschean concept: "Morality is herd instinct in the individual" (*TGS* 175:3:116).

8. Cf. Nietzsche: "'Rather do anything than nothing': this principle, too, is merely a string to throttle all culture and good taste" (*TGS* 259:4:329).

9. The Salon des Réalités Nouvelles had been championing abstract art since 1939. After the war, it held its "Premier Salon des Réalités Nouvelles" in 1946. Although he had refused to participate in 1939, Picabia's attitude had changed by 1940, whereupon he became an enthusiastic participant. By 1950, however, he had stopped participating, and his continually

fluctuating ambivalence toward abstractionism is evident here.

At the same time, Picabia's impoverished "reality" borrows from Nietzsche's discussion of "so-called reality" (in *TGS* 121–122:2:58).

10. This poem was first published on its own in October 1949 by PAB in an edition of nineteen copies.

11. Although not a particularly profound statement, this mini-poem says a bit more in a Nietzschean context: "An artist chooses his subjects; that is his way of praising" (*TGS* 215:3:245). Picabia could thus be read as stating his inability to praise, a disability which he often demonstrated throughout his career.

12. This poem is extracted from *TGS* 89:1:15.

13. Cf. Nietzsche: "the happiness of a god full of power and love, full of tears and laughter. . . . This godlike feeling would then be called—humaneness" (*TGS* 268–269:4:337).

14. Derived from Nietzsche's own little poem (*TGS* 57:Prelude:39).

15. See the last line of *TGS* 113:1:48; out of context, Nietzsche's meaning gets lost: "There is a recipe against pessimistic philosophers and the excessive sensitivity that seems to me the real 'misery of the present age.' . . . Well, the recipe against this 'misery' is: *misery*."

16. References to, and portraits of, Suzanne Romain (with whom he had his final turbulent relationship) abound in Picabia's art and poetry in these late years.

17. Cf. Nietzsche: "Pity is praised as the virtue of prostitutes" (*TGS* 88:1:13).

18. Compare to Nietzsche's portrait: "this clever, bovine piety, peace of mind, and meekness of country pastors . . . the mild, serious and simple-minded, chaste priestly type" (*TGS* 293:5:351).

19. This poem has been extracted from *TGS* 116:1:54, but Picabia has considerably complicated, through condensation, Nietzsche's analogies. See n. 50 for another instance of Picabia's drawing from this same passage.

20. See n. 4 above.

21. Cf. Nietzsche: "Being at odds with 'a firm reputation,' the attitude of those who seek knowledge is considered *dishonorable* while the petrification of opinions is accorded a monopoly on honor!" (*TGS* 238:4:296).

22. Cf. Nietzsche: "refined contempt is our taste and privilege, our art, our virtue perhaps" (*TGS* 341:5:379).

23. Nietzsche's context makes these the words of a holy man accused of cruelty for advising the father of a deformed child to kill it. See *TGS* 129:2:73.

24. Cf. Nietzsche: "How far the perspective character of existence extends or indeed whether existence has any other character than this; whether existence without interpretation, without 'sense,' does not become 'nonsense' . . . it is a hopeless curiosity that wants to know what other kinds of intellects and perspectives there *might* be" (*TGS* 336:5:374).

25. Although it is obviously impossible to confidently identify one word as a quote, the source of this title might be the last paragraph of *TGS* 76:1:1: "Consequently—. Consequently. Consequently."

26. Cf. Nietzsche: "[Philosophers] thought that the senses might lure them away from their own world, from the cold realm of 'ideas,' to some dangerous southern island. . . . philosophizing was always a kind of vampirism" (*TGS* 332–3:5:372).

27. This title reverses the words of Nietzsche's fool: "how can one constantly admire without constantly feeling contempt?" (*TGS* 209:3:213).

28. From Nietzsche's phrase *Menschen-Unverstand*, which contrasts with *gesunder Menschenverstand* (healthy common sense).

29. Cf. Nietzsche: "Strange and familiar, impure and clean, / A place where fool and sage convene . . . / Dove as well as snake and swine" (*TGS* 45:Prelude:11).

30. Cf. Nietzsche (from a section titled "The Intellectual Conscience"): "Among some pious people I found a hatred of reason and was well disposed to them for that; for this at least *betrayed* their bad intellectual conscience" (*TGS* 76:1:2).

31. Picabia borrows this title from *TGS* 144:2:88.

32. Cf. Nietzsche: "We laugh as soon as we encounter the juxtaposition of 'man *and* world,' separated by the sublime presumption of the little word 'and.' But look, when we laugh like that, have we not simply carried the contempt for man one step further? And thus also pessimism . . .?" (*TGS* 287:5:346).

33. Nietzsche's "question mark" involves a choice between two forms of nihilism (*TGS* 287:5:356), although Picabia may have had another one of his observations in mind here: "Women easily experience

their husband as a question mark concerning their honor" (*TGS* 128:2:71).

34. The inspiration for this title, if not its exact wording, also seems to come from *TGS* 127:2:71.

35. Cf. Nietzsche: "Why is it that warm, rainy winds inspire a musical mood and the inventive pleasure of melodies? Are they not the same winds that fill the churches and arouse thoughts of love in women?" (*TGS* 124–125:2:63).

36. This poem seems to have arisen, at least in part, from Nietzsche: "After Buddha was dead, his shadow was still shown for centuries in a cave. . . . God is dead; but given the way of men, there may still be caves for thousands of years in which his shadow will be shown" (*TGS* 167:3:108).

37. Cf. Nietzsche: "The problem of consciousness (more precisely, of becoming conscious of something) confronts us only when we begin to comprehend how we could dispense with it" (*TGS* 297:5:354).

38. Nietzsche provides a number of things that we should beware of thinking, in a section entitled, appropriately enough, "Let Us Beware" (*TGS* 167:3:109).

39. Cf. Nietzsche: "Women easily experience their husbands as a question mark concerning their honor, and their children as an apology or atonement. They need children and wish for them in a way that is altogether different from that in which a man may wish for children. / In sum, one cannot be too kind about women" (*TGS* 128:2:71).

40. This time Picabia reverses Nietzsche's phrase: "Love forgives the lover even his lust" (*TGS* 124:2:62).

41. Cf. Nietzsche: "*In the horizon of the infinite.*—We have left the land and have embarked" (*TGS* 180:3:124).

42. The title is that of one of Nietzsche's own poems (*TGS* 371:Appendix).

43. Cf. Nietzsche: "For thinkers and all sensitive spirits, boredom is that disagreeable 'windless calm' of the soul that precedes a happy voyage and cheerful winds" (*TGS* 108:1:42). The "dead calm" concluding this poem, then, leads quite naturally into the boredom of the next one.

44. Nietzsche applies this analogy of reverse alchemy to those who preach morality; see *TGS* 235:4:292.

45. Cf. Nietzsche: "Whoever looks into himself as into vast space and carries galaxies in himself, also knows how irregular all galaxies are; they lead into the chaos and labyrinth of existence" (*TGS* 254:4:322).

46. Another reversal; Nietzsche: "Why do you seek on? / Precisely this I seek: The reason why!" (*TGS* 67:Prelude:61).

47. Cf. Nietzsche: "Since I grew tired of the chase / And search, I learned to find" (*TGS* 41:Prelude:2).

48. Cf. Nietzsche: "The times of corruption are those when the apples fall from the tree: I mean the individuals, for they carry the seeds of the future" (*TGS* 98:1:23).

49. This title comes from Nietzsche: "Metaphysics is still needed by some; but so is that impetuous *demand for certainty*" (*TGS* 288:5:347).

50. See *TGS* 116:1:54: Nietzsche discovers existence to work in him, and when he wakes from the dream realizes he must continue to dream— "as a somnambulist must go on dreaming lest he fall."

51. Cf. Nietzsche: "the essential feature of all monological art . . . is based on *forgetting,* it is a music of forgetting" (*TGS* 324:5:367).

52. Cf. Nietzsche: "Well, in this case I have to side with the utilitarians. After all, they are right so rarely that it is really pitiful" (*TGS* 138:2:84).

53. This poem is modeled on a stanza from Nietzsche's "Song of a Theoretical Goatherd": "She promised—she is late—/ She would be mine; / But like a dog I wait, / And there's no sign" (*TGS* 361:Appendix).

54. The concluding line of *TGS* 77:1:2. Nietzsche's "injustice" consists in attributing an intellectual conscience to everyone simply because they are human.

55. An amusing rewriting of the last verse of Nietzsche's "Sils Maria": "Then, suddenly, friend, one turned into two— / And Zarathustra walked into my view" (*TGS* 371:Appendix).

56. Nietzsche ends *The Gay Science* with a poem entitled "To the Mistral" (*TGS* 373:Appendix).

57. This poem is rooted in *TGS* 133:2:79, which is entitled "The Attraction of Imperfection."

58. Nietzsche has a section entitled "Our Air," in which he describes the air of science: a "bright, transparent, vigorous, electrified air"—a "virile air" (*TGS* 235:4:293).

59. Cf. Nietzsche: "He is running away from people but they follow after him because he is

running ahead of them: they are herd through and through" (*TGS* 206:3:195).

60. The conclusion of *TGS* 89:1:14, although what precedes Nietzsche's statement says something of Picabia's regard for friendship: "a shared higher thirst for an ideal above them. But who knows such love? Who has experienced it? Its right name is *friendship*."

61. The title is Nietzsche's; see *TGS* 82:1:8.

62. Plucked out of *TGS* 294:5:351: "as a human being 'communicates himself' he gets rid of himself, and when one 'has confessed' one forgets."

63. See notes 19 and 50 above.

64. Cf. Nietzsche: "The ex-priest and the released criminal keep making faces: what they desire is a face without a past.—But have you ever seen people who know that their faces reflect the future and who are so polite to you who love the 'age' that they make a face without future?" (*TGS* 199:3:161).

65. Cf. Nietzsche: "Silly maxims, made in haste" (*TGS* 353:Appendix). The poem also echoes Nietzsche's "The Mysterious Bark": "Last night all appeared to doze, / Unsteady the wind that wailed / Softly lest it break repose" (*TGS* 359:Appendix).

66. For the title, see *TGS* 116:1:54.

67. Nietzsche's critique of the theater leads him to speak of "Theater and music as the hashish-smoking and betel-chewing of the European" (*TGS* 142:2:86).

68. Cf. Nietzsche: "Few people have faith in themselves. Of these few, some are endowed with it as with a useful blindness or a partial eclipse of their spirit" (*TGS* 229:4:284).

69. Although not a quote, this observation seems to be derived from *TGS* 225:4:278.

70. Cf. Nietzsche: "Consciousness is the last and latest development of the organic and hence also what is most unfinished and unstrong" (*TGS* 84:1:11). Picabia had published a fuller version of this quote in his last issue of *391*, signed by "An Instantaneist."

71. Cf. Nietzsche: "All women are subtle in exaggerating their weaknesses" (*TGS* 125:2:66).

72. Cf. Nietzsche: "what seduces men most surely is a certain secretive and phlegmatic tenderness" (*TGS* 130:2:74).

73. The last line of *TGS* 133:2:79.

74. From *TGS* 239:4:298. Nietzsche's "bird" is an insight, which he seizes with "poor words" that

ultimately kill it—a parable for a "thought *with* language."

75. Again rewriting Nietzsche, who said: "Thoughts are the shadows of our feelings" (*TGS* 203:3:179).

76. Although this isn't the first time Picabia uses this particular phrase by Nietzsche, this time he alters it, as the original stated the same thing about *old* women (*TGS* 125:2:64).

77. A paraphrase of Nietzsche; see *TGS* 236–237:4:295.

78. See *TGS* 297:5:354. *La conscience,* however, can also translate as the "conscience," which would be the sense more in keeping with Picabia's reading of Nietzsche. I have chosen to retain Nietzsche's original sense.

79. Picabia has altered Nietzsche's statement: *"All of us are no longer material for a society"* (*TGS* 304:5:356).

80. Cf. Nietzsche: "To this day the task of *incorporating* knowledge and making it instinctive is only beginning to dawn on the human eye and is not yet clearly discernible" (*TGS* 85:1:11).

81. Cf. Nietzsche: "There are noble women who are afflicted with a certain poverty of the spirit, and they know no better way to *express* their deepest devotion than to offer their virtue and shame" (*TGS* 125:2:65).

82. This question is derived from *TGS* 286–287:5:346: "The whole pose of 'man *against* the world,' of man as a 'world-negating' principle, of man as the measure of the value of things, as judge of the world who in the end places existence itself upon his scales and finds it wanting—the monstrous insipidity of this pose has finally come home to us and we are sick of it."

83. See *TGS* 131:5:77 (Nietzsche speaks of Southern *Europe,* though): "The vulgar element in everything that gives pleasure in Southern Europe . . . does not escape me. . . ."

84. This poem was first published on its own in September 1949 by PAB in an edition of thirteen copies.

85. Cf. Nietzsche: "I heard one of the common people say, 'he knew me right away.' Then I asked myself: What is it that common people take for knowledge?" (*TGS* 300:5:355).

86. Cf. Nietzsche: "Who has had the most convincing eloquence so far? The drum roll" (*TGS* 202:3:175).

87. Picabia reverses Nietzsche's statement: "All experiences are moral experiences, even in the realm of sense perception" (*TGS* 174:3:114).

88. Cf. Nietzsche: "Regarding all aesthetic values I now avail myself of this main distinction: I ask in every instance, 'is it hunger or superabundance that has here become creative?'" (*TGS* 329:5:370).

89. From *TGS* 115:1:51: "I favor any *skepsis* to which I may reply: 'Let us try it!' But I no longer wish to hear anything of all those things and questions that do not permit any experiment. This is the limit of my 'truthfulness'; for there courage loses its right."

90. This poem was first published on its own in September 1949 by PAB in an edition of twenty-five copies.

91. A twist on Nietzsche: "perhaps we shall meet again but fail to recognize each other. . . . Let us then *believe* in our star friendship even if we should be compelled to be earth enemies" (*TGS* 226:4:280).

92. This poem is a condensation of the ending of the first section of *The Gay Science:* "the short tragedy always gave way again and returned into the eternal comedy of existence. . . . man *has* to believe, to know, from time to time *why* he exists. . . . The most cautious friend of man will add: 'Not only laughter and gay wisdom but the tragic, too, with all its sublime unreason, belongs among the means and necessities of the preservation of the species'" (*TGS* 75–76:1:1).

93. This poem was first published on its own in November 1949 by PAB in an edition of thirty-three copies.

94. Cf. Nietzsche: "the path to one's own heaven always leads through the voluptuousness of one's own hell" (*TGS* 269:4:338).

95. Cf. Nietzsche: "I have given a name to my pain and call it 'dog'" (*TGS* 249:4:312).

For and Against

1. If one accepts the reference mentioned just above for this opening, then this shifts Picabia's discussion of love to a discussion of love for *oneself;* the lover in Nietzsche's text wants to conceal his or her faults to spare the beloved any suffering. Picabia, then, wants to conceal his faults from himself to prevent *himself* from suffering.

2. Cf. Nietzsche: "any small dejection and nausea was quite enough in the end to spoil life for Homer. He had been unable to guess a foolish little riddle posed to him by some fisherman" (*TGS* 242–243:4:302).

3. Picabia continues his variations on this phrase of Nietzsche's (*TGS* 125:2:64): first old women, then very young women, and now specifically thirty-year-old women strike him as being the best skeptics.

4. *TGS* 127:2:71.

5. Picabia has Y continue to draw from this same section of *The Gay Science,* but changes the *children,* which Nietzsche cites as the woman's "apology or atonement" (Nietzsche's context is actually criticizing this misogynist notion), into men. The substitution is significant, as it is one that Picabia made more than once, and blurs a line that he himself blurred throughout his life.

6. Also quoting Nietzsche, who just refers to "animals," not specifically lions. See *TGS* 129:2:72.

7. He may have, but he didn't. Nietzsche's observation is one of his odder ones: "'A small man is a paradox but still a man; but small females seem to me to belong to another sex than tall women,' said an old dancing master. A small woman is never beautiful—said old Aristotle" (*TGS* 130:2:75).

8. See *TGS* 89:1:14.

Poetic Humor

1. An approximation of the famous words of Nietzsche's madman, who proclaims the death of God: "'What after all are these churches now if they are not the tombs and sepulchers of God?'" (*TGS* 182:3:125).

2. Cf. Nietzsche: "One speaks of being sick of man only when one can no longer digest him and yet has one's stomach full of him. Misanthropy comes of an all too greedy love of man and 'cannibalism'; but who asked you to swallow men like oysters, Prince Hamlet?" (*TGS* 200:3:167). By implication, then, Picabia roots his notion of humor in misanthropy— *Nietzsche's* conception of misanthropy, though, which is rooted in an unrestrained love of man.

3. The poetic humor of this phrase is probably related to Picabia's promotion from Knight to Officer of the Legion of Honor on 20 March 1950.

4. See n. 2.

5. Another variation of Nietzsche's "recipe against misery": "the recipe against this 'misery' is: *misery*" (*TGS* 113:1:48). For the title of this poem, see n. 58 to *Chi-lo-sa*.

6. Again, a slight rewriting of Nietzsche: "'True to nature, all the truth: that's art.' / . . . They paint what happens to delight their heart. / And what delights them? What to paint they're able" (*TGS* 65:Prelude:55).

7. Cf. Nietzsche: "Its nostrils proud and pliant, / The nose looks out defiant. / That's why, a rhino without horn, / You fall forward, proud little man; / And straight pride generally grows / Together with a crooked nose" (*TGS* 65:Prelude:58).

8. Another use of *TGS* 208:3:206. See n. 10 to [Untitled] (p. 468).

What I Desire Is a Matter of Indifference to Me, Whether I Can Get It, That's What Counts

1. Cf. Nietzsche: "Take a chance and try my fare: / It will grow on you, I swear; / Soon it will taste good to you" (*TGS* 41:Prelude:1).

2. These two lines reverse Nietzsche's claim: "Since I grew tired of the chase / And search, I learned to find" (*TGS* 41:Prelude:2).

Sunday

1. The preceding is straight from *TGS* 104:1:35.

The Masked Saint

1. See Nietzsche's poem, "The Skeptic Speaks" (*TGS* 67:Prelude:61).

2. From *TGS* 61:Prelude:48.

3. From *TGS* 57:Prelude:39.

4. From *TGS* 57:Prelude:41.

5. From *TGS* 59:Prelude:45.

6. Also from *TGS* 59:Prelude:45.

7. From *TGS* 61:Prelude:49.

8. Is Picabia deliberately misreading Nietzsche? The original verse: "'All keys ought to go to hell, anon, / And in every keyhole be replaced / by a skeleton! / That has always been the taste / Of all who feel they matter / Because they are the latter" (*TGS* 63:Prelude:51). Whether intentionally or not, then, Picabia is taking on a deprecatory role in these lines.

9. From *TGS* 63:Prelude:50.

10. From *TGS* 61:Prelude:49.

11. See n. 8.

591

1. This poem is a melange of fragments from *TGS* 252:4:318 and 254:4:322.

2. Cf. Nietzsche: "Man has been educated by his errors" (*TGS* 174:3:115).

3. Cf. Nietzsche: "Perhaps there is nothing that separates men or ages more profoundly than a difference in their knowledge of misery: misery of the soul as well as the body" (*TGS* 112:1:48).

4. Picabia alters Nietzsche: "free spirits take liberties, even with science" (*TGS* 203:3:180).

5. These three stanzas come from *TGS* 255:4:324.

6. Nietzsche makes the same comparison: "Now she loves him and looks ahead with quiet confidence—like a cow" (*TGS* 125:2:67).

7. Another rewriting of Nietzsche: "What good is a book that does not even carry us beyond all books?" (*TGS* 215:3:248).

8. Nietzsche (in *Ecce Homo*): "I am the *anti-ass par excellence* and thus a world historical monster" (*Basic Writings of Nietzsche*, p. 719). It is worth noting that Picasso made the same claim in his journal *Comedy*: "I am the anti-painter par excellence; I am but a humble poet" (quoted in Huidobro, *Manifestos*, p. 61).

Mounted Flower

1. This title echoes that of one of *Chi-lo-sa's* poems (see n. 5 to that work).

Are We Not Betrayed by Seriousness

1. From *TGS* 121:2:57.

2. From *TGS* 324:5:367.

3. From *TGS* 142:2:86.

4. This title, and the two following, are all from *TGS* 239:4:298.

5. From *TGS* 254:4:320.

6. From *TGS* 224–225:4:278.

7. Cf. Nietzsche: "Thoughts are the shadows of our feelings" (*TGS* 203:3:179).

8. From *TGS* 204:3:187; see also n. 13 to "[Untitled]" (p. 468).

9. Cf. Nietzsche: "We love what is great in nature, and we have discovered this—because in our heads great human beings are lacking. It was the other way around with the Greeks: their feeling for nature was different from ours" (*TGS* 198:3:155).

10. See n. 8.

11. Cf. Nietzsche: "So far, he is running with the crowd and singing its praises; but one day he will become its enemy. For he is following it in the belief that this will allow his laziness full scope, and he has not yet found out that the crowd is not lazy enough for him, that it always pushes on, that it never allows anyone to stand still. And he loves to stand still" (*TGS* 201:3:170).

[Reply to a Survey]

1. Lines 1–3 are from *TGS* 240:4:299.
2. Lines 4–9 are from *TGS* 240:4:300.
3. Lines 13–17 are from *TGS* 242:4:301.
4. Line 19 is from *TGS* 243:4:303.
5. Lines 23–25 are derived from *TGS* 218:3:261.
6. Lines 26–27 are from *TGS* 230–231:4:287.

Yes No Yes No Yes No

1. This comment echoes back to an article from 1931 by Camille Mauclair (*Le Figaro,* 10 November 1931, pp. 1–2), which did not attack Picabia directly, but was aggressive enough to elicit his response. Among Mauclair's comments: "If painting is sick, it is because of those painting, and of their barnums."

MY PENCIL BUCKLES: Posthumous Writings

Or Else One Doesn't Dream

1. Nietzsche's original phrase speaks of a book, not a woman; see *TGS* 215:3:248.
2. Nietzsche says that it is the "poor" who misunderstand his voluntary poverty; see *TGS* 204:3:185.
3. From *TGS* 201:3:170.
4. Cf. Nietzsche: "As yet he does not have the poverty of the rich who have already counted all their treasures once; he is squandering his spirit with the unreason of squandering nature" (*TGS* 207:3:202).
5. Cf. Nietzsche: "the spirits who seek rest I recognize by the many *dark* objects with which they surround themselves" (*TGS* 199:3:164).
6. This narcotic is Nietzsche's description of the bourgeois theater; see *TGS* 141–142:2:86.
7. From *TGS* 219:3:265.
8. Cf. Nietzsche: "If you are always profoundly occupied, you are beyond all embarrassment" (*TGS* 216:3:254).
9. From *TGS* 208:3:207.
10. Nietzsche is clearer: "I'd sooner have people steal from me than be surrounded by scarecrows and hungry looks" (*TGS* 204:3:184).

BIBLIOGRAPHY

The following books have all informed, to varying degrees, my work on this book. Maria Lluïsa Borràs's monograph on Picabia, and the work of Michel Sainouillet as a whole, proved to be particularly useful, and were constant companions throughout the years I put together these translations and their notes.

I am also indebted to the University of Iowa, whose online Dada Archives (http://www.lib.uiowa .edu/dada/) enabled me to consult the original editions of a number of Picabia's publications.

Apollinaire, Guillaume. *The Cubist Painters.* Translated by Peter Read. Berkeley: University of California Press, 2004.

Aragon, Louis. *Paris Peasant.* Translated by Simon Watson Taylor. Boston: Exact Change, 1994.

Arp, Jean. *Arp on Arp: Poems, Essays, Memories.* Edited by Marcel Jean, translated by Joachim Neugroschel. New York: The Viking Press, 1972.

Ball, Hugo, Richard Huelsenbeck, and Walter Serner. *Blago Bung Blago Bung Bosso Fataka!: First Texts of German Dada.* Translated and introduced by Malcolm Green. London: Atlas Press, 1995.

Benoit, P. A. *À Propos des "Poèmes de la fille née sans mere."* Alès: PAB, undated.

Benson, Timothy O. *Raoul Hausmann and Berlin Dada.* Ann Arbor: UMI Research Press, 1987.

Bochner, Jay. *Blaise Cendrars: Discovery and Re-creation.* Toronto: University of Toronto Press, 1978.

Borràs, Maria Lluïsa. *Picabia.* New York: Rizzoli, 1985.

Breton, André. *Anthology of Black Humor.* Translated with an introduction by Mark Polizzotti. San Francisco: City Lights, 1997.

Breton, André. *Conversations: The Autobiography of Surrealism.* Translated with an introduction by Mark Polizzotti. Reprint, New York: Marlowe, 1993.

Breton, André. *The Lost Steps.* Translated by Mark Polizzotti. Lincoln: University of Nebraska Press, 1996.

Breton, André. *Manifestoes of Surrealism.* Translated by Richard Seaver and Helen R. Lane. Ann Arbor: University of Michigan Press, 1969.

Breton, André. *Surrealism and Painting.* Translated by Simon Watson Taylor. New York: Harper and Row, 1972.

Briggs, Isaac G. *Epilepsy, Hysteria, and Neurasthenia: Their Causes, Symptoms, and Treatment.* London: Methuen, 1921.

Buffet-Picabia, Gabrielle. *Rencontres avec Picabia, Apollinaire, Cravan, Duchamp, Arp, Calder.* Paris: Pierre Belfond, 1977.

Cabanne, Pierre. *Dialogues with Marcel Duchamp.* Translated by Ron Padgett. 1971. Reprint, New York: Da Capo Press, Inc., 1987.

Camfield, William A. *Francis Picabia: His Art, Life and Times.* Princeton, N.J.: Princeton University Press, 1979.

Clair, René. *"À Nous la Liberté" and "Éntr'Acte."* Translation and description of the action by Richard Jacques and Nicola Hayden. New York: Simon and Schuster, 1970.

Collectif. *Francis Picabia. Singulier ideal, Musée d'Art moderne de la Ville de Paris, 16 novembre–16 mars 2003.* Paris: Association Paris-Musées, 2002.

Conley, Katharine. *Automatic Woman: The Representation of Woman in Surrealism.* Lincoln: University of Nebraska Press, 1996.

Dachy, Marc. *Dada et les dadaïsmes.* Paris: Éditions Gallimard, 1994.

Dalí, Salvador. *The Secret Life of Salvador Dalí.* Translated by Haakon M. Chevalier. New York: Dover Press, 1993.

Dickerman, Leah, and Matthew S. Witkovsky, eds. *The Dada Seminars.* New York: Distributed Art Publisher, 2005.

Duchamp, Marcel. *Ingénieur du temps perdu: entretiens avec Pierre Cabanne.* Paris: Pierre Belfond, 1967 and 1977.

Duchamp, Marcel. *Marcel Duchamp, Notes.* Edited and translated by Paul Matisse. Boston: G. K. Hall, 1983.

Duchamp, Marcel. *The Writings of Marcel Duchamp.* Edited by Michel Sanouillet and Elmer Peterson. New York: Da Capo Press, 1989.

Everling, Germaine. *L'Anneau de Saturne.* Paris: Fayard, 1970.

Flaubert, Gustave. *Les Pensées suivi du dictionnaire des idées reçues.* Paris: le cherche midi éditeur, 1993.

Gough-Cooper, Jennifer, and Jacques Caumont. *Ephemerides on and about Marcel Duchamp and Rose Sélavy, 1887–1968.* In *Marcel Duchamp: Work and Life.* Edited by Pontus Hulten. Cambridge, Mass.: MIT Press, 1993.

Huelsenbeck, Richard, ed. *The Dada Almanac.* Presented by Malcolm Green. London: Atlas Press, 1993.

Huidobro, Vicente. *Manifestos Manifest.* Translated by Gilbert Alter-Gilbert. Los Angeles: Green Integer, 1999.

Jarry, Alfred. *Adventures in 'Pataphysics: Collected Works I.* Translated by Paul Edwards and Antony Melville. London: Atlas Press, 2001.

Jones, Amelia. *Irrational Modernism: A Neurasthenic History of New York Dada.* Cambridge, Mass.: MIT Press, 2004.

Krauss, Rosalind E. *The Picasso Papers.* Cambridge, Mass.: MIT Press, 1999.

Le Bot, Marc. *Francis Picabia et la crise des valeurs figuratives, 1900–1925.* Paris: Éditions Klincksieck, 1968.

Lippard, Lucy, ed. *Dadas on Art.* New York: Prentice-Hall, 1971.

Martin, Jean-Hubert, and Hélène Seckel, eds. *Francis Picabia.* Paris: Centre National d'Art et de Culture Georges Pompidou, 1976.

Massot, Pierre de. *Francis Picabia.* Paris: Seghers, 1966.

Motherwell, Robert, ed. *The Dada Painters and Poets: An Anthology,* second edition. Cambridge, Mass.: The Belknap Press of Harvard University Press, 1981.

Naumann, Francis M., with Beth Venn, ed. *Making Mischief: Dada Invades New York.* New York: Whitney Museum of American Art, 1996.

Nietzsche, Friedrich. *Basic Writings of Nietzsche.* Edited and translated by Walter Kaufmann. New York: Random House, 1968.

Nietzsche, Friedrich. *The Gay Science; with a Prelude in Rhymes and an Appendix of Songs.* Translated with commentary by Walter Kaufmann. New York: Vintage Books, 1974.

Nietzsche, Friedrich. *Poems: German–English.* Translated by Olga Marx. Zug: Edition Sven Erik Bergh, 1973.

Nietzsche, Friedrich. *The Portable Nietzsche.* Edited and translated by Walter Kaufmann. New York: The Viking Press, 1954.

Pascal, Blaise. *Pensées.* Translated by W. F. Trotter. New York: E. P. Dutton, 1931.

Picabia, Francis. *Écrits: 1913–1920.* Edited by Olivier Revault d'Allonnes. Paris: Pierre Belfond, 1975.

Picabia, Francis. *Écrits: 1921–1953 et posthumes.* Edited by Olivier Revault d'Allonnes and Dominique Bouissou. Paris: Pierre Belfond, 1978.

Picabia, Francis. *Lettres à Christine 1915–1951, suivi de Ennazus.* Edited by Jean Sireuil. Paris: Éditions Gérard Lebovici, 1988.

Picabia, Francis. *Poèmes.* Edited by Carole Boulbès. Paris: Mémoire du Livre, 2002.

Picabia, Francis. *Poèmes et dessins de la fille née sans mere.* Paris: Allia, 1998.

Picabia, Francis. *391: Revue publiée de 1917 à 1924 par Francis Picabia.* Edited by Michel Sanouillet. Paris: Pierre Belfond and Eric Losfeld, 1960.

Picabia, Francis. *Who Knows*. Translated by Rémy Hall. New York: Hanuman Books, 1986.

Picabia, Francis. *Yes No: Poems and Sayings*. Translated by Rémy Hall. New York: Hanuman Books, 1990.

Pierre, Arnauld. *Francis Picabia: La peinture sans aura*. Paris: Gallimard, 2002.

Polizzotti, Mark. *Revolution of the Mind: The Life of André Breton*. New York: Farrar, Straus, and Giroux, 1995.

Richter, Hans. *Dada: Art and Anti-Art*. Translated by David Britt. New York: Oxford University Press, 1978.

Rothenberg, Jerome, ed. *Revolution of the Word: A New Gathering of American Avant-Garde Poetry*. Boston: Exact Change, 1997.

Rothenberg, Jerome, and Pierre Joris, eds. *Poems for the Millennium, volume 1*. Berkeley: University of California Press, 1995.

Sanouillet, Michel. *Dada à Paris*. New edition reviewed and corrected by Anne Sanouillet. Paris: Flammarion, 1993.

Sanouillet, Michel. *Francis Picabia et "391": tome II*. Paris: Eric Losfeld, 1966.

Satie, Erik. *A Mammal's Notebook: Collected Writings of Erik Satie*. Translated by Antony Melville. London: Atlas Press, 1997.

Sawelson-Gorse, Naomi, ed. *Women in Dada: Essays on Sex, Gender, and Identity*. Cambridge, Mass.: MIT Press, 1999.

Stirner, Max. *The Ego and Its Own*. Edited by David Leopold. Translated by Steven Tracy Byington. Cambridge: Cambridge University Press, 1995.

Tzara, Tristan. *Œuvres complètes, tome I, 1912–1924*. Edited by Henri Béhar. Paris: Flammarion, 1975.

Tzara, Tristan. *Seven Dada Manifestos and Lampisteries*. Translated by Barbara Wright. New York: Riverrun Press, 1992.